ALSO BY MILES HARVEY

The Island of Lost Maps:
A True Story of Cartographic Crime

Painter in a Savage Land

RANDOM HOUSE | NEW YORK

MILES HARVEY

Painter in a
Savage Land

THE STRANGE SAGA

OF THE FIRST

EUROPEAN ARTIST IN

NORTH AMERICA

Published in the United States by Random House, an imprint of The Random House Publishing Group, a division of Random House, Inc., New York.

RANDOM HOUSE and colophon are registered trademarks of Random House, Inc.

Illustration credits can be found on p. 339.

Grateful acknowledgment is made to the following for permission to reprint previously published material:

THE BRITISH MUSEUM PRESS: Excerpts from *The Work of Jacques Le Moyne de Morgues: A Huguenot Artist in France, Florida and England*, Foreword, catalog and introductory studies by Paul Hulton, copyright © 1977 by the Trustees of the British Museum. Reprinted by permission. SARAH LAWSON: With thanks to reprint text from her translation of René de Laudonnière's *L'histoire Notable de la Floride* from the book *A Foothold in Florida*. TERRY LORANT: Excerpt from *The New World* by Stefan Lorant. Reprinted by permission of Terry Lorant on behalf of the Lorant family. THE UNIVERSITY PRESS OF FLORIDA: Excerpts from *Pedro Menéndez de Avilés: Memorial*, by Gonzalo Solís de Merás, translated by Jeannette Thurber Connor (University Press of Florida: Gainesville, FL, 1964); excerpts from *Pedro Menéndez de Avilés: Founder of Florida*, by Bartolomé Barrientos, translated by Anthony Kerrigan (University Press of Florida: Gainesville, FL, 1965); excerpts from *Laudonnière & Fort Caroline: History and Documents*, compiled by Charles E. Bennett (University Press of Florida: Gainesville, FL, 1964); excerpts from *Three Voyages*, by René Laudonnière, translated by Charles E. Bennett (University Press of Florida: Gainesville, FL, 1975); and excerpts from *Settlement of Florida*, compiled by Charles E. Bennett (University Press of Florida: Gainesville, FL, 1968). Reprinted by permission.

LIBRARY OF CONGRESS CATALOGING-IN-PUBLICATION DATA

Harvey, Miles.
Painter in a savage land: the strange saga of the first European artist in North America/Miles Harvey.
p. cm.
Includes bibliographical references.
ISBN 978-1-4000-6120-4
1. Le Moyne de Morgues, Jacques, d. 1588. 2. Botanical artists—France—Biography.
3. French—North America—Biography. 4. Colonists—North America—Biography.
5. Plants—Florida—History—16th century. 6. Le Moyne de Morgues, Jacques, d. 1588—Relations with Indians. 7. Timucua Indians—Florida—History—16th century.
8. Florida—History—Huguenot colony, 1562–1565. 9. Spaniards—Florida—History—16th century. 10. Florida—Ethnic relations—History—16th century. I. Title.
QK98.183.L4H37 2008
759.4—dc22
[B] 2007039105

Printed in the United States of America on acid-free paper

www.atrandom.com

2 4 6 8 9 7 5 3 1

FIRST EDITION

Book design by Barbara M. Bachman

IN MEMORY OF

MAE FISHER, MILES BURFORD,

BOB REID, AND JAMES WEINSTEIN

BELOVED MENTORS

IT IS NOT UNUSUAL IN HUMAN BEINGS WHO HAVE WITNESSED THE SACK OF A CITY OR THE FALLING TO PIECES OF A PEOPLE TO DESIRE TO SET DOWN WHAT THEY HAVE WITNESSED FOR THE BENEFIT OF UNKNOWN HEIRS OR OF GENERATIONS INFINITELY REMOTE; OR, IF YOU PLEASE, JUST TO GET THE SIGHT OUT OF THEIR HEADS.

~ Ford Madox Ford

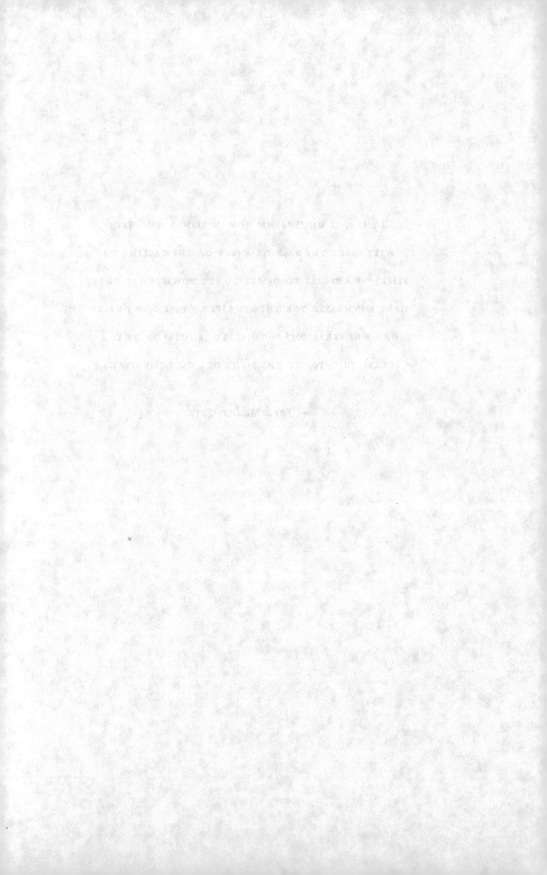

CONTENTS

...

Unstill Life

. . .

"ONE HUNDRED AND TWENTY THOUSAND DOLLARS. LAST CHANCE," said the auctioneer, peering around the crowded salesroom, his hammer cocked in anticipation. "At one hundred and twenty thousand—and down it goes!"

The hammer fell with a sharp crack. "At one hundred and twenty thousand dollars. Sold!"

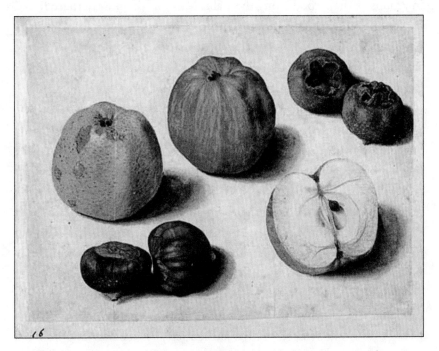

A watercolor study of apples, chestnuts, and medlars, attributed to Jacques Le Moyne de Morgues.

To the auctioneer's right stood a painting as unostentatious as it was enigmatic. Measuring just under six inches tall by not quite eight inches wide, the watercolor—an austere still life with apples, chestnuts, and medlars arranged on a plain white background—seemed somehow too small, too stark, to fetch such an extravagant price. These were not its only incongruities. There was no signature on the painting, nor had any information been made publicly available about the provenance of this previously unknown work, dated to the mid-1500s. Lost to history for more than four centuries, it had suddenly appeared, with great fanfare but little explanation, in a sale at Sotheby's, the venerable auction house.

This was in late January of 2004, a time when art collectors, curators, and dealers from all over Europe and America had congregated in Manhattan for a week devoted to auctions of drawings by old masters. The annual event typically features, in the words of one industry journal, "a great deal of schmoozing, drinking, and malicious gossip," but on this day the mood was sober and tense as buyers jammed into the salesroom, nervously fingering catalogs as they shifted in their seats or whispering in groups as they stood along the walls. Many of them were there to bid on the season's star attractions: a group of twenty-seven natural-history paintings, including the one that had just sold for $120,000. These works, painted in watercolor and gouache over traces of black chalk, had been executed in the sixteenth century but only recently rediscovered.

The artist to whom they were attributed was as mysterious as the paintings themselves. For hundreds of years, he was little more than a historical footnote, his name mentioned only on the browned pages of a few old books and kept alive by a small group of specialized historians and collectors. The better part of his work remained unknown, the breadth of his interests and achievements unrecognized. It was only in the twentieth century, as more of his paintings were properly identified, that he began to gain wider fame and academic attention. Yet even today his life story is full of gaps and riddles.

This sale marked the first major discovery of his work in more than forty years. And while none of the paintings were signed, the bidders were obviously convinced of their authenticity. As the morning wore on, prices spiraled skyward on one small watercolor after another: $85,000

for a study of a dragonfly, a stag beetle, two narcissi, and a columbine; $95,000 for a gillyflower, two wild daffodils, a lesser periwinkle, and a red admiral butterfly; $100,000 for five clove pinks. The purchasers included private collectors and prominent dealers, as well as such august institutions as the Metropolitan Museum of Art in New York and the J. Paul Getty Museum in Los Angeles. Dead for more than four centuries and for most of those years virtually forgotten, Jacques Le Moyne de Morgues was suddenly an artist very much in demand.

BY THE TIME I walked into the salesroom that morning, my own interest in this perplexing figure had already blossomed into a consuming curiosity. It had begun three years earlier, in the manner of so many memorable adventures: with an unintended detour.

In February of 2001, as part of the promotional effort for my earlier book, *The Island of Lost Maps: A True Story of Cartographic Crime,* I found myself in Jacksonville, Florida, at a literary festival affiliated with the city's public library. My first morning in town had been spent doing lectures before classes of half-awake high school students, and by the time it was over I was jet-lagged and ready to head back to the hotel.

Mark Allen had other ideas. An affable retiree who was donating his time to the festival, Mark was assigned to get me where I needed to go that weekend. We had struck up a quick rapport. He had lived an interesting life and, better yet, knew how to make good stories of it. Earlier that day, he nonchalantly flipped a street atlas into my hands, said, "Here, you're the map guy," and appointed me navigator. Then he launched into some marvelous yarn about his youthful adventures in the Philippines, causing me to forget my duties. An exit was missed; the Map Guy was teased. Now Mark had more fun on his mind.

"I've got one last stop for you," he cheerily announced. "How would you like to swing by the Fort Caroline National Memorial?"

I left the question unanswered. The temperature had been in the 20s when I left Chicago. In Jacksonville, it was more than 80 degrees. The hotel pool was big and wet. I had never heard of the Fort Caroline National Memorial.

"Trust me," he said. "This place will interest you."

So we took a drive. Heading east through downtown Jacksonville, Mark began to tell another engrossing story—this one about a group of Frenchmen who in 1564 attempted to establish the first permanent European colony in what is now the United States. That tale had a familiar ring to it, and by the time we pulled into the parking lot, shadowed by live oaks draped in Spanish moss, I knew why.

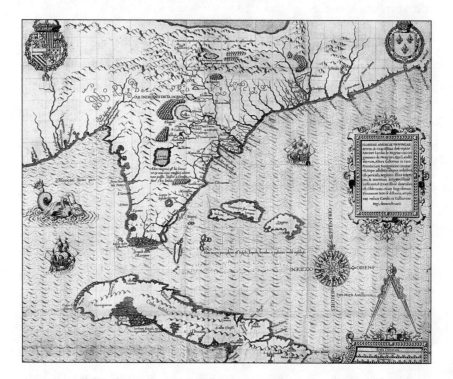

Before getting out of the car, I flipped open my battered copy of *The Island of Lost Maps*. The artwork selected for the book's dust jacket and endpapers was a cartographic treasure from 1591 called *Floridae Americae Provinciae Recens & Exactissima Descriptio*. It lay in front of me now. The map showed Florida as a vast region, covering all of the modern-day southeastern United States. This sprawling area was, in the sixteenth century, contested by Spain, England, and France, and the story of how these three powers battled for primacy there was one of the most gripping and bloody chapters in early American history. The map itself was intended,

in fact, to bolster France's claim to sovereignty, as evidenced by the royal coat of arms that occupied hundreds of square miles of Terra Florida.

Sitting there, I realized that the man who drafted this map more than four hundred years ago had resided not far from this very spot, somewhere around the bend from those upscale homes and shopping plazas we had just passed. I did not know then that Jacques Le Moyne de Morgues had barely escaped this place with his life, or that scores of his compatriots had been slaughtered near here, or that after the bloodbath he had somehow managed to make his way back to Europe in an ill-manned ship with nothing to eat but biscuits and water. I was, moreover, completely ignorant of Le Moyne's lives away from this place: as an important early botanical painter, for instance, or as an employee of Sir Walter Raleigh.

I had always had a special fondness for Le Moyne's map and its many curiosities: the toad-faced sea monster, the triangular shape of the Florida peninsula, the massive inland sea on the uppermost border, the Atlantic coastline that keeps veering east where it should turn north. One commentator had politely described the work as "curiously inexact"; another had less charitably declared it to be "compiled from a series of disjunct sketches drawn on different scales, or with no scale." It was a handsome map, a fascinating map, even an important map—just not a good map. Le Moyne was, at best, a run-of-the-mill cartographer. His contributions in another area of New World discovery, however, were entirely unique.

Jacques Le Moyne de Morgues was the first European artist in North America. Until he arrived near where I was now standing, the only images of native people and landscapes had been done by amateur adventurers or by draftsmen working with imported models or secondhand information in the safety of their European studios. Le Moyne was the first professional artist known to have visited what is now the continental United States with the express purpose of making a visual record.

In the course of my research for *The Island of Lost Maps,* I had come across his vivid and sometimes gruesome depictions of native life, made famous in a series of engravings. Full of tattooed Indians wearing clothes made of birds' heads and inflated fish bladders and moss and

practicing rituals that involved fruit-stuffed deerskins or severed human limbs impaled on long sticks, those images had always struck me as profoundly unfamiliar, not so much from another century as from another world entirely. But now, as I wandered around this exotic landscape, perfumed with lush subtropical smells, I began to feel that distant place pulling me in.

The Fort Caroline National Memorial is part of the forty-six-thousand-acre Timucuan Ecological and Historic Preserve, the setting for one of the last unspoiled coastal wetlands on the Atlantic coast. The memorial itself, however, is a modest place, more notable for what is missing than for what remains. At the visitors' center, Mark and I saw a wooden canoe made by the Timucua, the dominant Native American group in the region at the time of European contact. These people, I learned, had vanished centuries ago. We then visited a two-thirds-scale replica of the fort, modeled in part after an illustration attributed to Le Moyne. The original fort, it turned out, had also disappeared, leaving few clues about its exact location. In truth, there was not much to see: almost no trace of the people and places Le Moyne painted has survived. Yet perhaps those absences stirred my imagination, for later that day, as I sat in the pool after parting company with Mark, I could not stop wondering about the fort and the artist who had called it home.

Over the next several months, I began prowling libraries to find out more about Le Moyne. It was not easy work. Like so many other things associated with Fort Caroline, much of his life story had disappeared. Thirty years were missing from his biography before he came to the New World, and there was another gap of fifteen after he returned to France. And although Le Moyne produced an extraordinary body of work, both written and pictorial, about his experiences in Florida, we know it only secondhand. He left a riveting narrative of his adventures in the New World, but the original manuscript of that work, written in French, has long since disappeared, leaving only Latin and German translations of questionable accuracy. Of all his paintings of Native Americans, meanwhile, only one original has ever been thought to survive, and even its authenticity is highly questionable. The remaining images come to us from a series of prints based on his vanished artwork and

published by the Flemish engraver Theodor de Bry after Le Moyne's death. De Bry, however, is known to have liberally embellished, restructured, and recrafted the artist's work. It's often unclear where Le Moyne's hand leaves off and de Bry's begins.

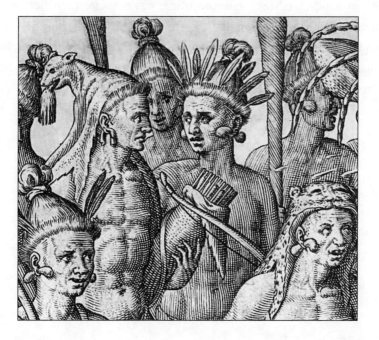

Yet for all that, those engravings haunted me. Le Moyne's visit to Florida lasted less than a year and a half, but it came at a historic juncture. Before he arrived, Europeans had been only sporadic visitors to what is now the United States; by the time he left, they were permanent residents. Because of this, his images serve as both a first glimpse of native North Americans and a last look at the indigenous people with whom he lived and worked, soon to be exterminated in the European conquest.

"The essence of the explorer's peculiar profession," wrote the historian Eric Leed, "is becoming lost . . . and returning with news of what does and does not lie beyond the boundary of the known." These days, of course, there are fewer opportunities than in Le Moyne's time to lose yourself, but as I pored over those pictures, I had the strange sensation that I, too, was embarking on a voyage of discovery—not into the hinter-

lands of the globe but the shadowlands of the past. Were the scenes in those engravings fact or fantasy? What did they tell us about that forgotten world? Could they lead to new discoveries? Who was Jacques Le Moyne de Morgues, and how had he wound up on our shores, paintbrush in hand? His story, I would learn, was stranger than fiction and sometimes more thrilling, a tale replete with shipwrecks, mutinies, religious wars, political intrigues, pirate raids, Indian attacks, famines, hurricanes, and mass murders. Surprised to find out how little had been written about this remarkable man, I set out to chronicle his adventures.

Painter in a Savage Land

Forbidden Flesh, Forbidden Fruit

. . .

THEY HAD HEARD COUNTLESS TALES OF ITS FERTILE SOIL AND ITS sprawling forests through which unicorns roamed, its secret waterways to the Orient, and its cities of gold. These marvels were what had inspired them to undertake this hard journey, but now, after a month at sea, they must have begun to wonder if they would ever reach the New World.

Detail of a French vessel used on the 1564 expedition,
from an engraving based on Le Moyne's work.

The men—about three hundred soldiers and sailors in all—had departed the Norman port of Le Havre on April 22, 1564, the day before William Shakespeare is thought to have been born. Following the usual route of European explorers, they then traveled south to the Canary Islands and, from there, west with the powerful trade winds. The sprawling territory to which the men were headed was almost entirely unknown to Europeans. Spain claimed Terra Florida as its own, but all its attempts to plant a colony there had ended in disaster. The French insisted the land was still up for grabs, free to be taken by the first country that could occupy it. But they, too, had failed miserably.

Just two years earlier, another expedition had sailed from Le Havre: the first French attempt to establish a settlement in La Florida. Landing at Port Royal Sound in what is now South Carolina, the explorers built an outpost, naming it Charlesfort after their eleven-year-old king, Charles IX. Then the ships returned home, leaving a small garrison behind. But the promised reinforcements did not arrive the following spring, and by that time the men had lapsed into idleness and infighting, their stores steadily dwindling. Finally, on the verge of starvation, they decided to risk a desperate return voyage in a homemade vessel. Powered by sails made from shirts and bedclothes, caulked with moss and pine pitch, equipped with tree-bark ropes supplied by Native Americans, this tiny craft, pieced together by men who knew little of shipbuilding, embarked for France in 1563. A sixteenth-century chronicler recounted the journey:

> They were restricted to eating not more than twelve grains by weight of corn meal per man per day. But even this gave out, and they devoured their shoes, leather collars, straps, and dried animal skins. . . . Finally, it was suggested that it would be wiser that one die rather than all of them. The lot fell on [a man named Lachere]. He was killed and his flesh was equally divided among them. Then they drank his warm blood.

Miraculously, they made it across the Atlantic, the men plucked from the waves by a passing vessel in the English Channel. And their horror

story would have been all too well known to those on this new mission, since as many as four survivors of the ill-fated journey were now returning to the New World. The flagship for this second French expedition was the *Ysabeau,* a three-hundred-ton man-of-war, armed with ten or twelve heavy guns. Accompanying her were two other vessels: the eighty-ton *Faulcon* and the *Petit Breton,* a ship of between 120 and two hundred tons, which carried the expedition artist.

No portrait survives of the painter, then about thirty years old. We do not know whether he was slim or burly, tall or short, handsome or disfigured, his voice deep or nasal, his complexion olive or fair. We know only that he was thick-skinned, that some combination of good genes and good luck bestowed on him a genius for survival. We have no idea what a lover would have remembered about his touch or a fortune-teller would have discovered in his palms, yet we can guess that his hands were strong and nimble, skilled at crafting illustrations of infinitesimal detail yet also adept at handling an arquebus, the unwieldy predecessor to the musket. We cannot say whether he inherited dark eyes from the Gauls or blue from the Normans, but the more we learn about him the more we are convinced that those eyes, whatever their color, took everything in and gave very little away.

Jacques Le Moyne de Morgues may have emerged from a culture that still owed much to the Middle Ages, but his outlook was, in many ways, modern: a keen observer of the world, he was also a skeptical one. We see this right away in the artist's description of his first meeting with the expedition leader, René Laudonnière:

> On our arrival [in Le Havre] he received us kindly and with splendid promises, but being well aware that courtiers are in the habit of making profuse promises, I wanted to know what he really intended and for what purpose the King wished, as he said, to take advantage of my loyalty. He then assured me that no obedience was called for from me unless it was voluntary.

Laudonnière and Le Moyne were followers of John Calvin, the exiled theologian whose writings had brought a religious revolution to France

during the first thirty years of the artist's life. Huguenots, as French Protestants were known, now accounted for as much as 15 percent of the population. Yet despite a shared faith, Le Moyne and his commander came from different social strata and seem to have had vastly contrasting temperaments. Laudonnière, a few years older than the artist, was a nobleman from a distinguished family. An experienced sea captain, he was, as Le Moyne observed, "without doubt a man of many accomplishments." Still, the artist felt compelled to note that Laudonnière was "not so experienced in military theory and practice as he was in naval matters"—no small concern, given that the commander would be tested overwhelmingly on dry land. And if Le Moyne had doubts about Laudonnière's skills as a soldier, he was soon to be even more concerned about his leadership abilities. The artist would find his captain "too easily influenced by others," a man with fatal weaknesses for cronyism in good times and indecision in bad. Le Moyne also left a pictorial record of Laudonnière, in which the captain comes off as something of a dandy, striking a mannered pose and donning finery more suited for the French court than the Florida bush. *Bombast:* We get that word from the stuffing used to puff up the costumes of sixteenth-century gentlemen, and it's hard to avoid the idea that Laudonnière had more than his share of it, at least in Le Moyne's eyes.

By contrast, the artist himself emerges from between the lines of his narrative as a man of discretion, determined to avoid cliques and controversy while striving to maintain a sense of objective remove. Yet although Le Moyne would often criticize his commander in the coming months, he would remain loyal to Laudonnière even in the worst moments. In the end, the two would be among the few French to come back from America alive.

They would have something else in common as well: Both would craft memoirs of the journey. Along with a carpenter named Nicolas Le Challeux, they would leave a vivid written record of a key chapter of American history that would have otherwise been lost. And now, in late May or early June of 1564, that story was about to begin. The French ships approached a lush tropical island, studded with cliffs. This was Dominica, on the eastern edge of the Caribbean. The New World stood before them at last.

———

LE MOYNE MUST HAVE been among those who crowded on deck as two Native Americans in small boats approached the fleet, which had dropped anchor off the coast in order to collect fresh water. Those vessels were filled with an exotic delicacy that the French had named *ananas,* derived from a Native American word for "excellent fruit." For the colonists, this juicy plant, which looked to Europeans like an overgrown fir cone, would soon be the source of great excitement—and great trouble. But at the moment they must have been preoccupied with the sight of those mysterious beings who filled the European mind with such fascination, derision, and fear: *les hommes sauvages.*

A woodcut depicting Native American cannibalism, from a book on geography published in 1527.

To get a sense of what that moment was like for the French, you have to imagine yourself in a spaceship just as it sets down on some distant planet, about which you know almost nothing except that it is inhabited by intelligent life. Few of Le Moyne's contemporaries had ever seen a

New World native firsthand. Their impressions came from pictures in books, most of which were far-fetched, just as our own depictions of space aliens must be. One widely distributed woodcut, for example, purports to depict Carib Indians—inhabitants of the very island off which the French were now anchored. It shows a group of "ferocious and loathsome people" at what appears to be a neighborhood butcher shop, hacking up human beings with a cleaver and devouring the raw meat. Even more bizarre: The natives have heads of dogs. Stranger still: The woodcut is based on the writings of Christopher Columbus.

It's true. On November 4, 1492, less than a month after his historic landing in the New World, Columbus began hearing reports of Indians in the eastern Caribbean "with dogs' snouts who eat men." Conflating two mythical races of antiquity—the canine-headed *cynocephali* and the man-eating *anthropophagi*—the mariner named these islanders "Caniba," apparently a corruption of *Galíbi,* the Carib Indians' own name for themselves, meaning "brave men." The cannibal was born. And while he would eventually lose his canine features, he would continue to haunt the European imagination for centuries.

Whether the Caribs actually ate other humans continues to be a matter of debate. Proponents cite accounts of explorers such as Columbus, whose soldiers were said to have found "a man's neck . . . cooking in a pot" on Guadeloupe, an island near Dominica; opponents insist there is scant archaeological evidence to support such reports. Fact or fiction, however, the *concept* of the cannibal had a profound effect on the Old World. For Columbus and successive generations of conquistadors, laws authorizing the persecution and enslavement of cannibals "allowed open season on all Indians, for anyone resisting Spanish imperialism was now considered 'Carib,' " in the words of one scholar. For artists, belief in the legend meant that the typical Native American was shown "as a cannibal, chopping up another Indian and preparing a fire and spit to barbecue him," wrote another.

But of course the artists who made those pictures had never been to the New World. Even when they weren't portraying Native Americans as cannibals, their depictions were necessarily based on speculation and myth. Some, for example, showed the Indians with hair all over their

bodies to resemble the Wild Man of the Woods, a recurrent character in medieval and Renaissance romance. Others depicted them as giants or other figures from legend, such as Amazons, the tribe of female warriors, or Blemmyes, headless men with faces in their chests. And such fanciful images, amalgams of artists' ignorance and explorers' overwrought imaginations, were still common when those French ships arrived on the coast of Dominica.

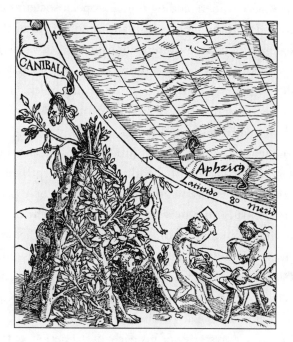

Native Americans as cannibals in a 1555 map.

Jacques Le Moyne embodied a new opportunity to understand Native Americans on their own terms, and it's hard to imagine that he wasn't at least vaguely aware of the groundbreaking nature of his work. Yet he also knew it was not an altruistic exercise. He would not just be making paintings but gathering intelligence, an assignment part and parcel with France's plans to claim La Florida as its own.

The Norman city Dieppe, where Le Moyne is known to have resided just prior to his departure for the New World, was then one of Europe's great maritime hubs. Not only had local ship outfitters established a

renowned school of cartography, but they had also seized upon the revolutionary idea of sending painters to distant lands to record the customs of other peoples. The forerunners of today's documentary photographers, videographers, and filmmakers, these artist-adventurers journeyed as far away as Sumatra. And while the information they brought back was largely intended to help kings plan imperial conquests and merchants establish trade relations, their wanderings nonetheless heralded a new way of understanding non-European societies and helped give rise to modern ethnography and anthropology. Even their equipment marked a major change. Watercolor painting—or, as it is also called, watercolor drawing—was new to Europe in Le Moyne's day. Thanks to its portability, simplicity, and speed of use, it had quickly become "the medium for the quick notation of strange, exotic and beautiful scenes," in the words of one art historian.

Le Moyne wrote that his official duties were "to chart the sea-coast and to observe the situation of the towns and the depth and course of the rivers, and also the harbors, the houses of the people, and anything new there might be in that province." It's not clear why he was singled out for this vital mission, but someone in the upper echelons of power seems to have had a guiding hand. The art historian Paul Hulton—noting the artist's apparent access to, and familiarity with, the French court—went so far as to speculate that Le Moyne's patron was King Charles himself. The nature of the artist's links to the royal entourage is one of the most intriguing mysteries of his early life, a period as full of blank spaces and conjecture as a sixteenth-century map of the North American interior.

EVEN WITHOUT CANINE SNOUTS and fangs, the natives of Dominica must have been an impressive sight. Men of the island went completely naked, their bodies painted red, their black hair dangling far down their backs, their beardless faces decorated with markings that made them look (at least to one later explorer) "like devils," their necks adorned with necklaces of human teeth. Laudonnière described that first encounter with the two men in boats:

As they approached our barque, one of them was in doubt about us and returned to land, running away. Our men, perceiving this, caught the poor Indian in the other little boat, and he was so astonished at seeing us that he did not know how to behave. I understood afterwards that he had feared that he had fallen into the hands of the Spaniards. These had once captured him and had cut out his testicles, as he showed us.

Whether the Spanish were actually to blame for the man's disfigurement is unclear: Laudonnière's interpretation of events was based entirely on sign language, and at least one contemporary account indicates the local warriors themselves made a habit of castrating captives from rival groups. Nonetheless, the commander took care to inflict no further harm on the man, sending him back to the island with "a shirt and certain trifles."

The prominent nineteenth-century historian Francis Parkman once remarked that "Spanish civilization crushed the Indian; English civilization scorned and neglected him; French civilization embraced and cherished him." This was, of course, an oversimplification, and no small one; yet there were indeed real, if subtle, differences in the way France and Spain conceived of their relations with Native Americans. What distinguished the French approach, which one modern scholar has dubbed "conquest by love," was not a mere matter of policy. Yes, Laudonnière had orders to maintain good relations with local chieftains, but such directives were hardly a French innovation. Spanish explorers and colonists had received many similar instructions in the past, to little effect.

The difference in the French attitude is best demonstrated not by some old document but by the inclusion of Jacques Le Moyne on the journey to Florida. For the Spanish, the notion of sending an artist on such a venture at that time was all but alien. It is true that the historian and naturalist Gonzálo Fernández de Oviedo y Valdés left an extensive, if crude, pictorial record of his travels in the New World, but even he conceded that he lacked artistic talent and training. And while Spanish authorities regularly asked explorers to bring back information on native

customs, "no request seems to have been made for drawings," observed the historians Paul Hulton and David Beers Quinn.

The first important European painter in Mexico, Simón Pereyns, did not arrive in the New World until two years after Le Moyne, and, once there, he painted the same things that he would have painted in Spain: religious scenes and portraits of his countrymen. The Spanish simply did

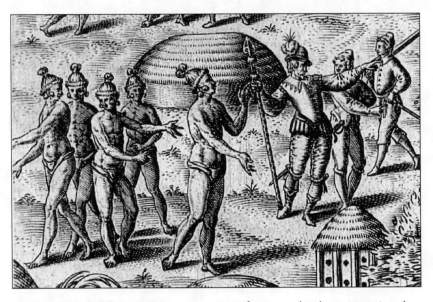

Detail of French soldiers visiting Native Americans, from a print based on Le Moyne's work.

not deem Native Americans worthy of paint and paper. "In wisdom, skill, virtue and humanity, these people are as inferior to the Spaniards as children are to adults and women to men; there is as great a differ-ence . . . almost—I am inclined to say—as between monkeys and men," declared the philosopher Juan Ginés de Sepúlveda in 1550.

The French were no less convinced of the superiority of European culture, and they were certainly no less covetous than the Spanish. But aware of the atrocities Hernando de Soto had inflicted on La Florida during his vain quest for gold from 1539 to 1542, they hoped diplomacy might succeed where Spanish terror had failed. Lacking the manpower to subdue the Indians, they knew that if they wanted to trade with them, to forge alliances with them, to live in their midst, they would have to

understand them, and that to understand them, they would have to observe them. By bringing Le Moyne, the French were, in some small but significant way, acknowledging the Indians as human beings. Yet even before he and his companions could depart from Dominica, their dreams of peaceful coexistence with the natives would be sorely tested— not by gold but by pineapples.

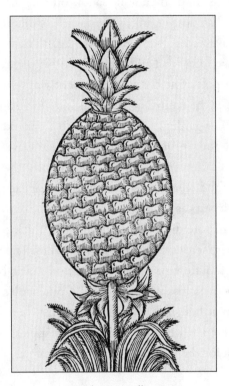

A sixteenth-century illustration
of the pineapple.

CANNIBALS WERE NOT THE only discovery Columbus had made during his 1493 visit to these islands; his men also stumbled upon a juicy yellow fruit whose "flavor and fragrance . . . astonished and delighted them," according to the chronicler Peter Martyr. The admiral named the fruit *piña de Indies*, or "pine of the Indies," and it quickly became a much-desired delicacy among European explorers. Magellan's men found it to be "a

very delectable fruit." De Soto thought it was "of a very good smell and exceeding good taste," while Jean de Léry, a Calvinist who went to Brazil in 1556, described it as being of such excellence "that the gods might luxuriate upon it and that it should only be gathered by the hand of Venus." But its sweet aroma and succulent flavor may have been only part of the pineapple's allure. Scurvy, an illness caused by the lack of vitamin C, was then the major cause of death among sailors on long sea voyages. And although scientists had not yet linked the disease to diet, European adventurers seem to have had a clear sense of the health benefits of the fruit.

It did not take long for Laudonnière and his men to fall under the spell of the pineapple. The colonists apparently developed such an impassioned taste for the fruit that the local Indians "begged us not to go near their homes or gardens. They said to do so would give them great displeasure, and they promised that we would have no shortage of pineapples," wrote the commander. To the Caribs, the plant was more than a source of food. They hung pineapples or pineapple crowns at the entrances to their huts as symbols of welcome, and they used the plants in self-defense, surrounding their villages with thick pineapple hedges full of dagger-sharp leaves to keep strangers at bay. The fruit also had an important ritual function: As a rite of manhood, Carib boys were forced to dash between two closely grown rows of pineapples to demonstrate their bravery. But although the Indians apparently honored their promise to keep the French well stocked with pineapples, temptation soon proved too much for the French. Wrote Laudonnière:

> One day some of our Frenchmen, who were anxious to see something new in this strange land, followed the path through the woods and arrived at the bank of a little river. Following the bank of this river, they noticed two great snakes which were in their way. My soldiers went ahead of the snakes, trying to keep them from entering the woods, but the serpents were not frightened and glided into the bushes, hissing loudly. Swords in hand, my men attacked them and later found that the snakes were nine feet long and as thick as a man's leg.

After this encounter some of the less discreet of my men gathered pineapples from Indian gardens, carelessly going into the very middle of them. With even less discretion they went toward the homes of the Indians. This made the Indians so angry that they rushed out furiously, let their arrows fly, and hit one of my men, named Martin Chauveau. He remained behind and we never knew whether he was killed on the spot or made a prisoner.

If the elements of this story—the Edenic setting, the forbidden fruit, the serpents (no doubt boa constrictors, still found on the island)—echo the original sin, there is, in fact, no evidence that the French viewed the episode in allegorical terms. Le Moyne, for instance, was matter-of-fact about what happened on that island: "We drew fresh water, losing, however, two of our men." Temptation, transgression, expulsion: They set sail for Florida the following day, hopeful, despite this failed first encounter, that paradise awaited them still.

First Sight

. . .

LE MOYNE'S INITIAL GLIMPSE OF THE PEOPLE HE WOULD LIVE and nearly die among came on June 25, 1564, three days after the French had first sighted the Florida coast, when the ships reached the mouth of a large river. Laudonnière assembled a heavily armed landing party, apparently including the artist, who reported that the French found "the whole coastline . . . beset by a great assembly of men and women lighting fires."

I imagine him climbing out of his boat and wading in through the surf, the bottoms of his breeches damp as he traversed that last stretch between sea and land, Old World and New, past and future, his nose filled with spray and smoke and voluptuous smells of the local flora, his eyes darting from face to face of those strangers on the beach, the men wearing deerskin loincloths, the women naked except for skirts of Spanish moss. Earlier in the century, when Europeans made their initial forays into these waters, the Indians "regarded it as a miracle, for they had never seen ships," according to one contemporary account. But even though the French had landed at this very spot just two years before, some of them even picking up enough of the native tongue to serve as translators, their arrival still seems to have been cause for wonder among the inhabitants. "They were somewhat astonished," the artist wrote, "when they noticed the difference between the smoothness and softness of our bodies and theirs, and the unfamiliar clothing we wore."

Le Moyne had much to be astonished about as well, with four hundred tattooed men and bare-breasted women pressing in on him and his

comrades, chattering in an otherworldly tongue. Fear, awe, desire: Some combination of these and other heightened sensations no doubt raced through his soul just then, but overriding them all, we can be fairly sure, was a voracious curiosity. Le Moyne's entire artistic career is testimony to an inquisitive mind, an unblinking eye for detail. He must have wanted to take out his charcoal and paper the second he set foot on that beach. The chance would come soon enough.

Stepping forward from the crowd to greet the French, wrote Le Moyne, was one of the local chieftains:

> When they had exchanged gifts and all manner of courtesies he indicated that he wished to show [the French] something special and asked them for this reason to go along with him. They agreed, but because they were aware that he was surrounded by a great number of his subjects, they set out in caution and vigilance in his company.

These fears would prove unnecessary. The Indians apparently had no intention of an ambush. Their trap would be of a far more subtle nature.

THEY KNEEL BEFORE IT, those beautiful women with flowing hair and warriors with sinewy frames, their arms outstretched in apparent ecstasy. Other than their bare skin and their earrings made of inflated fish bladders, they resemble the awestruck onlookers who crowd the edges of countless Crucifixions, Descents from the Cross, Pietàs, Resurrections, Ascensions, and other religious scenes from Renaissance art. In this picture, however, the object of their adoration is not Christ but a stone column bearing the royal arms of France.

This is Jacques Le Moyne's first eyewitness depiction of the New World, an image as difficult to make sense of as some half-remembered dream. It records an event that took place shortly after that encounter on the beach, when the Indians led their guests to a stone column that the French had planted during an ornate ceremony in 1562 as a means of establishing sovereignty over the land. By the mid-sixteenth century,

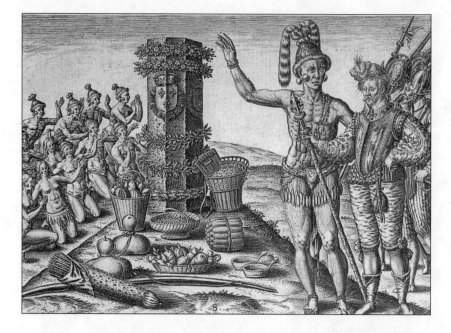

European explorers had developed a complex protocol of symbolic acts to claim possession of a territory. Such a ceremony typically required an actual presence on the soil (as opposed to a mere sighting from off-shore); a formal pronouncement of ownership, made before witnesses and record keepers; and the construction of an edifice to commemorate the takeover. These markers were often improvised affairs: crosses or gallows hewn from local lumber, piles of stones, earthen mounds. But in 1562, the French had come all the way across the Atlantic with hexago-nally shaped columns of white stone, intricately engraved with the royal standard. One of these they placed at the mouth of a waterway that they called the River of May—the modern-day Saint Johns. In the two years intervening, the marker had apparently become an object of veneration for the Indians. Wrote Le Moyne:

> Drawing close [the French] noticed that the Indians were worshipping this stone as if it were an idol. For when the chief himself had saluted it and shown it the sort of reverence he was accustomed to receive from his subjects, he kissed it; his people

copied him and encouraged us to do the same. In front of the stone were lying various offerings of fruits of the district and roots that were either good to eat or medicinally useful, dishes full of extravagant oils, and bows and arrows; it was also encircled from top to bottom with garlands of all kinds of flowers, and with branches of their most highly prized trees.

But if the French were flattered by local worship of the fleur-de-lis, they were even more intrigued by a present they received that day from a man who would become a close ally, and later a bitter enemy. He was Saturiwa, the most powerful local chieftain, who presented Laudonnière with a silver ingot. The captain—who may have already known the chief from the earlier French expedition, in which Laudonnière served as second in command—returned this favor by giving Saturiwa a knife and a few other gifts, with which "he seemed to be very well pleased." The French commander, too, claimed delight with the transaction, which appeared to promise not only that the territory was full of precious metals but that these riches would come to the colonists at little cost or effort.

Treasures for trifles: This "grossly unequal gift exchange," in the words of the scholar Stephen Greenblatt, represented the "European dream, endlessly reiterated in the literature of exploration.... I give you a glass bead and you give me a pearl worth half your tribe." Among the trinkets Laudonnière had brought to Florida precisely for this purpose were eleven gross of mirrors and some felt hats. Yet the Indians were not nearly as gullible as they appeared. They may have been sincere in their adoration of the stone column, but they also had very practical reasons for convincing the newcomers to remain in the area. If anyone was duped during this initial encounter, it would prove to be the French.

THE INDIANS IN THAT picture were members of the Timucua (pronounced *tih-MOO-koo-uh*), then the largest Native American group in the region, with a territory covering almost twenty thousand square miles of

what is now southern Georgia and northeastern Florida. Scholars believe that they may have had fourteen or fifteen distinct tribes and that their population numbered in the hundreds of thousands at the time of European contact in the early 1500s. Noted for their athletic builds, the Timucua decorated their bodies with tattooed and painted designs in azure, red, and black. As Le Moyne's portrayal of the encounter at the stone monument makes clear, their fingernails were long and pointed for use as weapons, and they wore their hair long, the men trussing it atop their heads, the women letting it hang loose, often to their hips. Their language, divided into as many as eleven different dialects, appears to have been most closely related to those of Caribbean, Central, and South American Indian groups—a possible indication of trade and social links to those distant cultures.

The French did not know it, but they had arrived at a volatile moment in Timucuan history. The Spanish explorer Hernando de Soto had wreaked havoc during his march through the western part of Timucua country in 1539, terrorizing villages, slaughtering warriors, chaining up captives for use as slaves, and unleashing bloodhounds on escapees. The appearance of the conquistadors, and later of the French, seems to have triggered a convulsion in the Timucuan political structure, as individual villages or groups of villages began joining forces in order to provide military protection. These alliances, in turn, upended the traditional balance of power. Near the mouth of the Saint Johns River, scattered villages had begun to assert their strength against the inland chief Utina by confederating around Saturiwa, the local chief.

For his part, Saturiwa seems to have come to a quick realization that the French, with their arquebuses and armor, could help him achieve his own military goals. Although he made a great show of friendship and devotion to the French, his real aims were apparent even at the stone column. As one Frenchman who was present observed:

> We stayed with the marker for half an hour and the Natives brought juice of the laurel and their excellent potions, and, embracing the marker, all were chanting TYMANGOUA, as

though wanting to say by so doing that they were going to be victorious over their enemies, whom they called TYMANGOUA, and that the Sun god had sent Mr. de Laudonnière, his brother, to avenge them. After giving them some presents, Mr. de Laudonnière ordered the return aboard ship, leaving those poor people wailing and weeping about our departure.

Laudonnière then set out to survey the river and nearby coastline, leaving Saturiwa "a number of little trinkets to keep our friendship alive." After several days of exploration, he gathered his men to announce that he had decided not to push north to Port Royal, the site of the previous French fort:

> I was of the opinion, and it seemed good to them, that we should set ourselves up around the River of May, since on our first voyage we had found it to abound in corn and material for flour, to say nothing of the gold and silver that was found there, a thing which gave me hope for some future happy discovery.

They returned to the River of May/Saint Johns, where, after some reconnaissance, they picked out a site near a steep rise (now known as Saint Johns Bluff), several miles from the river's mouth, a place that seemed both defensible and well situated to receive future colonists and supplies from France. The location also gave them control of the river, which they hoped would carry them to untold wealth that seemed to beckon from the Florida interior. "The sea may be seen clearly and openly from [the site]," wrote Laudonnière, adding that it had "a fragrance so delightful that perfume could not improve upon it." In short, he wrote, "The place is so pleasant that melancholics would be forced to change their character there!"

AT DAYBREAK ON THE MORNING of June 30, 1564, Laudonnière ordered a trumpet to sound so that he could assemble his men and offer

God thanks for their "favorable and happy arrival." Then they set to the task of constructing Fort Caroline. Soon they were visited by Saturiwa, accompanied by a huge entourage. Le Moyne described the scene:

> The chief was escorted by seven or eight hundred splendid-looking men, strong, hardy, athletic and highly trained as runners, who were carrying their weapons in the way they usually do when about to go to war. He was preceded by fifty youths carrying javelins or spears in their hands. Nearer to him were twenty pipers who were playing some primitive thing discordantly and raggedly, merely blowing the pipes as hard as they could. . . . Flanking the chief on the right was the sorcerer and his left his leading counselor, for he undertakes nothing without these two.

Taking no chances, Laudonnière readied his men for battle, but the native force proved to be less of a war party than a welcoming committee. The encounter would, in fact, evolve into a ritualized treaty between the two sides. In an earlier exchange, Saturiwa had convinced the French commander that large quantities of gold and silver could be found in the land of the chief's enemies, who lived up the river. "To increase his friendship," Laudonnière later recalled, "I promised to go with all my forces to assist him in battle there." It had been a rash decision, both diplomatically and militarily—one that committed the French to a war against an entirely unknown foe even before they had erected the first wall of their fort. And so, an entente between the two leaders was now formalized in front of their assembled armies. "Gifts were presented on both sides as a pledge of friendship and everlasting alliance," wrote Le Moyne. "Having gone through this procedure the chief came nearer to us and admired our weapons, especially our arquebuses."

It would not be long before the chief demanded that his new allies accompany him into battle with those guns. But for now he played the part of obsequious host, supplying his guests with eighty of his strongest men to help them build their outpost. For the French, wrote Le Moyne, everything seemed to be going just right:

Our fort was quickly built and the huts finished. . . . While this was being done all of us put our hands to the task, nobles, soldiers, craftsmen, sailors and others, in order to fortify ourselves against the enemy and protect ourselves against the weather, each one promising himself (on the strength of what had been given and what acquired by barter) that he would soon be rich.

EL DORADO, ATLANTIS, the Fortunate Isles, the Kingdom of Prester John, the Seven Cities of Cibola, the Enchanted City of the Caesars, Quivira, Xanadu, Eden: the words fall off the tongue and fill the mind like incantations. Such utterances, each a different name for desire, are necessary when you sail into the unknown, as necessary, perhaps, as fair winds or strong masts. Because it is not enough to risk all you have, abandon all you love, for the mere sake of exploration, the intellectual satisfaction of knowing the earth's contours. The courage to cross an uncharted ocean—that demands a promised land, a place of such beauty and abundance that you could never know sorrow there and never come home poor.

And there, in this one work of art, is the embodiment of all such yearnings: the paradisiacal setting, the ritual offerings to the white-skinned gods, the sensual natives genuflecting before the phallic totem of French power. But did this scene actually take place? Modern experts have noted that while some of the details seem correct, others are perplexing. The baskets at the base of that stone column, for example, appear to be of European design, and the fruits in those baskets "are very improbable—really impossible—for Florida," as one scholar put it. Is this engraving, one of the first eyewitness depictions of Native Americans in what is now the United States, an accurate portrayal? Is it even faithful to Le Moyne's original painting?

For centuries, such questions seemed impossible to answer, since all of the artist's work from Florida was thought to have disappeared. And then, around 1901, a small picture was discovered in the library of a chateau outside Paris. Painted in watercolor and gouache (thickened wa-

tercolor), it showed a familiar image of Indians bowing before a monument that bore the royal arms of France. Excited experts, noting the work was almost identical to the engraving, declared that one of Le Moyne's paintings, lost for more than three hundred years, had been discovered at last.

That painting is now housed at the New York Public Library, and on the afternoon I went to see it, a staff member in the prints division told me that for decades, the work "was considered one of the ten or so items in the whole library you made sure you grabbed if there was a fire." No longer, apparently. In recent years, it has lost much of its luster, dimmed by the doubts of experts who now question its authenticity. Among other criticisms, these skeptics argue that the "outrageously wrong" colors—Indians with pale pink skin and blondish hair, for example— offer evidence that Le Moyne could not have been the painter. Instead, they view the piece as a "near-contemporaneous copy by an anonymous artist": a painting patterned after the engraving, in other words, not the other way around. Far from answering questions about Le Moyne, the painting has only added new riddles.

The artist's opening image of the New World, like so many that would follow, remains an enigma. That some version of the scene— described independently by the artist himself, Laudonnière, and another witness—actually took place, there can be no doubt. Yet if the picture shows what the settlers saw, it also shows what they *wanted* to see. Part empirical fact, part imperial fantasy, it marks both a first and a final moment in the colony's history. Never again would Le Moyne portray Florida as quite such a paradise. Never again would the Indians seem so servile. Never again would the colonists be so sure of their destiny. Even in this initial moment of exuberance, the French were already in grave danger.

Corsarios

...

AT THE PRECISE MOMENT LE MOYNE WAS WITNESSING THAT CURI-
ous sacrament at the stone column, the monument's twin—another pil-
lar bearing the fleur-de-lis—was being hauled to Havana in a Spanish
frigate. It was all that was left of the previous French colony in North
America.

The Spanish had dispatched this vessel in response to alarming intel-
ligence reports about an enemy presence in La Florida. The leader of
this twenty-five-man mission, Hernando Manrique de Rojas, had re-
ceived explicit instructions to remove or destroy stone markers the
French were said to have left along the coast. He was also to look for a
settlement, "razing the fort so completely that no trace of it shall re-
main." The frigate sailed from Havana on May 12, 1564—just as Le
Moyne and his countrymen were closing in on the Caribbean.

Two weeks later, Manrique de Rojas was edging up the Florida coast,
inquiring after the French at every stop. He failed to find the column on
the banks of the Saint Johns, but on June 11 he went ashore in modern-
day South Carolina, where the Indians showed him "two iron axes, a
mirror, some pieces of cloth, small bells, knives and many other things
made by the hands of Christians." Then they told him about a young
Frenchman who lived nearby.

Manrique de Rojas sent two Indians ahead with a wooden cross "to
give to the Christian as proof that there were Christians in the land."
The man, seventeen-year-old Guillaume Rouffi, showed up a day later
in native attire. Under questioning, he told a haunting story.

Rouffi had been among those at Charlesfort, the earlier French out-post. The leader of that expedition, it turned out, was a man all too famil-iar to the Spanish. His name was Jean Ribault, a legendary mariner: "one of the best men of the sea in Christendom," in the words of a contempo-rary. When Ribault had returned to France, taking with him his second in command, René Laudonnière, he promised the twenty-six volunteers who remained behind that he would be back soon. But Ribault "did not come nor did any other Frenchmen," Rouffi told his interrogators. When the starving soldiers decided to build a makeshift vessel and try their luck on the high seas, Rouffi helped them prepare. At the last minute, how-ever, he decided not to sail. "Realizing that there would not be in the boat anyone who understood navigation, [he] was not willing to go with them and remained among the Indians of this section where he has been until now," Manrique de Rojas would later report. "It is about fourteen months since they went away and no news of them has ever been received."

Rouffi took the Spanish to the abandoned Charlesfort, which Man-rique de Rojas and his men promptly burned to the ground. The young castaway also showed them the nearby stone marker. They dug it up and took it back to the ship along with Rouffi, who was to be "held prisoner under close guard on board the frigate and taken to the town of San Cristóbal, Havana, and delivered to the governor to be dealt with as jus-tice might demand."

On June 15, just a week before the French arrived in Florida, the Spanish commander sailed south, giving orders to stick close to the shore if the winds would allow it. Rouffi had told him of a second stone marker, the one along the banks of the Saint Johns, and now he hoped to complete his mission by hauling it home. These two monuments, he knew, would be prized war trophies for Spanish officials in Havana, who, as recent history made brutally clear, had already suffered incalculable losses at the hands of the French.

JULY 10, 1555, WAS a day those officials remembered all too well. It had been near dawn on that fateful morning when a watchman in Havana had spotted a ship passing the harbor. Scouts, sent on horseback to in-

vestigate, soon returned to report that heavily armed men had landed
and were advancing on the town. Within hours, the invaders had over-
whelmed this vital Spanish outpost in Cuba, soon to be known as "Key
to the New World and Rampart of the West Indies." Then, for weeks,
they ran amok, pillaging residences, terrorizing citizens, destroying
boats in the harbor, ravaging the surrounding countryside, slaughtering
prisoners, and hanging African slaves whose only crime was that their
masters failed to pay enough ransom. Before burning the city to the
ground, the raiders added one final insult. Bursting into the local church,
they hacked up the Virgin Mary and other icons, burned a crucifix and
broke its arms off, and paraded around wearing stolen vestments.

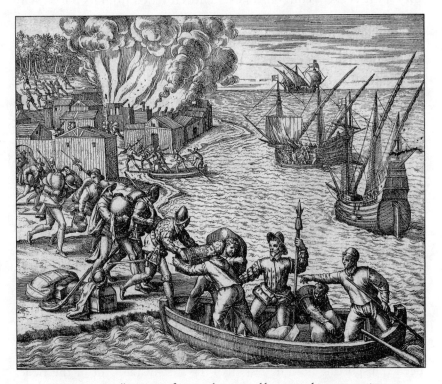

A contemporary illustration of Jacques de Sores and his men sacking Havana in 1555.

Their leader, described by one stunned Spanish colonist as a "huge
Lutheran heretic," was Jacques de Sores, a gifted but sadistic seaman
who came from the same circle of Protestant captains as Laudonnière

and Ribault. By the mid-sixteenth century, Norman navigators were becoming legendary not only as explorers but as pirates, or, as the Spanish bitterly called them, *corsarios*. In an age when the demarcations between commerce and crime, between government policy and private adventurism, between war and peace, were as vaguely sketched as the outlines of a New World map, the merchants and mariners of Dieppe and Le Havre had hit upon an enterprise that allowed them to serve their king, antagonize their political and religious enemies, and enrich themselves all at the same time.

Normandy got its name from the Scandinavian raiders, or "Northmen," who conquered the region during the Dark Ages, and the predatory spirit of the Vikings had never entirely faded from its ports. With the discovery of America, however, this piratical impulse gained a new urgency and logic. The French found ways to plunder Spain's New World interests almost as soon as the Spanish began plundering the New World itself.

As early as 1498, Christopher Columbus was taking measures to avoid "an armed fleet from France, which was on the lookout for me" as he began his third voyage to America. But the real possibilities of poaching Spanish vessels would not become apparent until 1523, when a Norman captain named Jean Fleury happened upon three treasure ships as they headed home from Mexico. The encounter came at a time when France and Spain were at war, and although the eight ships under his command were privately owned, Fleury carried a "letter of marque," which gave him royal permission to attack vessels from hostile nations and to appropriate their treasure. After a furious battle off Cape Saint Vincent in southwestern Portugal, Fleury's men were able to capture two of the three Spanish caravels, including the flagship. They were dumbfounded by what they discovered in the holds. The vessels had been transporting nothing less than the first installment of the riches that Hernando Cortés had looted from Montezuma's palace: dazzling jewelry and religious objects made of gold and silver, gems so stunning that one emerald alone was as large as a man's fist, some 680 pounds of pearls, five hundred pounds of gold dust in bags, and three huge cases of gold ingots, as well as other Native American treasures "so marvelous,"

in the words of Cortés, "that they cannot be described in writing, nor can they be understood without seeing them."

Fleury dutifully ushered this breathtaking booty to Dieppe, where he presented it to his employer, Jean Ango. The most celebrated French maritime entrepreneur of his time, Ango controlled a private navy of about seventy ships that he loaned out to the French king in times of war. Realizing the extent of the riches being shipped from the New World to Spain, Ango now increased the size of his corsair fleets and started sending them directly to the Caribbean. The great age of piracy in the Americas had begun.

By the 1550s, France and Spain were once again at war in Europe, and for the first time the Caribbean became an important theater of battle. In 1554, for instance, the Norman captain François Le Clerc—known to his Iberian enemies as Pié de Palo (Peg Leg) because of a limb he had lost in battle—arrived in the West Indies with eight large ships and three hundred troops. Taking Santiago de Cuba by surprise, he occupied the town for a month, relieving its inhabitants of eighty thousand pesos in booty. So devastated was Cuba's first capital that it never fully recovered and was soon overshadowed in importance by Havana.

A priest who visited Santiago de Cuba after the sack wrote that "the men had not a coat to their backs nor the women a chemise to put on." But at least Le Clerc, who may have been Catholic himself, spared the local church. With the arrival of Jacques de Sores in Cuba the following year, Europe's religious carnage began to spread to the New World. Sores saw himself as a Protestant avenger, a scourge against the false church. So deep was his hatred of Catholics that decades later, when he captured a Portuguese ship en route to Brazil with forty Jesuit missionaries on board, he ordered them thrown into the sea dead or alive, along with their holy images, books, and relics. By the time the massacre was over, all but six of the five hundred passengers were dead.

The devastating raids by Sores and other French pirates prompted a Spanish security clampdown in the Atlantic and the Caribbean. By the mid-1550s, Frenchmen caught in Spain's overseas dominions were no longer returned as prisoners for trial in Seville, as had long been the policy. Instead, King Philip II ordered that the sailors on French ships op-

erating in the Indies should be condemned to serve at the oars of Spanish galleys, while their officers were to be either hanged or hurled into the sea without mercy.

This did not stop the attacks, however, and by 1563 Spain had begun to detect a shift in strategy among French *corsarios*. No longer were they satisfied to raid ships and cities in the Caribbean and sail for home; now, it appeared, they were determined to set up their own base of operations in La Florida. And such an outpost, officials in Seville had come to realize, would not be just another nuisance, one more violation of Spain's self-declared sovereignty. It might threaten the entire empire.

WHEN PHILIP II HAD assumed the Spanish crown in 1556, he took control of the largest kingdom in the world, stretching from the Netherlands to Italy to America. Yet he also inherited massive war debts that consumed huge portions of Spain's annual revenues and sometimes caused Philip to renege on payments to creditors. Scores of other problems plagued the new monarch as well, including failed grain harvests in 1559 and 1561 and a humiliating naval campaign in which Turkish forces captured ten thousand Spaniards during a single battle in 1560. By that time, wrote the historian Henry Kamen, "the vulnerability of Spain to heresy, bankruptcy, rebellion and military defeat had never been more patent."

Despite such troubles, the king had one shining hope for salvation: the huge lodes of silver recently discovered at Zacatecas in north-central Mexico and at Potosí in the Andes. In 1557, a new method for refining this precious metal by treating the ore with mercury had been introduced to America, greatly increasing the productivity of mines and triggering a silver boom of almost unimaginable proportions. All told, more than thirty-five million pounds of American silver would be shipped to Seville from the beginning of the sixteenth century to the middle of the seventeenth—enough to triple the existing supplies for all of Europe. By comparison, about 407,000 pounds of gold would arrive during that same century and a half, increasing Europe's supplies by only one fifth.

The hard part was getting the silver home. By the start of the boom

in the 1560s, it was becoming clear to Philip and his advisors that the future of Spain, the only European power with direct access to American silver, hinged on protecting the empire's treasure ships. Twenty years earlier, raids by French corsairs had prompted the Spanish crown to begin deploying regular convoys, known as *flotas,* to carry the gold and silver of the Americas home to Seville. But it wasn't until 1564—the year Le Moyne left for Florida—that the *flota* system was strengthened into a well-organized operation that was to remain in place for a century. From that point on, two fleets would leave Spain each year, escorted by warships. One convoy would make its way to Mexico; the other to Nombre de Dios on the Isthmus of Panama, the primary pickup point for South American silver. After stopovers in Havana, both fleets would ride the Gulf Stream north, where, farther up the American coast, they would encounter trade winds that carried them home. But first, loaded full with the spoils of empire, they would have to pass through the Bahama Channel: that thin stretch of ocean, also known as the Florida Strait, separating the mainland from the Bahama archipelago.

The prospect of a permanent French base on this vulnerable alley of water threatened not only the treasure fleet but Spain's dominance in Europe. Yet for the staunchly Catholic Spanish crown, driving the French heretics from La Florida was not just a geopolitical necessity but a sacred cause—one that would be undertaken, like those earlier raids by the cutthroat dissenter Jacques de Sores, amid a mood of homicidal religious fervor.

THE CLASH NEARLY came at once. If the winds had been friendly, Manrique de Rojas might have made it to the mouth of the Saint Johns just as the French were arriving. Conditions were unfavorable, however, and the Spanish mariner abandoned his plans to search for the second pillar, tacking south through the Florida Strait while the French were approaching the mainland from a different angle, to the east and north of the Bahamas.

For Le Moyne and his unknowing compatriots, it had been a narrow miss. Yet even before Manrique de Rojas had returned to Havana, the

Spanish were already receiving reports of this second French expedition to La Florida. The next time a conquistador went looking for them, the colonists would not be so lucky. But for now they were consumed with the task of making a home for themselves in a place that was, as one colonist put it, "full of unknown lands and seas, of strange people, animals and plants."

Fort

. . .

T HEY BUILT A LARGE RESIDENCE FOR THEIR COMMANDER, HUTS
and barracks for the soldiers and colonists, a storehouse for munitions
and grain, a gate decorated with the arms of France. They hunted deer,
as well as less familiar game. (Alligator meat, one settler would later re-

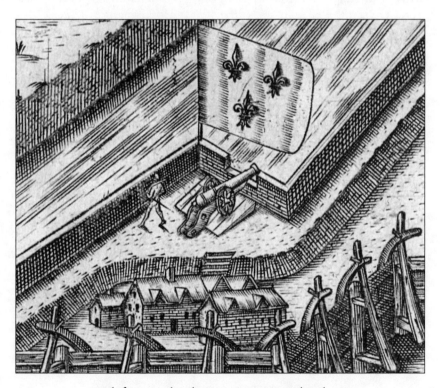

Detail of Fort Caroline showing a cannon mounted at a bastion,
from an engraving based on Le Moyne's work.

port, "was tender, white as veal, and had almost the same taste.") They picked native grapes—"sweet and plump, all of the dark variety," as another colonist put it—and, in true French fashion, made wine. They kept up the Calvinist tradition of singing psalms in the afternoon, encouraging the Indians to join them. They clung to the rituals and rhythms of their past lives in hopes that they might learn to feel at home in one of the most alienating places imaginable, an isolated outpost on the edge of a vast and unfathomable continent.

The fort itself appears to have been a structural hybrid, part state-of-the-art engineering, part seat-of-the-pants improvisation. The sixteenth century had seen a revolution in military architecture, necessitated by technological advances in gunpowder and artillery that allowed attackers unprecedented firepower. High walls of medieval castles were replaced by low, thick earthworks, while circular towers gave way to arrowhead-shaped bastions that not only eliminated "dead ground" that defenders could not reach with their cannons but allowed them to rake the length of an attacker's line, thus increasing casualties. And while Le Moyne's illustration of the fort makes clear that such innovations were integral to the outpost, the colonists also had to adapt their plans to local conditions. Structures inside the fort, for example, were roofed with palm branches thatched by the Indians because, as Laudonnière put it, "that is the only cover they put over buildings there." Le Moyne, meanwhile, noted that "a building was erected which the wind blew down soon afterwards because it was too tall." The experience, he wrote, "taught us that in that region, exposed as it is to high winds, buildings of lower height have to be constructed." Once completed, the fort was said to contain more than sixty houses within its walls and twenty more outside.

BUT WHAT WAS THE exact purpose of that outpost? Were the French there to establish a pirate base, as the Spanish feared? To practice their Calvinist faith without fear of persecution? To found a permanent colony from which to build a French empire in North America? To seek instant riches in the Florida interior?

No doubt all these ambitions came into play. And if the precise goal of Fort Caroline is difficult to pin down, it is because the mission's sponsor was a complex man with conflicted loyalties. Gaspard de Coligny was not only the foremost proponent of French expansion in the New World, but the most controversial Huguenot of his time. In 1562, tension between Calvinists and Catholics had erupted into a full-scale civil war, the first of several devastating sixteenth-century conflicts known as the French Wars of Religion. Coligny, who was the admiral of France, had joined the rebel side as leader of the Huguenot military. And although a peace agreement was reached in March of 1563, Catholics had not forgiven him for his role in the fighting, which left thousands dead.

Their antipathy only hardened in the waning days of the war, when a Calvinist gunman assassinated the duke of Guise, the outspoken leader of the Catholic cause and Coligny's arch foe. Insisting that the admiral was behind the murder, the duke's relatives were now demanding justice and threatening more violence. So far, however, such ultimatums had failed to sway Catherine de Medici, the cunning and powerful mother of the teenaged French king, Charles IX. A moderate papist and devout pragmatist, Catherine viewed the admiral as a necessary counterweight to Catholic hardliners in her court. The fates of these two shrewd and dominating politicians, both born in 1519, were to be forever intertwined. One day the queen mother would turn against Coligny, with catastrophic consequences for all of France. But for now she allowed him to pursue his dream of a colony in Florida, even giving the crown's unofficial blessing to the enterprise with a contribution of one hundred thousand francs.

Coligny's position in the court was tenuous nonetheless. Only weeks before Le Moyne and his companions had set sail, the admiral was forced to publicly protest his innocence in the murder of his enemy the duke. The prospect of securing La Florida for France promised not only to repair his own public image and that of his cause; it also might undercut the credibility of the Catholic Guise faction, which was closely aligned with Spain.

Some historians, in fact, have argued that Coligny was eager to provoke the Spanish into a war in the New World, perhaps as a means to

unite French Protestants and Catholics against a common enemy. Other scholars argue that instead of all-out war, he sought diplomatic leverage with the Spanish, who, out of concern for a French settlement near their shipping lanes, might have been convinced to make territorial or trade concessions in the New World. In either case, the admiral wanted to attract as little Spanish attention as possible until the outpost was firmly established. He planned to send a reinforcement mission the following spring; until then, he gave Laudonnière specific orders "to do no wrong against the subjects of the king of Spain nor anything by which he might conceive any unhappiness."

NOT ALL THE RESIDENTS of the new fort were Calvinists. According to the accounts of survivors, the outpost was also home to an unknown number of Catholics, as well as criminals who had been promised their freedom if they joined the mission and about fifty "Africans of unrecorded countries," who also may have been granted their liberty upon arrival in Florida.

The expedition included only a small number of women—perhaps four—but one of them soon became a figure of considerable controversy. This was Laudonnière's companion, "a poor chambermaid" in the commander's own words, "whom I had brought from an inn to take care of my household business and to take care of the domestic animals, such as the sheep and chickens which I brought over to establish in this land." That explanation, however, did not sit well with some colonists, who began to suspect that the woman's "household business" involved duties other than cooking and cleaning. Whether or not this was true—and Laudonnière later denied it—the allegation caused tension among the more devout colonists. In John Calvin's Geneva, after all, fornication out of wedlock was punishable by exile, adultery by death. In Florida, it seemed, the top Huguenot official had brought along his own mistress. Even more infuriating was the fact that, as Le Moyne revealed, Laudonnière had failed to supply the expedition with a "minister of God's Word."

This tear in the settlement's social fabric was soon to be accompa-

nied by another split, one that unraveled along class lines. Among those on the expedition, wrote Le Moyne, were "a great many noblemen and youths of established family," who had joined simply out of "some urge to explore far-off lands." The artist had nothing good to say about them. They had only come, he wrote, "in their own interests" and were "equipped very ostentatiously"—no small matter to Calvinists, who were banned from wearing immodest dress. Le Moyne expressed his disgust with Laudonnière for catering to such grandees, who had made clear they were after easy money, not hard work. When they did not instantly discover the riches that "they had promised themselves and imagined . . . complaints from many of them were heard every day."

In contrast to these aristocrats, Le Moyne embodied a dynamic new economic and social force: the emerging middle class. He lived in an age when the anonymous medieval painter, whose status ranked with tailors, shoemakers, and other craftsmen, was slowly transforming into the esteemed artist of the Renaissance, an independent virtuoso. Le Moyne did not say whether he viewed his own work as an elevated pursuit, but at Fort Caroline he kept company and even shared lodging with top officers—"evidence," wrote the art historian Paul Hulton, "of the importance attached to his mission."

LE MOYNE'S ILLUSTRATIONS of the men who lived in that outpost are often so specific that they seem to portray distinct individuals. The longer I spent on the artist's trail, the more I found myself poring over those pictures, consumed with the idea that one of them might contain a portrait of Le Moyne himself. Was he winking at me across time? Had he left some clue—an article of clothing, an unusual facial expression, the placement of some figure in the composition—that might reveal his identity? Could I pull him from the past?

I spent years staring at those engravings, only to discover what many previous observers had already learned: Le Moyne does not part easily with his secrets. Even his illustration of the finished fort is a puzzle to historians. Not only does it appear to be at odds with parts of the artist's own text, but it is also hard to reconcile with a drawing made by another

member of the expedition. And because this other picture was sketched shortly after the completion of the outpost and was promptly sent home on a ship returning to France, some scholars have questioned the accuracy of Le Moyne's illustration.

Detail of French soldiers from a print based on the work of Le Moyne.

The artist depicts Fort Caroline as triangular, for instance, while his fellow colonist shows it as arrow-shaped. One researcher, arguing that this other picture should be given "greater credence" than Le Moyne's, asserted that the outpost was "constructed as an elongated arrow." Yet the fact remains that Laudonnière, who knew the structure as well as anyone, consistently referred to it as triangular. Assuming the other colonist's lopsided configuration of the fort is not simply an amateurish attempt at perspective, such a design would have made little strategic sense, the off-kilter angles leaving the bastions unable to protect each other with cannon fire.

*The completed Fort Caroline, as seen in
illustrations attributed to Le Moyne (left)
and to another French colonist.*

Perhaps the apparent incongruities of Le Moyne's picture only indicate he was working from memory years after leaving Fort Caroline. Or perhaps, after what ultimately became of him there, he simply preferred to block the place from his mind. Like so many of his works, the engraving may never be fully understood. And yet every now and then Le Moyne does uncoil one of his mysteries from beyond the grave. An image closely related to that picture of the finished outpost has finally been decoded—with stunning results.

OPPOSITE THE ENGRAVING of the finished outpost in Le Moyne's narrative is what appears to be a second illustration of Fort Caroline. That picture shows more than a dozen Frenchmen at work on a structure: digging trenches, felling trees, hauling lumber, and putting up a building. Although the accompanying text does not refer to the fortification by name, it does mention the River of May—the modern-day Saint Johns—and describes how Le Moyne's expedition constructed its outpost there, at "a certain place near a hill." It turns out that the caption, which may have been written by the engraver Theodor de Bry after Le

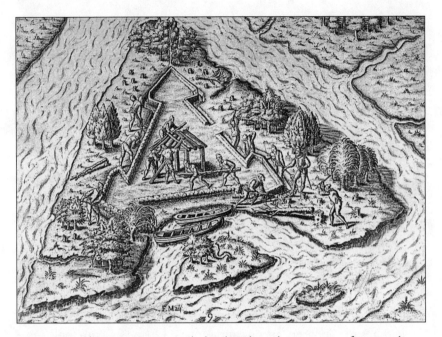

For centuries this engraving was wrongly thought to depict the construction of Fort Caroline.

Moyne's death, is wrong. But it also turns out that no one noticed the error for a full four centuries.

True, there are some puzzling differences between the two pictures. Although both show a triangular enclosure surrounded by water, the engraving of the completed outpost has Fort Caroline fringed on two sides by a man-made moat, while the other illustration seems to depict an actual island encompassed entirely by natural waterways. Nobody paid a great deal of attention to such discrepancies, however, until one day in 1989, when an archaeologist from the University of South Carolina began poring over the engravings.

Chester B. DePratter had recently joined the search for Charlesfort, the failed predecessor to Fort Caroline at Port Royal Sound. The location of this abandoned outpost, burned to the ground by Hernando Manrique de Rojas in 1564, had long been the subject of intense speculation. But so far every effort to find the fort had ended in failure. DePratter turned to Le Moyne's work, hoping that it might contain some overlooked clues.

He began by studying seven engravings of Le Moyne's work that document the earlier French colony from its arrival in Florida to just after Jean Ribault's departure for France, when supplies were beginning to run low. Reexamining these images, DePratter was struck by their geographical accuracy—an accomplishment that seemed all the more extraordinary since Le Moyne, by all evidence, did not take part in that first voyage to La Florida.

Then, glancing at that picture of Frenchmen constructing a fort, DePratter made a dazzling discovery. The topography bore an uncanny similarity to a landform he knew well. It was not the terrain around Fort Caroline. It was Parris Island—one of the prime suspects as the site of Charlesfort. "I just got a map and started comparing it with the engraving," DePratter told me, "and I realized that it was an extremely accurate depiction of Port Royal Sound and Parris Island. It really was a eureka moment. I began to think, Okay, maybe this thing is findable."

From that point on, DePratter and fellow archaeologist Stanley South limited their search to Parris Island. And in 1996, after numerous twists and turns in their investigation, they were able to announce that they had unearthed evidence of the fort on the grounds of a U.S. Marine Corps golf course. It had taken some brilliant detective work to locate Charlesfort beneath the remnants of an old Spanish outpost, but DePratter was all too happy to share the credit with Le Moyne. "Without him," he told me, "we couldn't have found the fort."

Yet in this elusive artist's ongoing story, even solutions to old mysteries seem to create new ones. How, for instance, are we to explain Le Moyne's depiction of a fort that had been burned down before he ever set foot in the New World? It's possible, of course, that he took part in that earlier voyage or that he had access to maps, notes, or drawings made by one of its participants. But it's even more likely that he traveled to the site of the destroyed fort during one of the many forays into the wilderness he would make in the months ahead—adventures that were to result in the first extensive visual record of native North Americans.

Among the Indians

. . .

HE DID NOT KNOW IT, BUT HE WAS PAINTING A WORLD OF GHOSTS. Warriors soon to be slaughtered or enslaved. Children forced to abandon their native dress, tongue, and traditions, even their own names. Strong, beautiful bodies wasted by disease. Villages razed. Sacred rites forgotten. A people obliterated.

American history is, sadly, full of such genocides. What made this

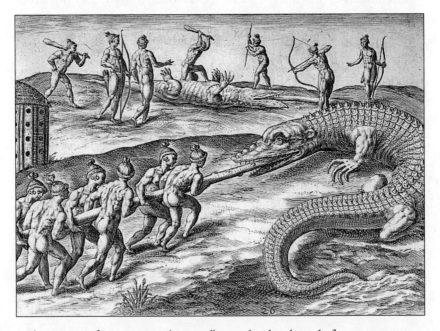

This engraving of Timucuan men hunting alligators, based on the work of Jacques Le Moyne, contains many curious errors. The head, eyes, ears, legs, and massive size of the animal in the foreground, for instance, are all anatomically incorrect.

one different is that a witness was there to record the doomed culture before it disappeared. Engravings of Le Moyne's work, now elevated to iconic status through repeated use in books and exhibits, have in effect become our collective memory of that long-vanished time and place. But what a flawed memory it is, addled by inconsistencies and inaccuracies, delusions and dreams. Le Moyne managed to cram a vast pageantry of native life into those few dozen pictures—warriors taking scalps; young men practicing sports; widows grieving for their dead husbands; cooks curing deer, snake, alligator, and other meats on a barbecue; transvestites caring for the sick; a weeping mother turning her newborn son over to executioners for a ritual sacrifice; a couple and their children out on a family picnic. Yet despite their stunning breadth and strange beauty, those images—works of unclear authorship, based on vanished paintings of a vanished people—defy simple understanding. It's what makes them at once so maddening and so seductive.

HE BEGAN HIS WORK, we can safely presume, by sketching events close to the fort. Le Moyne rarely included himself in his descriptions of the

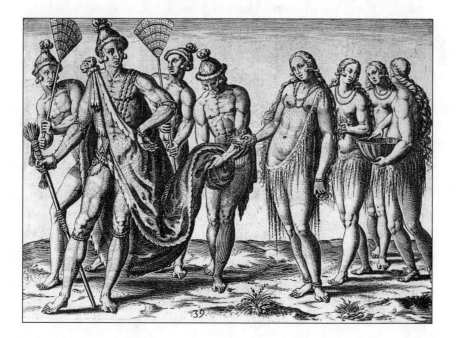

Indians, but once, he reported, "when . . . out hunting with some of my companions in the woods near Saturiwa's home," he spotted the local chieftain on "an evening walk alone with his principal wife, wearing a deerskin." The artist would later describe the scene:

> Next to the chief walked two young men carrying fans to cre-
> ate a soft breeze. Behind them was a third young man who wore
> small gold and silver discs dangling from his belt, and holding up
> the chief's deerskin so it did not trail along on the ground. The
> chief's wife and her maid servants were all dressed in a special
> kind of moss hanging from their shoulders or around them as a
> girdle. The moss grew on many trees and hung together like a
> chain, with its greenish azure color shining like silk. The trees on
> which this moss grew were beautiful to look at because it hung
> down to the ground from the highest branches.

For a European observer such as Le Moyne, this vision must have seemed at once familiar and strange. On the one hand, what could have been more ordinary than the image of man and wife off on an evening stroll? On the other, what could have been more bizarre than the sight of women clothed in nothing but clumps of still-living plant life? Even the Spanish moss itself, as Le Moyne's detailed description indicates, was a revelation to the artist. And then there was the tattooed skin, virtually unknown in sixteenth-century Europe. In attempting to make useful representations of such phenomena for an audience that lacked the cultural equipment to process them, he found himself facing a contextual gulf as wide as the Atlantic. Even the most basic question of how to portray the Indians' faces and bodies—so like those of the French and yet so unfamiliar—was utterly perplexing. As Jean de Léry, a French Protestant writer and artist who traveled to Brazil in the 1550s, once complained: "Because their gestures and countenances are so different from ours, I confess it is difficult to represent them properly in words or even in painting."

Le Moyne, it is true, seemed better suited than most of his contemporaries for the role of impartial observer. Little is known about his early

career, but it appears likely that he received his training as a botanical painter, detailing flowers down to the smallest hairs on their stems, fruits and vegetables to the subtlest shift in the colors of their skins. Yet inventing a new artistic language to describe the strange sights he witnessed in Florida was apparently beyond him, especially when it came to illustrating people rather than plants. He was forced to communicate through a familiar idiom: the consciously artificial style remembered today as mannerism.

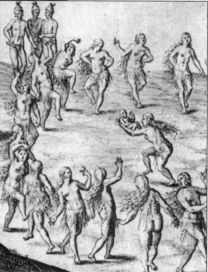

The mannered, arm-flailing nudes of (left) "Birth of Cupid," by the School of Fontainebleau artist known as Master of Flora, and (right) "They Sacrifice First-Born Sons to the Chief in Solemn Rituals," based on an illustration by Le Moyne.

It originated in Italy, where Michelangelo and younger painters had begun to reject the emphasis on beauty, harmony, naturalism, and rationalism that had characterized southern Renaissance art. This new movement came to France around the time of Le Moyne's birth, when

François I hired Italian artists to provide paintings and decoration for the Chateau de Fontainebleau, a palace forty miles from Paris. Soon the chateau was the king's main residence, and the School of Fontainebleau was a distinct style of art. Its hallmarks were erotic mythological scenes featuring female nudes with elongated and sinuous bodies (often contorted into serpentine poses), thin necks, small heads, and elaborate hairstyles.

This explains why the strolling Saturiwa and his wife bear less physical resemblance to any actual Native Americans than to the Greek and Roman gods found in countless paintings from the School of Fontainebleau. As the art historian Gloria-Gilda Deák observed, the engraving of the Indian couple is "a wondrous document of the mannerist penchant for flaunting the human anatomy." The chieftain is powerfully built and "Apollo-like" while the women "appear as statuesque as the men. Le Moyne has depicted them with all the exquisite artificiality of Botticelli madonnas." Even the moss skirts, "with the textural appeal of silk," are reminiscent of the gossamer veils and girdles of flowers that adorn many School of Fontainebleau nudes. Unable to break from his own artistic and intellectual milieu, Le Moyne could not manage to imbue the Timucua with an identity wholly their own. His engravings would help correct the notion that New World natives were cannibals or hair-covered wild men, only to replace those old myths with a new one: the noble savage.

IN 1562, DURING THE WORST horrors of the First War of Religion, a young magistrate and soon-to-be writer named Michel de Montaigne had a fateful meeting with three Tupinambá Indians, then visiting France from their native Brazil. The encounter took place in the Norman city of Rouen, a Protestant stronghold, which had just been overrun by royalist forces. The slaughter was so horrific, wrote one contemporary chronicler, "it took two days to remove the bodies from among the garbage on the pavement, and no matter what orders were issued by the king, order could not be restored."

Montaigne, in fact, had been among those who accompanied the young monarch Charles IX into Rouen after the royalist victory. Yet although himself a Catholic, he abhorred the sectarian bloodshed and throughout his life refused to be a partisan. (This was, the historian Jacques Barzun observed, "almost as dangerous as being one.") The carnage in Rouen no doubt weighed heavily on his mind as he met with the Tupinambá.

By comparison with the fratricidal madness of his own people, the Indians struck Montaigne as refreshingly clearheaded. When he asked what they found most remarkable about France, they replied that it seemed strange that some men lived in abundance while others starved, and that "so many tall, bearded men, all strong and well armed . . . should be willing to obey a child." Why, they wondered, did not the French select a grown-up to be their king?

So impressed was Montaigne by this encounter that it would later inspire one of his most celebrated essays. In "On Cannibals," he argued that far from being barbarians, inhabitants of America lived in "a state of purity," isolated from the corrupting influences of civilization. In contrast to the avarice of Europeans, the Indians existed in such "original simplicity" that "the very words denoting lying, treason, deceit, greed, envy, slander, and forgiveness have never been heard." Even the practice of cannibalism, Montaigne wrote, had a certain dignity compared to the religious butchery of Europeans. Was it not better, he asked, to "eat a man after he is dead" than to "tear by rack and torture a body still full of feeling," as his own warring countrymen had been doing in the name of God?

By juxtaposing the vices of Europe with the supposed virtues of America, Montaigne was building on an idea that had been proffered by earlier French writers. This was the concept of the noble savage, a formulation at once forward-looking and nostalgic. On the one hand, Montaigne was making a strikingly modern claim about the relative merits of cultures: "I do not believe, from what I have been told about this people, that there is anything barbarous or savage about them, except that we call barbarous anything that is contrary to our own habits."

On the other, he was drawing on the mythical past of the Golden Age, that time of primordial innocence described by ancient Greek and Roman poets.

Like Le Moyne, Montaigne had been born in 1533, the fifteen hundredth anniversary of the death and resurrection of Christ, and a year that many Europeans believed would mark the onset of the Final Judgment. (One noted mathematician went so far as to announce numerical proof that the end would come at precisely eight a.m. on October 19, 1533.) Both Le Moyne and Montaigne grew up in a world feverish with religious upheavals and apocalyptic dreams, a world in which men of faith engaged in all manner of atrocities, confident that in slaughtering their enemies they were serving as mere channels of God's wrath in the Last Days. It's no wonder that they might have wanted to believe in the existence of a simpler, purer, more harmonious way of living—an escapist yearning that had already found expression in French mannerist art with its idealized, erotically charged scenes from antiquity. Le Moyne crossbred these classical gods with the noble savage, creating a new species of deity, formed like young Spartans and dressed up in deerskins and Spanish moss.

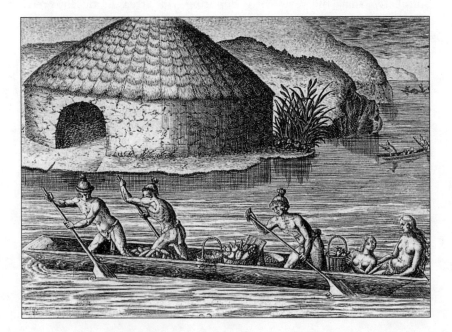

Europe's lost self: The Native American would never escape this role in Le Moyne's art. In the caption that accompanied a picture of the Timucua ferrying fruits and vegetables to a communal storehouse, for example, Le Moyne noted that "they go there for supplies whenever they need anything—no one fears being cheated. Indeed, it would be good if among Christians there were as little greed to torment men's minds and hearts." In another caption, the artist claimed to have met Native Americans who were three hundred years old. "They certainly put Christians to shame who reduce their span of life by holding immoderate feasts and drinking parties, and who deserve to be handed over for training to these base uncivilized people and brutish creatures in order to learn restraint," he wrote.

Such descriptions match Montaigne's notions of a New World in which there were no "riches or poverty, no contracts, no inheritance, no divisions of property," and "anyone palsied, or blear-eyed, toothless, or bent with age" was virtually unknown. Not surprisingly, however, they frustrate modern researchers, who can never quite be sure how to separate the noble savage of Europe's imagination from the Timucua of the artist's keen eye.

THERE IS AT LEAST ONE more possibility to consider here. If it's hard to get a clear picture of the Timucua from Le Moyne's illustrations, at least part of the reason may be that the Indians did not want to be seen. One of the artist's most indelible images appears at first glance to portray two groups of deer facing each other across a stream. It is only on closer inspection that we notice the darker realities of this seemingly picturesque vignette. Those are not deer on the left: They are deerskins, under which we glimpse human legs and arms, with bows drawn, arrows ready to fly. "The Indians, dressed like this, were able to approach and get really close to them without arousing their suspicions," wrote Le Moyne.

And if we study the picture in even greater detail, we discover one final surprise. In the stream—at which a deer in the foreground appears to be gazing—is the reflection of two stags, one from either shore. They

are virtually identical, down to the smallest tine of their antlers. This, we realize, is the scene as it must have looked in the eyes of the deceived.

Like those unsuspecting animals, the French mistook the Indians for something they were not, and the Timucua obliged by donning the mask and skin of the noble savage. But ahead for the colonists, in terra incognita, illusions would be shattered and roles reversed. Before the expedition was over, the Indians would seem far less like innocent inheritors of the Golden Age, and the French would behave like the most barbaric of savages, driven to extremes by dual obsessions: the need for food and the lust for gold.

Promised Land

. . .

"A LONG WAY FROM THE PLACE WHERE OUR FORT WAS BUILT THERE are high mountains, called the Apalatci in the Indian language, where . . . three large streams rise and wash down silt in which a lot of gold, silver and copper is mixed." These words accompany an illustration that shows a group of Indians panning for gold by collecting mineral-rich silt in hollow poles. "They put it in canoes and transport it down a great river, which we named the River of May and which flows to the sea."

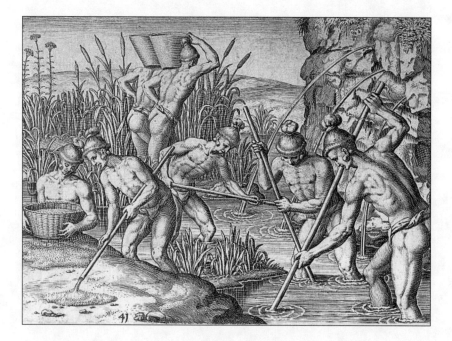

Such a matter-of-fact account of such monumental news: a land of gold, accessible to the fort by boat. The first sketchy reports of these mountains marked a turning point for the expedition. It would not be long before the colony was transformed into a quest.

THE FRENCH BEGAN to hear Indian stories about "high mountains which are full of many things," as Laudonnière himself put it, during the summer of 1564, when he dispatched two expeditions in small boats to explore the Florida interior along the Saint Johns River. As expedition cartographer, Le Moyne would have had reason to take part in both these journeys, particularly the second, "which must have had as one of its prime objectives the mapping of the river and the location of Indian settlements," wrote the scholar Paul Hulton. "This would probably have been Le Moyne's first real opportunity of observing the way of life of the Timucua as well as the natural life of the region."

It was during the course of this second expedition that the French learned of a man who would become a recurrent subject of Le Moyne's pictures. This was Chief Utina, who ruled over the land immediately to the west of the Saint Johns. An immensely powerful figure, Utina gave orders to more than forty vassal chiefs and controlled the main trail into the interior of northern Florida. But what intrigued the French about him most were stories of mysterious, mineral-rich mountains that lay somewhere beyond his territory. Utina, the explorers quickly concluded, was a man to have on their side. Wrote Le Moyne:

> His friendship was essential to us, because if we wanted to travel from our base to the "Apalatci" mountains (and we were eager to find these mountains because we understood that most of the gold and silver we had bought had been transported from there), the greater part of the journey had to be made through his territory.

So when the French learned Utina was at war with his neighbor to the west, Chief Potano, they immediately promised their support—

assuring an intermediary that together Laudonnière and Utina "would
return victorious from those high mountains."

This strategy, however, had one glaring flaw. Utina was also a bitter
enemy of the chief to his east, Saturiwa, with whom Laudonnière had al-
ready pledged "friendship and everlasting alliance." It had taken him
only weeks to waver on that treaty, but for the moment such diplomatic
niceties must have seemed minor compared with the riches awaiting the
French. True, the evidence for these mountains consisted almost entirely
of assurances from the Indians. Nonetheless, their existence soon be-
came an article of faith. In a letter sent home that summer on a departing
ship, one giddy colonist reported that French explorers "had discovered a
gold and silver mine at a place about 60 leagues from our fort." Sixty
leagues, 180 miles—the promised land had never seemed so close.

UNTIL THAT POINT, French ambitions in America had come to noth-
ing but long decades of frustration and delusion, punctuated by brief
episodes of disaster. This comedy of errors had begun in 1493, when
Pope Alexander VI, a Spaniard who owed his election to King Ferdi-
nand and Queen Isabella, issued a papal bull that neatly divvied up the
unknown world between Spain and Portugal. France was officially exiled
from terra incognita, an idea that so infuriated King François that he
quipped: "I would like to be shown the article in Adam's will that divides
the New World between my brothers, Emperor Charles V and the King
of Portugal, and excludes me from the succession. The sun shines on me
just as it does them."

It was not until the landmark year of 1533 that François gained
enough diplomatic leverage to press this line of argument with a new
pope, Clement VII. When the two men met in Marseilles—where the
king's son, Henri, was marrying the pope's niece, Catherine de Medici—
the pontiff agreed to reinterpret the earlier edict so that France could
enter the great American treasure hunt. Believing the Iberian monopoly
was no longer guaranteed, François promptly dispatched the explorer
Jacques Cartier to the New World with the twin goals of finding a

northwest passage to the Orient and discovering "certain islands and countries where it is said there must be a great quantity of gold and other riches."

Once again, however, fate was against the French. In November of 1533, as the Vicar of Christ and the king of France departed the marriage festivities at Marseilles amid great pomp, Francisco Pizarro, the illegitimate, illiterate son of a Spanish peasant woman, was leading a ragged and undermanned force into Cuzco, the heart of the Inca empire. His conquistadors wasted little time in gutting the temples, palaces, and storehouses of their gold, setting up a foundry so that the religious and artistic birthright of the Incas could be melted down into neatly stacked ingots bound for Seville. "No loot equaled this one," wrote one sixteenth-century Spanish adventurer, "nor in the Indies was there [ever] found such wealth."

Cartier, meanwhile, came back from his 1534 voyage with neither precious metals nor a route to China. But returning to Canada the following year, he collected native stories about a strange land of gold and spices called Saguenay, said to be inhabited by white men as well as by creatures who hopped about on one leg, people who had no anuses and survived on a liquid diet, and winged humans who flew like bats from tree to tree. Such yarns were greeted dismissively by some in the French court, but the king was not among these skeptics. It was an age of marvels, when virtually anything seemed possible, and François desperately wanted to believe that Saguenay would do for his treasury what Mexico and Peru were doing for that of his Spanish counterpart. He again dispatched Cartier to Canada in 1541, but the explorer's attempt to locate the elusive (and illusory) dominion ended in failure, as did Jean-François de La Rocque de Roberval's follow-up expedition.

Although Saguenay would remain on maps for more than a hundred years, the French eventually abandoned their search. After a failed effort to establish a colony in Brazil between 1555 and 1560, they turned their attention to Florida, still haunted by the dream of an enchanted destination. "They were convinced," wrote one sixteenth-century chronicler, "that everything had not yet been discovered, that the world was great

enough for men to bring to light other things even newer and stranger than those already revealed." And suddenly these hidden wonders all seemed to take the name Apalatci.

IT WOULD NOT BE LONG, however, before Laudonnière's obsession with these mountains would bring him trouble. At some point in late July or early August of 1564, Chief Saturiwa sent messengers to the French fort. They had come, wrote Le Moyne,

> not merely to confirm the treaty they had entered into be-
> tween them, but also in order that [Laudonnière] should stand by
> the terms of the agreement, specifically by proving that he was a
> friend of the chief's friends and an enemy of his enemies; for Sat-
> uriwa was planning an expedition against his enemies.

And those enemies were none other than the forces of Chief Utina, the very man Laudonnière now viewed as essential to reaching the Apalatci. By this point, the artist reported, "some of our men were with [Utina] and had already sent a large consignment of gold and silver to our camp, in settlement of a compact with him." Laudonnière, in short, had managed to make solemn alliances with both sides in an ongoing war. Now, faced with the inevitable outcome of such double-dealing, the French leader vacillated. Assuring Saturiwa's men that he "wished to as-sist" in the fight, he explained that he was not yet prepared to do so, both because he had failed to secure the proper food and supplies for the de-fense of the fort and because his men had not yet completed work on two barques, small vessels with hulls of thirty-five to forty feet, which would be necessary for the operation. Yes, insisted the commander, he would fulfill his promise to Saturiwa—in a couple of months.

The chief, however, was not so easily put off, showing up at the fort with what Le Moyne estimated to be twelve hundred to fifteen hundred men. Despite this force, which was at least five times the size of the en-tire French garrison, he was denied access at the gate and told he would be allowed inside only if accompanied by no more than twenty of his

men. "Taken aback by such a stipulation, he disguised his feelings and entered," wrote Le Moyne. There, the chief was met by a blaring display of European technology, aimed at inspiring awe and obedience:

> He was terribly frightened himself at the sound of the drums and trumpets, and at the reports of the brass cannon which were fired in his presence; and, when he was told that all his force had run away, he readily believed it, as he would gladly have been farther off himself.

Saturiwa, his ears ringing and pride bruised, managed to regain enough composure to remind the French commander of his earlier promises, insisting that his military campaign could not wait because he had already rounded up his supplies and assembled his vassal chiefs. When Laudonnière again begged off, the chief marched off to prepare for battle without him, assembling his subordinate chiefs and their men for a war ceremony.

Le Moyne, who left a haunting visual and written record of this ritual, may have been an eyewitness:

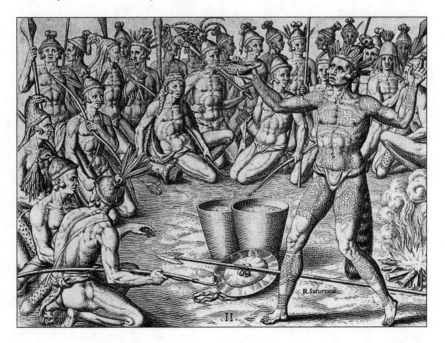

The warriors gathered around their chief in a close circle. To the left of him a fire was burning, to the right two large containers full of water. The chief rolled his eyes and, gesticulating wildly, growled as if consumed with anger. Sometimes he made terrifying screams which were echoed by his warriors who slapped their thighs so their weapons made a noise. Then he took up a bowl and turned towards the sun, respectfully and humbly asking for victory over his enemy, that their blood should be spilled like the water from the bowl. Then he threw the water in the air so it splashed upon his warriors, declaring, "do as I have done with the blood of your enemies." Then, pouring the water from the other container on the fire he cried, "thus you must exterminate your enemy and bring back their scalps." Then they all rose up and marched upstream to war as planned.

Thanks to a mixture of equivocation and intimidation, Laudonnière had managed to keep the French out of a conflict that imperiled their chances of reaching the Apalatci. In doing so, however, he had poisoned relations with the chief closest to the fort—a dangerous move. Utina promised the French gold, but Saturiwa was their main source of food.

LAUDONNIÈRE HAD ASSURED his men of adequate provisions for a year, but he apparently failed to look after the necessary arrangements to honor that pledge. To make matters worse, the expedition arrived in Florida too late to grow enough crops to be self-sustaining. Nor does there seem to have been much interest among the colonists in the hard and inglorious task of clearing, planting, and harvesting fields. That was the work of peasants, not tradesmen or soldiers—and certainly not aristocratic adventurers.

Because of all this, the French were, from the start, almost entirely reliant on Saturiwa and other local Indians for corn, trusting that the Timucua would have abundant supplies to share with them. That would prove to be a fatal assumption, but even now the harrowing specter of food shortages had started to loom. Wrote Le Moyne:

Laudonnière began to ration food and drink for each one, so that after three weeks each man was being given a daily cupful of wine diluted half and half with water. As regards foodstuffs, of which we had high hopes in this new world, there was not a morsel; and if the natives had not shared their food with us every day there is no doubt that some of us would have died of hunger, especially those who did not know how to use fire-arms for hunting.

This scarcity only intensified other resentments at the outpost. Of the roughly two hundred men at Fort Caroline, the vast majority had been cooped up in the tiny compound for the better part of their stay. With a land of gold so close that it almost seemed to cast a glow on the horizon, these impatient adventurers grew more frustrated with each passing week. They particularly resented a small number of fellow colonists whom the commander had allowed to venture into the wilderness and trade with the Indians. There were grumblings, whispered at first but later less muzzled, that Laudonnière played favorites, that he was aloof and ineffectual—complaints that Le Moyne, for one, seems to have found legitimate. "Laudonnière was too easygoing and was clearly under the influence of three or four parasites," the artist wrote, adding that "he despised the soldiers, especially those whom he ought to have valued."

One day soon, the commander's arrogance would come back to haunt him. Yet despite unrest within the fort and trouble with the Indians just outside its walls, the gravest threat to the colony's survival was still an ocean away, locked up—for the time being, at least—in a Spanish jail cell.

Prisoners

...

IN SEVILLE, THE PRISONER STARED AT THE WALL AND DREAMED OF what lay beyond. He was perhaps the greatest sea captain of the legendary Spanish fleet, a man whose dark, disdainful eyes and long, dour face projected an air of barely subdued anger and contemptuous self-importance. "The foremost man of his time": That's how one contemporary described him, and if the characterization smacked of sycophancy, it also contained at least a kernel of truth. For although Pedro Menéndez de Avilés was hardly among the guiding spirits of the Renaissance, he did, in his own frenetic way, personify the age: its bold spirit of ambition, individuality, and improvisation, its grim countercurrents of fanaticism and brutality.

He had been fighting the French since he was old enough to bear arms. According to one account, he was "still of tender age"—presumably in his teens—when he left his home in Asturias, a coastal region in northwestern Spain, to test the seas in an open boat. Soon he found himself battling a "real warship" full of French corsairs. Although his little vessel was "almost pounded to pieces by artillery fire," Menéndez and a small group of companions put up such a good fight that the French "dared not board," according to one chronicler.

By the time he was in his early twenties, Menéndez owned his own ship and had enlisted in "an armada . . . equipped against the corsairs." He quickly established himself as one of the most daring and aggressive *contra-corsarios,* as those who battled foreign pirates were known. In 1549, for example, the thirty-year-old Menéndez chased down and mortally

wounded the French pirate Jean Alfonse, who had seized a number of Spanish vessels off Galicia. This demonstration of ferocity in defending the Spanish coast gave the crown reason to hope that he might repeat this success in the pirate-infested Caribbean. Sent to the Indies to guard Spanish shipping, Menéndez was captured by French corsairs in 1552

An engraving of Pedro Menéndez de Avilés.

and had to be ransomed. It would not be long, however, before he was back in action, this time as captain-general of the treasure fleets.

Having made his own way in the world from a young age, he had developed an unshakable belief in his abilities and instincts, an absolute certainty that God was on his side. Yet with this self-confidence came a tendency to bend rules and disregard orders. Such behavior was evident

from his very first efforts as commander of the Indies fleet in 1555. Taking control of an unprecedented eighty-one ships, Menéndez departed for the New World with orders to escort the treasure fleets back and forth across the Atlantic. With typical audacity, he improvised on those plans, sailing home for Spain months earlier than his instructions had dictated. It was a huge gamble, but one that paid off: not a single ship was lost. In the years to come, many more of his exploits would be "carried out against the instructions given him, as it appeared to him that it was to the king's greatest interest that he should violate them," wrote his brother-in-law and biographer, Gonzalo Solís de Merás.

The following year, after he sank a ship under the command of the famous French corsair François Le Clerc off the Spanish coast, his reputation as a brilliant seaman and ruthless defender of Spanish interests continued to grow. Yet his tendency to go it alone earned him powerful enemies within the Casa de Contratación (house of trade), the body that oversaw commerce between Spain and its American possessions. In 1563 the Casa, which had its own quasi-independent judicial arm, arrested the mariner on charges of smuggling and other crimes. He had always found a way out of such imbroglios in the past, but this time his accusers were not willing to let the matter drop, even under royal pressure.

The misery of his confinement was heightened by news that his only son was missing—and possibly shipwrecked—somewhere off the Florida coast. (Intractability seemed to run in the family: The young man had disobeyed his own father's instructions to avoid the Bahama Channel during hurricane season.) His request to go in search of his son was rejected, however, and now, as his case sank deeper than ever into a legal morass, this man who had always controlled his own fate was learning just what it was like to feel powerless.

His luck began to change in the summer of 1564, thanks to two events an ocean apart. In July, Menéndez pulled off a jailbreak in Seville and rushed to the new Spanish capital of Madrid, where he promptly surrendered to authorities and was placed in the royal prison. His legal troubles were far from over, but he was no longer at the mercy of his enemies in the Casa de Contratación. King Philip II was much more inclined to overlook the captain-general's indiscretions, not because the

monarch was a lenient man but because he knew that no one could better protect his New World interests than Menéndez. During the navigator's long imprisonment, the king had turned to another adventurer to establish a colony in Florida and investigate reports of a French presence there. But the expedition, bogged down by disorganization and desertion, never even reached the mainland. By August of 1564, as Le Moyne and his compatriots were exploring the interior, the Spanish effort had disbanded, its leader fleeing Santo Domingo by night in a small boat. For conquistadors, La Florida was beginning to seem like a curse. Juan Ponce de León had died of wounds inflicted by hostile Indians; Pánfilo de Narváez had been forced to eat his horses before drowning in a makeshift raft off the coast; Hernando de Soto had succumbed to a fever on the banks of the Mississippi; and despite numerous colonial enterprises, Spanish explorers had utterly failed to secure the region for their king. The next attempt would belong to Menéndez.

IN LONDON, ANOTHER PRISONER stared at the wall and dreamed of what lay beyond. He had never intended to wind up in England, let alone be locked away in jail. For two long years, he had thought of little else but returning to Terra Florida.

When Jean Ribault left those twenty-six men at Charlesfort back in June of 1562, there was excellent reason to believe he could make good on his promise of a prompt return with reinforcements and supplies. At the time he embarked on the expedition, Calvinists were in an unusually strong position at the French court. Just prior to their departure, Catherine de Medici, who appears to have personally sponsored Ribault's mission, had issued the landmark Edict of January, which, for the first time, allowed Calvinists a limited right to worship in public. Ribault came home, however, to a different France. The bloody civil war had broken out between Catholics and Protestants, upending the delicate balance of power that made the original expedition possible. Worse, that conflict was already turning against the Huguenot side. When Ribault reached Dieppe in July, the city was imperiled by a Catholic advance. Desperate for help, the Huguenot leadership appealed to Protestant

England, where they found an ally in Queen Elizabeth. Yet by the time three thousand English troops arrived in Dieppe in October, it was too late. With Catholic artillery pounding the city's defenses, the trapped English and Huguenot armies had no choice but to lay down their arms.

Ribault helped negotiate the terms of surrender, which allowed the English troops a chance to return peacefully across the Channel before victorious royalist forces entered the city. When the English departed, he went with them—less to save his own skin, apparently, than the lives of those he had left behind at Charlesfort. Aware that no French resupply mission was possible amid the chaos of civil war, he now sought backing on the other side of the Channel. It was a place he knew well, having worked for the English as a high-priced maritime mercenary from the mid-1540s to 1555.

Desperate for any help he could get, Ribault soon began making plans with an English adventurer named Thomas Stukeley to launch a joint expedition to Florida. Yet despite the financial backing of Queen Elizabeth, the scheme was to prove disastrous. Soldier of fortune, spendthrift, spy, con man, and counterfeiter, not to mention avowed Catholic, Stukeley, rumored by contemporaries to be the illegitimate son of King Henry VIII, was anything but the ideal business partner for Ribault. As plans for the expedition went forward, it became obvious that the mercenary was more interested in raiding Spanish galleons than saving a few stranded Frenchmen. The partnership was further strained by worsening relations between France and England, and by June of 1563 Ribault wanted out. Perhaps convinced that he might once again be able to raise his own fleet in Normandy, he attempted to find passage back to France. Apprehended at the port of Gravesend for betraying his agreement with the queen, he was thrown in the Tower of London, where he had remained ever since.

In the mariner's year of captivity, however, the French had grown increasingly anxious for his return. Having promised Laudonnière that reinforcements would arrive no later than the following spring, they wanted Ribault, with his vast knowledge of the terrain and legendary skills as a navigator, to lead this crucial mission. By April of 1564, the French were pushing hard for Ribault's release, according to the English ambassador in France. The diplomat had been trying to do something

about the "great numbers of Englishmen committed to the galleys" of French ships, who "live in great misery," he wrote. But the French were unwilling to budge on releasing the English prisoners. "John Rybaud [Ribault] is partly the cause of this."

This much-coveted captive would not stay in the Tower for long. Although we do not know the exact date of his release, Ribault's long legal battles, like those of Menéndez, were to reach a decisive turning point during the summer of 1564.

The two mariners had already faced each other as enemies. In 1558, when the French were attempting to recapture Calais, a strategic port in northeastern France that had been occupied by the English for more than two hundred years, Ribault was in charge of maintaining the French naval supply line and fending off enemy reinforcements. Menéndez, meanwhile, sailed on the side of the English, then close allies of Spain. It may have been during this battle, won by France, that Menéndez gained an enduring respect for his rival. The Spanish navigator would later describe Ribault as "the most experienced seaman and corsair known," adding that "the King of France could do more with him with 50,000 ducats, than with others with 500,000; and [Ribault] could do more [damage to Spanish interests] in one year than another in ten."

Perhaps Menéndez recognized something of himself in Ribault. The two mariners had a similar bravura and compulsion toward risk, traits that no doubt accounted for much of their success but also explained their mutual penchant for trouble. Soon those instincts would lead one man to glory, one to death, when the mariners came face-to-face on a Florida beach.

IN SATURIWA'S VILLAGE, the prisoners stared at the wall and dreamed of what lay beyond. Unlike the famous inmates in Seville and London, the names of these Timucuan warriors have been lost to history. Yet just like those other captives, their confinement was to set off a high-stakes power struggle between rival interests, one that would have huge consequences for Le Moyne and his fellow colonists.

The prisoners had been brought to the village by Saturiwa, who in

August of 1564 returned victorious from his raid against Utina. In addition to killing an unspecified number of warriors and taking their scalps, the attackers took twenty-four captives, thirteen of whom went to Saturiwa, with the others divided evenly among his vassal chiefs.

In Timucuan culture, successful raids were cause for highly ritualized celebrations, sometimes lasting three days and nights. Le Moyne left a graphic illustration of one such ceremony, showing scalps and human limbs dangling from poles. Although the chief in the foreground is identified within the picture as Utina, one researcher, arguing that this might be a typographical error, has suggested the real subject of the picture is Saturiwa. In either case, Le Moyne's accompanying text offered a vivid account of Timucuan victory rites:

> They have a certain place where, on returning from war, they customarily gather. There they carry the legs, arms, and scalps taken from the enemy and place them with solemn ceremony on very long stakes which they have fixed in the ground in a kind of

row. Then, with men and women sitting in a circle in front of these remains, the sorcerer, holding a small image in his hand and muttering hundreds of imprecations in his usual way, curses the enemy. Opposite, at the far end of the area, three men squat down with knees bent, and one of them strikes a flat stone with a club held in both hands in answer to the individual words of the sorcerer; the two others flanking him on either side, hold in each hand the fruit of a particular plant, which grows like a gourd or a pumpkin, and which they open up at the top and bottom when it has been dried, taking out the marrow and seeds and filling it with pebbles or grain. These they shake, rattling them like bells . . . and singing in ancestral ritual after the sorcerer's mutterings. Their custom is to observe these feast days whenever they have captured any enemies.

Yet if this spectacle impressed Le Moyne, it was those captured warriors who caught the attention of his commander. Determined to curry favor with Utina, Laudonnière seized on the idea of liberating some of the prisoners and sending them home to their leader as a token of goodwill. He soon discovered, however, just how much his refusal to take part in the raid had alienated him from Saturiwa: "I sent a soldier to [the chief], asking him to send me two of his prisoners. This he refused to do, saying that he was not subservient to me and that I had broken my promise under oath, which I had sworn on my arrival."

Furious with the rebuff and intent on "bringing reason to this savage," Laudonnière marched to Saturiwa with twenty soldiers, demanding that the prisoners be turned over to him under the threat of force. Although Saturiwa eventually capitulated, it would prove a Pyrrhic victory for the French. "The chief was greatly irritated by this act," wrote Laudonnière, "and immediately began to think of every possible way by which he could get revenge on us."

Stable relations with Saturiwa would no longer be possible. But he was not the only friend Laudonnière had now managed to alienate: His own men were also beginning to lose confidence in their commander. Frustrated by food shortages and their inability to find gold, some colonists had started to whisper about taking matters into their own hands.

Mutiny

. . .

I N THE FALL OF 1564, THE DISTANCE BETWEEN THE NEW WORLD and Old seemed to grow even more immense, as if Terra Florida had come unmoored and was drifting steadily away from France and the past. Home had begun to feel like a distant memory, and so too had its laws and allegiances and codes of conduct, all the invisible ties that bound the colonists to their commander. An insurrection would come before winter—though Le Moyne and Laudonnière would offer dramatically different versions of how the uprising took shape.

*Detail of French soldiers sharing a private conversation,
from a print based on Le Moyne's work.*

The commander portrayed himself as the victim of a long-running conspiracy, led by a certain nobleman "in whom I had placed great confidence." While feigning devotion, this turncoat tried to turn others against his superior, claiming Laudonnière had deprived them of untold riches "by requiring them to work every day at the fort without sending them out to explore the countryside." He then began making plans for murder, including one plot "to hide a barrel of gunpowder under my bed," wrote Laudonnière. But the conspiracy was revealed, and the man "fled into the forest, where he lived for a while with the savages."

Le Moyne, in sharp contrast, described this same aristocrat as a man "of distinguished family, good natured, God-fearing, and well liked by all." Far from being a traitor, he was the victim of a smear campaign by a scheming rival who concocted the story to curry favor with the "credulous" Laudonnière. According to Le Moyne's chronology, in fact, plans for an uprising did not begin until after the man's unjust banishment from the fort:

> Many good men were distressed by [the nobleman's] exile, but they all kept silence. Gradually, however, some of them began to resent such niggardly supplies of food and the fact that individuals were being burdened with excessive and difficult work, certain noblemen in particular considering that more respect should be shown to them. Eventually, as one revealed his grievances to another, secret meetings began to be held.

Was Le Moyne's version of events the accurate one? Perhaps—but it's at least possible that he chose not to set down all that he knew, either to protect the nobleman's reputation or his own. And while there's no evidence the artist was as of yet involved in any plot against Laudonnière, he does seem to have had considerable sympathy for those who opposed their commander. The hour was fast approaching when he would have to choose sides.

BUT FIRST CAME GOOD NEWS. A man named La Roche-Ferrière, whom Laudonnière had dispatched deep into the wilderness to make

contact with Utina, returned to Fort Caroline with a report that seems to have swept away any lingering doubts about the existence of the Apalatci. La Roche-Ferrière and other scouts had already sent home "a quantity of gold and silver, with pearls and other rare things besides," in the words of Le Moyne. And now, back from the bush, the adventurer "definitely established that all the gold and silver sent to the fort came from certain mountains, called the 'Apalatci.' "

La Roche-Ferrière informed his commander that three smaller tribes were currently "preventing the great chief Utina from taking possession of these mountains." But with Laudonnière's help, these tribes could be pushed aside, allowing the French direct access to the Apalatci. Thrilled by this prospect, the commander promptly dispatched his scout back into the bush to estimate the strength of Utina's enemies.

Yet if Laudonnière had hoped these revelations would have a calming effect on his men, he was much mistaken. For one thing, La Roche-Ferrière seems to have had many detractors among his fellow colonists. Le Moyne, for instance, described him as a man "whose verbosity gave the impression that he knew everything," noting that he "had gained such standing with Laudonnière that the latter regarded his judgment as that of an oracle." If anything, La Roche-Ferrière's visit only confirmed the impression that Laudonnière was saving all the gold and glory for a few lucky cronies while the rest of the settlers passed their days in the dry-rot existence of the fort. "Many were jealous" of such men, wrote Le Moyne, "thinking they were getting rich quickly. And although Laudonnière promised that everything would be shared in common, there was a good deal of ill-feeling."

Another newcomer to the outpost would add to this unrest. In early September, a French ship commanded by a certain Captain Bourdet had dropped anchor off Fort Caroline, apparently on its way home from pirating raids in the Caribbean. As sailors from this expedition shared tales of their exploits with the frustrated and underfed colonists, a case of corsair fever began to spread through the ranks. The West Indies beckoned, offering not just the promise of instant wealth but, perhaps just as alluring, the simple hope of escape.

Bourdet appears to have left for France on November 10, following a two-month stay at the fort. And although he took with him seven or eight soldiers whom Laudonnière had deemed to be the worst trouble-makers, it did little to quell the rebellious mood. Bourdet's vessel was a tangible link to home, and its departure seems to have inflamed a sense of isolation and doom among the colonists. Just three days after he left, about a dozen sailors stole one of the expedition's only two barques—a small vessel, probably powered by oars as well as sails, that had recently been completed by shipbuilders.

Before setting sail, the thieves grabbed all the food they could get, taking along their arquebuses, spades, and shields as well as some artillery and ammunition. One of these men would later claim they had left because they were "treated badly," but Laudonnière insisted that the deserters simply thought "they could make a great profit in the Antilles." Shortly after this first group of mutineers fled, two other men made off with the second barque—"indeed an unlucky circumstance," the commander commented, "because I was already prepared for an exploration of the river."

Laudonnière had no idea how unfortunate the desertions would one day prove to be. Nor did he apparently realize that they were only the harbingers of a much larger mutiny. According to Le Moyne, secret plans to overthrow the commander were quickly gaining support. "It is quite certain," he wrote, "that all the most distinguished soldiers and noblemen took part in the meetings and prevailed upon the rest to do so, apart from those they looked down on as not shrewd enough and excluded from their company."

These noblemen and soldiers seem to have been particularly aggrieved that Laudonnière had pressed them into service alongside other settlers in the "common and lowly work" of building two new barques to replace the ones that had been stolen. In the mind of the commander, "the diligence I had imposed on the workmen" was necessary, since the only significant vessel remaining at Fort Caroline was the *Petit Breton,* the last of the three ships that had brought the expedition from France. Nonetheless, by forcing these aristocrats to "belittle themselves," he only

helped to fuel the insurgency. Soon some thirty men were plotting to take up arms. Before taking that fateful step, however, they determined to give Laudonnière one last opportunity to keep his command.

LE MOYNE SHARED quarters at Fort Caroline with an officer named François La Caille, whom the artist described as "a man of integrity." This soldier had apparently accompanied Laudonnière and Ribault on their earlier mission to Florida, where he had picked up enough of the Timucuan language to serve as an interpreter on the current expedition. Reliable, resourceful, and well practiced as a go-between, La Caille seems to have earned the respect of all parties at the increasingly factious fort.

When disgruntled colonists decided to confront Laudonnière with their grievances, La Caille, as senior captain at the outpost, was their choice as intermediary. Although he had not yet been let in on plans for an insurrection, the officer agreed to speak on behalf of the dissenters, even if "his own life should be endangered," because "he considered that their complaints were fair," according to Le Moyne. So one Sunday in November of 1564, five months after the expedition's arrival in Florida, La Caille requested that Laudonnière come to a meeting with the entire company.

After the colonists had assembled, La Caille faced his commander. He began, Le Moyne later recalled, by affirming that Laudonnière was "representative of our lord the King," and therefore must be followed "even if, for his Majesty's sake, we must give up our lives." Nonetheless, he said, the commander had created "a dangerous situation." Food supplies were now so scarce that there was "barely enough for a month," and if relations with local Indians continued to deteriorate, "we must expect starvation."

La Caille then came to the point. Calling the commander's attention to the *Petit Breton,* "which lies in this river even now," he announced that the men "urgently request you look to the repair and the fitting out of [this] ship . . . and to put on board what men you judge suitable and dispatch them to New Spain, which borders on this province, in order to obtain provisions by buying them or in some other way."

In some other way: This, of course, was a reference to piracy, and its meaning was not lost on Laudonnière. "I greatly feared that under the pretext of searching for food, they would undertake some enterprise against the subjects of the king of Spain," he wrote. And that was something he could not permit, as it went directly against his orders. Caught in a no-win situation, the commander once again waffled. There was no need to strike out for New Spain, he told the men. For the short run, he would supply them with goods from his own stock to trade with the Indians. After that, the new barques would be complete, and the men could use them to reconnoiter the coast, where, by trading with other native groups, they were sure to find "more than enough provisions for their needs."

His goal seems to have been to stall until the spring, when reinforcements were to arrive. Yet while the conspirators "pretended to be satisfied with this response," as Laudonnière himself put it, they continued to recruit others to their cause. Soon, noted Le Moyne, "the rest of the soldiers were so swayed that sixty-six of the most carefully chosen and experienced men gave them their support."

Among the few prominent figures to refuse were the scrupulous François La Caille and his roommate, the company artist:

> They . . . tried to win me over by means of some of my closest friends, showing me a list of those who had given their names and even threatening dire consequences for those who should not do the same. But I asked them not to trouble me for I confessed that I would be against them in this matter.

It was not that Le Moyne disagreed with the criticisms of his commander. Neither he nor La Caille appears to have borne the slightest illusions about Laudonnière. They simply seem to have put loyalty and duty first—a principled but dangerous decision.

ONLY EIGHT DAYS AFTER THAT SUNDAY MEETING, all the plans were in place. The conspirators knew what they had to do first. La Caille, who,

having "openly opposed their efforts when they disclosed their plans to him," was no longer a trusted brother in arms but a turncoat and a threat. They determined, wrote Le Moyne, to make sure he could do nothing to get in their way:

> In the evening of the night on which the conspirators had decided to carry out their plans I was informed by a Norman nobleman ... that the conspirators had decided to strangle La Caille, with whom I shared quarters, that night, and that therefore I should take myself elsewhere if I valued my life. But since it was impossible for me to go off anywhere else at this short notice I went back to my quarters and told La Caille what I had learned. He immediately dashed out the back entrance to go and hide in the forest, while I, commending myself to God's protection, determined to await eventualities.

I often picture the artist that night as he lay sleepless staring at the door, wondering when it would burst open. A hundred little sounds must have made the heart race. Perhaps as the hours wore on he tried to convince himself that the men had lost their nerve. But then came the hiss of whispers and the soft percussion of boots against sand, followed by the mutineers, eyes blazing in the torchlight, shadows swooning on the walls. And what was he to do then? Where was he to run? Was he to die now, alone, in this savage land?

OUTSIDE, DARK FIGURES crisscrossed the compound in the moonlight, their armor gleaming, as groups of mutineers raided the quarters of officers who remained faithful to their commander, instructing these men not to leave their lodgings "on pain of death." While this was taking place, wrote Le Moyne, other rebels made sure the coup d'etat was complete:

> At dead of night Fourneaux, leader of the conspirators, wearing his breastplate and carrying an arquebus, went with twenty

arquebusiers to Laudonnière's quarters which [Fourneaux] commanded to be opened up. Advancing straight to his bed he put the arquebus to his throat and, reviling him with the most terrible abuse, demanded the keys to the armory and corn store. When he had completely disarmed him and put his feet in chains, he ordered him to be led as prisoner to the ship lying in the river in front of the fort, escorted by two soldiers who were to guard him.

The artist's life was spared as well, though at first the conspirators stripped him of his weapons and ordered him to the barracks as a prisoner. But as he later recalled, "by the good offices of certain honorable individuals among the noblemen, who were not in sympathy with the conspiracy but had been prevailed upon by others, my arms were restored to me on the condition that I did not leave my quarters before dawn."

The sun came up on a very different New France. With "Captain La Caille wandering through the forest and consorting with wild beasts, and the rest of the dependable men deprived of their arms," wrote Le Moyne, "the conspirators turned the organization of everything upside down, even usurping Laudonnière's title and office."

The commander remained locked up for some fifteen days, during which time he was denied contact with his men and forced to sign a document that gave the mutineers permission to sail to New Spain. The mutineers also demanded that he instruct two experienced navigators to serve as their pilots. Then they set about pilfering whatever scant supplies still remained to outfit the two just-completed barques, even confiscating "some small casks of fine Spanish wine . . . reserved for the use of the sick." After making sure the vessels were heavily armed, wrote Le Moyne, the mutineers "sailed from Fort Caroline on December 8, calling us cowardly recruits, and threatening that, if we refused to take them back into the fort when they all returned rich from New Spain, they would crush us."

Learning of their departure, La Caille promptly came back from the woods and attempted to restore order among the depleted ranks of his fellow soldiers. Laudonnière was released and reappointed commander

by the common consent of those remaining. Hoping to keep his weak-ened force occupied until reinforcements arrived in the spring, he put the men to work reinforcing the structure of the fort and building yet another pair of barques, the first of which was completed in just eigh-teen days. "After the mutineers left," he would later boast, "I doubt there ever was anywhere a captain more strictly obeyed than I."

It is often surprising how swiftly order can be reestablished in such situations, especially when those involved are physically drained, when they are hungry, when their spirits have been worn into resignation. But any air of normalcy in the fort at that time was an illusion. The mutiny was to set off a series of events that guaranteed the expedition's doom. In the interior of Terra Florida, in fact, the trouble had already begun.

Warpaths

· · ·

WHILE THE INSURRECTION WAS BEGINNING TO TAKE SHAPE AT the fort, French soldiers in the wilderness found themselves in open warfare against the Indians for the first time.

These skirmishes had begun about two months before the revolt, in September of 1564, after a small group of troops arrived in Utina's vil-

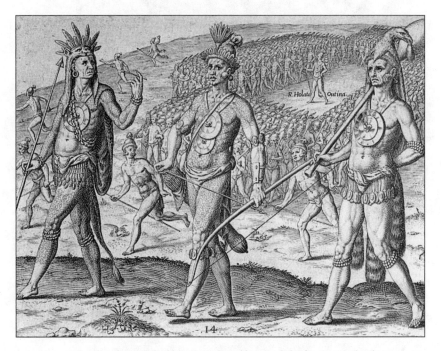

*Utina (standing amid soldiers in rear) and his vassal chiefs going into battle,
from a print based on Le Moyne's work.*

lage, bringing with them the captives Laudonnière had liberated from Saturiwa. History does not record Utina's precise thoughts about this goodwill gesture on the part of the Europeans, but it does make clear that he was impressed by their guns.

The Frenchmen, three officers and ten soldiers in all, were carrying arquebuses, the first handgun to be fitted with a shoulder stock. Weighing around twelve pounds and measuring more than four feet in length, the arquebus was equipped with a matchlock, a trigger mechanism that lowered a smoldering piece of cord into a pan that held a priming charge

*Detail of French arquebusiers, from an engraving
based on Le Moyne's work.*

of gunpowder. Notoriously unreliable, the weapon often misfired, causing a "flash in the pan" that could permanently blind a soldier or leave his face with ghastly burns. Yet compared with other weapons of the time, it was fairly inexpensive and efficient, with reasonable accuracy from a range of less than sixty yards. And the arquebus was not simply a tool of destruction: For those who had never heard its roar, seen its fire and smoke, breathed in its sulfurous stench, it was an agent of otherworldly terror.

In the decades to come, this gun would play a large role in the down-fall of the Timucua, just as it would for so many other indigenous peo-ples. Although they were undeniably skillful warriors—stunning the French with "how swiftly they can take the arrows into their hands and shoot them unbelievably straight and far," as one colonist put it—their stone-age arsenal would prove no match for the iron guns of Europe. But for now Chief Utina was interested only in the immediate possibilities of this strange weapon. He welcomed the Frenchmen with a feast, dur-ing which the two sides "made a solemn treaty and promised to preserve mutual friendship," wrote Le Moyne. Then, the formalities out of the way, he asked his guests to stay and help him fight his enemy to the west, Chief Potano.

Perceiving an opportunity to clear a path to the Apalatci Mountains, the French eagerly agreed to the plan. One officer took five soldiers back to Fort Caroline to keep Laudonnière abreast of developments, while another led the remaining troops straight into battle alongside Utina and some two hundred of his warriors. After marching all night, they surprised one of Potano's villages at dawn, the French leading the attack. Laudonnière later described the effect of the arquebus on the locals:

> They came out in a great company and saw that they were at-tacked by men with guns, something that they were not accus-tomed to; and they even saw the leader of their group fall dead at the very beginning of the battle. . . . So they fled, and the Indians of Utina entered the village, taking men, women and children as prisoners. Thus came the victory of Chief Utina by the assistance of our Frenchmen.

When the victorious French soldiers returned to the fort some eight or ten days later, they brought with them small amounts of silver and gold, as well as "a thousand thanks from the chief," who, added Laudon-nière, "promised that if in any affair of consequence I had need of his men, he would furnish me with three hundred or more."

It is not clear whether Jacques Le Moyne took part in this initial skir-

mish. We do know, however, that the artist would return to Utina's territory for another battle with Potano—an adventure that would inspire some of his most memorable images.

A FEW MONTHS AFTER the first raid, sometime in the winter or early spring of 1565, the chief once again summoned French forces to his side, informing Laudonnière that, as the captain later put it, "when this enemy was defeated, he would give me passage and conduct me to the mountains so that nobody could stop me." Laudonnière quickly dispatched twenty-five to thirty arquebusiers under the command of his lieutenant, Seigneur d'Ottigny. Among them was Le Moyne, who would provide a detailed, firsthand account of the campaign.

The chief greeted their arrival "with great joy," noted the artist, "because the reputation of the arquebus had spread through the neighborhood and was inspiring terror." Two days later the French set out, accompanied by three hundred of Utina's warriors. This effort, however, would not go as smoothly as the previous one. Because of marshy terrain and excessive heat, the Indians were "obliged to carry the Frenchmen on their shoulders," wrote Le Moyne. Then, near enemy territory, some of Potano's subjects spotted the approaching war party and ran off to warn their comrades—a turn of events that terrified Utina. Unsure whether to press forward with the attack now that the element of surprise had been lost, he turned to his shaman, a figure thought by the Timucua to have extraordinary powers, including the ability to foretell the future.

From this incident would come a sublime and uncanny work of art. In the center of Le Moyne's picture kneels the shaman, arms corkscrewed behind him, back contorted, fingers crooked in a spastic clench, lips drawn back like those of a cadaver, tongue bayoneting the air. To his left is an agitated Utina, muscles tense with anticipation. Le Moyne was clearly an eyewitness to the scene:

> The sorcerer prepared a place in the middle of the army, and catching sight of [a French] shield . . . placed it on the ground. He drew a circle five feet in diameter around it and added certain

characters and signs. Then he squatted on his heels with knees
bent on the shield so that no part of him was touching the
ground, and then made various gestures with unintelligible mut-
terings as if he were launching into an oration. This went on for a
quarter of an hour and after that he looked so frightful that he no
longer presented a human appearance; for he was twisting his
limbs in such a way that one could hear the bones snapping out of
place, and in the end he did many things that were not natural.
When this was finished, he instantly returned to his original con-
dition, although he was extremely tired and in a kind of daze.
Then he walked out of the circle [and] greeted the chief.

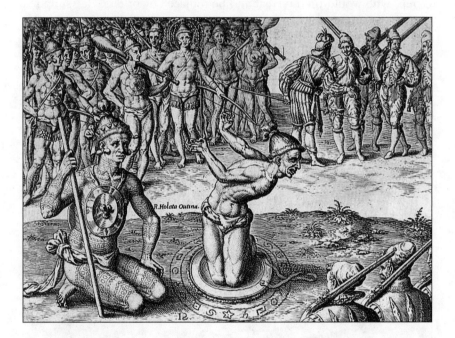

His prognostication was far from encouraging. Not only did Potano
know of Utina's arrival, the shaman announced, but he was now waiting
with no fewer than two thousand warriors, specially equipped with
cords to tie up all the enemy prisoners they expected to take.

Hearing such a gloomy report broke Utina's will to fight, and he in-
formed Ottigny that he did not wish to go on. This infuriated the
French officer, who told the chief that he would regard him as "con-

temptible and spineless if he did not try his luck." Shamed, Utina reluctantly agreed to fight—on the condition that French soldiers lead the way into battle.

MUCH OF WHAT WE know about Timucuan warfare comes from Le Moyne's writings and illustrations. In contrast to the French, who were accustomed to long campaigns aimed at the total destruction of the enemy, the Indians practiced a kind of warfare in which "there was never a fight that could truly be called a battle," observed the artist. Instead, their clashes "consisted of secret incursions or skirmishes involving small groups who would then retreat and be replaced by others." He supplied

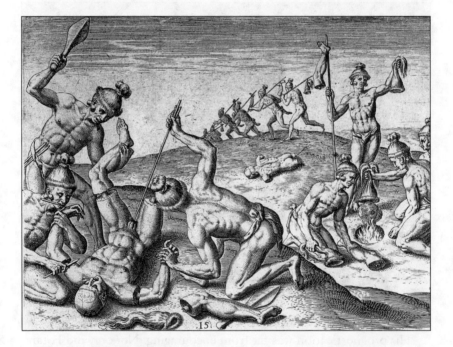

an unflinchingly graphic description of the traditional code of conduct in such clashes:

> The first side to kill an enemy, no matter how lowly he was, would claim victory, even if that side subsequently went on to lose more people. There were those who were especially employed to

carry away the dead during these skirmishes and cut off their en-
emies' scalps. They did this with a reed, sharper than any steel
blade, by cutting the skin around the head, then tying the
hair . . . into a bun and pulling it off at the skull. . . . After the bat-
tle they used these same reeds to cut open the flesh of the arms at
the shoulders and legs below the hips so that they could break off
the bared bones with a piece of wood. Then, after drying these
bloody and battered limbs over [a] fire, they carried them home
with their scalps triumphantly on their spear points.

Le Moyne's eerie but strangely bloodless illustration of this practice
is considered the first known representation of Indian scalping. Recent
scholars, in fact, have used it to help dispel a popular incarnation of the
noble-savage myth: the idea that scalping was not an indigenous custom
but was introduced to America by Europeans. He also documented the
curious Timucuan practice of thrusting an arrow into the anus of an
enemy soldier after removing his scalp and limbs. The warriors, he
wrote, "never leave the battlefield" without completing this final rite,
which "sometimes cannot be done without great danger."

This highly ritualized style of fighting baffled and frustrated Le
Moyne's fellow soldiers, not because it was gruesome—their own brand
of combat had plenty of gratuitous gore and dismemberment—but be-
cause they did not see what it accomplished. They were used to a kind of
warfare that stressed killing rather than capturing and above all else
prized the taking of new territory. Their Timucuan allies, meanwhile,
had much smaller goals in mind: revenge or replacement of lost labor
through brief and sporadic battles. It was thus with vastly different
agendas that Utina and Ottigny marched together into battle.

That clash lasted three hours and ended, predictably enough, with
the French—that is to say, the arquebus—emerging triumphant. But
after the skirmish, Utina abruptly turned back home, refusing Ottigny's
demands to push on for a complete rout of the enemy. Tensions between
these allies would continue to grow in the coming months. One day they
would explode in tragic violence, but for now the frustrated French, hav-
ing left some soldiers at the chief's village to protect against a retaliatory

raid by Potano, headed back to the fort, no closer to reaching the Apalatci than before they had set out.

DID THE FRENCH EVER doubt the existence of those mountains? That question kept looping through my mind as I studied this period in the colony's history. By that point, I was well into my own journey of discovery—and, to my frustration, found that the object of my search, like the Apalatci, often seemed to retreat beyond the horizon.

In a 2005 issue of *Archaeology* magazine, for example, a leading expert on the history of the Timucua came to a stunning conclusion. "I now question," wrote Jerald T. Milanich, "whether Jacques Le Moyne actually did any paintings of Florida Indians."

Milanich, an archaeologist at the Florida Museum of Natural History, described how he once saw the engravings of Le Moyne's work as a kind of Rosetta stone that offered a reliable documentary record of the long-vanished Timucuan culture. He had always been aware of certain incongruities in those illustrations—tools of European design, weapons and clothing borrowed from other Native American groups, images lifted from other artists—but for a long time, he wrote, "I was too stubborn and too caught up in my research" to raise a lot of questions. Over the years, however, his doubts grew.

Now he had come to suspect that many, if not all, of the Florida engravings were simply fabricated from scratch after Le Moyne's death by the Flemish engraver Theodor de Bry. "I am afraid there is no Rosetta Stone, no miraculous portal to the past for Southeastern archaeologists," he concluded. "Until someone finds an actual, documented Le Moyne drawing or painting of Florida Indians, I am going to assume we have been duped."

Was the saga of the first European painter in North America a myth, like those other New World tales about unicorns and giants and dog-headed cannibals? That thought unnerved me, but I was soon to learn that Milanich's skepticism was far from universal among scholars. "I think Le Moyne's engravings are accurate representations of events and people

in the Southeast," declared Chester B. DePratter, the archaeologist who located the long-lost French outpost of Charlesfort with the help of those illustrations. "The kinds of activities they're showing fit extremely well with what I know of Southeastern Indians." Even illustrations that get specific details wrong, DePratter told me, often get the big picture right. "I believe that the information in most of those engravings is good."

Boston University's John T. McGrath, who wrote *The French in Early Florida,* seconded DePratter's view. "As a historian with some knowledge of the workings of late-sixteenth-century European publishing, I see no good reason to doubt that these scenes were created by someone who had witnessed them," he insisted. "It's possible that some aspects of Indian life they present might be exaggerated, mistaken, or even invented. However, the details of everything that is verifiable—the Frenchmen's clothing, the fort, their guns and tools—have considerable, and sometimes astonishing, accuracy. To believe that someone was so painstakingly accurate about these things, yet entirely fabricated all the little details of the Indians, just doesn't make any sense to me."

I admired Milanich and his work, but I, too, had serious reservations about his article. Perhaps the engravings are not a "miraculous portal to the past," but even if all they can offer is a refracted, house-of-mirrors view of Indian life, it does not necessarily mean that they contain no useful information or that Le Moyne had no hand in them. Take, for example, his battle scene depicting the French victory over Potano. True, it has a number of bewildering errors, including the Timucua's use of South American weapons and European battle formations. And then there are those mysterious mountains looming in the distance, even though the actual fighting took place on flat ground, far from the nearest foothill. To Milanich, such mistakes suggested that the scene was entirely fabricated. Yet it seems possible that a more complicated dynamic is at work. One expert, for instance, conjectured that the engraving was based on "a very rough sketch by Le Moyne of the few Frenchmen and Indians engaged in battle similar to that shown in the foreground." The background, according to this theory, was a later addition—tacked on by de Bry to fill in the scene and make it more dramatic. The enigmatic end

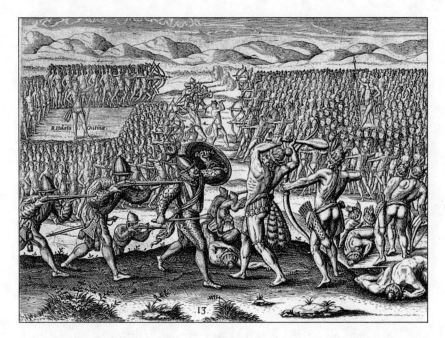

result, like so much of Le Moyne's work, is "a combination of realism and idealism, a blend of the documentary and the romantic," in the words of one art critic.

No, it is not a photographic representation—but does that mean we should simply ignore it? It turned out that not even Milanich was proposing such a response. The *Archaeology* article, he told me in an interview, was intended as a kind of wake-up call to fellow scholars, whom he hoped to make more circumspect about the artist's work. Nonetheless, he did not mean to suggest that they turn their backs on Le Moyne. "Although the engravings may be inaccurate, they're among the first representations of Southeastern Indians, and they're very important because of that. So it's vital that we keep studying them," he said.

"They are all that we have."

THE FUNDAMENTAL NATURE of a quest is to desire something just out of reach. What kept me searching for Le Moyne, despite the vagaries of his past and elusiveness of his work, was the hope that I might put his

life in context, fill in his biography, find a missing piece or two in the great puzzle of early American history. And perhaps some similar yearning for discovery, not just simple greed, drove the men of Fort Caroline to continue their chase of the Apalatci, even though their promised land remained obstinately beyond the horizon. But theirs was not the only hunt that had gone awry. In the Caribbean, their mutinous comrades were learning that the life of a corsair was far less lucrative, and far more dangerous, than it had seemed from dry land.

Avenger

...

THE SLEEPY CUBAN VILLAGE, TOTAL POPULATION NO MORE THAN ten, was not the sort of prize normally coveted by pirates. But these particular pirates, apparently short on food since the beginning of their journey, were in no position to discriminate. Appearing off Cuba's

Detail of a small French vessel, from a print based on Le Moyne's work.

northern coast in "a very good 18-bench galley boat," as a Spanish report would later describe it, they had captured a small coastal vessel, which they now used to raid the local hamlet. Seeing them coming, the few inhabitants fled, leaving the intruders to plunder what they could find—not much, it seems, for soon they were on the move again.

Taking the master of the captured boat prisoner, they set out for Matanzas Bay, later to become a notorious haven for pirates. But "perhaps God wanted them to miss the port and made them go near Havana," as one Spanish official later wrote. Not far from that city, they put in at a small port called Arcos. When they went ashore to search for fresh water, their captive escaped, heading to Havana to warn others. Spanish officials promptly sent out two armed ships, which hunted down and captured the interlopers.

Such was the brief and inglorious pirating career of the original eleven deserters from Fort Caroline. Eight of the men were imprisoned in Havana, the other three sent to Spain. But first they told interrogators everything: the nature and size of the French mission, the location of Fort Caroline, and the extent of its artillery. Officials recorded these disclosures in a report dated December 22, 1564. It was the Spanish crown's first solid evidence that France had established a new colony in La Florida.

More proof was to come several weeks later, when Spanish ships closed in on French corsair vessels anchored at a harbor in Jamaica. On board were members of the main party of mutineers, those who had departed Fort Caroline in December before raiding towns in Hispaniola and Cuba and capturing a number of Spanish vessels. Yet despite all that, they told one of their prisoners, they now carried enough food to last only two days.

When the battle was over, two corsair ships were captured, a small number of their crews killed and the rest taken prisoner. The only French who managed to escape were about two dozen men, among them several leaders of the mutiny, who scrambled into a small vessel and fought their way out of the harbor into open seas.

Their pirating days were near an end. And while they had proved to be bumblers, their actions nonetheless set off a panic among Spanish of-

ficials. Not only had the French established a foothold on soil Spain claimed as its own by divine right, but this garrison was within striking distance of the treasure fleets. Worse, it had already proven itself a nest of pirates—and not just any pirates but, as one Spanish report put it, "ardent Lutherans." No group was more hated—or feared—by the Spanish crown.

IN MARCH OF 1564, the month before Jacques Le Moyne and his confederates had sailed for La Florida, a great public spectacle was held in Barcelona to honor Philip II, the thirty-six-year-old Spanish king who was then visiting Catalonia. Staged in splendor at a public square, the event—an auto-da-fé, or act of faith—was a peculiarly Spanish institution, combining the somber pomp of a grand religious ritual with the giddy bloodsport of a public execution, all in an ornate ceremony designed to compel spiritual and political orthodoxy, inspire awe for the Holy Office, and serve as a dreadful preview of Judgment Day. Lasting long hours and drawing huge crowds, the typical auto-da-fé included an elaborate procession, a solemn mass, and a sermon, but its central purpose was the pronouncement of sentences against those who had been brought before the Inquisition. In Barcelona that day, Philip and his attendants watched from a window overlooking the plaza as inquisitors read out the punishments of thirty-eight people, all but six of whom were French. Many were condemned to the galleys, years of slavery at the royal fleet's oars. Eight others were sentenced to death. Handed over to secular authorities, they were led past the crowd to a nearby *quemadero*, or place of fire, where they were lashed to upright stakes and wreathed in piles of wood. Then they were burned alive, the sound of their last shrieks drifting off with the smoke.

"Lutheranism," as the inquisitors invariably called all varieties of Protestant belief, was to sixteenth-century Spain what "terrorism" would be to the dominant power of a later epoch: an all-encompassing enemy that, no matter how vaguely understood, seemed to pose a dire threat to the nation's security, empire, and very way of life. The Reformation had been slow in coming to Spain, but when it finally arrived, in the late 1550s, with the discovery of alleged heretic cells in Seville and

Valladolid, the news set off "an emergency without precedent in Span- ish history," wrote the historian Henry Kamen. Jolted into action after a long period of relative calm, the Spanish Inquisition followed a wave of arrests in 1558 with a series of autos-da-fé over the next several years, during which more than one hundred people were condemned to death. At the same time, the crown issued harsh censorship laws, rushed through an updated index of forbidden books, and enacted new restric- tions on study abroad.

Perhaps no one was hit harder by this crackdown than people of French descent. Within a few short years so few Spanish-born Protes- tants, real or imagined, could be found that the Inquisition began to focus the bulk of its prosecutions against foreign traders, sailors, and other im- migrants. *Tierras de herejes,* heretical countries: That was how the inquisi- tors described all foreign nations, and no land inspired a more intense brand of Spanish xenophobia than France. "The flames are spreading everywhere," King Philip wrote about the advance of French Calvinism, which threatened to ignite further unrest in the Spanish Netherlands, where inquisitors had already burned or drowned thousands of heretics, and perhaps even to engulf the Iberian homeland. Determined to quench those fires, Philip soon found his hands full with Huguenots, rushing them to the stake in Spain while supporting Catholic forces in France during the First War of Religion. And if that wasn't enough, he now had to contend with an urgent Calvinist threat in the New World.

To halt these Norman *corsarios,* the king would turn to the ultimate *contra-corsario,* a fierce seaborne vigilante once described as having the zealotry of "a good inquisitor." This was not hyperbole. For Pedro Menéndez, the task of cleansing the French from Florida would be not just a military duty but a religious crusade: his own version an auto-da-fé.

THROUGHOUT THE FALL OF 1564, the long-incarcerated mariner had remained trapped in the ornate labyrinth of the Spanish legal bureau- cracy. The low point came on November 23—the probable date of the main mutiny at Fort Caroline—when a court in Madrid found the mariner guilty on nine of fourteen charges against him, fining him three

thousand ducats and sentencing him to three years without office in the Indies. Then, suddenly, his luck began to change. It had to: The crown needed him. His fine was slashed to one thousand ducats, after which King Philip personally cut it by a further 50 percent. By February of 1565, several other legal issues had also been conveniently settled in the captain-general's favor. Once again, this gifted and fiery warrior was ready for action.

Because of the plodding and unpredictable nature of transatlantic communications, news of the existence of Fort Caroline had not yet reached the Spanish court. Nonetheless, the king was already so concerned about the French threat to the Caribbean that he asked Menéndez to write a report on what should be done. The mariner did not mince words. The situation, he told the king, was dire. If France, England, or any other power was able to establish an outpost along the Florida Straits, it would not only jeopardize the treasure fleets but might also undermine Spanish rule in other parts of the Caribbean. And even more daunting was the possibility of an alliance between Protestant heretics and Florida heathens, two groups that the mariner insisted, held similarly abhorrent beliefs:

> If other nations should go on settling and making friends with the Indians, [La Florida] would be difficult to conquer, especially if settled by French and English Lutherans, as they and the Indians have about the same laws.

The notion that Huguenots and Native Americans somehow had a common faith now seems absurd, of course, but Menéndez was apparently serious about it. An inflexible ideologue, he was, like many men of his age, incapable of making even the most basic distinctions about those who were different from him. (In fact, it was precisely this inability that allowed such men to slaughter their enemies without remorse, for to understand one's victims as individuals is to transform their killings into murders.) All Menéndez needed to know about French Protestants was that "their way of life was vicious, and thus similar to the Indian practice," in the words of his sixteenth-century biographer Bartolomé Barri-

entos. From this sweeping conclusion came another: that Huguenots "would encounter no opposition from the savages; thus they would need no large fleets or armies." And as strange as it may seem, there was at least a grain of truth to this idea: The French did indeed hope to conquer Florida with a relatively small number of soldiers, by forming alliances with the Native Americans rather than by subduing them.

To forestall such an unthinkable prospect, Menéndez proposed a comprehensive plan of action. A contingent of armed men should be dispatched as soon as possible to build a series of forts in North America and finally establish a permanent Spanish presence there. It should include four Jesuits, so that children of Indian chiefs could be taught the Catholic faith. The total number of soldiers needed for this initial enterprise would be five hundred, he estimated, but if French intruders were discovered, "it would be necessary to increase this squadron by four more galleons and one thousand more men, principally marines."

Such steps were essential, he told his sovereign, "for the salvation of so many souls, and the aggrandizement of your kingdoms." But he also had his own ambitions in mind. Menéndez wanted desperately to lead a new mission to Florida, not only to rebuild his damaged reputation and to enhance his estate but to search for his beloved son, Juan, still missing in the aftermath of a shipwreck. In appealing to the king for permission to sail, the mariner clung to the hope that, as Barrientos put it, "his boy might be restored to life."

THE KING GAVE MENÉNDEZ nearly everything he wanted, issuing a contract in March of 1565 that named him *adelantado,* or frontier governor, of Florida. His mission there would be threefold. First, he was to explore and chart a vast stretch of the North American coastline, searching for the best sites to establish settlements as well as for signs of unauthorized intruders. Second, he was to people the land, building two or three towns and filling them with five hundred "religiously clean" Spanish settlers within three years. And finally, in keeping with the evangelistic mission of the Catholic faith, he was to bring missionaries to convert Native Americans.

The contract granted Menéndez many benefits, including a number of extremely generous trading privileges and an immediate cash payout of fifteen thousand ducats, as well as the power to distribute lands in Florida and the right to claim more than fifty-five hundred square miles of territory for himself. But while potentially worth a fortune, the agreement did not come without considerable financial risk. The mariner would have to finance the venture himself, providing ships for it from his own fleet. And he would have to organize the entire expedition in a matter of weeks, for the anxious king wanted him to sail with five hundred men by May 31.

Signing the agreement on March 15, Menéndez departed Madrid to make preparations for the journey—plans that would change dramatically just two weeks later with the arrival of a ship called the *Vera Cruz*. The vessel bore the three captured *corsarios* from Fort Caroline and an urgent dispatch from the governor of Cuba that not only disclosed the existence and location of the French outpost but also revealed that colonists there were expecting reinforcements that very spring.

En route to the north coast of Spain, where he planned to assemble his fleet, Menéndez was overtaken on the road by a post rider bearing a message from the king. In that dispatch, Philip described the news from Cuba and "stated he had not believed it possible the Lutherans had dared invade the Indies, while France was in the turmoil of rebellion," according to the biographer Barrientos. The shocked monarch now realized that he must expand the mariner's mission. Despite facing fierce financial burdens in other parts of his empire, Philip agreed to commit royal troops and warships to the undertaking, sharing the financial burden with Menéndez and making the expedition a joint venture.

Menéndez was thus transformed from an explorer and colonizer into an avenging angel. News of a Protestant presence in La Florida prompted calls for blood from the mariner's militantly Catholic countrymen, typified by the exhortation of one Spanish official to his king. "Seeing that they are Lutherans . . . it is not needful to leave a man alive," he wrote, "but to inflict an exemplary punishment, that they might remember it forever."

Want

. . .

WHEN THEY SAW THOSE SAILS FLAPPING IN THE DISTANCE, THEY thought they were saved. They had been expecting a ship from France any day, a ship filled with new colonists, desperately needed supplies, and enough food to make their gnawing hunger seem like some strange and soon-forgotten dream. Even Laudonnière, rushing out of the fort after an Indian told him about a vessel anchored near the mouth of the river, had allowed his hopes to soar. But now, as he got a closer look, the captain came to a bitter realization.

The men aboard that brigantine were French, all right, but their faces, more gaunt than the last time he had seen them, could hardly have been a less welcome sight. The few remaining mutineers were back, not to revel in their triumphs or to show off their riches but to scour the inhospitable Florida countryside for food.

Laudonnière would later learn they were tricked into this return visit by their pilot, Captain Trenchant, who had been forced to sail with them three months earlier. Following their narrow escape in Jamaica, the ill-fated pirates had become "oppressed by famine," and Trenchant, realizing any future raids were doomed to fail, decided to take matters into his own hands. Working with a few confederates, he managed to cross the Bahama Channel one night while the others slept. Now, in late March of 1565, the wayward rebels had returned.

It would take another trick to get them back inside the walls. This one was perpetrated by Le Moyne's roommate, the levelheaded François

La Caille, who convinced his rash commander that confronting the mutineers directly might only cause them to flee. Instead, La Caille took a small vessel known as a pinnace to meet the other ship before sunrise. Only he and a couple of other men could be seen in the purple predawn shadows, but hidden away with them were an additional twenty-five arquebusiers. Le Moyne described the encounter:

> When [the mutineers] saw our pinnace and recognized from a distance La Caille and the other two soldiers, they allowed them to come closer without taking up their weapons, but after our pinnace had come alongside their boat, our soldiers suddenly leapt out and boarded them. Taken by surprise, they ordered their men to start firing and dashed for their weapons, but too late, for they were deprived of them at once. They were informed that they should come before the King's lieutenant [Laudonnière], at which there was great consternation since they realized that their lives were in grave peril.

In the end, Laudonnière decided to repatriate most of the men, making an example of four mutiny leaders. They were promptly put to a firing squad, their bodies left to hang along the banks of the river, carrion for the vultures that circled Fort Caroline.

THE THREE AND A HALF MONTHS between the mutineers' departure in December and their return in March had been grim times at the outpost. By the beginning of January, the local Indians vanished from the vicinity of the fort for their annual winter hunting season, during which they lived on whatever game they could kill in the woods. Chief Saturiwa, still furious over his betrayal by Laudonnière, had no motivation—and probably no means—to provide for the French while he was gone, and even on his return apparently kept his people at a cool distance from the fort. All Laudonnière could do was pray that his meager provisions would last until the arrival of reinforcements, which he expected no later than the end of April.

The jigsaw puzzle of Jacques Le Moyne's life is missing a piece during this period. For much of it, the artist wrote nothing about events at the fort, quoting instead long passages from Laudonnière's account. This narrative gap has caused scholars to speculate that Le Moyne was out of contact with the outpost, perhaps as part of a small group that spent two months deep in Indian country, staying with Chief Utina and exploring the Florida interior. It may have been during this period of intense contact with the Indians that he executed some studies of lasting ethnographic and historical interest.

Detail showing a pair of two spirits transporting food.

AMONG THOSE WORKS are startling images of men dressed as women. Such figures, fairly common in Native American cultures, played an important role in societal, spiritual, and even military affairs by bridging the gap between male and female spheres. Le Moyne incorrectly identified them as "hermaphrodites," apparently due to an anatomical misunderstanding on his part, but perhaps because he simply lacked a better term. Today such people are often referred to as "two spirits," a reflection of their unique place in Indian cultures as a kind of third gender, distinct from men and women but embodying vital attributes of both.

Some writers have even embraced them as the spiritual ancestors of modern gays and lesbians, children of nature who were able to assume their own sexual and gender identities at a young age in a culture that encouraged individuality and honored difference. But other experts— citing evidence that the decision about who would grow up to be a two spirit was made by parents and tribal authorities, not by the children themselves—have denounced this idealized image of a sexually free society as the latest incarnation of the noble-savage myth.

Like other explorers, who usually described the two spirits as being large and robust, Le Moyne noted that they were "very strong." His illustrations portrayed them as even more muscular than other Timucuan males, their bulging biceps juxtaposed with such female traits as their skirts of Spanish moss and their long, curly hair. In one picture, Le Moyne showed two spirits taking baskets of fruit, vegetables, and smoked meats to the communal storehouse: a sacred task, according to modern experts, since the bearing of such foods was part of an important ritual known as a "first fruits" ceremony. In another illustration, the artist depicted two spirits performing a second sacred task, transporting the bodies of the dead and the severely ill.

Another important Timucuan custom he put down on paper was the imbibing of a beverage known as *cassina,* or the "black drink." This potent concoction served as a ritual purifying agent. It was brewed from the yaupon holly, a plant native to northern Florida whose scientific name, *Ilex vomitoria,* refers to the drink's power to induce vomiting, thus cleansing the drinker of bodily pollution and restoring a state of equilibrium within his world. Le Moyne's illustration depicts an instance of just such purging. In the foreground, three women brew the beverage for men at a council meeting. At the rear, some warriors consume the black drink, while others regurgitate it in great streams to the ground. In addition to its use as an emetic, wrote Le Moyne, the beverage also had other benefits:

> When they have drunk this brew, they can endure hunger and
> thirst for twenty-four hours; hence the only provisions which the
> hermaphrodites carry for those who are going to war are gourd

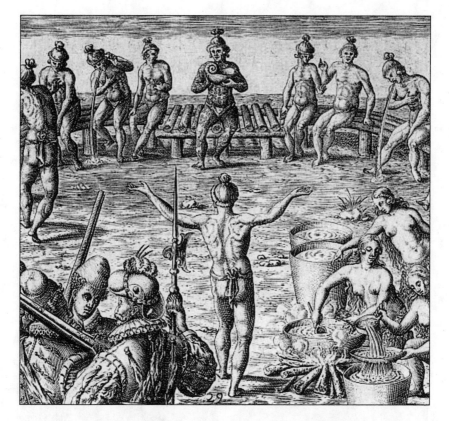

bottles or wooden vessels full of this concoction. And although it feeds and strengthens the body yet it does not affect the head, as we observed when we were holding gatherings of this sort.

To a sixteenth-century European, the idea of a beverage that could stimulate without intoxicating must have seemed miraculous indeed. Coffee, tea, and chocolate were still virtually unknown in the Old World, where the ubiquitous refreshments, wine and beer, caused only drunkenness and lethargy. The black drink contained massive doses of caffeine, which, in addition to lessening fatigue and enhancing flow of thought, seems to have had the added benefit of inspiring in its users something of an ecstatic spiritual state.

Relatively little is known about the religion of the Timucua, though here again Le Moyne appears to have made a vital contribution by documenting one of the most important annual ceremonies. The specificity

of both his illustration and descriptive text suggests he was an eyewitness to the event, which took place in late February of 1565 in Utina's territory—another indication that the artist was away from the fort during this period. In the foreground of the picture, Chief Utina stands on a small hill, his left arm around a French soldier, his right arm gesturing to the bottomland below. There, in a scene reminiscent of the one that took place shortly after the arrival of the French in La Florida, a group of Timucuan men are gathered in a semicircle, some kneeling, some rising, some swaying on their feet, all of them with their arms extended in apparent rapture. The object of their veneration is a tall pole topped with the body of a stag.

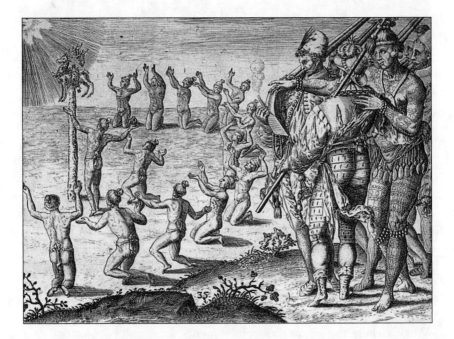

Le Moyne's text, which one scholar has described as "uniquely important," explained the ritual:

> Every year, a little before their spring … the Chief Utina's subjects take the skin, complete with antlers, of the biggest stag they have been able to catch. They stuff it with all kinds of the choicest plants that their land produces, sew it up again, and deck

the horns, the throat, and the rest of the body with their more special fruits made up into wreaths and long garlands. Thus decorated, it is carried away to the music of pipes and singing into a very wide and beautiful plain, and there it is placed on a very tall tree trunk, with its head and chest turned toward the sunrise, prayers being repeatedly uttered to the sun that he should cause to grow again in their kingdom good things similar to those offered to him.

Back at Fort Caroline, the French too were praying for food—any scrap they could find. And if their doctrine forbade them from worshiping the sun, it is hard to imagine they did not begin to surround it with superstition in those lean days, watching with animistic anticipation as it arrived from the other side of the sea, beseeching it, each new day, to bring ships. But no ships came. February passed into March and March into April. The mutineers returned from the sea, Le Moyne from his travels, the Indians from their winter in the woods. The sun rose, one morning after the next, always alone on the horizon.

THEY DID NOT ABANDON HOPE. At times, in fact, they were even careless about conserving what little food they could scrounge, so convinced were they that the ships would arrive. Then, in late April of 1565, a day finally came that, for all their anguish and apprehension, they had not quite expected: the day they could no longer adequately feed themselves.

> The month of May coming and no assistance having arrived from France, we fell into great need of foodstuffs, and we had to eat roots and a type of sorrel plant that we found in the fields. . . . This famine continued throughout May and through mid-June, during which time the soldiers and workmen wasted away and could not work. They did nothing but go, one after the other, to the lookout at the top of the mountain near the fort, to try to discover some French vessel if they could.

So wrote Laudonnière, who put much of the blame for the crisis on the Timucua:

> The mischievous Indians, since they knew of our great hunger, sold [us food] at very dear prices. For practically nothing, they obtained from us every bit of merchandise which remained. To make matters worse . . . they would not come within gunshot range of the fort. At that distance they brought their fish in their little boats; and there our soldiers were forced to go. Oftentimes I saw our Frenchmen give the very shirts off their backs to obtain one fish. If at any time they remonstrated with the savages about excessive prices, these villains would answer brusquely, "If you value your merchandise so greatly, eat it, and we will eat our fish." Then they would break into laughter and mock us in derision.

Le Moyne, on the other hand, offered a far different version of events. With typical candor, he suggested that the French, whose captain had so thoroughly alienated Saturiwa and other Native American neighbors, had brought the disaster down upon themselves.

> A great famine followed because the Indians, both those nearby and those farther away, cut themselves off from us for many reasons. First because nothing was given them in exchange for provisions; then because very often they had been violently treated by our men in their attempt to obtain provisions—indeed some had been so senseless, and I might almost say perverse, as to burn down their houses, thinking that they would extort provisions from them more easily by this means. But things got so much worse that three or four miles had to be covered before any Indian could be found.

And still the colonists waited, climbing to the lookout, scanning the empty sea, clinging to some last dream of salvation. But where were the ships? What had become of the ships?

CHAPTER TWELVE

False Starts

· · ·

T HE CROWDS HAD BEEN GATHERING AT THE QUAYSIDE in DIEPPE
for months: sailors, soldiers, settlers, men, women, children, all there to
take part in an expedition to La Florida under the command of the leg-
endary Jean Ribault, recently released from the Tower of London.

Detail of a French ship at anchor, from an engraving
based on Le Moyne's work.

The French effort to reinforce Fort Caroline was a huge undertaking, involving seven hundred to a thousand people who would soon board seven heavily armed ships. The force included some five hundred soldiers equipped for a long stay, as well as many skilled craftsmen. An unknown number of the men were also bringing their families.

Among the settlers was Nicolas Le Challeux, a carpenter by trade who would later turn his hand to writing. He would leave a lively narrative of his adventures, a work that, in comparison with those of the well-connected Le Moyne and the aristocratic Laudonnière, comes closest to presenting the experience through the eyes of a rank-and-file colonist.

Le Challeux reported that once Ribault had begun to organize the expedition, "news of this voyage was quickly spread abroad, and many were persuaded to serve." They came to Dieppe "in legions," many of them "believing they would be made rich by this voyage because of the gold." By January of 1565, the city was teeming with recruits. Since the Atlantic crossing often took about two months, the French needed to sail by late February if they were to reach Florida by the end of April, as Laudonnière presumably had been promised. But February came and went, then March, then April, with the ships still docked and the colonists still milling about town. Wrote Le Challeux:

> The plan was not put into effect as quickly as some desired, especially those who had received the soldiers into their inns and houses. These people were weary of keeping men who made merry without paying their bills, even though the soldiers promised their hosts that they would shortly be paid and fully contented. They were four months or more in this town before they set forth.

It was by then May, and the men at Fort Caroline had already run out of food. Exactly what led to this long delay remains a matter of speculation. One factor was an apparent lack of coordination among the expedition's sponsors, Admiral Coligny on the one hand and Catherine de Medici and Charles IX on the other. But the historian John T. McGrath has cited a more dramatic reason for the delay: In the midst of their preparations, the French discovered that they were not the only ones as-

sembling a mission to Florida. Having learned from their ambassador to Spain that the dreaded Pedro Menéndez was planning to sail "with a good fleet of 600 men to fight the French and put them to the sword," Coligny and the crown appear to have decided to beef up their own force with additional soldiers and arms, a move that set back the departure by at least a month. A dispute over wages may have further contributed to the wait, but even after the men had been paid six months' wages and the ships almost completely outfitted, new problems suddenly arose, according to Le Challeux.

> When the orders came for the men to embark, some of those who had been paid were seized with anxiety at the prospect of so long a voyage. Frightened by the angry seas, they changed their minds and deserted secretly without waiting any longer. Now, to make haste, lest their numbers should daily diminish, the muster was called again. The men were commanded to go aboard ship at that very hour. This was the tenth day of May.

And still they did not sail. A week passed, then ten days, the men waiting in the ships, the ships waiting in the port, the whole venture waiting for the resolution of last-minute details.

WHILE THE FRENCH vessels sat at anchor, a Spanish secret agent monitored them from the docks. Dr. Gabriel de Enveja had a rare gift for the art of intelligence gathering. He had been in Dieppe for only three days, but already he had amassed a wide-ranging dossier of detailed and accurate information—some of it straight from an indiscreet Ribault, with whom the spy somehow managed to speak personally.

Enveja described the captain as being a man of good size, with a long, reddish beard and red hair, who looked younger than his forty-five or fifty years. With the mariner was his grown son, Jacques, who would serve as his lieutenant, along with five hundred soldiers, two hundred of whom were of aristocratic origin, including seven German noblemen. These troops were well equipped and well armed, almost all of them car-

rying arquebuses. In addition, the spy reported, the French ships were transporting two hundred dismounted cannons for future use at Fort Caroline.

Enveja further noted that the expedition included about one hundred farmers, as well as a seaborne menagerie that would have made Noah proud: stallions and mares, rams and sheep, bulls and cows, boars and sows, even burros. Also stored in the holds were many axes, hammers, and other tools, along with two separate stocks of food: one to ensure a safe journey across the sea and back again, the other to supply a year of provisions in Florida.

Like their captain, who was "renowned as an honest and valiant man but also a huge Lutheran," all the members of the expedition were Protestants, according to the spy, who added that the ranks included no fewer than seven or eight ministers. The purpose of the mission, he concluded, was "to conquer the land, populate it, fortify it, and to plant there, as they say, the gospel. They permit no books to be brought except Lutheran ones."

Whether or not Enveja was correct about the evangelistic intent of the expedition, there is no reason to doubt that the venture was overwhelmingly Protestant. And if a large contingent of ministers was indeed on those ships, as the spy claimed, it would indicate that Admiral Coligny now intended for the colony, which currently had no pastor, to become a bastion of the faith. If that wasn't bad enough, Enveja offered solid proof that the French planned to establish a permanent, self-sustaining, and heavily armed outpost directly in the path of the treasure fleet. The spy, in short, was describing Spain's worst nightmare.

When Enveja's findings reached Madrid in early June, King Philip declared his "amazement" at their contents. According to the agent, the French crown had pledged one hundred thousand francs to the expedition—despite the fact that France and Spain were formally at peace and that Catherine de Medici had recently denied knowledge of any such venture. Nor did the French plans end there. Enveja reported that preparations were already underway to send four or five more ships in 1566, then two whole fleets each following year.

Philip promptly sent a message to Pedro Menéndez, describing the

spy's discoveries and warning him that the French fleet was about to sail. It was devastating news. Distressed that Ribault might reach Florida before him and outraged that the enemy ships were manned by "partisan[s] of the perverse and pestilential Lutheran sect of the devil," Menéndez was more anxious to sail than ever. Yet although his contract had required him to depart by the end of May, the conquistador, like his French antagonist, found himself falling further behind schedule with each passing day.

THE TASK MENÉNDEZ had undertaken was monumental. The king instructed him to organize the entire expedition in just two and a half months, during which the mariner was expected to recruit soldiers, sailors, and settlers; procure and transport supplies; enlist, refurbish, arm, and outfit ships; and, perhaps most difficult of all, arrange financial backing for the whole venture. To make matters even more difficult, he had to assemble not just a single armada but two: one that would sail from Cadiz, a seaport in southwestern Spain that served as headquarters of the treasure fleets, and another that would be composed of ships from in and around his homeland in the north.

As he crisscrossed the country in a flurry of preparations, it became apparent that his problems were not just logistical but political. His old foes among the merchants of Seville and the officials of the Casa de Contratación had not forgotten their long-standing grievances with the mariner, to which they now added his escape from their jail. The fact that they were once again required, by order of the king, to assist Menéndez did not mean they would make life easy for him. Like bureaucrats everywhere, Casa officials came armed with the time-tested weapons of indifference, inaction, and red tape, and now they turned these big guns on their enemy in a relentless cannonade. On May 18, as Nicolas Le Challeux waited aboard ship in the Dieppe harbor and Dr. Gabriel de Enveja watched from the docks, a frustrated Menéndez was writing the crown to complain that the Casa's obstructions were making it impossible to load goods aboard his flagship, the *San Pelayo*.

Such setbacks tormented the mariner, who longed to search for his

son, now missing near Florida for two long years. Yet in at least one as-
pect of the preparations, his own stubbornness may have added to the
wait. Now that he was again seen as indispensable to the crown, Menén-
dez was determined to use his leverage to squeeze from the royal trea-
sury every possible ducat: not just the moneys pledged to him for the
current venture but also the sums he claimed were due him for past serv-
ice to the king. One particular point of contention was a matter of
twenty thousand ducats that Menéndez insisted the Casa de Contrat-
ación owed him for his 1563 voyage to the New World. On May 28, he
wrote the king to declare that he would not sail for Florida until he was
paid completely. It was not, in retrospect, an opportune moment to take
such a stance. For just as Menéndez was digging in his heels, his enemies
were finally on the move.

THEY HAD BEEN DISPATCHED into the Atlantic six days earlier, not by
an order from Coligny or Ribault but by an act of God. Le Challeux de-
scribed the scene at Dieppe:

> A great tempest arose. The wind blew from every quarter, and
> the waves struck with such violence that our sailors were fright-
> ened. They could do nothing but cut our cables and let the an-
> chors go, delivering us to the wind's pleasure.

The storm chased the ships north to Le Havre, where the expedition
remained for three more days while awaiting orders. It was not until
May 26 that they finally gained the open seas. Watching the coast of
Normandy vanish in the distance must have caused the colonists consid-
erable anxiety, but for many of them, whatever lay ahead—even a clash
with the Spanish—was better than the poverty and religious persecution
of their homeland. Some of them had "a sincere desire to know and see
the country," wrote Le Challeux, but others simply "wanted with heart
and soul to make war, preferring to risk the rage of the waters rather
than to remain in their accustomed condition—which was just as pre-
carious."

And it was looking more and more as though those who wanted a fight would get their wish, for the purpose of the French expedition had changed. What had begun as a reinforcement effort was now a full-fledged military operation, its primary goal to protect Fort Caroline from Spanish attack. And there was only one way to succeed: get there first.

WHEN NEWS OF THE French departure reached the Spanish crown some two weeks later, Philip II immediately called off plans for a last-ditch diplomatic effort aimed at convincing Catherine de Medici to halt the expedition. The final chance of averting an armed confrontation having now been lost, the king ordered Menéndez to redouble his efforts.

"Every day he lost was a day of life gained by the Lutheran heretics, as they fortified themselves and used the opportunity to open avenues of communication with the Indians and to capture their wills," wrote the contemporary biographer Bartolomé Barrientos. By late June, however, the Casa had finally released a large portion of the funds Menéndez was demanding, and he was ready to get the expedition underway at last.

On June 29, an armada of as many as nineteen ships sailed from the ancient southern city of Cadiz, led by Menéndez in his own massive galleon, the San Pelayo, with a cargo capacity of nine hundred tons. At the same time, another fleet was departing from northern Spain. In all, there were thirty-four vessels carrying 2,646 people, according to the mariner's brother-in-law, Ganzalo Solís de Merás, who was among those taking part in the adventure. The Cadiz contingent alone comprised several clergymen, twenty-six married men with their families, 117 tradesmen (including stonemasons, carpenters, tailors, shoemakers, millers, silversmiths, tanners, sheepshearers, a hatmaker, a bookseller, and an embroiderer), as well as 995 sailors and soldiers, among them "some of the principal gentlemen of Asturias, Galicia and Biscay, whom a thousand Frenchmen would not dare to face," in the words of Solís de Merás. Also along on the journey were the three captured French mutineers, who were being sent back to the New World to help Menéndez locate and destroy Fort Caroline.

The Spanish were departing more than a month after Ribault had left Dieppe. Yet the race to Florida was much closer than it seemed. Unfavorable winds had forced the French to anchor at the Isle of Wight off the coast of southern England, where they remained for two long weeks. It was not until June 14 that Ribault finally began to make his way across the Atlantic. And by that time, Le Moyne and his starving companions had lost all hope of being rescued and were about to embark upon a desperate course of action.

Famine and Folly

. . .

"SOME . . . DIED OF HUNGER AND THE REMAINDER WERE SO EMA-
ciated that the skin was hanging off their bones." With those few words
Jacques Le Moyne summarized months of starvation at Fort Caroline.
He left no visual record of the famine, nor did he attempt to chronicle
his own struggle for survival. Was he forced to live on roots and berries,
like so many of his compatriots? Was he one of the poor souls whose
crushing hunger caused them to devour puppies fresh from the womb?
Did he suffer the chronic diarrhea, the anemia, the listlessness, the de-
pression, the utter wasting of body and spirit common to those mal-
nourished over long periods? Were all his thoughts and desires (even the

Detail of French soldiers, from an engraving based on Le Moyne's work.

urge to paint) overthrown by waking dreams of food? He chose not to reminisce: "If anyone wanted to describe in detail the deprivations to which we were reduced it would be a pitiful story; my purpose is merely to write down what happened as briefly as possible."

To get a clearer picture of that ghastly summer of 1565, we must turn to Laudonnière, who, unlike the artist, left a detailed account of the colony's decline. His narrative reads like a tragedy in three acts: first, the full onset of starvation, which forced the colonists to pursue a dangerous counter-measure that in turn led to another even more hopeless scheme, all culminating in a catastrophic denouement: more suffering, more death.

By the end of May, wrote Laudonnière, "neither grain, nor beans, nor acorns were to be found in the villages," because the crops of the local Indians had not yet ripened. With the Timucua stubbornly conserving their own remaining foodstuffs, the French were left with almost nothing:

> The misery was so great that I remember one [colonist] who gathered from among the garbage of my house all the fish bones that he could find, which he ground into meal for making bread. The effects of this hideous famine clearly appeared among us, for our bones came so close to the skin that most of the soldiers had their skins pierced by their bones in many parts of their bodies.

Laudonnière's greatest worry during this period was that the local Indians, realizing the settlers were too weak to defend themselves, "would rise up against us." And although this fear was not immediately realized, relations between the colonists and at least some of their neighbors had collapsed into open antagonism. The French controlled the guns, but the Timucua controlled the food and were willing to engage in what amounted to a war of attrition, charging exorbitant prices and maintaining a merciless attitude toward their starving rivals. "Our soldiers were at the point of cutting them to bits to make them pay for their arrogance," wrote Laudonnière. The commander, terrified that such actions would prompt bloody reprisals by the Indians, "took pains to calm down the impetuous soldiers because of the importance of not being in controversy with the savages at that time."

How well Laudonnière managed to rein in his men is unclear, though we do know from Le Moyne that at some point French soldiers committed "senseless" and "perverse" acts of violence against the Indians in an effort to extort provisions. Yet even these reckless actions did nothing to halt the famine's implacable progress. "Suddenly," wrote Laudonnière, "we came to a complete end of all of our food. Even the river did not have the supply of fish that was usual, and it seemed that land and water fought against us."

THE COLONISTS NOW FACED a stark choice. They could continue to wait for ships from France to come and rescue them—and by waiting, risk mass starvation—or they could attempt to save themselves. Laudonnière described their decision:

> Despairing all hope, they came together to ask me to give orders that they all return to France, feeling that if we let pass the season of good sailing weather we would not be likely to see our country again. They reasoned that there must be trouble in France, since the assistance promised from there had not been forthcoming.

It says much about Laudonnière's leadership, or lack of it, that such an important course of action was initiated by the men and not their commander. The captain—who, according to Le Moyne, had been slow to abandon his belief in the imminent arrival of reinforcements—must have had grave reservations about the decision to sail. The survivors of the last French colony in La Florida, after all, only made it home thanks to the desperate remedy of cannibalism. How could Laudonnière, with so many more mouths to feed and so little food on hand, hope to keep his men alive during the long transatlantic crossing? Yet whatever his doubts, he was apparently in no position to stand in the men's way, unable to propose a realistic alternative to their plan other than slow death.

At least the captain could count on a seaworthy ship in the *Petit Breton,* which had brought Le Moyne from France and was still anchored

near the fort. Yet even though this vessel boasted a cargo capacity of more than one hundred tons, it was still not large enough to transport all of the settlers. Laudonnière thus ordered his shipwrights to expand its passenger space as best they could, as well as to make more room on a smaller vessel. To expedite this effort, he dispatched teams of soldiers to chop down trees and mill them into planks. The ships, his master carpenter assured him, would be ready to sail by early August.

"NOW ONLY THE MOST important thing remained," wrote Laudonnière, "which was to obtain enough foodstuffs to feed us during our work." He undertook this task himself, boarding one of the barques with twenty-nine of his men to search for provisions in outlying areas. Packing no food of their own, the malnourished adventurers sailed for "a long time," covering as much as 150 miles while surviving on berries and palmetto roots foraged from riverbanks. To Laudonnière's credit, it seems to have been a truly heroic effort—heroic but unsuccessful.

We can only imagine the disappointment he must have seen in his men's faces when he came home empty-handed. The captain had put his own credibility on the line with that quest, and had it succeeded, his authority would have been bolstered at a crucial time. Now that he had failed, however, the colonists were once again determined to act on their own.

> I returned to the fort, where the soldiers were beginning to be weary of working because of their great hunger. They counseled together and suggested to me that since we could not obtain any more foodstuffs from the Indians, we should capture a . . . hostage for the procurement of foodstuffs.

Laudonnière resisted, telling his men that "such a deed should not be attempted . . . before the full consequences of it had been considered." He knew that the proposed kidnapping of a Timucuan chieftain would put the captain in direct violation of his orders from Coligny and the

crown, whose strategy for colonizing Florida was contingent upon main-
taining good relations with Native Americans. True, Laudonnière had
often failed in that objective, especially in his rift with Saturiwa, but so
far his missteps had never been so grievous as to endanger the very exis-
tence of the French enterprise. Now, perhaps still clinging to a last hope
of rescue, the commander was loath to take any action that might di-
rectly imperil Fort Caroline and perhaps the entire effort to colonize
Florida. The men, however, were determined: and in the end, "I was
constrained to agree . . . in order to evade a worse result, the sedition
that I saw if I refused them."

So it was that Laudonnière sat down with his men to target a Timu-
cuan leader. Their victim, they decided, would be the man in whom they
had long placed all their hopes.

UTINA'S FALL FROM GRACE took place largely in the subtext of Le
Moyne and Laudonnière's narratives. By the summer of 1565, the French
must have begun to doubt whether their ally could deliver them to the
promised land of the Apalatci—and perhaps even whether those magical
mountains existed. Neither chronicler, however, made explicit mention
of any such misgivings. All discussion of that paradise simply vanished
from the French narratives during the famine, a period in which the
need for food overwhelmed the lust for gold and Utina the Savior
turned into Utina the Villain.

In Laudonnière's account, that transformation took place around the
time of the failed food-gathering expedition, when the captain reached
out to his ally for help.

I decided to send word to Utina, praying that he deal fairly
with his subjects and that we could be helped with corn and
acorns. This he did but in a very small amount, sending me twelve
to fifteen baskets of acorns and two of pinocqs, which are little
green fruit growing in the grass of the river and about the size of
cherries. Even this was only accomplished by giving them twice as

much as they were worth in exchange. This was so because the subjects of Utina saw clearly the necessity we were in, and had begun to treat us like other Indians. As is easily seen, hard times can change good will among men.

To treat us like other Indians: what a long way the French had fallen, especially in their own minds, since that first day at the stone column. Back then, they had imagined themselves to be white demigods among subordinate savages, but now power relations were almost completely reversed. It was the Indians who were calling the shots.

The next time the French came to Utina for food, in fact, he refused to supply it, demanding instead that they help him raid the village of a disobedient vassal chief. If the attack was successful, he said, the soldiers could no doubt pillage some corn and acorns.

Desperate, Laudonnière complied. But his soldiers returned from the adventure "almost dead from hunger" with news that Utina had deceived them. Instead of raiding a vassal chief, he had used the arquebusiers to attack one of his enemies. Worse, there were no stores of food to be captured, and the soldiers were now as furious as they were famished. They demanded that Utina be the one taken hostage, not only because he was likely to command a large ransom but also "to punish the wrongs that had been done to us."

Laudonnière had little choice but to board the barques with fifty of his ablest troops and head upriver to strike out at the man he had spent so many months trying to please. Going ashore, the French hiked to Utina's village, some eighteen miles from the river, where they seized the chief and his young son, "but not without great cries and alarms being sounded." They rushed the captives back to their waiting vessels, giving the village elders two days to round up enough food for purchasing Utina's freedom. But, Laudonnière wrote, "I could not get very much food from them at this time, the reason being that they thought that after I had taken the food from them I would kill their king."

Having failed yet again to obtain the needed provisions, a frustrated Laudonnière returned with his captives to Fort Caroline, where he

found the men so weak they were losing their will to carry on. "On ac-count of our short rations," he wrote, "I had difficulties allotting the work on the ships which we were building for our return to France."

WHILE UTINA REMAINED at the fort, just one more mouth to feed, Laudonnière launched yet another frantic foraging expedition into the wilderness. Acting on a tip from some Indians, he took a group of men to search for corn. For once, the journey was not an utter failure: They found a small crop that had just ripened. But even "from this good luck something bad came," wrote the commander, "because the majority of my soldiers fell sick from eating more than their weakened stomachs could digest."

The next day the men traveled to an island on the Saint Johns River, a place already notorious among the French. It was there that an adven-turer named Pierre Gambié had established himself among the Indians as an autocratic white overlord, à la Kurtz in Joseph Conrad's *Heart of Dark-ness*. Jacques Le Moyne, who gave the most complete account of the Gam-bié saga, reported that this "tough and lively young soldier," raised from an early age in Admiral Coligny's household, had received permission from Laudonnière to depart the fort alone so that he might make his for-tune. "Loaded up with cheap merchandise and his weapons, [he] began to trade throughout the province," wrote Le Moyne. "So successful was he in his dealings that he achieved some sort of power over the Indians."

Gambié soon ensconced himself on the island, where he became close friends with the local chief, took one of the headman's daughters as a bride, and "bent his energies on accumulating wealth." He amassed a modest fortune, wrote the artist, but at a price.

When he was in complete control during the chief's absence he treated the chief's own men so tyrannically that he forced them to search for what they could not find [i.e., gold and silver], and in the end made himself hated by all of them; but because he was dear to the chief nobody dared to complain.

The murder of Pierre Gambié, from an engraving based on Le Moyne's work.

Then one day, as he attempted to bring his loot back to Fort Caroline in a canoe, Gambié was murdered by two Indian escorts—a scene captured in one of the most grisly, if fanciful, images attributed to Le Moyne. In life, this audacious adventurer must have been resented by his fellow colonists; in death, he became their martyr, a symbol of their suffering at the hands of the Indians. Just before they arrived, the local chief, fearing that they were "going to revenge the evil that he had done," fled with all his people. His worries were not unfounded. "I could not restrain my soldiers from burning down the village," wrote Laudonnière, "because of their anger at the murder of their companion."

Having sated their rage if not their hunger, the men returned to the fort with whatever meager supplies of corn they had been able to scrounge during the trip. There, the captain wrote, they were greeted by chaos:

> They saw me coming from a distance. Because of their great hunger they could not wait until I brought the food to the fort it-

self, and they ran to the river bank, where they thought I would land. When I arrived, I distributed the little corn that I had to each one before getting out of the barque. They showed their extreme famine, by eating it before taking it out of the husks.

More bad news soon followed. Two of the company's carpenters were killed by Indians as they attempted to steal food, a severe blow to the ship-rebuilding effort.

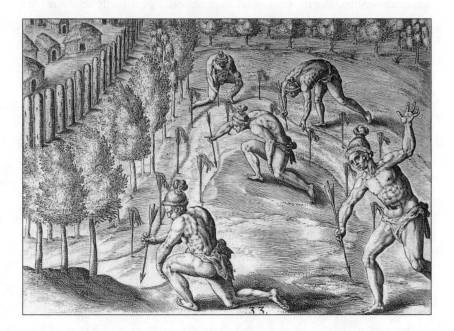

THE ONLY ONE OF Le Moyne's illustrations that can be positively dated to the time of the famine shows five Timucuan warriors plunging arrows into the ground on the outskirts of a native village. "When one chief is going to declare war on another who is his enemy," wrote the artist, "he does not use a spokesman to announce it, but gives orders for fixing arrows, with locks of hair attached to the notches, along the public pathways."

This might sound like just another detached description of a quaint local custom, but neither the text nor the illustration is as simple as it seems. The image does not, in fact, depict the onset of hostilities be-

tween two rival chiefs, as Le Moyne's caption appears to suggest. The Indians in that picture were declaring war on the French.

The artist personally saw such arrows when, as he explained, "we were leading the captive chief Utina round through the villages of his dominion for the sake of replenishing our corn supply." Those travels had begun when three of Utina's subjects, including a two spirit, showed up at the French outpost to announce that grain was now ripe in most of their area. The kidnapped leader, hearing this news, pleaded with Laudonnière to take him home so that he could personally see to it that the provisions were handed over.

Three separate excursions to Utina's village would follow, each more disastrous than the one before. On the first, Laudonnière arrived to find that all the residents had fled into the woods. He then released the chief's son as a token of goodwill. The boy did not return. Nor was any ransom paid, the Indians claiming that their grain was not yet ripe.

Two weeks later, after Utina promised Laudonnière that his subjects would now have "no difficulty" in paying the ransom, the French returned to the village. This time the Indians demanded that Utina himself be set free. The flustered captain, who by this point must have felt he had little to lose, agreed to this proposal but demanded as collateral two Indian hostages, whom he put into chains. The chief was released. Again no ransom:

> They told me that they could not entirely satisfy me and perform their promises and the best that they could do at that time was to require that each subject bring his share of grain. They were willing to do this if I returned the two hostages in ten days.

Utina had slipped through their fingers, and now all the French could clutch was one last hope that the food would be delivered despite the utter futility of all their dealings with the chief. Had they been able to read the warning signs—the "scalps on arrows stuck up along the edges of the trails"—they would have understood the full extent of their folly.

———

LE MOYNE WAS AMONG those who returned to Utina's territory for the third and final time ten days later. Because collecting the corn promised to be a difficult mission, Laudonnière, perhaps due to his lack of experience in land soldiering, gave the command to his lieutenant, Seigneur d'Ottigny, who had led previous military operations in Florida. For his own part, the captain remained at the fort, ostensibly to oversee work on the ships.

In what was now an all-too-familiar trek, the French landed some eighteen miles from Utina's village, where Ottigny "put his men in military order and marched straight toward the great house which was the king's," wrote Laudonnière. "There the principal men of the country were assembled, and they ordered a large quantity of food to be brought forth."

So far, so good: The ransom, long promised, was finally being laid before the soldiers. Nonetheless, the slow pace with which the Indians were assembling this booty soon aroused French suspicions. As the process dragged on for three or four days, some of the soldiers went to Utina, who had secluded himself in a small house, to complain about the delay. The chief's response, wrote Laudonnière, was hardly reassuring:

> He answered that his subjects were so incensed against us that it was impossible to make them as obedient as he would have wished and that he could not prevent them from waging war against Lord Ottigny.

It was during this conversation that Utina explained the significance of those arrows along the pathways. The payment of the ransom, he made clear, was just a trap. The Indians had no intention of letting the soldiers get out alive.

With both sides now certain that their transaction would end in violence, collecting the extorted corn became an increasingly tense affair. The Indians demanded the immediate release of the two hostages

held by the French; Ottigny refused to allow it until the ransom was delivered to the boats. The Indians insisted that the smoldering tapers the French soldiers always kept lit for firing their arquebuses were causing panic among the women and children and thus slowing the handover of food; Ottigny declined to disable the weapons even if his hosts were willing to set aside their bows and arrows. The Indians attempted to abduct one colonist and slit his throat; French troops heard the man's screams and plunged into the woods to rescue him. The Indians made secret plans to ambush the soldiers as they left with their haul; the French made secret plans to defend themselves against just such an assault.

On the morning of July 27, the entire ransom having finally been paid, Ottigny prepared to depart. At the edge of the village lay a great open pathway, perhaps one hundred yards in length and surrounded on each side by tall trees. The men marched cautiously into this gap, each carrying a heavy sackful of grain. Ahead of them strode a French officer and eight arquebusiers, whom Ottigny had sent ahead to "flush out any danger." Finding it, wrote Laudonnière, did not take long:

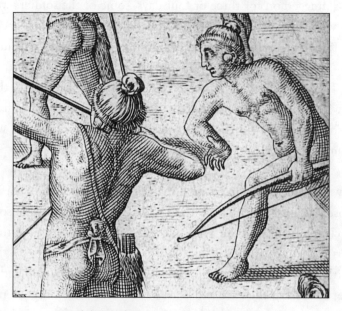

Detailed view of Timucuan archers, from an engraving
based on Le Moyne's work.

When [the officer] arrived at the end of the open space he en-
countered two or three hundred Indians who met our Frenchmen
with a swarm of arrows and with such fury of spirit that it was
easy to see how anxious they were to attack us. However, they
were so taken back by the response which my ensign and his men
gave them [with their arquebuses] that those Indians who fell
dead somewhat cooled the ardor of those who remained alive.

But the French were vastly outnumbered. Ottigny and his men soon
stumbled into another three hundred Timucuan warriors, who am-
bushed them from the front while the first attackers set upon them
from the rear. Amid a cloudburst of arrows, they had to fight their way
to the barques. The battle raged from morning until night. When it was
over, virtually all the corn had been lost, the clumsy bags tossed aside in
the heat of battle and never recovered. Two soldiers were dead, and
twenty-two others were injured so badly they had to be "moved to the
barques with great care." Among the wounded was Jacques Le Moyne de
Morgues.

Sails

. . .

OVER THE COURSE OF MY JOURNEY INTO THE LOST WORLD OF
Jacques Le Moyne, I spent hours perusing sixteenth-century medical
manuals. I do not recommend this disturbing experience to anyone, es-
pecially those contemplating a hearty meal. Although there had been
some notable advances in surgery during Le Moyne's lifetime, treatment
of battlefield wounds was still a medieval and macabre affair, undertaken
not by university-trained physicians but by lowly barbers or even less-
qualified men. A soldier with an arrow lodged in his flesh often had lit-
tle choice but to grit his teeth in agony as the surgeon sliced it from his
flesh or pushed it through until it popped out the other side of his body,
since pulling it out sometimes caused even worse damage. Such opera-
tions were performed in the most primitive of working conditions,
without anesthesia, using clumsy and unclean instruments. Once the
arrow had been removed, the wound was often cauterized with hot oil, a
torture that could be more harrowing than the original injury. Gangrene
and amputations were frequent. Even so, the wounded man could only
be grateful he had not been hit by gunshot, which caused far more hor-
rific damage.

The exact nature and extent of Le Moyne's wound is lost to time.
The artist himself made just one passing reference to it, noting simply
that he had received a leg injury in the battle with Utina. He did not
record how it happened, but one contemporary chronicler, who spoke to
some of those involved in the skirmish soon afterward, wrote that the
Indians, realizing their arrows were not piercing the body armor of the

Field surgery, from a sixteenth-century medical treatise.

colonists, "shot at their faces and legs, which were the places that the Frenchmen were hurt." Based on this account, it seems likely the artist did suffer an arrow wound: perhaps a fairly serious one, since we know he was disabled for several weeks. Yet no matter how excruciating or gruesome it may have been, that injury was to prove a blessing in disguise. One day it would save Le Moyne's life.

For the moment, however, he and his fellow colonists must have thought the end was finally upon them. As devastating as it was to come home without the ransom, they had lost far more on that battlefield than their pride and a few dozen bags of corn. Twenty-four of Laudonnière's best and healthiest soldiers—perhaps a full half of those he had sent to collect the grain—were dead or injured. The French force, al-

ready severely depleted by the mass mutinies, now consisted of "not above forty soldiers left unhurt," according to the same contemporary chronicler who described the battle scene. There were no longer enough troops, he wrote, to launch further raids against the Indians, at least not without leaving the fort unguarded.

But then, just after this darkest of many dark days for the French in Florida, their luck suddenly changed. Corn was starting to ripen throughout the area, and at least some of the Indians had enough on hand that they were now willing to assist the colonists. Laudonnière had managed to maintain particularly good relations with the widow of a chief whose land was "the most productive in corn of any along the coast." When the captain sent some of his men northward into this territory, along the Satilla River in modern-day Georgia, the Indians agreed to fill their barques with corn. More good news came from Le Moyne's housemate, the ever-reliable François La Caille, who also returned from a trip with "large quantities of grain."

Confident now that he had collected enough provisions for the long voyage back to France, the commander instructed his men to prepare for their departure. Some scrambled to finish work on the ships, which, because of the lack of experienced carpenters, was far behind schedule. Others dismantled the houses that stood outside the fort and even began to rip apart the stronghold itself, hoping to ensure that it would never fall into the hands of Saturiwa or the Spanish. This task of tearing down what they had worked so long and hard to build up "tortured our spirits," wrote Laudonnière.

But then, on August 3, just a week after the devastating loss to Utina, came another stunning turn of events. Glancing to the sea, Laudonnière spotted four sails on the horizon. When he informed the men, "they were so overjoyed that they laughed and jumped around as if they were out of their minds." But for his own part, the commander remained cautious, unsure whether the vessels were friend or foe. He described the tense scene that followed:

> After these ships had cast anchor, we saw that they were send-
> ing one of their barques to land, whereupon I caused one of mine

to be armed and sent to meet them in order to find out who they were. Fearing that they might be Spanish, I put my soldiers in order and in readiness.

Now all the commander could do was hold his breath. Depending on who was inside that approaching barque, the French might be delivered from their miseries—or they might be dead men.

AFTER STARTING WEEKS BEHIND Jean Ribault in the race for Florida, Pedro Menéndez de Avilés had been in a hurry to make up for lost time. Only five days after setting sail from Cadiz on June 29, he reached the Canary Islands off North Africa. There, his ships were supposed to meet up with the second Spanish fleet, which had embarked from the northern coast. But those ships had not yet arrived for the rendezvous, and Menéndez, in his zeal to reach the New World before Ribault, was unwilling to wait for them. Leaving instructions for the northern armada to meet him in Puerto Rico, he departed from the Canaries on July 8.

By now his own fleet, which may have included as many as nineteen vessels when he left Spain, was down to just eight, with much of the original armada apparently accompanying him only as far as the Canaries. That number would soon shrink again. One of the shallops began to leak badly, and the men, fearing they would drown, forced their pilot to return to port. Making matters worse, Menéndez's own vessel and a smaller ship were now separated from the rest of the group. Then came a hurricane, "the most wild and violent that men have ever seen," in the words of the expedition's chaplain, Francisco López de Mendoza Grajales. "The sea was so high it seemed to wish to swallow us up alive." The chaplain's little vessel barely survived the storm, which was so hellish that even the nine-hundred-ton flagship *San Pelayo* was in serious danger of foundering before Menéndez ordered several pieces of artillery thrown into the ocean. The wind stripped away two of the *San Pelayo*'s masts, though the vessel managed to continue on toward Puerto Rico.

Two other ships never made it that far. The first, filled with supplies for the expedition, was lost near Guadeloupe, its crew either drowned or

taken prisoner by the feared Carib Indians. The second was blown west-ward to Hispaniola, only to be captured, along with more than one hun-dred Spanish soldiers and a considerable cache of supplies, by French corsairs. It was not until August 8, five days after Laudonnière had spot-ted those sails on the horizon, that Menéndez reached the Puerto Rican port of San Juan, followed by what was left of his scattered and battered fleet. Those vessels off the Florida coast were not, in short, Spanish. Yet neither were they French.

THE MYSTERY SHIPS WERE, in fact, commanded by one of the true sea-faring giants of the sixteenth century, a legend in his own time and a figure of controversy ever since. To some scholars, he was a brilliant

A seventeenth-century engraving of John Hawkins.

seaman, statesman, and maritime strategist; to others, an unprincipled opportunist who founded one of the most abhorrent institutions in history, the English slave trade. As with many complicated human beings, both versions of John Hawkins were probably true. Even contemporary paintings of him hint at a man as protean as the seas he traveled, his eyes shrewd, riveting, remorseless.

Hawkins was born in 1532 or 1533, making him an exact contemporary of Jacques Le Moyne. He grew up in the rowdy English seaport of Plymouth, the son of a merchant-adventurer and part-time pirate who made a number of expeditions to the New World in the 1530s. The younger Hawkins would one day be renowned for his courtesy, charm, and diplomatic savvy, but from a young age he also exhibited a brutal side. At the age of twenty, he killed a man in a brawl, a crime for which his well-connected father obtained a royal pardon. Around the same time, he joined the family business, a hybrid of legitimate shipping and piracy, activities as inseparable to the merchants of Plymouth as they were to their cross-channel rivals in Dieppe.

In the early 1560s, Hawkins hit upon a new kind of money-making scheme. From his business contacts in the Canary Islands, he had learned about the financial possibilities of taking black prisoners in Africa and selling them to Spanish colonists in the Americas, where demand for forced labor often outstripped supply. After lining up a modest syndicate of investors, Hawkins set out in October of 1562 for the west coast of Africa, the first Englishman to attempt such a venture. On the way there he commandeered a number of Portuguese vessels already containing several hundred Africans bound for slavery. Then he sailed for the Indies with his captives, a huge percentage of whom appear to have perished along the way. Hawkins had no license to trade in the Spanish Caribbean, and foreigners were banned from such endeavors, but through a combination of charm, duplicity, and bribery, he managed to unload his human cargo and return to Plymouth in the summer of 1563 with a huge profit.

So successful was that first slaving expedition that plans were soon underway for another such venture, this one with the direct financial backing of prominent members of the court and Queen Elizabeth her-

self. The monarch seems to have had some moral concerns about the project, insisting that "if any African were carried away without their free consent it would be detestable and call down the vengeance of Heaven upon the undertakers." Such doubts, however, did not stop her from loaning Hawkins one of the largest ships in her navy, the seven-hundred-ton *Jesus of Lubeck*. He left Plymouth in October of 1564, and after reaching western Africa secured, through various means, more than four hundred slaves. Then he sailed to Venezuela, where, when other methods of persuasion failed, he used the threat of force to gain access to local markets. Again he turned an impressive profit, later estimated by the Spanish ambassador to England to be 60 percent.

He did not head directly home but lingered in the Florida Straits for a period of weeks. An informant in England later told the Spanish that Hawkins was lying in wait there, hoping to attack the treasure fleets. But those who took part in the journey reported that the mariner, having been carried too far west by tricky Caribbean currents, failed to make landfalls in Jamaica and Cuba and was simply attempting to find a good place to replenish his fresh water. After scouring some deserted islands, Hawkins decided to head for Florida in hopes of better luck.

There happened to be a man in his company with an intimate knowledge of the Florida coast. Martin Atinas, a pilot from Dieppe who sailed on Ribault's journey to Florida in 1562, had guided Hawkins to Fort Caroline, and now it was he who stepped off that barque to greet his old comrade Laudonnière, bearing gifts of bread and wine.

HAWKINS HIMSELF CAME ashore the next day, accompanied by "well-dressed and unarmed gentlemen," according to Laudonnière. The landing party included John Sparke, a prominent merchant and future mayor of Plymouth, who upon his return would write a chronicle of the adventure.

Sparke seems to have been shocked to discover the French in such a wretched state, but he could find no one to blame but the colonists themselves. The Florida soil, he noted, seemed sufficiently fertile to feed the men, "but they being soldiers desired to live by the sweat of other

men's brows." Not only did the settlers fail to grow their own crops, but they "would not take the pains so much as to fish the river before their doors, but would have all things put in their mouths." Sparke explained that the Indians caught fish using weirs: fences placed across streams. For a long time, he observed, they had been willing to share their catch with the colonists, but when hostilities between the two groups broke out, the Timucua removed their weirs. The French, wrote Sparke, were simply too lazy to rebuild them.

It is impossible to assess the accuracy of this anecdote. So much about the famine is simply beyond our understanding, especially without the benefit of Le Moyne's perspective. Laudonnière, for instance, wrote that in welcoming Hawkins to Fort Caroline, he prepared a feast by having "certain sheep and poultry killed, which to this hour I had carefully guarded in the hope of using them to stock the countryside." The French commander added that because "I had not allowed one chicken to be killed" during the famine, there were now "more than 100 of them." What are we to make of this baffling claim? Was it a mere fabrication, meant to reassure the crown that Laudonnière had taken seriously his assignment to establish a permanent colony and had remained in control until the end? And if the story was true, what then? How could the captain have presumed to put the lives of a hundred chickens above those of his men, and how could the men have failed to slaughter and roast him right along with those birds?

Hawkins's actions are also something of an enigma. James A. Williamson, who wrote a landmark biography of the seaman, surmised that the expedition had a secret agenda: to pump new life into a troubled Anglo-Spanish alliance by helping, whenever possible, to oust French corsairs from the Caribbean. But if Hawkins intended to uproot the colony—and a number of scholars dispute this notion—he went about it in an extremely subtle way. Instead of burning down the outpost, he simply offered its residents a ride home. Wrote Laudonnière:

> [Hawkins] quickly understood the desire and necessity which
> I had to return to France, and he offered to take me and my entire
> company; but I would not agree, being in doubt as to why he was

so liberal in his treatment. I did not know how things stood be-
tween France and England; and even though he promised to put
me in France before going on to England, I feared he might want
to do something in Florida in the name of his queen.

Laudonnière's flat refusal may have been what duty demanded, but
for his starving and impatient men, it was the final straw. Because work
on the French ships had fallen so far behind schedule, much of the
planned expansion of the *Petit Breton* had simply been abandoned, and
the other vessel the French hoped to use was so inadequate that many
feared it would never survive the crossing. Refusing the Englishman's
offer therefore "caused a great murmur among my soldiers, who said that
I wanted to kill them," wrote Laudonnière. And Hawkins, for his part,
did nothing to discourage those misgivings.

> The dissension and talk built up more and more when, after
> the general had returned to his ships, he told some of the gentle-
> men and soldiers who went to see him off that he greatly doubted
> that we would be able to make it in the ships which we had, and if
> we tried it we would no doubt be in great peril. [Hawkins] said
> that, if I wished it, he would take part of the men with him and
> that he would leave a little ship for transportation of the others.

All lingering allegiances to Laudonnière suddenly seemed to vanish.
The men came together and presented him with a blunt choice: He
could accept the Englishman's offer, or he could stay behind and com-
mand an abandoned fort. Laudonnière requested an hour to consider
the matter and summoned his top advisors, but there was never any
doubt about what his decision would be. In the end, he was able to nego-
tiate the purchase of a small ship, along with a quantity of food, some wax
for making candles, and fifty pairs of shoes for his ragged, barefooted sol-
diers. In return, he gave the English four bronze cannons and a thousand
pounds each of balls and powder, as well as a promissory note. The deal
ensured that Laudonnière could keep both his honor and his command,
since the addition of a second seaworthy vessel meant that no French

soldiers would have to seek passage with the English. For Hawkins, it was probably no great sacrifice to part with this ship, since he maintained only a small crew and had already unloaded his vast human cargo.

Soon cannons were being hauled down from Fort Caroline's bastions, while barrels of flour, beans, and salt were being ferried in to the outpost. Those tasks accomplished, Hawkins and his men returned to their fleet, smaller now by one ship, and promptly weighed anchor. Their visit had lasted only three days. It would change the world.

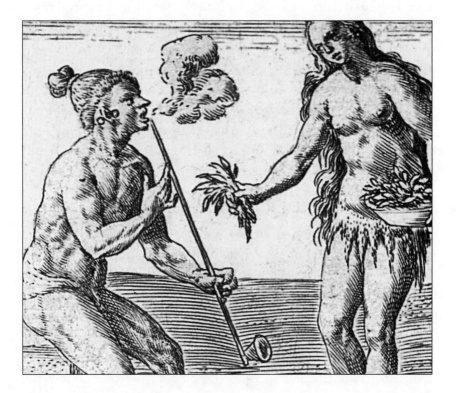

IN ONE OF THE ENGRAVINGS of Le Moyne's work, a Timucuan man puffs on a long pipe, thick smoke emerging from his parted lips. Next to him, a woman holds a basket of "a certain plant, whose name escapes me, but which the Brazilians call *petum* and the Spaniards *tabaco*."

Tobacco had long held a central place in the world of the Timucua and other Southeastern Indians, who, in addition to using it as a medicine and appetite suppressant, prized it as a kind of spiritual enhancer in

various rituals and ceremonies. Europe, however, was then just beginning to discover this extraordinary herb. In 1560, the French ambassador to Lisbon, Jean Nicot, had obtained some cuttings of tobacco plants from Florida, which he grew in the embassy garden. Convinced of the plant's medicinal powers, Nicot (from whom "nicotine" gets its name) sent seeds and specimens to Catherine de Medici and other members of the nobility, touching off a sudden French craze for tobacco snuff.

But the plant was still little known in England when Hawkins and his men arrived at Fort Caroline—so little known that the expedition's chronicler, John Sparke, had trouble even finding words to describe the strange custom of smoking:

> The Floridians when they travel have a kind of herb dried, who with a cane and an earthen cup in the end, with fire, and the dried herbs put together, do suck through the cane the smoke thereof, which . . . satisfies their hunger, and therewith they live four or five days without meat or drink.

Sparke reported that all the French had picked up on this curious practice—not surprising, given what we now know about the addictive potency of the plant. But some of his own comrades also appear to have become hooked during their brief Florida interlude. Today Hawkins and his crew are often credited with introducing tobacco to England.

In doing so, they helped spark a cultural, economic, and geopolitical revolution. By the end of the sixteenth century, English pipe smoking, or "dry drinking," as it was often called, had grown from a novelty into a national obsession. Edmund Spenser celebrated "divine tobacco" in verse, Francis Bacon noticed its strange power over those who partook, and Ben Jonson satirized its grip on the contemporary imagination in *Every Man in His Humour,* a farce starring the actor-turned-playwright William Shakespeare. Rabid demand for the "Nicotian weed" also helped to fuel an expansionist agenda in the New World. Lacking a foothold in America, England was forced to import all its tobacco from Spanish colonies, an arrangement as injurious to national pride as it was to the national economy.

It would take until the next century for the dream of a permanent English settlement in the New World to become a reality, and it would take tobacco. In 1612, a man named John Rolfe, the future husband of the legendary Pocahontas, would plant some tobacco seeds at the Jamestown colony in Virginia. Within six years, the outpost would be sending home twenty thousand pounds of the local weed, its mild fragrance and flavor quickly embraced by the English smoking public. By 1629, exports totaled 1.5 million pounds per year. The labor for this enterprise was initially performed by indentured servants from England, but in 1619 the colonists bought twenty Africans from a Dutch trader, paying not with cash but with the precious crop. And so it was that slavery took root in North America thanks to tobacco—both industries, in a curious way, tracing their histories back to John Hawkins.

In retrospect, then, the mariner's short stopover seems eerily pivotal, prefiguring much of the continent's future, including the eventual English domination of what is now the eastern United States. The French did not know it yet, as they packed up and prepared to leave Fort Caroline, but this was to be their last stand in La Florida.

LAUDONNIÈRE'S ACCOUNT of his final days at the outpost reads like an exercise in self-justification. He claimed that "if we had been reinforced at the time and place promised," the disastrous war with Utina would never have happened. He claimed that although he had "antagonized the Indians," his "principal object" had been to "win them and be friendly with them." He claimed that eight chiefs had remained loyal to him and that the arrival of Hawkins had prompted others to request new alliances, "even those who had formerly wished to go to war with me." He claimed that in the end, as these former foes "declared themselves my friends and servants," he promised the Indians he would return within ten months "with such strong forces that I could make them victorious over all enemies."

Of his troubled relations with his own men, he again stressed only the positive: "You can imagine how actively we worked because of the great desire we had to be on our way." There was much to do, and fewer

hands than ever to do it because of the injuries to Le Moyne and the other soldiers. Those healthy enough to work made biscuits from the newly acquired flour, repaired barrels to carry fresh water, and continued to demolish the fort. By August 15 they were ready to leave. Once again, however, luck was against them. The winds were not favorable. Their departure would have to wait.

The weather continued to mock them for nearly two weeks. It was not until August 28 that conditions were finally right for the two French vessels to set out. Then, just as they were making their final preparations, more sails shot up over the horizon.

Arrival

. . .

AT THE EDGE OF THE RIVER, SOLDIERS GRABBED THEIR GUNS AND armor and clambered into one of the barques. On the nearby hill, watchmen scrambled to the tops of trees. In the fort, Laudonnière "put my men in order with their battle equipment, to be prepared in case those who came were enemies."

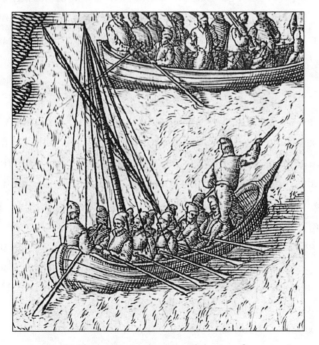

Landing boats entering the Saint Johns River, from an engraving based on Le Moyne's work.

There was good reason for alarm. Just beyond the river's mouth, the French scouting boat had encountered a larger craft sent by the distant ships—and now came word from the lookouts that "if they could judge correctly, this barque seemed to be chasing my barque," wrote Laudonnière. The two vessels then disappeared in the direction of the alien fleet, still too far off to identify across the glimmering blue expanse.

This happened at two in the afternoon. By sunset, a worried Laudonnière was still awaiting the men's return, his anxiety compounding all through the night and into the next morning. Then, around eight or nine a.m., came a new shock:

> I saw seven barques, including mine, enter the river, each carrying guns and armor, and coming in battle formation along the shore where the sentinels were. They gave no response to the sentinels in spite of all the demands that were made on them to do this.

One of the French guards fired a round at the approaching vessels. It fell short of its target, but Laudonnière, expecting more violence, "sent each man to his battle position and made plans for defense against persons I believed to be enemies."

WAS IT POSSIBLE that Menéndez had overtaken Ribault? When his hurricane-ravaged armada yawed into the harbor of San Juan just a few weeks earlier, the odds had seemed long. Not only were his remaining ships badly in need of repair, but his fleet from northern Spain was still nowhere to be found, and another vessel, which was supposed to supply him with two hundred soldiers once he reached the Caribbean, had also missed the appointed rendezvous. Colonial officials in Hispaniola had been ordered to contribute another three hundred men, along with horses, supplies, and a ship, but now he received word that they were having second thoughts about sailing to Florida at the height of hurricane season. And if all that wasn't enough, Menéndez learned that more than thirty of his men had just deserted, including three priests. "They could not be discovered, dead or alive, which made the general very

angry," reported Francisco López de Mendoza de Grajales, the expedition chaplain.

Yet despite these setbacks, the daring and resourceful Menéndez had still not given up on the race. After hastily patching together his damaged vessels, he departed Puerto Rico on August 15, 1565, the fleet now consisting of just five ships. Before leaving, he had publicly proclaimed that he would proceed as scheduled to Havana in order to rendezvous with the reinforcements from Hispaniola and make final preparations. But in truth he seems to have had a different destination in mind from the start, and once at sea he summoned all the captains and military leaders to his galleon and announced an audacious change of plans. Instead of going to Cuba to wait for the rest of the strike force, the fleet would try a more direct route to Florida through the Bahamas, a nautical maze consisting of hundreds of islands and untold hazardous shoals and channels. True, the route was untried and therefore all the more dangerous, but as Menéndez told his assembled officers, their only hope was to surprise the French before their reinforcements arrived. "In taking this risky step with his diminished forces," the historian Eugene Lyon observed, "Pedro Menéndez de Avilés was staking his whole enterprise on the gamble of first arrival in Florida."

Menéndez later reported that his top naval and military men offered their enthusiastic and unanimous support, after which he "felt as if he had already gained a victory over the Lutherans," in the words of his contemporary biographer Bartolomé Barrientos.

> He ordered celebrations throughout the fleet. Drums were sounded and fifes played; banners, standards and fleet pennants were run up over all the ships. As the royal standard was raised, an appropriate salute boomed out. All the arquebuses and cannon fired at once. A double ration was issued to every man that day. Everyone was vastly pleased and the demonstration of pleasure was universal.

Given the obvious risks of the undertaking, however, some skepticism is required about this claim of unbridled support. Father López, for

example, noted that the captain of his ship openly confronted Menéndez on a number of occasions along the route, declaring in one testy exchange that "the voyage was not being pursued safely." The priest apparently agreed with this assessment, describing a harrowing journey in which the ships, sometimes traveling blind through unknown waters at night, regularly came close to running aground or being dashed to pieces on the rocks.

Menéndez attempted to ease his men's fears by reminding them they were "fighting in defense of the Holy Catholic Faith" against "tyrants and evil men," and could therefore "anticipate that the Divine Majesty would strengthen them and give them the victory in any encounter." And if they needed proof, it soon seemed to write itself across the stars. "Our Lord," wrote Father López, "showed us a mystery of the sky . . . a comet . . . giving such a light from itself that it appeared to be like the sun, and it went traveling to the west, where Florida is." On the very day after this apparent omen, the Spanish spotted the mainland.

Their shortcut had allowed them to leapfrog so far up the Florida peninsula that they now found themselves near present-day Cape Canaveral, only about 150 miles from Fort Caroline. As the mariner's brother-in-law later described it, they set about scouring the coast "very much distressed, and in great suspense, not knowing whether the French were north or south."

IN COMPARISON WITH the ordeal of his Iberian rival, Jean Ribault's two-month trip to the New World had been a veritable pleasure cruise. Crossing the Atlantic farther north than the Spanish, he avoided the storms that so devastated their fleet. On August 14, with Menéndez still stuck in Puerto Rico, Ribault reached Florida. Despite his long-delayed departure from Dieppe and his frustrating layover on the Isle of Wight, he had managed to build up an almost insurmountable lead on his enemy.

Nothing could stop Ribault now. Nothing, that is, except Ribault himself. Always impetuous, the French mariner was about to make the most confounding move of his whole career. From August 15 to August 27,

the same twelve-day stretch during which Menéndez was putting his entire mission on the line by taking the shortest route to the French outpost, Ribault was putting his own mission at risk by *not* taking the shortest route. Instead of sailing directly to his destination, he lingered along the coast, exploring rivers and taking soundings, as if he had been on a mapping venture rather than a rescue operation.

Ribault's lack of urgency has baffled historians ever since. Not only was he well aware of Spanish plans to attack Fort Caroline, but he also knew the outpost "had but little food and men have suffered hunger," in the words of Dr. Gabriel de Enveja, the spy who spoke to him just before he set sail. Given all that, what could possibly have prompted him to delay? One potential answer comes from Le Moyne, who claimed Ribault "had been told that we were all dead." Yet whatever the French commander's logic, it is clear that he was "oblivious to the realities of his situation," wrote the historian John T. McGrath, who did not exaggerate in describing the delay as a "colossal and inexcusable blunder." By the time Menéndez burst out of the Bahamas, the race to Fort Caroline was neck and neck.

NOW, AS THOSE UNIDENTIFIED boats approached the outpost, Laudonnière ordered his soldiers to train two small cannons on them. The men were nervously awaiting orders to fire when one of the newcomers spoke a familiar name in a familiar tongue. Captain Ribault, he announced, had arrived at last.

We can only imagine how the men must have felt at that moment when "God bestowed happiness upon us in place of the long suffering we had endured," as Le Moyne put it. Instead of shooting at the intruders, the soldiers promptly fired a salute in their honor, to which their countrymen responded in kind. Then Ribault and his troops came ashore for what must have been a delirious celebration, shouts of joy rising from every corner of the ruined structure as long-parted friends rushed into each other's arms.

Only one man among them had reason for remorse. Laudonnière welcomed Ribault "with honor and delight," but his old comrade brought

bad news. The founder of Fort Caroline was to be relieved of his command. Ribault turned over a letter from Admiral Coligny, instructing Laudonnière to return to France, where he would have to answer to charges of misconduct leveled against him by former colonists. Not least was the claim that he had "acted grand" and "played the king" and "would resist anyone coming [to the fort] except under my command." It was this possibility, in fact, that had prompted Ribault to approach the fort with his men armed, armored, and ready for battle.

Laudonnière could not have looked forward to the prospect of going home to defend his name. Nonetheless, when Ribault offered to bend the rules and allow him to stay in Florida, he refused. "I said that I would rather be considered the most wretched beggar in the world," he wrote, "than to be commanded in a place where I had endured so much in my duty." And so the two men made plans for the transition of power.

The next day, as the French began to unpack their ships and rebuild the just-demolished fort, several chiefs stopped in to find out who the newcomers were. Some of them recognized Ribault from his earlier visit, his long red beard as exotic and memorable to them as their tattoos were to the French. Apparently impressed by his large, well-armed fighting force, not to mention the gifts he doled out to them, the chiefs promptly pledged their allegiance to the new commander. Wrote Laudonnière:

> They promised that in a few days they would take him to the . . . mountains where they had agreed to take me and that if they did not fulfill this promise they would be willing to be cut to pieces. They said that there one could find red copper, which in their language is called *sieroa pira,* meaning red metal. I had a piece of it and I immediately showed it to Captain Ribault, who had it studied by his goldsmith. He reported that it was, in fact, pure gold.

Suddenly it was as if the last fifteen nightmarish months had never happened. Once again the French were in control. Once again the Indians were bowing before them. Once again Florida was the land of plenty.

"Everything resounded with joy," remembered Le Moyne. "But it was very short-lived."

In fact, this golden age of New France lasted just six days. On September 4, a group of soldiers who had gone to the beach for a walk glanced out to sea. Approaching from the distance was the Spanish fleet.

Winds of Fortune

...

IN THE DAYS BEFORE ARRIVING AT THE ENEMY OUTPOST, PEDRO Menéndez had ordered his troops to take target practice on the decks of their vessels. Prizes were awarded to those who demonstrated the best shooting eye, but the commander apparently did not have high hopes that his soldiers would be crack marksmen. Most of the men were raw recruits, and his first priority was simply to help them overcome their fear of the arquebuses.

His army's inexperience was just one of the captain-general's worries. He had left Puerto Rico with twenty-four horses, planning to use cavalry as an integral part of his Florida campaign, but only one of those animals had managed to survive the passage. As for troop strength, "I found myself with 800 persons, 500 of them soldiers who could be landed, and 200 seamen, the other hundred being useless people, married men, women and children, and officials," he wrote. This force was less than one third its original size—still sufficient to capture Fort Caroline, he reasoned, but only if it got there before reinforcements arrived.

And so, after several frustrating days of searching the coast, when Menéndez finally came upon four French vessels anchored near the mouth of a river, his heart must have sunk. Nonetheless, he ignored the "sensible and sound" advice of his captains to turn around and head to Hispaniola, where he could rendezvous with the remaining ships and return to Florida the following spring with overwhelming force and firepower.

It was too late to go back, he told the officers. The fleet had already

been spotted by the French ships and was in no position to outrace them, since four of the five Spanish vessels had recently lost masts in a storm. In such a situation, he insisted, it was better to attack than be attacked. If they struck now, they might be able to neutralize the enemy's naval capability and take control of the harbor. If they failed to strike, "all might be lost." With the debate framed in such stark terms, the captains could do little but sign off on the captain-general's plan, return to their ships, and prepare for battle.

That night, the Spanish vessels closed in. The French attempted to repel them with sporadic cannon fire but missed, and the Spanish dropped anchor near the bows of the enemy ships. "Not a word was spoken from one side to the other," remembered Father López, the Spanish chaplain. "Never since I was born have I seen such a great silence in people." This hush was apparently broken by the sound of Spanish trumpets hailing the enemy. The French answered with trumpets of their own. Then Menéndez stepped forward to address those aboard the opposite flagship. Barrientos described the exchange:

> "Gentlemen," he said, "whence comes this fleet?"
> "From France," they replied. And he asked again:
> "What are you doing here?"
> They brought infantry, they said, and artillery, and supplies for a fort which the King of France had in this country, and for other forts he would soon have.
> "And are you Catholics or Lutherans?" [Menéndez] persisted.
> "Lutherans," they replied; and added that their general was Jean Ribault. They asked our side the same questions they had been asked.
> Again [Menéndez] spoke. He said he was captain general, and was called Pedro Menéndez; the armada belonged to the King of Spain, who had sent him out to hang and behead any and all Lutherans found in that land or on that sea. Exactly thus had he been commanded by his King. At daybreak he would comply with his orders. Any Catholics among them would be singled out, and given good treatment.

At this the Lutherans jeered him and shouted insults. Unable to bear his outrage, [Menéndez] ordered the call to arms sounded and the attack launched.

In order to edge close enough to board the French vessel, Menéndez commanded his men to loosen the ship's anchor cables. But according to one witness, the sailors, whether from confusion or fear, "did this unwillingly," and by the time the mariner had leaped down from the bridge to hurry up his hesitant crew, all four French ships had cut their own cables and were heading out to sea. The Spanish gave chase, unleashing cannon volleys at the departing French vessels as both fleets vanished into the night.

FOR JACQUES LE MOYNE and the others camped out in the remains of the French fort, the disappearance of the ships "made us extremely worried all night long." The outpost was teeming with hundreds of newly arrived soldiers and sailors who had been put ashore during the previous several days, and Ribault, unsure what might happen next, now put these troops into a state of high alert. Ordering all the available boats and smaller craft to be readied for battle, he deployed hundreds of arquebusiers to the shore, ready for action in case of a Spanish attack.

The men remained in this anxious condition all through the next day and into September 6, when the French ships began to reappear in the distance. Unable to get close to land because of wind conditions, the vessels signaled for those on shore to come out to them. "But fearing that some of the enemy might have captured our ships and might be doing this to lure us out, Ribault was unwilling to expose his soldiers to this danger, although they would have boarded the ships most willingly," wrote Le Moyne.

At length the men spotted a lone swimmer on the waves. A boat was sent out to pick him up and bring him back to shore, at which time it was discovered that he was a French sailor, carrying a letter to Ribault from one of the ship captains. It described how the Spanish had continued to pursue the French vessels for hours, "firing many shots at us," but could

not keep up and finally gave up the chase. After that, the letter reported, the Spanish fleet had dropped anchor somewhere down the coast, "taking off the ships a large company of negroes" who appeared to be readying to build something. Local Indians soon came to Fort Caroline with a similar story. The Spanish, they said, had "lodged themselves on the land and had made protective trenches around themselves." Ribault could not escape an alarming conclusion: The Spanish were now building a fort of their own.

The new commander hastily assembled a war council in the quarters of his predecessor, who had been taken ill with "a great and continual fever," which, by his own estimation, resulted from "being worn out" from work, as well as "depressed by the false rumors that had been spread about me." Also on hand were thirty or so officers, noblemen, and other officials. Le Moyne may have been among them, since he, like Laudonnière, left a record of what happened in that room. So often in the past he had been at odds with his captain, but now he found himself taking Laudonnière's side in a dispute with Ribault about what to do next:

> The more reasonable part of this council was of the opinion that the fort should be rebuilt and fortified as soon as possible and that a large section of the soldiers, under the leadership of Laudonnière, men who knew the routes, should be dispatched to the place where the Spaniards were; and thus it would happen that, with God's help, the matter would be quickly settled.

But when Ribault "realized that everyone was inclining towards [Laudonnière's] view," he countered with a plan of his own. The French should immediately load all their men into the ships and rush to attack the enemy vessels at the place they were anchored. Once those ships were destroyed, the Spanish would be trapped, said Ribault, "since they will have nowhere to take refuge except the rampart which the negroes have just made."

Laudonnière, perhaps having learned from his own impetuosity in the past, pointed out that Ribault's idea would leave Fort Caroline un-

protected and was especially ill-advised at the height of the hurricane season, when trying to navigate the shoreline was more unpredictable and perilous than ever. The new commander, however, insisted that Admiral Coligny had personally instructed him to yield nothing to Menéndez. As a result, wrote Le Moyne, "Ribault alone, rejecting the opinion of the others, stood firm in his plan."

Like Menéndez in the Bahamas, Ribault was now betting his entire expedition on a single risky scheme. After ordering his own men to prepare to board the ships, he requested that Laudonnière muster any veterans of Fort Caroline who were still healthy enough to fight. Ill and embittered, the ousted commander was relegated to staying behind as overseer of the ruined fort, powerless to stop his headstrong successor.

Thirty-eight of Laudonnière's men, including his top officers, boarded ships on September 8. With them was Jacques Le Moyne de Morgues, still hobbling from his injury. Florida, it is safe to say, had by this point tested every fiber of his being. He may have begun the trip as a courtly painter of flowers, but he was now a grizzled adventurer who had survived a famine and faced down death on the battlefield, with the scars, still fresh, to prove it. One more clash now awaited.

But the vessels did not sail as scheduled on September 8, nor did they leave on the following day. Le Moyne later attributed this delay to adverse winds, but Laudonnière insisted its real cause was that Captain La Grange, the head of infantry operations under Ribault, refused to take part in what he considered a foolhardy endeavor. On September 10, the reluctant La Grange was finally convinced to join the ranks, and the ships hoisted sail early that morning. Le Moyne, however, was no longer aboard. "In making an inspection of Laudonnière's troops Ottigny found me not yet properly recovered," he recalled, "and consequently put me in a boat . . . and made me return to the fort against my will."

He said goodbye to his comrades and left. It was the last he would ever see of them.

THIRTY MILES DOWN the coast, the Spanish were digging in at a Timucuan village called Seloy. Located at a river mouth that made for an ade-

quate, if far from ideal, harbor, the site had impressed Menéndez when he passed it a few days earlier. Now, after failing to destroy the French fleet, he returned there to set up a base within striking distance of Fort Caroline.

On September 6, he landed two hundred men to begin building fortifications from earth and wood. The next day, he sent ashore another three hundred men, women, and children, along with most of his artillery and munitions. By September 8, when Menéndez himself landed amid great pomp to take formal possession of the land, he was surprised to see how much of the entrenchment had been completed. This progress was especially impressive because, as he explained to King Philip in a letter two days later, the soldiers had no shovels, pickaxes, or other iron tools, since the ship carrying this equipment had not yet made it to Florida.

The mariner named his makeshift outpost Saint Augustine, after the church leader whose feast day, August 28, had coincided with his discovery of the site. It was then little more than a trench around the house of the local chief, yet despite its modest beginnings Saint Augustine would survive. Today this vibrant town bills itself as the oldest permanent settlement in the United States, while Fort Caroline has been so forsaken by history that archaeologists are still searching for its faint ghost in the soil.

Fully expecting a French attack, Menéndez raced against time to prepare for it. Some of his men scrambled to bolster their fortifications while others rushed to get supplies off the ships. Of particular concern were the two largest vessels, which were too heavy to enter the harbor. Fearing that they would be captured by the French or smashed against the rocks in bad weather, Menéndez hurried to unload these ships so that he could dispatch them to Hispaniola. In the end, he was in such haste to get them out of harm's way that he ordered the nine-hundred-ton flagship *San Pelayo* to take flight with much of the colony's foodstuffs still in its holds. It sailed under cover of darkness during the early morning hours of September 10. At dawn that day, the French squadron appeared off Saint Augustine.

Ribault's plan to destroy the whole Spanish fleet was thus foiled even

before he arrived, but his ships were soon able to corner a couple of ves-
sels anchored just outside the harbor. "If the French had attacked at once
when they arrived, it would have been a very great capture, because our
people were not supplied with arms and were carrying provisions,"
wrote Father López. Aboard one of the vessels, in fact, was Menéndez
himself, who realized that his only hope for escape was to reach the
safety of the harbor. It was low tide and the risk of running aground on
the shallow entrance to the port was very real, but with typical bravura
the captain-general cut the anchor cable and hoped for the best. Heavily
laden with men and supplies, his vessels somehow managed to slide over
the sandbar.

Because of the size of the French ships, Ribault could not follow
him—at least not until the tide came in. So he waited. Although con-
temporary accounts are frustratingly vague and contradictory, it appears
that the situation quickly developed into a stalemate in which "the
Spaniards could not escape, while the French could not, or would not,
attack," in the words of the historian John T. McGrath. Inaction had al-
ready cost Ribault a great deal on this expedition. His failure to go di-
rectly to Fort Caroline had left the French unprepared for the arrival of
Menéndez, and his two-day lag in launching this attack on Saint Augus-
tine had allowed the most valuable and vulnerable Spanish ships to es-
cape. Now delay would be his doom. Wrote Barrientos:

> For two hours the Lutherans lay to, waiting for an opportunity
> to cross the bar. Suddenly, at the end of that time, although the
> weather had been very calm and clear, the sea grew turbulent. A
> strong contrary wind blew out of the north, with such force that
> the Lutheran fleet was driven away. It was hurled along the coast
> for a distance of sixty leagues, all the way to Cape Canaveral,
> where at the end of twelve days all the ships had been smashed to
> pieces, and the men aboard cast away.

Was it coincidence that this storm, which several accounts describe
as a hurricane, hit precisely as the French were about to attack? Was it
luck that Ribault bet everything and lost, while his rival, who had taken

at least as many risks, just kept winning? If not for some gale, would Jacques Le Moyne's mother tongue now be the official language of *les États-Unis*? Did the entire history of the French in La Florida hinge on mere happenstance? Certainly not to the pre-Enlightenment minds of those involved. "It was Our Lord's will to save us miraculously," declared Menéndez, who took the storm as one more sign to slaughter Protestants. Yet even for Le Moyne, those winds had nothing to do with luck. Ribault's disastrous decision to sail, the artist later wrote, "was no doubt the will of God, who chose this means of punishing his own children, and destroying the wicked."

God's will or no, the punishment and destruction were about to commence.

BACK AT FORT CAROLINE, Laudonnière was stunned at the sudden force of the storm, which "the Indians assured me . . . was the worst that had ever come to that coast."

When the French ships did not return after two or three days, he realized that the outpost—or what remained of it—was in real danger. Calling the garrison into assembly, "I advised that if misfortune had come to those who were at sea, we might expect bad times since we were in such small numbers and in so many ways disabled." The fort, he said, must be rebuilt as soon as possible, for a Spanish attack was all but inevitable.

In fact, Menéndez was already preparing to march. On the very day the storm hit, he called a council and announced plans to assault Fort Caroline by land. If the French ships were not already lost at sea, he reasoned, it would be impossible for them to return in the near future because fierce winds were blowing from the north. His instincts also told him that Ribault had taken his best troops with him and that the few men left behind were "the poorest soldiers, the least courageous, and the most insignificant in every way."

On September 16, he set out on foot amid blinding squalls with five hundred men, including three hundred arquebusiers, two Indian guides, and a French mutineer named François Jean. In front of them lay miles

of uncharted swampland that they would be attempting to traverse amid unremitting rains with little to eat. Their enemies were in worse shape. Of the 150 men, women, and children at Fort Caroline, the vast majority, wrote Le Moyne, "were either servants or craftsmen (who had never even heard an arquebus fired), or king's commissaries more capable of wielding the pen than the sword." Fewer than thirty could bear arms, including a cook, four boys who took care of Ribault's dogs, and an invalid flower painter, who was among those haggard souls now assigned to guard the fort.

One Thousand Evil Things

...

FOR TEN DAYS THE RAINS WERE SO RELENTLESS THAT THEY THREAT-
ened to flood Fort Caroline, the swollen river nipping the remains of the
outpost like a coyote at a carcass. On September 20, as another gray
dawn broke, the showers only seemed to get worse. Taking pity on his
soaked and exhausted sentinels, the head of the guard unit ordered the

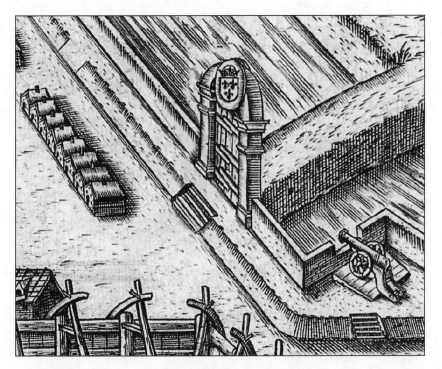

Detail of the main entrance of Fort Caroline, from an engraving based on Le Moyne's work.

men to take some rest. Jacques Le Moyne de Morgues limped off to his quarters.

Following the disappearance of the French fleet, the colonists had managed to reestablish palisades along the riverbank with planks origi- nally intended to rebuild ships. Yet these efforts were to prove fatally misdirected. Convinced that Menéndez would strike by sea, Laudon- nière "did not foresee that the enemy would come by land and entrap him," observed Nicolas Le Challeux, the elderly carpenter who wrote an account of his adventures. So little attention had been paid to shoring up defenses away from the river, in fact, that when the Spanish stormed from the woods on that soggy September morning, they found the French ramparts virtually undefended and gained easy access to the sleeping outpost through the main gate.

Even as Le Moyne was returning to his room and laying down his ar- quebus, hundreds of enemy soldiers were already moving in on the gar- rison, the sounds of their whispers and footfalls mixing with the hush of rain. The artist described what happened next:

> All wet through as I was, I threw myself into a hammock, which I had slung up after the Brazilian fashion, hoping to get a little sleep. But on hearing outcries, the noise of weapons, and the sound of blows, I jumped up again.

He charged to his doorway to see what was happening. There he was met by two conquistadors, swords drawn.

THE SPANISH TROOPS had left their outpost "dispirited and depressed" at the prospect of marching into an unknown wilderness in the middle of a violent storm. More than one hundred of the men soon gave their comrades the slip and returned to Saint Augustine, claiming that they were exhausted or had lost their way. Others, certain that Menéndez was leading a suicide mission, never even departed the fort. One captain who stayed behind, feigning illness, told his fellow conquistadors: "I swear to God that I am expecting the news that all our soldiers have been killed,

so that we who remain here may embark on these three ships and go to the Indies, for it is not reasonable that we should all die like beasts."

The downpour went straight to the skin of the marchers, their clothes becoming deadweight, their small rations of biscuits ruined, their gunpowder rendered useless. They were forced to cross several swollen rivers and swamps without any boats, the nonswimmers clutching desperately to the outstretched pikes of their more athletic colleagues. At night they searched frantically for a place to make camp, "but the ground was so flooded," wrote the contemporary chronicler Bartolomé Barrientos, "that their way seemed to be across a sea rather than across land." Many were forced to go "without sleep and even without a place to lie down, unless they chose to lie in water, mud and mire."

After four days of slogging through flooded lowlands and tangled underbrush, the men became openly rebellious. Gonzalo Solís de Merás recalled that Menéndez "feared greatly to take counsel with the captains, either as to going back or going forward to the fort of the Frenchmen, because some were beginning to be insolent, and his officers were saying abusive words against him." Within earshot of Menéndez, one underling brashly declared the commander knew "no more about land warfare than an ass." Yet so tenuous was the captain-general's grip on power just then that instead of punishing the man, he simply pretended not to hear. Other officers, reminding him that the mission now lacked both food and ammunition, urged a retreat. The soldiers, though weak, might be able to make it back to Saint Augustine by eating palmetto buds, these officers said. Any other course of action "would be plainly foolhardy." Undissuaded, Menéndez insisted on pressing forward.

A few years earlier, on a misadventure in the Brazilian jungle, Spanish soldiers had staged a bloody uprising, slaying the leaders of their expedition and renouncing their allegiance to the crown. For Menéndez, a similar mutiny now seemed no more than a few hours of rain and a few more setbacks away. Yet once again it was as if the captain-general's armor had been forged from a substance that made him impervious to disaster. On the following morning, September 20, the captured French mutineer François Jean recognized a path in the woods and told Menéndez they were very near his old fort. Climbing a hill, the commander saw

outlying structures and began to prepare for battle, sending out orders, to be passed mouth-to-mouth among the men, that no matter what their officers said, "all must follow him, under penalty of death."

Outside the fort, an advance party encountered and subdued a French soldier. When the man began to yell, Menéndez ordered his troops to attack. Worried that some might refuse, he tried to embolden them by shouting that victory was already at hand. "God is helping!" he roared, as they rushed toward the French outpost in the driving dawn rain.

JACQUES LE MOYNE DE MORGUES never ceased to marvel at why those two conquistadors did not run him through with their swords, why they passed him by as though he did not exist, even though he brushed against them in that doorway. "Whenever I call to mind the great wonder that God, to whom truly nothing is impossible, brought to pass in my case," he wrote, "I cannot be enough astonished by it, and am, as it were, stunned with the recollection."

Stumbling out of his quarters, the artist now emerged into a deluge of rain and blood. Everywhere he looked was "nothing but carnage," as the Spanish, armed with pikes and swords, hacked his dazed countrymen to pieces as they shuffled from their beds, many naked or dressed only in nightshirts, their howls ripping through the downpour like cracks of thunder. There would be no counterattack. The invaders had already captured the barracks, from which he heard "cries and frightful groans" of doomed soldiers. Terrified, he turned and ran, heading straight for an opening in the wall. Stumbling past five or six dead comrades, he leapt down into the moat surrounding the outpost, then scrambled, breathless, into the woods above the fort, where "it was as if God gave me back my consciousness; for it is certain that the things that happened since my leaving the house were as though I had been out of my wits."

In another part of the compound, the elderly carpenter Nicolas Le Challeux was departing his cabin for work, tools in hand, when he, too, was accosted by a group of Spaniards. As with Le Moyne, animal instincts and adrenaline took over:

A pikeman chased me, but by the grace of God my strength was doubled—poor old man that I am, and gray-headed. I leaped over the rampart, which I could not have done if I had thought about it, for it was eight or nine feet high. Once over, I raced toward the forest.

Realizing that no one had followed him, Le Challeux turned toward the fort and "heard the horrible sounds of slaughter." The Spanish had placed their standards on the ramparts: The outpost, he realized, was already taken. "Having now abandoned all hope of meeting my friends again, I put my trust in God and plunged into the heart of the wood."

René Laudonnière was still trying to defend his fort, chased by conquistadors who were determined to impale him, when those Spanish flags were raised.

They struck me with their pikes, but I fended them off with my shield. . . . I went into the yard of my lodging, where they pursued me. If there had not been a tent there, I would have been taken. The Spaniards who followed me became involved in cutting the ropes of the tent, and as they did that I went through the breach on the west [wall] . . . and escaped into the woods.

It had taken mere minutes for the French empire in La Florida to come crashing down. When the last anguished moan had faded from inside those walls, 132 of Le Moyne's colleagues lay dead, their corpses—some, if not all, of which had been beheaded—piled in heaps. Menéndez grudgingly spared about fifty women and children but reported great "anxiety at seeing them in the company of my people, because of their evil sect." Not a single Spanish soldier perished. A lone man was injured, but even he, the captain-general would later boast, soon recovered.

RUNNING FOR HIS LIFE on a wounded leg, the artist had only one thing going for him. Having spent the previous fifteen months exploring, painting, and mapping the local landscape, he was, by his own esti-

mation, "thoroughly familiar" with the trails that led away from Fort Caroline. Now he followed one of those paths into the woods, praying that no enemies were in pursuit.

> When I had gone on a little way, to the great delight of my heart, I came upon four other Frenchmen, and having comforted each other, we began to discuss what was to be done. Some were of the opinion we should stay in that spot until the next day, when perhaps the fury of the Spaniards would be appeased, and then put ourselves in their hands rather than stay where we were and expose ourselves to the appetite of wild beasts or perish from hunger which we had endured so long on other occasions. Others were not in favor of this view and decided to search for a distant Indian settlement where we might live until God showed us another way.

But Le Moyne had a different idea. Reminding his comrades that a few small French ships had remained moored on the river when Ribault's fleet departed, the artist proposed that they "strike through the woods towards the seashore" in hopes that these vessels had not been captured. This plan was met with blank stares from the other survivors, who "thought my scheme quite impracticable and took themselves off to the Indians, leaving me alone."

He now found himself, as Dante so famously put it, "in dark woods, the right road lost," and if he ever felt abandoned by God, this was the moment. Yet at least it would not be long before he once again found human companionship. In his flight, he happened upon a tailor named Grandchemin, who agreed to go with him in search of the ships. By the end of the day they had managed to make their way out of the woods to wetlands near the coast. But after a night of continuous rain, in which the two men had to slosh through swamps thick with tall reeds, the water rising above their waists, Grandchemin decided to turn himself in. Perhaps, he said, the Spanish would spare the two of them because they were craftsmen with skills that could be put to good use; and if not, "Was

it not better to be killed by them than to languish in this wretched condition?" Unable to dissuade his comrade, Le Moyne finally broke down and promised that he, too, would surrender.

Had he made good on that pledge, the world would never have known an extraordinary artist, his name, his work, his life story all lost to time. But when Le Moyne drew close enough to see the outpost again and hear the "uproar and rejoicing" of the Spaniards, he realized he had already overcome too much in Florida to give up now. Begging Grandchemin to stay in the woods, he told his comrade to trust that "God will open some way of safety to us . . . and will save us out of all these dangers."

> But he embraced me, saying "I will go: so farewell." In order to see what should happen to him, I got up to a [higher spot on the hill] and watched. As he came down from the high ground, the Spaniards saw him, and sent out a party. As they came up to him, he fell on his knees to beg for his life. They, however, in a fury cut him to pieces, and carried off the dismembered fragments of his body on the points of their spears and pikes.

A horrified Le Moyne hobbled back into the woods. Despite the despair and isolation he must have felt just then, he forced himself to keep moving, eventually coming upon Laudonnière's injured maid and two other survivors. Deciding to make their way toward the sea, they began to pick up more refugees, including Laudonnière himself. By the time they reached the marshes along the coast, their number had grown to around fifteen.

The carpenter Le Challeux, meanwhile, was with another group of survivors who were wading through those same wetlands. When members of this second party spotted figures moving among the tangles of wild roses, they feared that the Spanish had caught up with them. Coming closer, however, "we perceived they were as desolate and naked as we," wrote Le Challeux. "Then we knew they were our countrymen seeking safety."

Unsure what to do next, the two groups sent a scout to scale a nearby

tree. He returned with the first good news they had received since the attack: One of their ships could be seen in the near distance.

AT LEAST THREE FRENCH vessels had been moored on the river when the Spanish arrived. The largest of these was the *Perle,* captained by Jacques Ribault, son of the mariner whose recklessness had just led to the disappearance of the French fleet. Excess bravado, however, was hardly the younger Ribault's problem. Le Moyne and Laudonnière, who disagreed about so many other things, both later excoriated the mariner as weak, selfish, and disloyal, a coward content to sacrifice others in order to save his own skin.

When Menéndez and his men came charging out of the woods, Jacques Ribault's ship was anchored directly in front of the outpost, perhaps with a second French vessel, while two others were on the river a few miles away. Some residents of Fort Caroline were able to flee to the *Perle,* but, according to the artist, Ribault did little else to stop the slaughter. Although the mariner had "no lack of ammunition," complained Le Moyne, he did not fire a single shot in all the time that the Spanish were "perpetuating that butchery."

Now that the massacre was over, Menéndez turned his attention to these French ships. Going to the riverbank, he ordered the trumpeter to sound a peace call, instructed his men to hold out a white flag of truce, and dispatched François Jean, the captured mutineer, to negotiate a surrender with his former colleagues. Jean had twice forsaken the French—once by deserting, and now by leading the Spanish back to the fort—but "although the traitor was so brazen as not to hesitate to go aboard Jacques Ribault's ship," Le Moyne wrote, "yet Ribault was so spineless and cowardly that he was afraid to arrest him."

Still, Jean was unable to convince his former comrades to surrender. According to one Spanish account, Menéndez told the French that if they gave up all their weapons, he would allow them to sail for France, taking with them the captured women and children. But Ribault—who, having just witnessed the slaughter of his countrymen, had little reason to trust the enemy commander's offer of clemency—refused those

terms, withdrawing instead to the mouth of the river, where he met up with two other French ships the following day. By that time, Le Moyne, Le Challeux, Laudonnière, and their fellow survivors were making their way to the water, where they would be pulled to safety by the crew of the *Lévrier,* one of the vessels that had recently arrived from France.

After the evacuees, several dozen in total, had been picked up, the French officers met to discuss their next move. Since they still did not know what had become of their fleet, Laudonnière asked Jacques Ribault "whether they ought not to search for his father." But the young mariner, according to Le Moyne, had no interest in blood ties or heroics: "He wanted to go back to France." And so it was decided that they would dismantle one of the three ships and use its equipment to fit out the remaining two, the *Perle* to be commanded by Ribault and the *Lévrier* by Laudonnière. A couple of tense days followed as the French took aboard fresh water and made other preparations for the journey while Spanish soldiers watched them from small boats. The French, wrote Le Moyne, expected an attack at any time, and "knowing what they had inflicted on our comrades, we had resolved to defend ourselves vigorously." But the Spanish, apparently realizing their little boats were no match for the well-armed French vessels, never came within firing range.

What Le Moyne and his colleagues did not know was that Menéndez had determined to stop them from sailing. After renaming the French outpost San Mateo and marking out the future site of a Catholic church, he quickly departed for Saint Augustine with thirty-five of his ablest soldiers, intent on dispatching ships to capture the French vessels.

WHILE MENÉNDEZ WAS springing into action, Jacques Ribault was equivocating. Because the *Lévrier,* on which Le Moyne was to sail, had no experienced navigators, Laudonnière had asked Ribault to spare one of the four pilots aboard his ship. Ribault promised to comply, wrote Laudonnière, "yet he did not do it when we were ready to set sail, even though I told him that the thing I asked was for the service of the king."

On September 25, five days after the attack, Le Moyne set off on a seemingly impossible ocean passage in his ship, which not only lacked a

pilot but also was "poorly equipped with sailors and provisions," as the artist put it. And what of his drawings? Was he able to escape with any of his work? That question, so key to our understanding of the Florida engravings, still haunts scholars. "We should recall that he was an experienced campaigner," mused the art historian Paul Hulton, "and was presumably used to moving at short notice with his possessions, among which he would surely consider his drawings the most valuable." Nonetheless, even Hulton thought it unlikely that Le Moyne would have been able to secure his sketches amid the chaos of the raid, much less keep them intact during his sodden escape through the swamps.

A cryptic passage written by the Spanish chaplain may contain clues about the fate of those drawings. In the ransacked fort, wrote Father López, the Spanish found evidence of "a Lutheran who was a great map-

Detail from an engraving based on the work of Jacques Le Moyne.

maker and necromancer who had a thousand other evil things." We do not know whether this refers to Le Moyne, but there is no record of a second cartographer on the expedition, and it seems at least plausible that the Spanish, who believed native religious practices to be black magic, would have described the heretic artist who recorded such rites as a necromancer himself. Did that enigmatic mention of "a thousand evil

things," in fact, refer to Le Moyne's Florida drawings? In that same passage, Father López mentioned a "great quantity of Lutheran books," which Menéndez, good inquisitor that he was, promptly ordered burned. Perhaps that bonfire also included illustrations of naked savages practicing their blasphemous sorcery, the flames consuming those pages just as history would soon consume the people they commemorated, the carefully rendered lines and forms and figures blurred and then blotted by ash, the blackened papers peeling into the Florida sky and floating off like ghosts, like lost dreams, like memories drifting to oblivion.

Matanzas

. . .

Oɴᴇ ɴɪɢʜᴛ, ɴᴏᴛ ꜰᴀʀ ꜰʀᴏᴍ ᴡʜᴇʀᴇ ʟᴇ ᴍᴏʏɴᴇ ʙᴇɢᴀɴ ʜɪs ʜᴏᴍᴇ-ward voyage, I stood on a beach, staring out at where the sky met the sea in darkness. Somehow the Atlantic seemed even more immense in that gloom, and I found myself meditating on what thoughts must have been coursing through the artist's head as he left America behind. In our own time, survivors of mass killings often report that during the worst of their horrors they experienced a kind of psychic numbing, a shutting off of emotion. ("We were incapable of thinking of anything at all," wrote the death-camp survivor Elie Wiesel. "Our senses were blunted; every-thing was blurred as in a fog.") Perhaps it was like that for Le Moyne. Perhaps he felt as cold and insensate as the fish flitting beneath the hull of his pilotless ship. If not, it's hard to even conceive of his terror at that moment. Having just endured a famine, having just been wounded in war, having just witnessed the massacre of his countrymen, he was now entering a vast churning ocean amid storms of stunning violence, with only biscuits and water to live on and barely enough clothing to cover his back. Yet for all that, he must have known that whatever perils awaited him at sea, he was lucky to be alive.

Terra Florida now vanished from view. On that shore the slaughters continued.

Dᴇsᴘɪᴛᴇ ʜɪs ʀᴏᴜᴛ of the French fort, Pedro Menéndez was an anxious man. After a second rain-tormented trek through flooded forests, in

which he and his men became utterly lost, the Spanish commander had finally arrived back in Saint Augustine on September 24, the day before Le Moyne set sail. Determined to catch the French ships before they could escape, he ordered two armed vessels to be made ready as soon as possible. But just as those ships were about to depart, bad news reached Saint Augustine: The French had slipped over the sandbar and were already at sea. A frustrated Menéndez would have to give up the chase.

This only compounded his worries. The Spanish had killed more than 140 men at Fort Caroline, but as far as he knew the vast majority of the enemy force was still at large. Menéndez had correctly guessed that wind conditions would keep the storm-tossed French fleet from attacking Saint Augustine while he was gone, but he still did not know the enemy armada's location and had every reason to fear it would regroup. Expecting a French counterattack, he hurriedly shored up fortifications at Saint Augustine while dispatching a vessel loaded with cannons, powder, and ammunition north to the newly captured outpost to bolster defenses there.

Then came monumental news. On September 28, Indians arrived at Saint Augustine with word that white men were stranded on a beach a few miles to the south. Perhaps out of sheer exhaustion, Menéndez initially sent underlings to investigate; then he thought better of it and rushed to the scene, aware that whatever happened on that beach might well mean the difference between victory and defeat.

Accompanied by about fifty of his troops, Menéndez reached an inlet about fifteen miles south of Saint Augustine late that night, where he spotted campfires on the opposite shore. The following morning, French soldiers scrounging for shellfish at the water's edge glanced up to see Spaniards on the far bank. The men sent a swimmer across, who informed Menéndez that he and his companions were part of the enemy armada commanded by Jean Ribault. The French fleet, he said, had been wiped out by the hurricane that lashed the Florida coast earlier in the month. Driven toward shore by the harrowing winds, most of the vessels had broken up in the heavy surf. Some men drowned; others were killed or kidnapped by Indians. The flagship carrying Ribault and some two hundred others had run aground on some shoals, the envoy reported,

adding that he did not know what became of those on board. He and his compatriots were survivors from other ships, some 140 men in all, who had followed the beach north, hoping to reach their outpost by foot. The terrain, however, had played a cruel trick on them. By clinging to the shoreline they had unwittingly walked to the tip of a thin peninsula many miles long, and now, surrounded on three sides by water, they found themselves trapped. They had eaten almost nothing in nearly two weeks, said the envoy, who asked that the Frenchmen receive safe conduct back to Fort Caroline.

In his own version of the encounter, Menéndez bluntly refused:

> I answered him that we had taken their fort and killed those in it . . . and that I, as governor and captain-general of these provinces, would wage a war of fire and blood against all those who should come to people these lands and implant the wicked Lutheran sect . . . and that therefore I would not give them safe conduct; rather would I follow them on land and sea, until I had taken their lives.

More envoys followed, one of whom purportedly offered the captain-general a ransom of fifty thousand ducats in return for sparing everyone marooned on that beach. But Menéndez stood firm. Parading war spoils and captives from Fort Caroline before the men as proof that their outpost was now securely in Spanish hands, he urged them to "place themselves at his mercy . . . in order that he might do with them what God should direct him," in the words of his brother-in-law Solís de Merás, who added that Menéndez told his enemies they could expect to be treated "with all possible cruelty."

Probable death: Take it or leave it. It seems difficult to understand why the French, desperate though they were, would accept such an offer, if indeed that was the one Menéndez actually made. It is possible, of course, that his proposal was somewhat more ambiguous than he later claimed, or even that he led them to believe they would be spared. Yet it is also possible that the castaways, having lost their ships, their fort, their food supplies, and now their way, had also lost their will to go on. This

much is sure: After "much parley," the marooned soldiers sent across a boat containing their flags and their swords and their armor, along with their last twenty pistols and sixty arquebuses, as tokens of surrender.

Menéndez ordered his men to bring the French across by boat ten at a time. After debarking, the prisoners were led to a spot where their countrymen could not see them. Then their hands were tied behind their backs, and the captain-general asked if any of them were Catholic. Those who said yes, apparently no more than a dozen in all, were spared, along with a few craftsmen whose skills were useful to the Spanish. The rest were taken in groups behind a dune, where, at a line drawn in the sand by Menéndez, Spanish soldiers knifed them to death, lopping off a head here and there for good measure. It was past sunset when the killing was done. They left the corpses on the beach and shuffled back to Saint Augustine, worn out from the long day of slaughter.

TWELVE DAYS LATER, the Indians came back to Saint Augustine to report spotting another large group of Frenchmen, stranded on the very same beach as their predecessors. Realizing that these must have been the survivors of the missing flagship under Jacques Ribault, Menéndez quickly embarked with 150 of his men.

The events purportedly transpired much as they had in the first encounter. After some initial posturing on both sides, a French officer approached Spanish forces on behalf of Ribault to request safe passage for as many as 350 shipwrecked men returning to their fort. Menéndez replied that everyone at the outpost was dead, as were the other French castaways, and to prove it he led the officer to the corpses of the previous massacre, still strewn on the sand. Then he declared that there would be no safe passage or promises of clemency: The French must "put themselves at my mercy, for me to do with their persons as I might wish." The officer took this message back to Ribault, who soon arrived in person to offer Menéndez a ransom of some two hundred thousand ducats. But the captain-general refused, and Ribault, realizing he was out of options, decided to lay down his arms.

That, at any rate, is the tale told by Menéndez and his biographers. A

different account comes from Le Moyne, who claimed to have learned about the encounter from an eyewitness, "a certain sailor of Dieppe who slipped out of Spanish hands" and later returned to France. In this version of the story, the French officer sent to negotiate with the Spanish was none other than the artist's former housemate, the shrewd François La Caille, who managed, wrote Le Moyne, to procure from Menéndez a "sworn promise in writing and endorsed with his seal" that if the French surrendered, their lives would be spared.

Some historians have dismissed this tale, implying that the mysterious sailor from Dieppe was a fabrication of Le Moyne or perhaps his publisher, created as part of an anti-Spanish propaganda campaign. Such a theory, however, does not explain why so many particulars of the artist's narrative are consistent with Spanish eyewitness accounts, to which he would have had no access. Even his contention that the cool-headed La Caille was sent to negotiate with Menéndez seems to accord with Spanish descriptions of the unnamed envoy as a man of "great composure," who witnessed the decomposing corpses of his companions "without showing any sign of grief." The key difference in Le Moyne's version of the encounter is his assertion that the French were led to believe they would be sent home "in a large ship splendidly equipped with all requirements."

On the morning of October 12, 1565, Jean Ribault crossed that water between the French and Spanish camps for a final time, the last in a series of poor decisions he made on the journey. Presenting Menéndez with his sword and other weapons, along with two royal standards and a seal Admiral Coligny had given him to stamp all edicts and titles, Ribault informed the captain-general that about half of his men had decided to lay down their arms. The others, after making an attempt on Ribault's life, had fled under cover of darkness.

Menéndez ordered his brother-in-law, Gonzalo Solís de Merás, and a second soldier, Captain Juan de San Vicente, to take Ribault away. They led him off toward that same line in the sand where his countrymen had been cut down twelve days earlier. Having now realized that he, too, would be killed, "Ribault repeatedly begged to speak to the commander to remind him of his promise," wrote Le Moyne, "but his words fell on

deaf ears." The Spanish chronicler Bartolomé Barrientos described what happened next:

> Ribault had been wearing a felt hat and Captain San Vicente now asked him for it. When it was handed to him he said: "You know that captains must obey their generals and carry out their orders, and so we must tie your hands." His hands bound, Ribault was marched ahead for a little distance. Captain San Vicente then thrust a knife in his belly, and Gonzalo de Solís ran him through the heart with his pike; then they cut off his head.

By various accounts, between seventy and 250 Frenchmen were slaughtered in this same manner that day, among them many nobles and top officers. The area where their killings took place is still known as Matanzas, the Spanish word for massacres.

Three days later, Pedro Menéndez sent a dispatch to the Spanish king, boasting that he would soon control Florida "without opposition or anxiety." True, among the French who remained at large were a few dozen men in two "badly damaged" ships, he informed his monarch. But there was reason to hope that "as they are ill-provided and ill-equipped they might not reach France."

THE CAPTAIN-GENERAL'S words almost proved prophetic. On just their second afternoon at sea, the two French vessels separated from each other, never to be reunited. Jacques Ribault had the superior ship and was apparently in no mood to nurse the other across the ocean. Le Moyne and his companions watched the *Perle* edge farther and farther ahead before vanishing on the horizon. From now on, each crew would be on its own.

The elderly carpenter Nicolas Le Challeux, who sailed with Ribault, described a "perilous and lamentable voyage," in which "the bread we ate was moldy, and the fresh water stank—and all we could have of it was one small cup a day." One morning before dawn in the middle of the sea, a Spanish ship swooped in to attack, but the French "fired so much gun-

shot into her that she yielded, while blood ran out of the scupper holes."
Near the end of the voyage came another close call, when winds threat-
ened to drive the ships into the Spanish coast. But the crew managed to
steer clear of enemy territory, landing safely at the French port of La
Rochelle. Upon returning home to Dieppe, Le Challeux would write a
poem about his experiences:

> *Who wants to go to Florida?*
> *Let him go where I have been,*
> *Returning gaunt and empty,*
> *Collapsing from weakness,*
> *The only benefit I have brought back,*
> *Is one good white stick in my hand,*
> *But I am safe and sound, not disheartened,*
> *Let's eat: I'm starving.*

About his own vessel's journey, Jacques Le Moyne said little. Never
one to dwell on hardship, be it the famine at the fort or the wound to his
leg, the artist summarized the crossing with typical concision: "We suf-
fered much." As usual in difficult times, it was Laudonnière who left the
more detailed record, outlining a trip in which the men battled difficult
winds and their own hunger but managed to reach Saint George's Chan-
nel, a strait separating Ireland from southwestern Wales, more than six
weeks after setting sail. Laudonnière then attempted to navigate around
the southern tip of England at night, hoping to reach Dieppe the follow-
ing morning. Perhaps for lack of a skilled pilot, however, he awoke to
find himself still in Saint George's Channel, a body of water "feared by
all navigators . . . where many have been shipwrecked." Deciding he had
already endured enough perils, Laudonnière docked at the Welsh town
of Swansea, where he abandoned his sea-worn vessel and declared his
intention to travel home via safer and more reliable means.

> I went to Bristol [by carriage] and thence to London, where I
> paid my respects to Mr. de Foix, who is the ambassador for the
> king there. He took care of my money needs on account of my sit-

uation. From there I went [by ship] to Calais and then to Paris. I was there advised that the king had gone to Moulins for a sojourn, to which place I went as quickly as I could, with part of my company.

It is almost certain Laudonnière's entourage included the official artist and cartographer. The expedition had been a complete failure, but Le Moyne had reason to be proud of his own role in it. He had broken new ground. Juan Ponce de León was the first European to make landfall in La Florida, but there is much more to the act of discovery than setting foot on some distant shore. The hard part, the part that takes centuries, is the mental discovery: achieving a real understanding of the place and its inhabitants. More than five hundred years after Columbus came to the New World, we still barely know the people who were living on those shores, but our understanding would be far more impoverished without the pioneering work of Jacques Le Moyne de Morgues. And now, home at last, he was ready to report his findings directly to the king of France.

Map

. . .

THE MAP ADVERTISES ITSELF AS "A RECENT AND MOST EXACT DRAFT of Florida, a province of America, by Jacques Le Moyne," who, we are told, "industriously surveyed both the interior and coastal areas of that region . . . as he himself showed, on his return, to Charles IX, King of France." No detailed record of this meeting survives, but we can be sure the young monarch was intrigued by what he saw that day. The map swarms with wonders: a crescent-shaped lake, a donut-shaped lake (complete with a circular island at its center), a lake "so great . . . that it is not possible to see one bank from the other," and an even larger body of water that seems to cover much of the continent. Yet none of these curiosities would have interested the king more than a vast mountain range

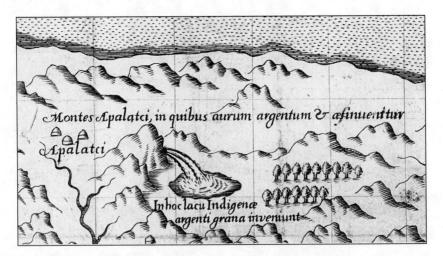

The Apalatci Mountains, from a detail of Le Moyne's map.

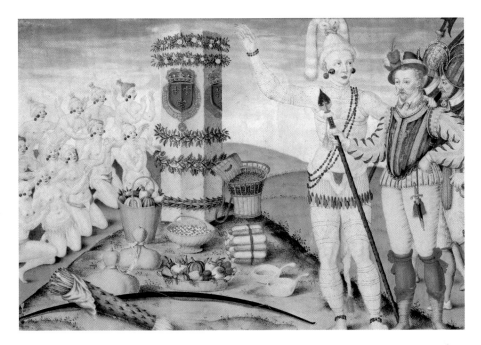

Experts once believed this watercolor, now housed at the New York Public Library,
was Jacques Le Moyne's last surviving painting of Native Americans.
More recently, however, some scholars have expressed doubts about its authenticity.
All of Le Moyne's other original artwork from the Florida expedition
of 1564–65 has been lost to time.

Another mystery surrounding the first European artist in North America is the precise location of his long-vanished fort. Although the National Park Service built this replica not far from where the outpost must have stood, archaeologists are still searching for the real Fort Caroline.

*In addition to his groundbreaking illustrations of
Native Americans, Le Moyne is known today for his work
as an important early botanical painter.*

*Le Moyne's ability to detail a flower down to the tiniest hairs on its stem,
a pear down to the subtlest blemishes on its skin, reflected
a reawakening to the natural world among Renaissance artists.*

Le Moyne worked for some of the most prominent figures of his time, including the famed author, courtier, and explorer Walter Raleigh. New evidence suggests he also may have had a professional connection to the notorious Mary Queen of Scots.

The ancient French city of Châteaudun may hold the key to Le Moyne's mysterious past.

A few miles outside of Châteaudun stands the hamlet of Morgues.

MAP 173

near the top of the map. From its highest peak explodes a waterfall of such epic size that, judging by the map's scale, the rapids plunge a full thirty miles before reaching the rocks below, while from its foothills flows a river that offers easy passage to the spot where the French fort once stood. The loss of that outpost, the map seems to assure us, is only a temporary setback. New France lives on. There, stamped into Terra Florida, is the French royal coat of arms, and there, inscribed across those great cliffs, is "Montes Apalatci," where, the map informs us, "gold, silver and copper are found."

THE ARTIST'S AUDIENCE with Charles IX probably took place in March of 1566, more than five months after his departure from Florida. It was then that Laudonnière, having spent a period of time in England recovering from illness, finally reached the town of Moulins in central France, one of the court's last stops on a long royal tour of the kingdom. The goal of this epic procession, which had been plodding from one city to another for nearly two years, was to unite the troubled country around its teenage king. But in fact religious rancor had once again reached a boiling point, with Catholic zealots trying to talk Catherine de Medici and young King Charles into "cutting off the heads" of Huguenot leaders, and Protestants charging that the crown had formed a secret alliance with Spain and was planning a crackdown on religious dissent.

In an attempt to avert a second civil war, Catherine, still the functional head of state, used her stay at Moulins to convene an Assembly of Notables from across the kingdom, bringing together high-ranking aristocrats and government officials of both religions. Declaring that it was impossible to deal with the affairs of state until private feuds were settled, she insisted on a public rapprochement between the Calvinist luminary Admiral Coligny and the ultra-Catholic Guise family. In late January of 1566, Coligny was formally acquitted in the assassination of the duke of Guise some three years earlier. Catherine even persuaded the admiral and the dead man's brother to kiss each other.

By then, however, stunning news was beginning to trickle into the French court, news that would fuel the flames of religious hatred and

touch off a new diplomatic crisis with Spain. The first bad tidings came in mid-December, when Jacques Ribault and the other survivors from his ship arrived back in France, bringing word of the capture of Fort Caroline. For several weeks that followed, Catherine and Charles could still cling to the hope that their remaining forces would somehow escape slaughter, but in mid-January the ambassador to Spain fired off a grim dispatch: Menéndez "did not spare anyone at all." The Spanish government's official confirmation of the massacres arrived at the French court in mid-March, just as Laudonnière and his entourage were reaching Moulins.

The beleaguered sea captain soon found himself the scapegoat of this fiasco. Even before the slaughters, Laudonnière had faced troubling charges about his conduct as commander, but now he had to deal with much more serious allegations. These came from Jacques Ribault, who, having reached France before Laudonnière, wasted no time in blaming his fellow officer for the fall of Fort Caroline. It seemed to matter little that the younger Ribault had himself failed to defend the outpost when he had the chance, or that his own father deserved the lion's share of the blame for the disaster. Because Jean Ribault had died and René Laudonnière had lived, the former was now celebrated as a martyr while the latter was censured for neglecting to defend the fort, failing to maintain an adequate garrison, and allowing himself to be surprised by the Spanish. Forced to borrow fifty crowns from Catherine de Medici just to eat, Laudonnière became so desperate and disillusioned that he initiated secret talks aimed at offering his services to Spain. Even those sad overtures, however, were apparently met with rebukes.

The expedition artist, by contrast, seems to have received a much warmer welcome at the court. In his description of the encounter, Le Moyne noted (with typical reserve but apparent pride) that he was able to satisfy the king "to the best of my ability." Presumably this means he presented pictures of Native Americans along with an early version of the map later published by the Flemish engraver Theodor de Bry, though whether such images were prepared in Florida or hastily reconstructed afterward remains a mystery. He also impressed the court with an oral account of his adventures, according to de Bry:

MAP 175

He was urged by the king, to whom he related the whole affair on returning to France, to put it down on paper, and this he carried out faithfully in his own tongue. But he kept it private to himself and his friends and . . . was unwilling to publish it.

NOT EVERY SURVIVOR was so reluctant a storyteller. In May of 1566, less than six months after returning to France, the elderly carpenter Nicolas Le Challeux published an account of his own escapades, a work that would prove not just a riveting adventure tale but an incendiary piece of political propaganda.

The Spanish, in Le Challeux's depiction, were blood-drunk butchers who "vied with one another to see who could best cut the throats of our people." Unlike Le Moyne and Laudonnière in their later narratives, Le Challeux insisted women and children were among those annihilated in the "horrible, tragic slaughter" at Fort Caroline. He also provided a gruesome version of the Matanzas killings, purportedly based on the testimony of an escaped eyewitness. It unfolded like a New World passion play, starring Jean Ribault as a man of "grace and accustomed modesty" who was tricked into surrendering, then sacrificed by his Spanish betrayers. In the final scene, the killers sliced off the dead man's beard as a trophy before "quarter[ing] his body and his head, which they stuck at the four corners of the fort."

The book, which went through two editions in its first year, helped spark an anti-Spanish backlash in France. The massacre quickly became a cause célèbre, even among some Catholics, who saw it as an affront to national honor. Day by day, the inventory of supposed Spanish atrocities grew longer and more outrageous. One publication, also circulated in 1566, went so far as to assert that "Ribault was burned alive, thirty-five officers were hanged by their private parts, the captains of the marine were nailed by their ears to the masts of the ships, [while] the soldiers and sailors were sewn into the sails and thrown into the sea."

The clamor for vengeance reverberated from many quarters, none louder than the Calvinist maritime community in Normandy. Yet while

Catherine de Medici claimed to be "beside myself" with grief over the killings, she took no immediate action. Instead, a long diplomatic stalemate ensued in which Catherine called on Spain to punish Menéndez and make reparations, while King Philip countered that the real blame rested with Coligny, "the venom of that kingdom," for establishing an illegal settlement on Spanish soil. This jockeying continued all through 1566, until Philip finally issued a one-sentence edict in December, flatly refusing all French demands.

By then, many Huguenots, appalled by Catherine's seeming indifference to the slaughter of their brethren, were beginning to believe that the French crown had indeed joined Spain in a secret alliance aimed at wiping out religious heresy. These simmering fears boiled into an all-out panic in 1567, when ten thousand Spanish troops skirted the French border en route to crushing a Calvinist uprising in the Netherlands. Convinced that a similar crackdown was imminent in France, where the crown had recently hired some six thousand Swiss mercenaries under controversial circumstances, Coligny and other Huguenot leaders decided to strike first. In September of that year, they launched an unsuccessful coup, touching off the Second War of Religion, which sputtered along with no clear winner until a fragile truce was signed the following March. Within six months, there would be a new round of sectarian hostilities—but first came news that gave Catholics and Protestants alike reason to cheer. Finally France had settled the score in La Florida.

THE MAN WHO WOULD become famous as the "avenger of Matanzas" was not, it appears, a Calvinist zealot but a Catholic nobleman whose reasons for embarking on the mission may have had nothing to do with religion. Instead, Dominique de Gourgues seems to have been driven by a strident French nationalism and a long-standing personal vendetta against Spain.

Captured by Spanish forces as a young soldier, Gourgues had been chained to a bench and forced to ply the oar as a galley slave, an experience that etched him with hate. The cruelty he was willing to ascribe to his former masters seems to have had no limit. An account of his es-

MAP 177

capades, likely written by Gourgues himself, insisted that the Spanish not only killed the women of Fort Caroline but raped them first, that they "cut the throats of the little children without mercy," and that they "tore out the eyes of those they had murdered, and having stuck them to the ends of their daggers, competed among themselves to see who could flick them the farthest." As for Ribault, the killers "flayed [him] and sent his skin to the king of Spain."

Real or imagined, such atrocities outraged Gourgues, who, like many of his countrymen, had grown increasingly frustrated by the crown's failure to retaliate. In 1567, he decided to sail for Florida himself "to perform an act . . . necessary to the honor and reputation of France." Financing the expedition with his own funds and help from private investors, he embarked in August with three ships and 150 soldiers, including a survivor from Fort Caroline to serve as interpreter. After a leisurely journey that may have involved pirating activities, Gourgues reached Florida in April of 1568. He anchored near Fort Caroline (renamed San Mateo), anxious to redress "the insult done to the king and to all France," and apparently also to settle a few private scores with the Spanish empire.

On shore he happened upon a man with a similar grudge. Saturiwa, that onetime friend and sometime nemesis of Laudonnière, was finding the new residents of the fort even less to his liking than their predecessors. In many ways, in fact, the Spanish tenure at San Mateo had followed an all-too-familiar storyline: food shortages and frustration followed by mutiny and mistreatment of the natives. In March of 1566, during a violent uprising at the outpost, Spanish soldiers ran wild in the countryside, murdering a number of Indians. No longer willing to suffer such indignities without a fight, Saturiwa declared war, inflicting devastating casualties on the conquistadors in a series of ambushes and killing a priest who had just arrived to convert the natives. Having refused to halt such attacks, even after the Spaniards kidnapped one of his sons and shot dozens of his warriors, the old chieftain was overjoyed to discover a heavily armed French contingent in his midst.

Gourgues showered Saturiwa with gifts, and the chief, swearing he had "never ceased to love the French," feted his new friend with the black drink (which the adventurer found so vile he "pretended to

drink . . . but did not swallow"). Having thus solemnized their alliance, they marched on San Mateo, which their combined forces easily overran, along with two smaller outposts the Spanish had erected nearby. Some conquistadors managed to escape into the woods, but an unknown number of others were "killed and cut to pieces" on the battlefield. Those who surrendered were brought before the French commander, who ordered them strung from trees and hanged, their corpses left to dangle in the sun like butchered deer: a "robber's death," the narrative of Gourgues's adventure called it.

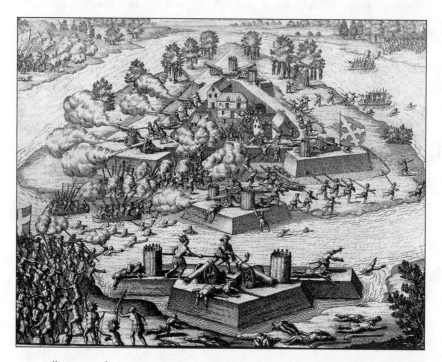

An illustration of Gourgues's attack on Fort Caroline, renamed San Mateo by the Spanish.

The French set fire to the outposts, then headed back to their ships. Gourgues promised the Indians he would return in a year, but although the account of his journey credited him with having "reconquered Florida," neither he nor any of his countrymen were to set up another colony there. Le Moyne's map, which was published along with his journal and Florida engravings in 1591, may give the impression that Florida

MAP 179

belongs to the French, but in reality Gourgues's raid was their last hurrah. From then on they would concentrate mostly on Canada, leaving Spain and England to fight it out for the Southeast.

THAT MAP, IT TURNS OUT, is full of fictions. There were no sprawling lakes in Florida, no inland oceans, no waterfalls of Olympian grandeur. The nearest mountain range was not within easy striking distance of Fort Caroline, as the map indicates, but hundreds of miles to the north. All the months of trying to reach the Montes Apalatci, all the alliances made and broken, all the hardships endured and battles fought and lives lost: The whole quest came from a monumental misunderstanding. Beyond Chief Utina's lands stood no mineral-rich peaks but the pine forests of the Florida panhandle, home to an aboriginal group known as the Apalachee. The French transformed this country, just out of their reach, into a dreamworld called Apalatci that, like all dreamworlds, was destined to disappear. Only its name would survive. That the great highlands of the eastern United States are today known as the Appalachians is due in part to Le Moyne's influential map, though neither the cartographer nor his comrades ever set foot anywhere near those mountains.

Historians have long puzzled over how Le Moyne could have gotten it all so wrong. True, it was common for sixteenth-century cartographers to base their work on rumor and speculation when direct observation was impossible, so he can hardly be blamed for locating the Apalatci where the French believed those hills stood. Yet other errors are more difficult to understand. The map indicates, for example, that the Saint Johns (or River of May, as the French called it) gave the colonists access to the northwestern interior of La Florida and that one of its tributaries afforded them a direct passage to the mountains. No such tributary ever existed, however, and the Saint Johns led not northwest but south, into the swamps of east-central Florida. Why Le Moyne would have made such mistakes is hard to fathom, since he explored, and presumably charted, the river himself. Scholars have attributed such errors to his lack of cartographic training or to the loss of his field notes or to his attempts to square the map with those of earlier chartmakers or to changes made

by his publisher, Theodor de Bry. But as the historian David Beers Quinn pointed out, there is a more disturbing possibility. It may be that the map was never meant as an accurate representation of Florida but was crafted to justify Admiral Coligny's colonization schemes. It may be that, in presenting it to the French crown, Le Moyne "intended to deceive."

Detail of Indians carrying mineral-rich silt in the Apalatci Mountains.

LE MOYNE'S ILLUSTRATION of natives panning for gold in the Apalatci also turns out to be either a fantasy or a fraud—one of the few Florida engravings with no basis in fact. Yet like all inventions of the imagination, it contains psychological truths. At the rear of that picture, two spectral figures stride away from the beholder, their backs turned so that none of their features can be seen. They are like characters from a dream: exotic, obscured, unknowable. Eternally disappearing around the bend, carrying with them the long-sought treasure, they embody the vain French quest for the Apalatci.

But in the years I spent searching for Jacques Le Moyne, I also came to see those figures as symbols of the engravings themselves. You can never make perfect sense of the people in those illustrations. Sometimes

MAP 181

you get close, or at least think you do, but then they turn away again, drifting out of the frame, out of history, beyond comprehension. A fantasy map and forty-two illustrations of such enigmatic meaning, such dubious accuracy, and such unconfirmed authorship that they can seem as difficult to decipher as the runic scribblings of a lost language: This is the pictorial legacy of the first European artist in North America. As odd as it may seem, Le Moyne often speaks most clearly to a modern audience through his prose. His account of the expedition, published years after those of Le Challeux and Laudonnière, is strikingly candid and fair-minded by comparison. In attempting to make sense of the colony's failure, for example, Le Challeux, with typical anti-Catholic venom, placed much blame on the "monstrous cruelty" of the Spanish, while Laudonnière, ever anxious to clear his own name, incriminated his martyred rival, Jean Ribault. For his own part, Le Moyne spared neither Ribault nor Laudonnière from censure, and he too, decried the "extreme treachery and atrocious cruelty of the Spaniards." Nonetheless, his Calvinist faith taught him that the colonists could condemn no one but themselves:

> For the destruction of Ribault and his men we should not blame the Spaniards, whom the Lord used as rods to scourge us according to our deserts, but ourselves and our sins, which were responsible for our misfortunes. And to God the omnipotent, and His Son, Jesus Christ our Lord, and to the Holy Spirit, be honor and glory forever. Amen.

Those were the final words of Jacques Le Moyne's memoir. His adventures, however, were far from over. History would reclaim him in another time and place.

Blooms and Blood

...

FOR THE FIFTEEN YEARS BETWEEN 1566 AND 1581, WE KNOW LE MOYNE only through his art. His flawed Florida map was to be his last cartographic venture; there is no evidence that he ever attempted another one. Instead of plotting mountains or coastlines or rivers, he would chart the infinitesimal landscapes of hollyhocks and clove pinks, corn poppies and pot marigolds.

The flower, wrote the art historian Germain Bazin, "is a Renaissance discovery: the abundance of flowers in our gardens was born from that age's new appetite for knowledge." As Europeans awoke from the Middle Ages with a fresh interest in nature, gardens emerged from behind the high walls of monasteries, abbeys, and castles, where for centuries they had lain hidden "like roofless outdoor rooms," in the words of one observer. A horticulture craze swept through the French nobility, whose vast and elaborate grounds were designed as works of art in their own right. Commoners, too, began to see their gardens as places of beauty and relaxation, not simply as sources of food and medicine. The first recognizable commercial nurseries began to appear during the sixteenth century, as did the first botanical gardens. Plant collecting became a passion, fueled by a dizzying influx of exotic flowers, first from southern Europe and the Levant, then from Africa, Asia, and the New World.

The age also witnessed a revolution in botanical illustration—one in which Jacques Le Moyne stood at the vanguard. His ability to capture a single flower's minute variations of color and texture, of shadow and light, of transparency and opaqueness, was "unsurpassed in his time," in

the words of one art historian. He would devote the rest of his career to
this craft. It was as if, having already experienced so much tumult and vi-
olence, he wanted to withdraw into a silent world of beauty and color, as
if he hoped to hide from the horrors of his age amid orange lilies and
wild columbines. But even as he painted the graceful petals of the bitter-
sweet, a plant believed to ward off evil spirits, or sketched the common
borage, used by contemporaries "for the driving away of sorrow, and in-
creasing the joy of the mind," the terrors of the sixteenth century were
once again closing in on Jacques Le Moyne de Morgues.

BY THE SUMMER OF 1572, the Wars of Religion had been raging in
France for a full ten years. Catholics had slaughtered Protestants at their
prayers, burned at the stake printers and peddlers of banned books,
dragged the bodies of heretics through the streets, disemboweled them,
cut off their genitals, and rallied to the cry of "For the flesh of God, we
must kill all Huguenots!" Protestants had smeared human excrement on
baptismal fonts, mutilated sacred relics and icons, tortured members of
the clergy, assassinated the top Catholic leader, and even attempted to
kidnap the king. Three separate civil wars had been fought, in which tens
of thousands of combatants, Catholic and Calvinist alike, lost their lives.
And all this was a mere dress rehearsal for the horror that came next.

In August, amid a political atmosphere even more stifling than the
summer heat, noble families of both faiths crowded into Paris for the
wedding of the king's sister, Marguerite, to a Huguenot leader of royal
blood, Henri de Navarre. Catherine de Medici, the ever-calculating
queen mother, had hoped the marriage would serve as the centerpiece of
a reconciliation between the religious parties in France.

The ceremony itself took place on August 18 at the Notre Dame
cathedral and was followed by four days of sumptuous banquets, tourna-
ments, balls, and ballets. This outward show of merriment, however, be-
lied an increasingly tense mood on the narrow streets of the capital,
where close proximity only inflamed old hatreds. Paris had long been a
hotbed for Catholic extremism, and in the months before the marriage,
fanatical preachers and end-times prognosticators, warning that "God

will not suffer this execrable coupling," had been urging their followers to take action against the heretics swarming into their midst.

The chaos began with an arquebus blast. On August 22, a gunman, perched in the upper window of a house near the Louvre, opened fire on Admiral Coligny, the controversial Huguenot leader who had organized Le Moyne's expedition to Florida. The assailant escaped capture, and his precise motivations and affiliations remain unknown, the subject of countless conspiracy theories in the centuries since. He appears to have had at least some link to the Guise family, Coligny's Catholic archenemies who owned both the house from which the shot was fired and the horse on which the gunman escaped. Less certain is what role, if any, Catherine de Medici played in the plot. Although some scholars doubt her involvement, others are convinced that the queen mother, jealous of the admiral's growing influence over her son, approved the scheme in advance. But if she thought that silencing the foremost Huguenot leader would bring stability to her tortured country, she had made a horrible miscalculation. The shooting did not kill Coligny, who received only minor injuries, but it did set off one of the bloodiest massacres in European history.

Calvinists rushed to their wounded leader's bedside, publicly vowing revenge. These threats, in turn, unleashed rumors of an imminent Huguenot uprising. An air of dread pressed down on Paris, as thick and pregnant as the stifling humidity. It was all too much for Charles IX, who gathered his advisors on the day after the shooting. Now in his early twenties, the boy king had grown up to be a sickly, weak-willed, and emotionally disturbed young man. Earlier he had promised Coligny a full investigation along with harsh punishments to those involved, but now, perhaps at the urging of his mother, he began to see the admiral as his enemy. Apparently convinced that Huguenots were planning a coup against the royal family, the impulsive Charles ordered a preemptive strike.

The slaughter began before dawn on August 24: Saint Bartholomew's Day. The duke of Guise, who still blamed Coligny for the assassination of his father nine years earlier, led a group of soldiers to the house where the admiral was lodged. Overwhelming the guards, they burst

into his chambers and stabbed him repeatedly, then hurled his body to the street below. One of the duke's followers cut off the dead man's head and carried it off to the royal palace as a trophy for the king and his mother. Then a crowd of young Catholics began to mutilate the corpse. Chopping off Coligny's hands and genitals, they dragged the butchered carcass through the streets, set fire to it, and dumped it into the river— only to haul it out again after they deemed it unworthy to feed the fish. Before long, all sense of order had broken down in the capital, with frenzied mobs terrorizing any Huguenot who happened to cross their path. Throughout the city, Calvinists were tracked down, tortured, and slaughtered, their homes looted. In all, an estimated two to three thousand men, women, and children were shot or hacked to death in a rampage that lasted four days.

The killing quickly spread to the provinces, leaving more than a dozen cities awash in a torrent of violence that cost approximately three thousand additional lives. In the Norman city of Rouen, where Calvinists had been rounded up, ostensibly for their own protection, Catholic zealots took control of the town, locked the gates to prevent anyone from escaping, broke into the jail, and slaughtered several hundred heretics. A mob then marched on nearby Dieppe. It was turned away by the local governor, who, in return for saving the lives of his Huguenot citizens, is said to have demanded that they all convert to Catholicism.

We do not know where Le Moyne was while this carnage unfolded— only that, once again, he proved himself a survivor. Yet even without a clear picture of his life during this period, we can infer that the Bartholomew's Day massacre, which delivered a crippling blow to Protestantism in France and left Huguenots in a more dangerous position than ever, was a pivotal event for the artist. Like thousands of other French Calvinists, Le Moyne would be forced to conclude that he was no longer welcome in the land of his birth.

PERCHED JUST ACROSS the water from Normandy, the town of Rye was at that time the most frequent destination of French citizens bound for England from Dieppe. A regular passage having long been estab-

lished between the two ports, it was natural that Rye had become a refuge for Norman Calvinists during the Wars of Religion. Following an outbreak of violence and persecution in 1568, for example, the English port received a number of prominent Huguenots including the notorious corsair Jacques de Sores, who, along with his wife and eleven servants, had "come out of France, as they say, for the safe guard of their lives," as one English official reported at the time.

Yet while Frenchmen were a familiar sight on the cobblestone streets of the town, residents were unprepared for the number of refugees who swarmed in after Saint Bartholomew's Day. Among the first to set foot on English soil was Jacques Ribault, his genius for saving his own neck apparently undiminished since the sack of Fort Caroline. In the next few weeks more than seven hundred exiles made the passage, and as the months wore on, ships continued to bring "great numbers of the French ... to the great coy [i.e., disdain] and grief of the inhabitants of Rye and other places about the same," according to one surviving town record. Local officials ordered that no French exiles except for merchants, gentlemen, and messengers be permitted to disembark, but the ban was "little regarded," forcing officials to impose tougher sanctions against the refugees.

Despite these efforts, Huguenots continued to swarm across the Channel for years after Saint Bartholomew. At some unknown point they were joined by Jacques Le Moyne de Morgues, a wanderer once more. This time, his long, strange odyssey would lead him into the upper echelons of English society.

Alias Morgen

. . .

T UCKED JUST INSIDE THE CITY WALLS AT THE CONFLUENCE OF the Thames and Fleet rivers, the Blackfriars district had been a conspicuous symbol of medieval London. From the thirteenth until the early

The Blackfriars district of London, from a map published around the time Le Moyne lived there.

sixteenth centuries, the site was home to a rich Dominican friary with
close connections to the English crown. Visiting monarchs were occa-
sionally housed at the friary's magnificent guest house, and its great hall
was sometimes used for sessions of Parliament. But all that changed in
the 1530s, after Henry VIII renounced papal authority and established
the Church of England. The holy brothers from whom Blackfriars had
taken its name were evicted, their church torn down, their land sold to
private investors—all part of a nationwide takeover of monastic proper-
ties. Quickly shedding its past, Blackfriars had, by the 1580s, come to
embody the cosmopolitan spirit of the Elizabethan era.

London had grown from a town of about fifty thousand people early
in the century to a bustling city of 120,000 in 1583, with huge waves of
newcomers washing in from the countryside each year. Among them was
a young William Shakespeare, who first visited Blackfriars shortly after
his arrival from Stratford-upon-Avon in the mid-1580s and later pur-
chased the gatehouse of the old friary as his home. One of the first the-
aters in London was established in the district in 1576, the forerunner of
the renowned Blackfriars playhouse, where many of Shakespeare's plays
were performed. The area had also begun to attract immigrant artists
and artisans from Europe. The great watercolor miniaturist Isaac Oliver
(circa 1565–1617), whose parents were Huguenot refugees from Rouen,
grew up in Blackfriars and would spend much of his professional life
there. The famous baroque Flemish painter Anthony Van Dyck (1599–
1641) would also make the district his home, as would the gifted artist
Cornelius Janssen (circa 1593–1661). But first came Jacques Le Moyne
de Morgues.

A census of foreign immigrants shows "James Le Moyne, alias Mor-
gen, painter" residing in Blackfriars as of April 1583, having emigrated
from France "for religion." With him were his French wife, Jeane, and
"one child, born in England." Since Le Moyne was then about fifty—
elderly for the time—it seems likely that his spouse was at least ten years
younger, though the documents offer few other clues about their life
together.

Even so basic a question as when the artist came to England cannot
be answered with certainty. Records show that he received his patent of

denization, a document purchased from the crown that granted him certain perquisites of English nationality, on May 12, 1581. Yet this date may have had little correlation with his actual arrival. Few foreign nationals ever bothered to become denizens, and when they did, it was often with a specific purpose in mind. Le Moyne, for instance, may have been motivated by his wife's pregnancy, since to bequeath property to an English-born offspring, an immigrant was required to be a denizen prior to that child's birth. He may, in fact, have already been in the country for years, perhaps immigrating as early as 1572, shortly after the Saint Bartholomew's Day massacres.

In England, he would be variously known as James Morgen, James Morgan, James Morgane, James Morgayne, Johne Mogayn, and Jacques Morgues. Life in this new land was not easy for "strangers," as foreign immigrants were then called. Xenophobic Londoners, who blamed these newcomers for all the unemployment, crime, and other ills brought on by the city's helter-skelter expansion, staged violent anti-immigrant riots that sometimes rivaled the religious persecutions in France. Nonetheless, Le Moyne could always count on his prodigious talents to guarantee him a certain amount of protection, as well as an income. Among his patrons, in fact, was one of the most legendary figures of the age.

LET US ACCOMPANY him as he goes to meet this man. Because London was then a labyrinth of twisting lanes, congested and filthy, on which no horse-drawn vehicles were available for hire, the most common and convenient way to get from one side of town to the other was by water. Some two thousand rowboats regularly ferried passengers up and down the Thames, and Le Moyne no doubt would have taken one of these river taxis to his destination.

Waiting for a ride among fellow Londoners, who shouted "Oars!" or "Westward ho!" or "Eastward ho!" as they tried to flag down passing boats, the artist might have heard crowd noises swelling from the bull-fighting and bearbaiting rings across the river, great wooden arenas that were monuments to the Elizabethan love of blood sport. To the east, he

could see the London Bridge, a strange city unto itself, its deck lined from one side of the Thames to the other with elaborate homes and shops suspended over the water on struts, its arches festooned with the heads of traitors to the crown. On this day, however, the artist's business was in the opposite direction, upstream toward the royal palaces of Whitehall and Westminster. Stepping into a boat, he glided past Bride-well prison, a facility set up to deal with London's swelling homeless and unemployed populations, where, in the words of one contemporary chronicler, "vagabond[s] and idle strumpet[s]" were "chastised and com-pelled to labor, to the overthrow of the vicious life of idleness." Next he passed Whitefriars, a former ecclesiastical property that had become a notorious haven for cutpurses and murderers, and then the Temple Gar-dens, in which Shakespeare, writing *Henry VI, Part I* around 1589, set the beginning of the Wars of the Roses. Beyond the famous law schools of the Inner and Middle Temples, the river's north bank was lined with magnificent palaces of the country's most ambitious courtiers. Among these structures was a steep-roofed hall, "stately and high, supported with lofty marble pillars," which, wrote one sixteenth-century observer, "standeth upon the Thames very pleasantly." It was here that Le Moyne told his oarsman to dock. Before him now rose a flight of steps leading to the sprawling home of the remarkable Walter Raleigh.

DURHAM HOUSE, LIKE BLACKFRIARS, once belonged to the Roman Catholic Church. The centuries-old London residence of the bishop of Durham, it had played a curious role in the advent of the English Refor-mation, serving as an unlikely backdrop to the romantic intrigues of Henry VIII. The king's first wife, Catharine of Aragón, resided at Durham House prior to her marriage to Henry—and so, years later, did his would-be second wife, Anne Boleyn, who waited there in vain for Pope Clement VII to annul that earlier bond. After Henry broke with the Vatican and married Anne, he used the house for the entertainment of ambassadors and other dignitaries. It was briefly returned to the Catholic Church during the reign of Queen Mary, a papist whose hus-band, King Philip of Spain, resided at Durham House in 1555. But after

An engraving of Durham House,
based on a seventeenth-century illustration.

Mary died and her Protestant half-sister, Elizabeth, ascended to the throne in 1558, the mansion became a fashionable residence for status-seeking diplomats and courtiers. Like her father, in fact, Elizabeth seems to have viewed Durham House as a convenient place in which to harbor those closest to her heart.

By the early 1580s, she had no greater favorite than Raleigh, a dashing poet and adventurer who stood more than six feet tall and had towering intellect, ego, and ambition to match. The queen, then nearing fifty, was almost twenty years older than Raleigh, and although it proba-

bly did not involve a physical relationship, her infatuation with this rising star caused much consternation in the court. "The truth is," wrote one contemporary, "she took him for a kind of oracle, which nettled them all." As other courtiers became "sensible of their own supplantation," Elizabeth rewarded Raleigh with lucrative monopolies, positions, and perks—including lavish accommodations at Durham House, into which he moved in late 1582 or early 1583, completing a meteoric rise to power.

Born near the seafaring hub of Plymouth in southwestern England around 1554, Raleigh was the scion of an old family of strongly Protestant leanings. Possessed of a ravenous appetite for adventure, he had volunteered at an early age, perhaps as young as fourteen, to serve on the Huguenot side in the French Wars of Religion. Historians believe that he fought in France on and off for as long as five years, taking part in the Battle of Jarnac, a disastrous defeat for Calvinist forces in 1569. Like Le Moyne's life, his had been profoundly shaped by the bloody conflict, in his own words "a misery more lamentable than can be described." But Raleigh, who spoke French, had not called the artist to his home to trade war stories or discuss European politics. His sights were now set on the New World.

ENGLAND WAS JUST then making a belated entry into the competition to colonize North America, thanks largely to the efforts of Raleigh's half-brother and longtime mentor, the late Sir Humphrey Gilbert. Older than Raleigh by seventeen years, Gilbert had died at sea in 1583 during a disastrous attempt to found a settlement in Newfoundland. Now his kinsman was vowing to carry on the cause, and in 1584 the queen obliged her favorite by granting him a patent of discovery similar to the one Gilbert had previously received.

By then Raleigh had transformed Durham House into something of a think tank on New World exploration. From his study atop one of the mansion's towers, he summoned navigators, mapmakers, scientists, and a multitude of other experts to help him plan his enterprise. Among them was the brilliant young mathematician Thomas Harriot, who was

employed "at a most liberal salary" to instruct Raleigh and his sea cap-
tains on the art of astronomical navigation, using innovative techniques
of his own invention. Also associated with the venture was the Reverend
Richard Hakluyt, a noted geographer and compiler of travel narratives,
who aided Raleigh by writing an influential treatise arguing that the col-
onization of North America would, among other benefits, provide En-
gland with an outlet for its surplus population, a source of raw materials
for its manufacturers, and a market for its goods.

Le Moyne was soon to join this circle of experts, probably in or
around 1585, when plans for the colony were reaching a crucial juncture.
During the previous year, Raleigh had dispatched a small group of ex-
plorers on a reconnaissance mission to the New World. Landing on the
Outer Banks of modern-day North Carolina, they took formal posses-
sion of the territory, explored the surrounding countryside, and headed
home, arriving back in England in September of 1584 with two Native
Americans along as human souvenirs. As a reward for this initial success,
Elizabeth knighted Raleigh and lent her own name to the new province:
Virginia, after the Virgin Queen. By April of 1585, a second expedition
was preparing to return, setting sail from Plymouth. This time the goal
was to establish a permanent base of operations in North America.

Despite this lofty ambition, Raleigh and his associates knew rela-
tively little about the territory on which they hoped to build an empire.
Because of England's late entry into New World colonization, they were
forced to seek out information from other countries. Reverend Hakluyt,
for instance, had already collected and translated a series of accounts by
explorers from various lands, including René Laudonnière's narrative of
the Fort Caroline expedition. It must have seemed like a godsend, there-
fore, to discover that the official artist of that journey was now residing
in London. According to Hakluyt, Raleigh was willing to pay "no small
charges" to secure the services of "the skillful painter James Morgues . . .
[who] was an eye-witness to the goodness and fertility of those regions."
For this commission, the artist provided a pictorial record of "things of
chiefest importance . . . lively drawn in colors."

Those were, of course, the illustrations on which the famous engrav-
ings were later based. At least some of them were probably copies of

those Le Moyne had made shortly after, or even during, his journey to Florida. (It is possible, for instance, that he had managed to send field sketches home with the French corsair Bourdet prior to the fall of Fort Caroline.) But any new illustrations he crafted, any details he added or revisions he made, would have been based on memories now clouded by the passage of almost twenty years. And even if entirely accurate, those paintings would have offered fairly little in the way of useful ethnographic intelligence, since the Timucua Indians of Florida and the Carolina Algonquians were distinct cultures. In the end, in fact, the now-vanished illustrations may not even have been Le Moyne's most important contribution to the enterprise. He also appears to have played an important role as mentor to an enigmatic figure who would become the new expedition's artist.

Protégé

. . .

ALMOST NOTHING IS KNOWN ABOUT JOHN WHITE BEFORE HE AR-rived in the New World—one of the many curious affinities between his career and that of Jacques Le Moyne.

A generation younger than the French artist, White does not show up for certain on the historical record until 1585, when documents de-scribe him as a member of the expedition to establish a colony in Vir-ginia. Yet by then he seems already to have been an experienced adventurer, apparently having taken part in the English explorer Martin Frobisher's second journey to the Arctic in 1577. White is also assumed to have been on that first reconnaissance expedition that Raleigh sent to Virginia in 1584. At some point around the time of that journey, he came under the influence of Jacques Le Moyne de Morgues.

The circumstances of their association are unknown, though it ap-pears that White had direct access to the older artist's work, since he seems to have made at least two copies of Le Moyne's now-vanished Florida paintings. And while White's style of painting is clearly distinct from his mentor's, the younger artist "must have learned much from Le Moyne of the possibilities of portraying the inhabitants of newly discov-ered lands," according to the art historian Paul Hulton. Le Moyne also aided White's development as a natural-history painter. The English-man's botanical illustrations show the clear influence of Le Moyne, wrote Hulton, who added that White "may well have learned all the older artist could teach of analytical observation and assiduous, delicate execution."

An engraving of Carolina Algonquian Indians praying around a fire,
based on a painting by John White.

Like Le Moyne before him, White was charged with surveying and
charting the land, as well as recording anything else of importance: the
flora, the fauna, the people, and the customs. Unlike Le Moyne, he would
have help. Thomas Harriot, the brilliant young scientist and mathemati-
cian with close ties to Raleigh, was to work in tandem with White, taking
notes and collecting specimens as the artist produced illustrations.

Walter Raleigh's first full-scale expedition to Virginia embarked from Plymouth on April 9, 1585, with some six hundred men on seven vessels of various sizes. Notably absent from the undertaking, however, was Raleigh himself, whom Elizabeth had forbidden to sail. The queen, unable to bear the thought of losing her favorite, was well aware that none of Spain's rivals had succeeded in establishing an outpost on North American soil since the fall of Fort Caroline twenty years earlier. And making the new venture even more perilous was the fact that the English and the Spanish were now on the verge of war.

Relations between the two European powers, long teetering on the brink of disaster, would plunge into the abyss just a month after John White and his companions set sail. For years, Spain's King Philip II had been outraged about Queen Elizabeth's clandestine support of Calvinist rebels in the Spanish-ruled Netherlands, not to mention her toleration of corsairs such as John Hawkins and his notorious younger kinsman Francis Drake, who had plundered as much as two million pesos in Spanish booty during his famous circumnavigation of the globe a few years earlier. In May of 1585, Philip, in need of more vessels to guard against future raids on his treasure fleet, ordered the seizure of all English, Dutch, and German ships at Spanish ports. Elizabeth had, until then, refrained from taking any action that might touch off a direct military conflict. But when news of the ship seizures reached England, it caused a public outcry and prompted the queen to commit to a course of aggression. Among other actions, she signed a formal treaty of alliance with Protestants in the Netherlands and gave Drake permission to launch another raid on the New World. The famous corsair embarked with a fleet of more than two dozen ships in September of 1585, just as John White and his colleagues, having landed on Roanoke Island in what is now North Carolina, were finishing their fort.

JACQUES LE MOYNE would have to wait more than a year to learn the fate of his fellow artist's expedition. But when the story finally came to him, possibly from White's own mouth, it must have sounded painfully familiar. The first English colony in North America repeated many of

the mistakes, and suffered many of the same misfortunes, as its French predecessor.

The journey had begun well enough. Although the fleet was scattered by a storm five days out of Plymouth, it managed to reunite upon reaching the Outer Banks in June of 1585. By August, the colonists were settling in at their newly christened Fort Raleigh, and the ships were beginning to head back home. They reached England in October, having captured a Spanish treasure vessel carrying as much as a million ducats in gold, silver, pearls, and other valuables. The returning vessels also brought glowing reports about the new colony from its leader, Ralph Lane, who wrote that Virginia abounded with virtually any valuable agricultural commodity that could be found in "Spain, France, Italy or the East."

Raleigh must have been thrilled. But for the 108 colonists now left to their own devices in the New World, things were not looking quite so sunny. Roanoke Island was hardly the ideal site for an outpost, lacking the deep-water port necessary for a pirating base and perched behind the shoal-infested Outer Banks, an area so dangerous it would one day earn the nickname "Graveyard of the Atlantic." Worse, the surrounding countryside seemed to contain neither a mother lode of mineral wealth nor a long-sought passage to the Pacific. But a more pressing problem was basic subsistence. In failing to bring along enough agricultural laborers, or even adequate numbers of skilled huntsmen and fishermen, expedition organizers had committed the same blunder that had helped doom Fort Caroline. As with that earlier fiasco, the colony's ranks were overstuffed with soldiers and blue-blooded adventurers—many of whom, complained Harriot, were unprepared for a life in which they could avail themselves of neither "their old accustomed dainty food, nor any soft beds of down or feathers." Such aristocratic slackers, wrote Harriot, were only interested in instant riches and "after gold and silver was not so soon found, as it was by them looked for, [they] had little or no care of any other thing but to pamper their bellies. . . . The country was to them miserable."

For Harriot and White, by contrast, Virginia was a wonderland of the unfamiliar, abounding at every turn with novel phenomena to be

Engraving of an Indian with bow and arrows, based on a painting by John White.

transformed into words and pictures. They traveled widely and worked furiously during their stay, Harriot cataloging everything he saw and describing it in detail while White made illustrations. The painter is thought to have produced hundreds of field sketches in the New World, many of them studies of the Carolina Algonquians and their way of life. And although White had apparently learned much from Le Moyne about how to portray the Indians, his style was unique, more fluid than the older artist's and far less bound by mannerist traditions. This was posterity's gain, for as the art historian Paul Hulton observed, White's "unusual ability to free himself from the European artistic conventions then in fashion" enabled him to create a body of work "more spontaneously naturalistic than anything known by an English artist at this period or for the next half century at least. This quality is so marked as to seem revolutionary."

White and Harriot are sometimes credited with initiating the great tradition of scientific exploration carried on by James Cook and Charles Darwin. Yet while their landmark survey was taking shape in the wilder-

ness, events back at the outpost were following a course that would have been depressingly familiar to Jacques Le Moyne. Because of food shortages, the colonists were making ever more desperate demands on the meager supplies of the local Indians, causing strained relations and finally open hostility between the two groups. Thomas Harriot blamed his fellow colonists, who "towards the end of the year showed themselves too fierce in slaying some of the [native] people . . . upon causes that on our part might easily enough have been borne withall."

Animosities between the English and the Algonquians eventually prompted the colony's combustive leader, Ralph Lane, to launch an attack, from which his forces emerged on June 1 with the severed head of a belligerent chief. But the Indians weren't his only worry. With resupply ships now two months overdue, the commander also faced growing dissent from his own men. Just when the situation seemed as though it could not get worse, the commander received stunning news: A mysterious fleet of ships had arrived along the Outer Banks. "Whether they were friends or foes, [the men] could not yet discern," wrote Lane. He would just have to wait at the fort and "stand upon as good guard as I could."

PEDRO MENÉNDEZ MARQUÉZ, the nephew of Fort Caroline's conquerer, was now Spain's governor in Florida, which he defended from all interlopers with the same cold-bloodedness as his legendary forebear. In late 1585, having received reports of an English settlement, he dispatched a vessel with forty soldiers to locate the fort. When that foray proved unsuccessful, turning back short of the English outpost, Menéndez began making plans to expand the hunt just as soon as he could assemble the necessary ships and men.

He never got the chance. In late May of 1586, a huge fleet appeared off Saint Augustine, its soldiers bringing artillery ashore to bombard the town's defenses. Menéndez, seeing he had no hope of defeating this vastly superior force, withdrew his men into the woods, sacrificing the outpost to save lives. The attackers burned every last building, but not

before carefully stripping them of their windows, doors, and locks. The removal of these items baffled the Spanish, but to Francis Drake it made perfect sense. Such hardware, he reasoned, might come in handy at the new English settlement in Virginia.

A few days later, a relieved Ralph Lane would learn that those ships anchored off the Outer Banks were under the command of his own countryman. Drake's arrival on those shores may have been something of a last-minute detour. He had rushed in from the Caribbean, where, although failing to intercept the treasure fleet, he nonetheless managed to cause plenty of chaos, plundering and destroying Santo Domingo on the island of Hispaniola before laying waste to the key South American port of Cartagena. The adventurer would later claim that over the course of these raids, he learned (perhaps from one of the Spaniards he took prisoner) that Pedro Menéndez Marquéz "had organized an expedition to Virginia, in order to root out utterly the British colony which had not yet consolidated its settlement there." In an apparent improvisation, he had set a course toward North America "with the object . . . of rescuing Ralph Lane . . . and his people from death."

Drake agreed to provide the hungry and ill-clad colonists with food, clothing, tools, weapons, and other supplies. He also promised to turn over a seventy-ton vessel that would allow Lane to seek out a more suitable harbor along the coast. But after that provision-laden ship was swept out to sea by a sudden storm, never to return, Lane had little choice but to accept Drake's offer to carry his whole colony back to England. "The very hand of God, as it seemed, stretched out to take us from thence," he would later lament.

There was yet one more disaster to come. Drake sent some of his men ashore in boats to transport the settlers and their belongings to his ships—but it proved to be slow and difficult work, and in their haste the impatient sailors began to dump baggage into the sea. "All our cards [i.e., charts and maps], books and writings were by the sailors cast overboard," Lane wrote. In that one rash moment, a large amount of John White and Thomas Harriot's landmark work, meticulously compiled over the course of a year, vanished into the black depths. Luckily, the artist seems

to have already sent home some of his notebooks on the ships that departed the previous summer. And he may have made sure other materials never left his possession as he sailed for home, arriving in Portsmouth in late July of 1586.

White would have had much to tell his mentor, but the older artist had been busy too. During White's time in the New World, Jacques Le Moyne de Morgues was putting the crowning touches on his extraordinary career.

Reborn Spring

...

AT THE FRONT OF A STUNNING BOOK OF FLOWER PORTRAITS, NOW in the possession of the British Museum, a sonnet is inscribed in ornate italic hand:

> *Discordant harmony and stable movement,*
> *Winter and Summer, Autumn, reborn Spring,*
> *Renewing her sweet scents and coloring,*
> *Join in the praise of God's unfailing judgment.*
>
> *This loving God gives every argument*
> *To look for zeal from each created thing,*
> *To bless His Name eternally and sing*
> *All He has made in earth and firmament.*
>
> *Above all He made man with head held high*
> *To watch each morning as new light arrives*
> *And decorates earth's breast with varied flowers.*
>
> *There is no fruit, or grain, or grub, or fly*
> *That does not preach one to God, the least flower gives*
> *Pledge of a Spring with everlasting colors.*
>
> *Jacques Le Moinne*
> *called Morgues, Painter*
> *1585*

This is, as far as we know, the closest the painter ever came to a statement of artistic and spiritual belief. Influenced by the ideas of John Calvin, who helped revitalize the scientific study of nature by imploring his followers to view "the elegant structure of the visible world . . . as a kind of mirror in which we may see God, who is otherwise invisible," Le Moyne had long sought the sublime in the petals of wild daffodils and the wings of dragonflies and the roots of water chestnuts. Now that quest was near its end. Having survived a turbulent half century, he was, by the standards of the day, an old man, one who had known more discord than harmony, more movement than stability. Yet there he stood, head held high, finding new solace in those blooms. A poem written years earlier, apparently also by Le Moyne, had portrayed flowers as a symbol of transience, from which "the colors of a gay spring . . . fade in an hour." Now, even in "the least flower," he found evidence of the eternal, of "a Spring with everlasting colors."

Le Moyne seems to have achieved equilibrium in these final years, returning to his real passion as an artist with that book of flower paintings in 1585 and the publication of a volume of natural-history woodcuts the following year. In this latter work he enjoyed the patronage of an exceptional and sympathetic benefactor, a woman who, like the artist himself, cherished the beauty of the world but knew its darkness all too well.

LADY MARY SIDNEY HAD BEEN one of the most glamorous figures in the English court: attractive, sophisticated, and supremely well connected. Her husband, Sir Henry Sidney, held what Queen Elizabeth herself called "two of the best offices in the kingdom," administering about one fourth of the English realm as the overseer of both Wales and Ireland. Her brother, the handsome Robert Dudley, was such a favorite of Elizabeth that he was widely believed to be her lover and a potential husband. Mary Sidney was also in the queen's inner circle, appointed as a gentlewoman to the privy chamber in 1559.

In 1562, however, her life took a tragic turn. When Elizabeth suffered a near-fatal attack of smallpox, the noblewoman nursed her ailing monarch back to health—and in so doing, contracted the disfiguring dis-

ease herself. The queen suffered no permanent blemishes, but Lady Sidney was not nearly so lucky. Her husband later recalled his shock at seeing the results of that "evil accident" when he returned from a trip to France:

> When I went to [Le Havre] I left her a full fair lady in mine eye
> at least the fairest, and when I returned I found her as foul a lady as
> the smallpox could make her . . . the scars of which (to her resolute
> discomfort) ever since hath done and doth remain in her face.

Like the accursed heroine of some fairy tale, Lady Sidney had been transmogrified from beauty to pockmarked crone almost overnight. As a result of this disfigurement, she largely recoiled from the glare of public life, choosing "to hide herself from the curious eyes . . . [rather] than to come upon the stage of the world with any manner of disparagement," in the words of one contemporary. Turning inward, she seems to have devoted herself to raising her children, seeing to it that they received a rigorous humanist education. In later years she could take pride in seeing her eldest child, the poet Philip Sidney, celebrated as one of the great literary figures of his age. But her own star continued to fade at the court, and she became increasingly embittered by what she saw as the queen's indifference and ingratitude. By the 1580s she had left Elizabeth's side for good, her health declining, her husband openly contemplating the prospect of a new marriage after she was gone.

She is believed to have been the "Madame Sidney" to whom the artist dedicated the last known work of his life: a small book, entitled *La Clef des Champs* (Key to the Meadows), which contains ninety-six simple woodcut images of various beasts, birds, flowers, and fruits. How she became aware of the artist is not known. One scholar has suggested that Philip Sidney, who was keenly interested in American exploration, learned of Le Moyne from Walter Raleigh or Richard Hakluyt. But it seems equally plausible that Lady Sidney knew about the artist even before he began to work for Raleigh, since her family, adamant supporters of the Calvinist cause, had longstanding ties to the Huguenot intelligentsia in France.

La Clef des Champs—just three copies of which survive today—is Le

A pair of woodcuts from La Clef des Champs.

Moyne's only known printed work. The volume was not intended as a piece of art in its own right but as a pattern book, providing archetypes of plants and animals for other craftsmen to copy and use in their own work. In "composing this little book," he wrote:

> I have chosen among the animals a certain number of the most remarkable birds and beasts . . . which . . . are accompanied by as many of the most beautiful flowers and fruits which I judged most fitting, all taken from life, and which might serve those who love and wish to learn good and seemly things; among whom are the young, both nobles and artisans, these to prepare themselves for the arts of painting and engraving, those to be goldsmiths or sculptors, and others for embroidery, tapestry and also for all kinds of needlework.

Lady Sidney's own interest in the project would almost certainly have stemmed from its use in embroidery, which was considered an important art form in the sixteenth century. Intricate needlework, often containing as much visual information as the most sophisticated of paintings, could be found on wall hangings, carpets, table carpets, cushions, bed curtains, and valances, covering the mansions of nobles from

floor to ceiling, just as it covered the nobles themselves from head to toe. Kings and queens wore magnificently embroidered costumes designed to bedazzle all onlookers, while those who attended the court not only had to spend extravagantly on their own clothing but make sure that their followers were also richly attired. Noblewomen were educated in needlework from a young age, for to excel in this endeavor was considered a mark of great refinement.

The craft seems to have had a special place of pride in the home of Lady Sidney, whose daughter—Mary Sidney Herbert, the countess of Pembroke—was celebrated as one of the great embroiderers of her age. "She wrought so well in needle-work, that she / Nor yet her works, shall ere forgotten be," wrote one contemporary poet. This gifted noblewoman no doubt learned the craft from her mother, who perhaps found solace in the quiet comforts of embroidery after she drew back from public life because of her disfigurement.

With its wealth of botanical patterns, La Clef des Champs would have been particularly useful to Lady Sidney. Flowers were ubiquitous in sixteenth-century needlework, bursting into bloom on the backs of furniture, coiling through the decorative strapwork of wall hangings, arabesquing along the edges of curtains and carpets. Fruit ripened on the gowns of great ladies, while inches away, amid thickets of embroidered jewels, insects hovered, birds perched, other beasts slithered, sauntered, pounced. In one portrait, Queen Elizabeth wears sleeves embroidered with roses, carnations, grapes, and strawberries; in another, her gown has been sewn with English wildflowers; in a third, she stands in front of a floral-stitched chair, her embroidered outer gown opening into a huge bestiary of a skirt, swarming with painted birds, bugs, snakes, and sea serpents as well as lilies, irises, and other blossoms.

"The love of flowers is evident in abundant measure in Elizabethan embroidery," wrote the textile historian George Wingfield Digby, who stressed that the two passions were "very much linked together in the Elizabethan mind." For this reason, observed Digby, Le Moyne was an artist of special importance to the history of sixteenth-century needlework: "His paintings, and the woodcuts in his book, survive to demon-

An embroidered cornflower, worked with silk, late sixteenth century (left),
and a cornflower from La Clef des Champs, *a book by Jacques Le Moyne intended*
to provide patterns for embroiderers and other craftsmen.

strate how embroiderers and other craftsmen depended on this [emerg-
ing] school of flower paintings, which primarily served botanists and
herbalists as well as the ordinary flower lovers of those days."

La Clef des Champs appears to have been something of a labor of love
for Le Moyne. Although he and his patroness, both born in the early
1530s, were from vastly different backgrounds, they seem to have had a
real affinity for each other. The artist addressed both a dedication and a
sonnet to Lady Sidney, for whom his praise was effusive ("Your Virtue,
holy ornament / Lifts you from earth to scale the firmament"). Yet ac-
cording to the scholar Paul Hulton, these tributes were not just standard
exercises in sycophancy:

> Their tone, at once deferential and flattering, and at the same
> time affectionately grateful, suggests that he believed he had
> found a patron who understood his aims and enjoyed his very
> personal and characteristic skill. No doubt this was of even
> greater value to him than the less disinterested support of
> Raleigh.

Unfortunately, this satisfying professional relationship was not to last. In poor health for many years, Mary Sidney finally left her troubled life on August 9, 1586, just a few months after Le Moyne had prayed for her "future happiness" in the dedication of *La Clef des Champs*. Whether he knew it yet, the artist's own days were now numbered as well.

ONE OF THE LAST references to Le Moyne during his lifetime came in 1587, when the chronicler Richard Hakluyt published an English translation of René Laudonnière's Florida narrative. In an epistle to Sir Walter Raleigh at the beginning of the book, Hakluyt noted that the artist "hath put down in writing many singularities which are not mentioned in this treatise; which he meaneth to publish together with portraitures before it be long, if it may stand with your good pleasure and liking." The implication was clear: Le Moyne hoped to publish his own account as soon as possible, but Raleigh had not yet committed financial support.

The nobleman had more pressing matters on his mind. He had not given up on establishing a permanent settlement in North America, but this time he wanted it to be a fundamentally different kind of colony: one operated by civilians instead of soldiers, artisans instead of aristocrats, doers and makers instead of dreamers and malingerers. And in a surprise move, his choice to lead this utopia of craftsmen was one of their own. In January of 1587, John White was officially named governor of the "City of Raleigh in Virginia."

White must have had high hopes when he sailed from Plymouth in May of that year with eighty-four men, seventeen women, and eleven children, along with two homebound Indians. But long before the expedition reached the North American coast in July, he had become locked in a bitter feud with his Portuguese pilot, whose real interest lay in pirating. Although the governor had planned to establish his settlement on the Chesapeake Bay, a site well suited for a deep-water port, the mutinous pilot refused to take him there. Instead he dropped the colonists back on Roanoke Island, where they soon felt the wrath of hostile Indians and faced the prospect of food shortages. In late August, only a month after the expedition arrived, the settlers came to White as a group,

insisting that he return home to ensure timely relief supplies. He reluctantly agreed to go, leaving the other one hundred or so colonists behind, including his daughter and her newborn baby—the first English child born on those shores, a girl named after her birthplace, Virginia.

White returned to England in November, having crossed the Atlantic in an undermanned and ill-provisioned vessel in which he "expected nothing but . . . to perish at sea." It had been a nightmarish journey, but finding a way back to Virginia would prove even harder. He could not have picked a worse time to try to organize a relief mission. Spain was assembling a fleet of staggering size: 130 ships carrying 19,000 troops, which, joined with another 81 ships, 194 barges, and almost 30,000 soldiers from the Netherlands, was to be used in an invasion of England. In the face of such a dire threat, White could muster little interest in the lives of a few lost souls across the ocean. Eight months would pass before he could finally arrange a mission to resupply the colonists left in the lurch on Roanoke Island.

Jacques Le Moyne would have known just what those stranded settlers were feeling. To live in exile on the far edge of the map, to pray to the sea for any sign of salvation, to feel reality, even selfhood, drain away and the fierce void of hunger fill their place, to learn fear from a hundred different angles: Perhaps, in his waning days, the artist relived those old horrors, his heart racing, temples sweating at the memories. Or perhaps he just felt blessed to have endured and escaped, to have lived so long on borrowed time, to have had a chance to find God in the fragile petals of a delphinium. Those long-ago traumas had, after all, prepared him for the hour at hand. He was well acquainted with death.

John White would never see the older artist again. His rescue mission finally sailed for Virginia in April of 1588, but White soon discovered the two ships were manned by "evil disposed mariners" who had little interest in saving his stranded colonists. Instead they dallied in the Atlantic, attacking and robbing whatever vulnerable vessels they could find. Then, in early May, White's ship was itself set upon by Huguenot pirates near the North African island of Madeira. The hour and a half of grisly hand-to-hand fighting that followed left twenty-three men dead and many others injured, including White himself, who "was wounded

twice in the head, once with a sword, and another time with a pike, and hurt also in the side of the buttock with a shot." The French corsairs emerged triumphant from this fray, plundering the very stores that might have been the colony's last hope. Left with a damaged vessel, a depleted crew, and only a "small quantity of biscuit," the vanquished English had little choice but to return home. White reached the port of Bideford on May 22, one day after "Johne Morgayn, painter" was buried in Blackfriars.

Death and Deliverance

. . .

HE HAD SURVIVED FAMINE, HURRICANE WINDS, AND MASS MURDERS. He had been wounded by Indians and menaced by mutineers. He had endured countless hardships in the Florida wilderness and even more on the journey home aboard a vessel with no pilot and nothing to eat but biscuits and water. He had persevered through wars of religion in France (the count was up to eight by the time of his death) and anti-immigrant violence in England, as well as frequent outbreaks of plague, smallpox, typhus, and other deadly epidemics.

We don't know whether it was some fatal illness or another mishap that finally caught up with Le Moyne. His last will—dated May 16, 1588, five days before he was laid in the ground—offers few clues about his death except that he saw it coming. Nor does it shed much light upon his life. Instead of itemizing his possessions, for instance, the artist simply left them all to his spouse, adding that "I know none kinsfolks of my kindred." This lack of contact with blood relatives may suggest that he had been in England for a considerable time. Or perhaps it only indicates that all his family members in France were dead. Indeed, having survived until "the age fifty and five years or thereabouts," in the words of his will, Le Moyne had outlasted most of his contemporaries. Life expectancy for men of that era was between twenty and twenty-five in London's poorer parishes, thirty and thirty-five in the richer ones. Only the wealthiest, heartiest, and luckiest were likely to weather on into their fifties and beyond.

Among those who had preceded Le Moyne to the grave was his old

A sixteenth-century woodcut by Hans Holbein the Younger
shows Death carrying away a victim.

commander. Despite finding himself an outcast at court after the Fort Caroline disaster, René Laudonnière went on to have a long career in the French fleet, making several trips to the West Indies. Some of those adventures were apparently pirating raids, but at least one seems to have been largely commercial and scientific. In the spring of 1572, Laudonnière put to sea on an expedition aimed at collecting exotic birds and other New World animals, curiosities that were now generating great interest among European collectors. This mission may have saved the mariner's life. A resident of Paris, Laudonnière was still away from home during the Saint Bartholomew's Day massacre, in which his longtime associate Admiral Coligny and scores of other prominent Huguenots were

slaughtered. He is thought to have lived until 1582, four years before his own Florida narrative finally appeared in print.

Le Moyne had also outlasted the man responsible for butchering his fellow colonists. After sacking Fort Caroline, Pedro Menéndez de Avilés continued to firm up Spanish control of the region, building forts and bringing in Franciscan friars to establish missions. His efforts to convert the Indians met with fierce resistance, however, and by 1573 he was calling on the crown to wage a war of extermination against those "infamous people, Sodomites, sacrificers to the devil . . . wherefore it would greatly serve God Our Lord and your majesty if these [Indians] were dead, or given as slaves." One day that genocidal dream would be realized with horrible totality, but the conquistador would not be there to see it. While in Spain in 1574, he declared that "after the salvation of my soul, there is nothing in this world that I desire more than to see myself in Florida." Ten days after writing those words, Menéndez died of fever at age fifty-five. He apparently never found his shipwrecked son.

No doubt Le Moyne, too, dreamed of Florida in his final days. And if he found himself reliving the horror he had felt on that rainy morning when two conquistadors appeared in his doorway, swords drawn, it was not because he suffered from deathbed delusions. From the street below, all the conversation reaching his window would have been about Spanish invaders. The Grand Armada was about to sail.

WHEN MY SEARCH for Jacques Le Moyne finally led me to the neighborhood where he died, I found it full of upscale businesses. The corner where the priory of Blackfriars had been founded in 1278, for instance, was now home to a self-described "human capital management consultancy," while nearby storefronts brimmed with designer sunglasses, expensive running shoes, and picnic backpacks, complete with place settings and bottle coolers, designed for wine-and-cheese-toting urban adventurers. Even so, the streets were small and winding, just as they had been in the artist's time, and it was not hard to imagine how a mood of panic might spread through those cramped corridors at the news of the Armada's approach.

The riverfront must have been eerily quiet in Le Moyne's last days, with most of the water-taxi pilots having gone off to join the English navy. In Spain, King Philip II had declared that the victory of his flotilla, the largest such undertaking ever mounted, was God's will: "Nothing less is at stake than the security of our seas and of America and of our fleets, and the security of our own homes." Along the English coast, Francis Drake, soon to be joined by John Hawkins, had rushed to assemble a fleet to meet the enemy force, while Walter Raleigh organized land defenses. In London, the approach of the Spaniards had set off yet another xenophobic backlash—with all outsiders indiscriminately targeted. "It is easier to find a flock of white crows," wrote a European observer during the crisis, "than one Englishman (and let him believe what he will about religion) who loves a foreigner."

As Le Moyne savored his final few moments on earth, dire astrological tracts were predicting that "if, this year, total catastrophe does not befall, if land and sea do not collapse in total ruin, yet will the whole world suffer upheavals, empires will dwindle and from everywhere will be great lamentation." By some odd quirk of circumstance, the year 1588 had attracted the same sort of doomsday prognostications as the year 1533. And now the coming of the Armada seemed to offer proof that this "year of wonders" would be "afflicting mankind with woeful destiny." The world Le Moyne was leaving behind seethed with the same apocalyptic terrors as the one he had entered fifty-five years before.

The artist was laid to rest one day after the Spanish fleet sailed. We cannot, of course, presume to know Le Moyne's final destination; we can only hope his journey was better than the Armada's. After embarking amid pomp and panoply from Lisbon, a key Spanish port since Philip II's conquest of Portugal in 1580, the great fleet was quickly scattered by storms. Forced to take shelter at a port in northern Spain, where food supplies were already running low, the expedition's captain-general wrote his king to ask whether those tempests might not have been a sign of divine disfavor: "It would appear that what has just happened must be His doing, for some just reason." Philip, however, was adamant: The attack must go on. It would prove the worst mistake of his monarchy. Menaced by horrendous weather, bad planning, and an English fleet that

boasted better maneuverability and superior firepower, the Armada was to suffer one of the most ignominious defeats in naval history. Of the 130 ships that set sail for England, only sixty are known to have made it home. As many as fifteen thousand Spaniards perished.

English playing cards celebrating the defeat of the Spanish Armada.

The battle has sometimes been portrayed as the birth of the British empire, a pivotal moment that helped open the way for English control of North America. Yet for many Elizabethan adventurers, it seemed to mark a different sort of turning point: a last gasp of glory before their luck began to run out. In the years to come, John Hawkins and Francis Drake would both perish on a pirating expedition to the Caribbean, while Walter Raleigh would die disgraced on the executioner's block, his expeditions to South America in search of the mythical El Dorado having ended in disaster, just like his colony in Virginia.

John White would be the sole survivor of that colony. Unable to launch another resupply mission until after the Armada crisis passed, he finally put to sea again in March of 1590. Reaching Roanoke in August,

three years to the month after he had left, White discovered a few scattered remnants of the settlement, including "my books torn from the covers, the frames of some of my pictures and maps rotten and spoiled with rain, and my armor almost eaten through with rust." But his compatriots were gone—vanished without a trace.

He returned to England, where he published the story of the Lost Colony, as it would afterward be known. And then White himself disappeared, his subsequent actions, his whereabouts, even his ultimate fate fading from the historical record. That White's images of Native Americans did not wind up in the trash heap of history like those maps he found amid the dust at Roanoke is due largely to the efforts of one man—the same man, in fact, who was to make sure that Le Moyne's work endured long after the artist had commended his soul to God and relinquished his body to the ground.

ALTHOUGH THEODOR DE BRY did not enter Jacques Le Moyne's life until it was all but over, they nonetheless "formed a deep friendship," in de Bry's words. And while de Bry may have had ulterior motives for this assertion, a bond between the two men would hardly have been unlikely. Both were artists and ardent Protestants who, buffeted by the great upheavals of the age, had been forced to endure nomadic lives as exiles.

Five years older than the Frenchman, de Bry was born in Liège, a Flemish city in what was then part of the Spanish Netherlands. Faced with financial setbacks apparently caused by anti-Protestant persecutions, he relocated first to Strasbourg and finally to Frankfurt, the Protestant hub of the book trade. Looking back as an old man, he observed that his convulsive existence had known only one constant:

> I was the offspring of parents born to an honorable station, and was in affluent circumstances and in the first rank of the more honored inhabitants of Liège. But stripped of all these belongings by accidents, cheats, and ill terms of fortune and by the attacks of robbers, I had to contend against such adverse chance

A self-portrait engraving of Theodor de Bry.

that only by my art could I fend for myself. Art alone remained to me of the ample patrimony left me by my parents. On that neither robbers nor the rapacious bands of thieves could lay hands. Art restored my former wealth and reputation, and has never failed me, its unwearied devotee.

De Bry had been trained as a goldsmith, an honored profession during the Renaissance and one that required a vast range of artistic skills. Yet although he would continue to describe himself as a member of that trade for most of his life, his lasting fame would come in another art. Copperplate engraving had set off a publishing revolution in the sixteenth century, producing illustrations with a level of detail and a range of tone that was vastly superior to those made with the traditional woodcut method. And because the tools, materials, and techniques of

the engraver were so similar to those of the goldsmith, many craftsmen practiced both professions. De Bry proved to be not only a brilliant engraver but a visionary one, pioneering a new way to bring together picture and word.

In 1590, de Bry would begin publishing a series of illustrated volumes on New World exploration, a project that would consume him for the rest of his life and provide employment for generations of his heirs. Prior to this venture, most travel narratives about the Americas either lacked pictures or contained only crude woodcuts, often borrowed from earlier books. But de Bry would pack his volumes with high-quality copperplate prints, bringing the people and events of distant lands to life via state-of-the-art technology. He would do so, moreover, on a hugely ambitious scale, carrying out what one scholar described as "the first attempt to introduce . . . a pictorial image of the New World as a whole."

This grand literary undertaking began with his meeting with Le Moyne in 1587. De Bry was then nearly sixty, a fierce-eyed man whose motto was *nul sans souci* ("nothing without hard work"). He had come to London to engrave a series of drawings depicting the funeral procession of the poet Philip Sidney, who was killed fighting Spanish troops in the Netherlands. De Bry and Le Moyne, who likely met through mutual connections in the Sidney family, spent much of their time discussing the artist's Florida exploits, about which de Bry "gathered information on a great many questions," as he later wrote. They also engaged in business negotiations, though the exact nature and outcome of these talks is difficult to decipher. De Bry would later insist that they had "reached an agreement about publishing" the Florida materials, presumably consisting of the journal, the map, and the paintings. Yet the facts remain that Le Moyne failed to turn them over, perhaps because he still hoped to publish the book himself, and that de Bry went home empty-handed when he left London.

By the time he returned to England a year later, however, Le Moyne had died. With renewed hope, de Bry approached the artist's widow and pressed his offer—this time with success. "Filled with joy" at the acquisition, he set about plans for his publishing venture, expending "diligent

pains in engraving the pictures on copper plates." In so doing, he would forever preserve—and forever obscure—the work of Jacques Le Moyne de Morgues.

OF ALL THOSE ENGRAVINGS, perhaps none is more riveting than the image of a Timucan executioner towering over a pair of kneeling prisoners. He has just whirled a huge paddle-shaped club into the skull of one of these men, leaving a deep wound from which blood and brain matter pour. Now he cocks it back again, ready to deliver the *coup de grâce*.

In a rare first-person interjection, Le Moyne noted in his caption that he witnessed this macabre scene with his own eyes, which only makes a curious inaccuracy in the picture seem all the more puzzling. That club the killer hoists above his head: It's from South America. As scholars have observed, these distinctive oarlike weapons were typical of coastal Brazil. They are not known to have existed anywhere in North America.

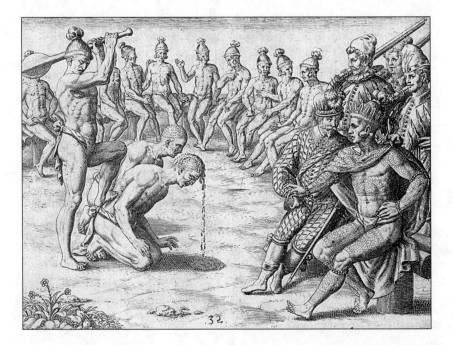

So how did a weapon from Brazil find its way into the hands of a warrior from Florida? It is possible, of course, that Le Moyne himself was responsible for the mistake. Perhaps, sitting down to recreate the scene months, years, or even decades after the fact, he discovered he could no longer recall the exact shape of a Timucuan club. Unable to consult his long-vanished field notes, he may have simply decided to appropriate the weapon from another artist's work—André Thevet's illustrated Brazil narrative of 1557, for example.

But a more likely explanation is that Theodor de Bry made the change. Although he claimed that every illustration was "taken from life" and "substantiated by [Le Moyne] himself," de Bry was far more interested in making beautiful pictures for a wide audience than in leaving a scientifically accurate record. His goal, in the words of one contemporary admirer, was to provide "pleasing entertainment," and if that meant altering details to make a scene more dramatic or a composition more attractive, he did not hesitate. Never having been to America, he had little understanding of differences between native cultures and felt free to mix and match. In subsequent volumes he would dress up the people of Hispaniola in the garb of the Peruvian Inca and place Mexican acrobats in the Andes, creating what the scholar Bernadette Bucher described as a "Tower of Babel of the Amerindian peoples."

Such incongruities are somewhat less common in the Le Moyne engravings, which "despite the fancifulness of many details . . . show a spirit of documentation and ethnographic observation rare in the iconography of the time," wrote Bucher. Nonetheless, the prints are riddled with disparities that cloud our understanding not only of Timucuan culture but of Le Moyne himself. In addition to altering certain images, de Bry invented others entirely, and he also may have added to the mannerist excess of those illustrations. He is thought to have fabricated some of the picture captions and may have taken it upon himself to make editorial revisions in the journal itself. The violence he did to Le Moyne's work, in short, was sometimes as severe as the harm inflicted by the wayward Brazilian club in that engraving. It was a death of sorts, but also a deliv-

erance. Because of de Bry, we will never know the artist well; without him, we might not know him at all.

DE BRY HAD ORIGINALLY intended to make Le Moyne's volume his inaugural offering, but by the time he sent the book to press in 1590 those plans had changed. Instead he chose to publish Thomas Harriot's survey of Virginia, featuring the illustrations of John White.

An earlier edition of Harriot's work was printed in London in 1588 under the title *A Brief and True Report of the New Found Land of Virginia,* but that volume included none of White's illustrations. De Bry was able to obtain these priceless drawings with the help of Richard Hakluyt, who, along with Walter Raleigh, urged him to postpone printing the Florida project in order to promote English colonization efforts in Virginia. De Bry agreed to the change, though somewhat reluctantly, as he made clear in his introduction to *A Brief and True Report.* "I have in hand the history of Florida which should be first set forth because it was discovered by the Frenchmen long before the discovery of Virginia," he wrote, "yet I hope shortly also to publish the same."

He was able to carry out that pledge the next year, producing both Latin and German editions of Le Moyne's narrative, illustrated with forty-two copperplate engravings based on the now-vanished paintings. Like the Virginia volume before it, it was a huge commercial success. Many more would follow. The series, collectively known as the *Grand Voyages* (comprising books about the New World) and the *Petit Voyages* (books about Asia and Africa), occupied most of de Bry's energies until his death in 1598, then continued under his sons and successors for an additional thirty-six years. All told, it would stretch out over almost thirty volumes, a landmark in the history of publishing.

IN 1593, TWO YEARS after the publication of Le Moyne's narrative, a major outbreak of the bubonic plague swept through London, killing as many as twenty-six thousand people. Theaters, fairs, bearbaitings, and bullfights were shut down in an attempt to contain it, but the epidemic

only gained momentum through the spring and summer months. Those who could manage to get out fled the city; the rest watched corpses pile up on the death carts and prayed that they would avoid the same fate. The carnage reached its peak around the middle of August, leaving cemeteries all over the city pocked with overturned earth. Among the victims was a "Mrs. Moorge, widow," laid to rest in Blackfriars on the thirteenth of the month. Her last will, written four days earlier when she was "sick of body but sound in her soul and spirit," made no allusion to a son or daughter. Her child with Jacques Le Moyne, noted in a census ten years before, was now apparently dead. The artist, it seems, had been the last of his line. Soon, most other traces of his story would begin to disappear as well.

Vanishings

· · ·

THE FORT WAS THE FIRST TO GO. THE FRENCH HAD ALREADY BEGUN to tear it apart by the time Menéndez arrived in 1564, and a fire gutted it a few days after his victory. The Spanish rebuilt it, but when Dominique de Gourgues captured it in 1568, one of his Indian allies set off a fire that burned most of the buildings. This time, Menéndez decided to abandon it for good, establishing a new military outpost on nearby Cumberland Island. The place that might once have launched an empire soon faded into obscurity.

*Detail of Timucuan women mourning, from an engraving
based on Le Moyne's work.*

In the late eighteenth century, the British built a defensive earthwork on the bluff that had overlooked the outpost. Confederate forces constructed more fortifications there during the Civil War, as did the U.S. military during the Spanish-American War of 1898. By that time, however, no one could figure out where the fort had once stood. In the 1880s, a low-lying area beneath the bluff washed away after the Army Corps of Engineers deepened the channel of the Saint Johns River. Some experts believed the last remnants of the outpost were scattered by those currents or entombed below tons of silt. Others clung to the hope that they still lay intact somewhere beneath solid earth. Either way, Fort Caroline was nowhere to be found.

THE TIMUCUA WERE NEXT to disappear. Although initial Spanish attempts to convert the Indians were met with violent resistance, Catholic missions began to take root in La Florida by the end of the sixteenth century. Saving souls was far from their only goal. As one church official wrote: "We are the ones who are subduing and conquering the land." Operated by Franciscan friars, the missions required adult Timucua not only to convert to Catholicism but to take Christian names, to learn the Spanish language, and to adopt European tools, manners, and beliefs. So successful were these efforts that by 1620 a missionary based near the site of the old French fort was boasting that local people no longer even remembered their "pagan" superstitions. The younger generation, he wrote, "derides and laughs" at elders who occasionally still attempted to practice the old ways.

By turning the Timucua into Catholic subjects of the crown, the mission system neutralized them as potential enemies, made them dependent on the Spanish empire, and molded them into a workforce of conscripted labor. It also helped bring about their annihilation. Most modern scholars believe European diseases had been ravaging the native population since at least 1539, when Hernando de Soto led his expedition through Florida. No doubt Le Moyne and his compatriots also brought deadly germs with them from France. But the close quarters of the missions gave the Timucua unprecedented exposure to illnesses

against which they had no natural immunity. A severe epidemic of unknown nature in 1595 was followed by "great plagues and contagious diseases" that swept through the missions between 1612 and 1616, taking "a very great harvest of souls," according to contemporary reports. In 1657, the Spanish governor noted that some local populations had been "wiped out by the sickness of the plague and smallpox which have overtaken them in the past years." Two years later, officials were reporting that ten thousand Indians had died in a measles outbreak.

A woodcut from a confessional that Franciscan friars prepared for the Timucua in the early seventeenth century. The image was probably intended to show Indians that Satan would attempt to keep them from confessing their sins.

Combined with other hardships caused by colonization, these epidemics led to what the archaeologist Jerald T. Milanich called a "demographic disaster" in which "fewer babies were born, fewer young people reached child-bearing age, and fewer adults lived to old age. The death rate exceeded the birth rate, and populations declined, then plum-

meted." A census of the missions taken in 1689, for example, found that only 646 Timucuan families remained in Florida. Assuming five people per family, the population at that time was 3,230—less than 2 percent of the estimated two hundred thousand Timucua who had lived there at the time of European contact.

Then came another threat. The British, who had finally succeeded in establishing a lasting colony in Virginia in the early seventeenth century, were now expanding southward toward Florida. In 1670, they founded a permanent settlement near the site of modern Charleston, South Carolina, from which they quickly began chipping away at Spanish control of the Southeast. Despite a 1670 treaty between the two countries that gave each the right to lands they already controlled, the English were determined to oust their rivals from Florida.

To do this, they entered into military alliances with Indian groups from Carolina, using guns, rum, cheap trade goods, and promises of plunder as incentives. Deploying these native mercenaries as shock troops, the English launched a series of bloody raids into Florida, wiping out the missions and capturing members of the Timucua and other native groups to sell into slavery. During one such incursion, in 1702, a force led by the governor of South Carolina failed to capture Saint Augustine but returned with five hundred Indian prisoners. More attacks followed. In the first decade of the eighteenth century, between ten and twelve thousand native people were taken as slaves, according to the governor of La Florida.

By 1717, only 250 Timucua were known to survive, all of them living in refugee towns near Saint Augustine. Nine years later that number had dropped to 157. Then another epidemic hit, after which only about seventy remained. In 1759, there were just a dozen—several of whom, unable to find suitable mates among their own people, had married members of other tribal groups. The story of an ancient people who had once sprawled out across almost twenty thousand square miles of the Southeast was about to come to an end. First, however, they would suffer one final indignity.

In 1763, Spain surrendered Florida to Britain without a fight. Two centuries of uninterrupted occupation came to an abrupt and inglorious

end when the Spanish were forced to part with Saint Augustine as a ransom for Havana, which the English had recently captured. Spanish residents promptly withdrew to Cuba, taking with them eighty-nine Indians who lived in or near the town. Among these were the handful of remaining Timucua, by now so dependent on the Spanish that they chose to live out their lives in exile rather than remain in the land of their forebears. Two hundred and fifty years after the Spanish explorer Juan Ponce de León had reached their shores, the Timucua were no more. Like ghosts, Le Moyne's images were all that remained of them above the soil.

BUT LE MOYNE HIMSELF had already faded deep into the shadows. His original manuscript, written in French, vanished at some point after his widow turned it over to Theodor de Bry. Le Moyne's prose came down to readers only through Latin and German translations, which robbed the work of its clarity, subtlety, and individuality, just as de Bry's engravings obscured the accuracy and meaning of his Florida paintings. The artist's natural-history drawings, meanwhile, were entirely forgotten, the plants, flowers, birds, and insects that he had preserved in such microscopic detail now lost to the world or attributed only to some anonymous hand. By the nineteenth century, none of Jacques Le Moyne de Morgues's original artwork was still known.

Even the events he recorded had largely faded from history. The people Le Moyne painted and described—the Timucua, the French, and the Spanish—all wound up losers in the epic struggle for the American Southeast, their story forgotten by the winners. In 1822, one year after Florida had become a territory of the United States, a city was founded near the forgotten site of Fort Caroline. It was named after Andrew Jackson, a celebrated general and future president who embodied an age of aggressive American expansionism. Control of Florida had returned to the Spanish after the American Revolution, but Jackson's ruthless and unauthorized invasion of 1818 persuaded the Spanish that selling the province was better than losing it by force. Bringing Florida into the fold cemented Jackson's status as folk hero. Of humble origins in backwoods Carolina, he was hailed by his countrymen as an untutored man of ac-

tion whose whole life stood as a repudiation of Europe and its old, formal ways. It was a time of chest-thumping nationalism and feverish reinvention. Here was a new city, an American city: Jacksonville. Here was a fresh start. What had happened along this stretch of the Saint Johns before no longer seemed to matter.

In the self-congratulatory age of Manifest Destiny, Anglo-American achievements came to dominate the history books. It was as if the Florida that Jacques Le Moyne had seen, known, drawn, and described had vanished like the mythical land of Apalatci. The only thing that saved those memories, and the artist himself, from drifting all the way into oblivion was the enduring popularity of Theodor de Bry's illustrated travel books. Acquiring a complete set of these beloved volumes, explained the bibliographer Thomas Frognall Dibdin in 1824, had become the highest ambition of every book collector:

> What toil, difficulty, perplexity, anxiety, and vexation attend the collector—be he "young" or "old"—who sets his heart upon a PERFECT DE BRY! How many have started on this pursuit, with gay spirits and well replenished purses, but have turned from it in despair, and abandoned it in utter hopelessness of achievement!

Yet even though Le Moyne's narrative was prized, if not actually read, by a small group of bibliophiles and scholars, it was virtually unknown to a wider audience. So obscure had it become that as of the three hundredth anniversary of Le Moyne's journey to Florida, no one had ever bothered to translate his book into English. A Boston publisher would finally take on that long-neglected task in 1875, perhaps inspired by the noted historian Francis Parkman's *Pioneers of France in the New World,* published a decade earlier, which made several references to Le Moyne. Parkman was well ahead of his time in documenting the French contribution to North American exploration, but even he saw the story as a "half-forgotten chapter in the book of human life." It would not be until the next century that three separate enthusiasts, with little in common but a lack of formal scholarly training, would bring Le Moyne's life and work back before the public eye.

Rediscoverers

...

"IOFTEN FEEL AS IF I WERE ALREADY DEAD," THE PRISONER SCRIB-
bled in a diary at his Munich jail cell. "I lie on my bed for hours, staring at
the ceiling—inert, feeling nothing. Then, just as suddenly, I awake from
apathy, the will to live asserts itself with overwhelming power. I am full of
plans and ideas and energy. But these are fleeting moments of happiness.
Soon the thought of death is with me again, and I can't get rid of it."

It was March 19, 1933: just four days after Adolf Hitler, the new
chancellor of Germany, assumed dictatorial authority. In the weeks lead-
ing up to this consolidation of power, the Nazi leader had ordered a sys-
tematic roundup of tens of thousands of his political opponents. Among
those dragged from their beds was the disconsolate writer of that clan-
destine prison diary, a magazine editor named Stefan Lorant. Arrested
on suspicion of involvement in "Bolshevist intrigue," Lorant now found
himself under "protective custody," a euphemism for being imprisoned
indefinitely without charge. At first he had assumed that his case would
be heard and that he would be released, but as the days dragged on, he
grew despondent: "I don't believe I shall ever leave these walls alive."

It was not an unrealistic assumption. The Budapest-born Lorant
knew that as both a foreigner and a Jew, he had good reason to fear for
his life. By the most conservative estimates, there were more than one
hundred thousand political arrests in Germany in 1933—and, in a horri-
ble preview of the carnage to come, at least six hundred of those prison-
ers died in custody. Luckily, Lorant was not one of them. Thanks to
pressure from the Hungarian government, he was abruptly released in

October of 1933 and ordered to leave the country. His home had been ransacked, his salary impounded, his car commandeered by the Nazis, but after six and a half terrifying months in prison, he was a free man.

Improbably, Stefan Lorant had been brought back from the dead. Even more improbably, so had Jacques Le Moyne de Morgues.

IT IS HARD to imagine a less likely champion of Le Moyne's Florida engravings than Lorant, who first achieved notoriety as a silent-movie cameraman, scriptwriter, and director in Austria and Germany during the 1920s. A Zelig-like persona with "a certain affinity for celebrity," in the words of *The New York Times,* the young man befriended Greta Garbo, became an intimate of the future Nazi filmmaker Leni Riefenstahl, and gave Marlene Dietrich her first screen test, after which he advised the actress, "Get married, don't worry about film. I don't think you have any talent whatsoever for the movies." He was even "coffeehouse acquaintances" with the aspiring politician Adolf Hitler, with whom he once shook hands. The future Führer's grip, he would later recall, was clammy and soft.

Lorant quit cinema in his mid-twenties and moved into the world of magazines, where he quickly rose to the rank of editor in chief of the *Münchner Illustrierte Presse* (Munich Illustrated Press) and established himself as a pioneer in the emerging field of photojournalism. During the 1920s, German camera makers had developed new handheld models that gave photographers unprecedented mobility, spontaneity, speed, and precision, and Lorant was far ahead of his contemporaries in understanding how these advances would transform magazines. As a filmmaker he had learned to tell stories through a sequence of images, and now he transferred those techniques to the page, giving photographs primacy over text in his publications. After leaving Germany, he moved to London, where he founded the influential *Weekly Illustrated* and later created the *Picture Post,* an instant commercial success with an estimated readership of half the adult population of England in the late 1930s. Credited with helping to inspire the American picture magazines *Life* and *Look,* Lorant has often been described as "the godfather of photojournalism."

In many ways, in fact, Lorant was a twentieth-century incarnation of that earlier publishing-industry innovator, Theodor de Bry. Both men embraced cutting-edge technologies to transform the relationship between image and word. Both were popularizers whose genius rested in their "ability to take a potentially successful idea or concept, improve and repackage it, then offer it as something unique to the waiting world," in the words of Lorant's biographer, Michael Hallett. Both were victims of political and religious persecution, forced to drift from place to place and profession to profession, but always with success. And both—the devout Protestant from Liège and the cosmopolitan Jew from Budapest—brought Jacques Le Moyne's work to a wide audience.

Unable to secure British citizenship, Lorant immigrated to the United States in 1940, where he added another unlikely job title to his résumé, this time transforming himself into a popular historian. While imprisoned by the Nazis, he had managed to get his hands on a German translation of Abraham Lincoln's speeches and writings, which "immediately hit me in the solar plexus," he later recalled. "It was ironic to have been there for months and months and to have seen what was happening under the Nazi regime, and then to read that there had been the fellow in America who preached charity to all." The sixteenth president became such a source of inspiration that Lorant "tried to think, feel and live as he had." And after he reached his hero's homeland, this obsession turned, by chance, into a profession:

> When I arrived in America, as a pictorially minded person, I looked at all his photographs. I went to the library, to collectors, and gathered photographs. I obtained pictures of Lincoln and tried to understand what he looked like in 1863, when he delivered the Gettysburg address, what he looked like at the beginning of the war, and then when he signed the Emancipation Declaration. I put all these pictures on the floor of my New York hotel. One day a friend of mine came for tea and asked what I was doing. I explained I was learning American history—my way. He was amazed and suggested I write a book. But the suggestion was

crazy; how could I be expected to write a book on Lincoln when I had lived in America for less than a year?

By his own admission, Stefan Lorant knew relatively little about Lincoln. But what he did know, perhaps as well as anyone in the world, was how to tell a story with pictures. It took him just six weeks to complete *Lincoln, His Life in Photographs,* and the book was in stores less than a year and a half after he had arrived in the United States. It was a resounding commercial and critical success.

Lorant later wrote that it embarrassed him to hear himself described as a "Lincoln expert." But that did not stop him from embarking on an even more ambitious historical project in his second book—the idea for which, according to biographer Hallett, came from one of Lorant's most famous acquaintances. In 1940, while Lorant was still editing the *Picture Post* in England, Prime Minister Winston Churchill personally suggested he produce a special issue on the history and customs of the United States, which the government hoped would soon join the fight against Hitler. Out of Lorant's research for this project would grow plans for a book that brought together the eyewitness accounts of early English and French explorers to North America. Published in 1946, *The New World: The First Pictures of America* featured a new translation of the narrative of Jacques Le Moyne de Morgues along with the accounts of Nicholas Le Challeux, Thomas Harriot, John White, and other adventurers. But as its title made clear, the volume was built around its illustrations. Struck by the photographic immediacy of Le Moyne and White's work, Lorant was determined to reintroduce these long-overlooked images to the American public.

Once again he was to prove a visionary. *The New World* was an immediate success, selling thirty-five thousand copies—a feat all the more impressive because the large-format book came with the then-hefty price tag of twenty dollars. It was also a critical hit, praised by the *New York Herald Tribune* as "the most important historical volume of the year" and awarded the Carey-Thomas Award by *Publishers Weekly* for "the best example of creative publishing." True, some scholars were less than impressed. The Pulitzer Prize–winning historian Samuel Eliot Morison, for exam-

ple, charged that the translations of the texts were sometimes inaccurate and that the reproductions of White's watercolors were often "so completely off as to bear slight resemblance in detail and in coloring to the originals." No one, however, could dispute the impact of Lorant's work. "That book really made people aware of those engravings," the archaeologist Jerald T. Milanich, a leading expert on the Timucua, told me. "Lorant provided easy entrée for the public and politicians and scholars into the French presence in Florida. He made de Bry famous—and Le Moyne."

Because of Stefan Lorant, the engravings of Le Moyne's work would find a new place in the collective memory, showing up in numerous books and museum exhibits in the years to come. Another unlikely savior, meanwhile, had begun an even more extraordinary reclamation project: bringing the artist's botanical paintings back from oblivion.

THE LINNEAN SOCIETY of London has been associated with some of the greatest scientific minds of all time. The place gets its name from the great Swedish naturalist Carl Linnaeus, originator of the modern scien-

tific method of classifying and naming organisms, whose botanical and zoological collections are housed in its library. The first public airing of the theory of natural selection also took place at the society, when a joint paper by Charles Darwin and Alfred Russel Wallace was presented there in 1858—a milestone moment in the history of human thought. Founded in 1788, the organization is the world's oldest surviving botanical society, its doors having been graced by generations of distinguished researchers.

That Spencer Savage managed to assume an honored place among those scholars is something of a miracle. Born in 1886, he was forced to leave school at age fourteen and never finished his formal education. Those who knew Savage decades later, long after he had established himself as the society's erudite librarian, would have been shocked to discover that he was largely self-taught, his vast knowledge gained through evening courses and arduous private study. Hired as a mere clerk in 1911, the intelligent and inquisitive Savage quickly began to command the respect of his better-educated colleagues. But his career was interrupted by World War I, the horrors of which he witnessed firsthand as a machine gunner on the Western Front. Had Spencer Savage died in those trenches like so many of his colleagues, it would have been a keen loss for scholarship. For in 1922, just three years after returning from battle, he was to make a stunning discovery, one that would solidify his reputation as a researcher and lead to a dramatic reinterpretation of Le Moyne's career.

There are two types of treasure. One is hidden; the trick is to find it. The other is in plain sight; the trick is to recognize it. The treasure Spencer Savage recovered was already on public display at the Victoria and Albert Museum in London. It was a small volume the museum had purchased in 1856 for its ornate binding, an extremely fine example of French workmanship from the late sixteenth century. In the case of this particular book, however, the old adage was apropos: It had been too much judged by its cover. Until Savage came along, no one had evidently bothered to pay much attention to the pages inside.

Having received a tip that those pages contained watercolor portraits of flowers, fruits, and butterflies, Savage went to investigate. He was by

A portrait of Spencer Savage from 1935.

then something of an expert on sixteenth-century botanical illustration, and it did not take him long to realize that he had made an important find. Not only did the drawings, fifty-nine in all, demonstrate "a keen love and perception of the delicate beauties of plants," he concluded, but they also displayed "great artistic skill" as well as "an individuality, an honesty of vision, and an entire freedom from superficiality." It was obvious to Savage that he was witnessing the work of a master.

He also found an intriguing clue about that artist's identity. Scrawled beneath the first portrait, in what may have been the painter's own hand, was the word *demorogues*. Could this be, he wondered, a reference to Jacques Le Moyne de Morgues, the French artist responsible for the woodcuts of plants in that rare little book *La Clef des Champs*? It was certainly possible: A watermark indicated that the paper used for those paintings had been produced in France during the late 1560s. And when

Savage compared the engravings from *La Clef des Champs* to the flower portraits from the Victoria and Albert volume, he was thrilled by what he saw. "I am convinced," he wrote, "that some of the woodcuts of plants . . . were made from these drawings." *Demorogues* and de Morgues were one and the same.

This finding soon attracted the attention of *The Times* of London, which hailed it as "a discovery which has many points of interest, artistic and literary, French and English." The publication did, however, express surprise at just how little information was then available on Le Moyne: "The remarkable fact is, that . . . he seems to have entirely escaped the notice of both English and French compilers of biographical dictionaries of artists."

Thanks to Savage, that would begin to change. Not only did his research draw new attention to the painter, but it also forced scholars to evaluate his career in an entirely new light. No longer would he be seen primarily as a cartographer and expedition artist whose main contribution to art history was the series of engravings from Florida. Now it was clear that he was also a very accomplished, and very important, early botanical painter.

Similar discoveries would follow, perhaps the most important of which was an album purchased by the British Museum in 1962, containing fifty paintings of fruits and flowers. By the year 2000, several other manuscripts had been tentatively added to the artist's fast-expanding oeuvre of plant portraiture, and even more would reemerge early in the new century. Some of these works may have been painted before the artist's departure for Florida, others dated to after his return to France, still others to his years in England. When Spencer Savage stumbled upon that small book at the Victoria and Albert Museum in 1922, Le Moyne was virtually unknown as a natural-history painter. Eight decades later, it was apparent that botanical illustration had been his life's work—and that the New World adventure was perhaps less a defining moment than an extraordinary detour.

Savage, who died in 1966, once lamented that he "never had the opportunity of becoming a trained thinker." His interest in Le Moyne was

driven less by any intellectual concern than by a simple passion: "that subtle pleasure which one feels in the presence of a real work of art." The next step in Le Moyne's resurrection was to come from another amateur enthusiast: a man whose fascination with Fort Caroline took him all the way to Congress, where he would become one of the foremost lawmakers of the twentieth century.

Crusader

...

LATE IN LIFE, CHARLES E. BENNETT WOULD REMEMBER WHEN THE idea had first begun to form in his mind. Those pilgrimages to the Saint Johns Bluff on an unpaved road. That hard uphill drive through sand

Rep. Charles E. Bennett receives the Legion of Honor from the French ambassador to the United States, Jacques Kosciusko-Morizet, in 1976.

which sometimes swallowed his tires whole. That broad vista of the winding river that awaited him on top, populating his imagination with all those who had stood there before him: Native American, English, Spanish, French, soldier, slave—the whole history of his country writ in rough draft on this one spot.

He would recall sitting on his parents' porch in Jacksonville as their friend T. Frederick Davis, a prominent local historian, regaled him with stories of a vanished fort: the mutinies, the mass murders, the uncanny escapes, the adventurers with those poetic names, Laudonnière and Ribault, Le Challeux and Le Moyne de Morgues. He would remember the first time he laid eyes on those mysterious pictures of the aboriginal inhabitants, images that would one day be so much a part of him that they seemed to be engraved not just on paper but straight into his consciousness. And although he was just a newcomer to the town then, having moved there with his parents as a young man, he had already begun to identify with all those long-dead figures in some strange but intractable way. They would haunt him for the rest of his life—an obsession lasting nearly seventy years.

When he began his quest, the whole saga of the French settlement in Florida was little more than a local legend, a neglected piece of the past that garnered scant mention in history books. Bennett was determined to bring it to a national stage by creating a park in honor of those who had lived and died along the nearby riverfront. He was just a small-town lawyer with a huge dream back then, and at the start he could claim no grander title than president of the Jacksonville Junior Chamber of Commerce. That, however, did not stop him from concocting countless schemes to draw attention to the forgotten outpost: contacting MGM Studios in Hollywood to propose "an historical moving picture" about the colony, writing Ripley's Believe It or Not! to offer some eyebrow-raising tidbits about the old fort, and lobbying the U.S. postmaster general to create a special stamp to honor the settlement. "If this idea is accepted by you," Bennett wrote in 1940, "I would suggest that the picture on the stamp might appropriately be a picture of Fort Caroline as drawn by an actual eye witness and as now can be found in a book by Le Moyne."

Those proposals, and many more like them, were politely ignored or flatly rejected. That did not stop Bennett. In November of 1940, the young attorney was elected to the Florida House of Representatives, where he introduced a bill to establish a state park honoring Fort Caroline. It got nowhere, but that did not dissuade him either. Nor did the crippling case of polio he contracted during World War II while leading guerrillas through the Philippine jungles. Although no longer able to walk without the help of a leg brace and canes, he was elected to the U.S. House in 1948, where his first order of business was a bill to create a new national park. The legislation was initially opposed not only by the Department of the Interior, the agency charged with running the proposed facility, but also by the board of commissioners for Duval County, the locality in which the park was to be erected. But Bennett kept pushing. Constituents wrote angry letters. "I hope you will forget this 'dream' and concentrate on some of the vital issues at stake in our national affairs," implored one. "Why in the name of goodness can't you grow up as other men and women have done and become a realistic adult?" demanded another. Bennett did not back down. "As to my own political fortunes and the effect that this project may have upon them, I am willing to abide the outcome on that," he told one critic, adding that his popularity at the polls was "of small importance anyway as long as I do what I sincerely believe to be right."

It was never wise to underestimate Charles Bennett. Once described as the "epitome of a Southern gentleman," he had a welcoming face and a smooth voice, burnished by his earlier days as a square-dance caller. But this courteous exterior belied an iron will and ferocity of purpose. Despite all odds, he would triumph, imposing his vision on the banks of the Saint Johns the way an artist does on a blank canvas. Bennett would accomplish many great things in his long and noteworthy career as a Democratic member of Congress, but the Fort Caroline National Memorial would be his masterpiece.

IN APRIL OF 1953, Representative Bennett—or Charlie, as most friends and constituents called him—took a short break from his hectic schedule

to get married. It had already been a very good year for the lawmaker. In January, the secretary of the interior had signed an order establishing the Fort Caroline National Memorial, the final bureaucratic hurdle to a bill Bennett had pushed through Congress three years earlier. After fifteen long years of letter writing, lobbying, and arm-twisting, his dream was about to become a reality. A parcel of land had been secured along the Saint Johns River, just west of the bluff. Whether it was the same spot where the fort had once stood, no one could be sure. But to Bennett, that was not really the point. Fort Caroline would finally have an official place in American history. And to make matters even sweeter, the forty-two-year-old bachelor had found himself a soul mate. "He told someone the reason he married me was because I would sit and listen to him talk about Fort Caroline," Jean Bennett, a lively and outgoing woman, told me.

After the ceremony, she recalled, the newlyweds set off on what the bride would forever describe as her "hysterical, historical honeymoon," a tour of historic landmarks in the Southeast concluding with a visit to Colonial Williamsburg, the restored eighteenth-century town in Virginia. Her husband wanted to gather ideas. Although the future site of the Fort Caroline Memorial was still little more than a tangle of brush, he could already envision a museum there, filled with sixteenth-century artifacts. And he knew just how he was going to pay for those pieces, according to his wife: "When we got married, he said, 'Now, I get this money from the Veterans Administration, but you will never see it.' That money went to the museum."

Because of the financial demands of the Korean War, Congress had authorized no actual funds for the memorial, and Bennett had been forced to raise the money through private contributions. Of the forty thousand dollars needed to acquire lands for the park, he contributed about nineteen thousand himself. Some of those funds came from his veterans-disability benefits, which he had been turning over to the Treasury since his very first day in Congress, insisting that the money go to the National Park Service for the proposed monument.

Eventually his total contribution would add up to hundreds of thousands of dollars—one of the civic-minded gestures that would earn him the nickname "Mr. Clean" among fellow lawmakers. Many of his dona-

tions were used to obtain historical items for display at the memorial, which finally opened to the public in late 1957. Among those artifacts were a Timucuan canoe and a totem in the shape of an owl, along with various European weapons, tools, and navigational instruments from the Age of Discovery. The congressman also hoped to obtain several works by Le Moyne, "the great artist who is responsible for the fact that we know so much about [Timucuan] culture." But this proved no easy task. He contacted the British Museum, for example, about a book that "I have forgotten the name of . . . but it deals with wild flowers, I believe." Apparently this was a reference to *La Clef des Champs,* of which only three copies were known to exist in the world. "An act of Parliament has to be passed," came back the terse reply, "to enable even one museum item to be loaned or leave the building." He received better news from the Peabody Museum of Archaeology and Ethnology at Harvard, which agreed to donate a drawing reputed to be of Saturiwa—but officials there informed him that the sketch was "probably not an original Le Moyne but a European copy." Despite these frustrations, Bennett did manage to procure a 1591 edition of the artist's narrative, which is still in the memorial's archives.

IN THE HALLWAY OF A house in Glastonbury, Connecticut, hang three original engravings by Jacques Le Moyne de Morgues, restored at considerable expense by their current owner. One shows French explorers greeting the Indians along the Saint Johns River during Ribault's first journey to Florida in 1562; another depicts the construction of a French outpost now thought to be Charlesfort; a third, the completed Fort Caroline. For many years these pictures hung in a Capitol Hill office noted for its magnificent view of the Rotunda. But when Charles Bennett retired from Congress in 1992 after forty-four years in the House, he decided to give the engravings to his son, James, with whom he shared a love of the past.

"He knew I would respect them and take care of them," explained James Bennett, a slim, thoughtful man who is employed as the executive director of the Historical Society of Glastonbury. "He thought Le

Moyne's work was fantastic. He thought the engravings were beautiful, but he especially liked the fact that they reflected history."

That Charles Bennett never donated those pictures to the Fort Caroline Memorial, as he had with so many other treasures, is a sure indication of how much he cherished them. They were part of his inner sanctum, his own private shrine. How many thousands of times had he glanced up at them from his desk while reading briefs or meeting with staffers or calling colleagues to round up support for a new piece of legislation? It must have pained him to take them down, to dismantle that shrine, but as he emptied out his office, he could look back with pride on a remarkable career.

For a period of more than forty consecutive years, Bennett did not miss a single vote on legislation before the U.S. House of Representatives. Not one. Nor did he ever accept a gift from a lobbyist or allow his staff to do so. He consistently voted against congressional pay raises. He prohibited his employees from using long-distance phone lines for personal calls. He personally responded to constituents' letters. To save tax money, he often drove from Jacksonville to Washington—no easy trek for a man with polio who had to use a special car that he controlled with his hands. But Bennett was used to long hauls. By the time he left office, he could boast the ninth-longest tenure in the history of the House. "When dealing with Bennett," wrote one newspaper, "it was difficult to be cynical about government."

Somehow he also found time to write several books on the early history of the Southeast. Among them were three volumes on Fort Caroline, including *Settlement of Florida,* published in 1968, which featured a translation of Le Moyne's narrative and color reproductions of the artist's engravings. It was not a hit like Stefan Lorant's book, but family members say he had a special fondness for the volume, which paid tribute to the artist who had for so long fired his imagination.

He continued to play an active role at the Fort Caroline Memorial throughout his career. There were many successes and a few notable failures. In the 1960s, for example, Bennett became so enamored of Colonial Williamsburg and other historic reconstructions that he pressured the Park Service to build a replica of Fort Caroline. Such structures were

popular tourist destinations at the time, but this project proved to be both ill conceived and poorly executed. Other than Le Moyne's illustration of the outpost, officials had only scant documentary and archaeological evidence on which to base their blueprints. The resulting replica, a very rough approximation of the fort's outer walls, constructed partially out of cinder blocks, was "perhaps the least successful attempt at Park Service reconstruction" in the country, according to critics.

Overwhelmingly, however, the park thrived under Bennett's stewardship. His crowning achievement came in 1988, when he pushed through legislation establishing the Timucuan Ecological and Historic Preserve. When it began, the Fort Caroline National Memorial had encompassed only 116 acres; now it was part of a forty-six-thousand-acre refuge created to protect the environmental and historical resources of some of the last unspoiled coastal wetlands on the Atlantic seaboard. And even in retirement, the eighty-one-year-old Bennett had big plans to purchase more land. His son would get his Le Moynes, but the National Park Service would get his unspent campaign funds—a farewell gift of more than $270,000.

BY THE TIME I FINALLY met Charles Bennett, I had come to see him as something of a guiding spirit. His obsession was now my own, and I hoped that he might offer me direction in my search for Jacques Le Moyne. Unfortunately, I found him in poor health. It was February of 2003, seven months before his death and shortly after he had suffered a stroke that robbed him of much of his ability to speak. His wife had been hesitant to allow me to see him, but because Bennett had read *The Island of Lost Maps* and because he would no doubt be interested in my new research, she determined that he might at least enjoy meeting me.

Jean Bennett accompanied me to the Jacksonville nursing home where her ninety-two-year-old husband was then residing, and we waited for him to be wheeled into the lobby. When I caught sight of him, his head was tipped back in the chair, mouth agape and eyes squeezed shut. He was wearing a business shirt and sweatpants that hung loose on his emaciated frame. Although five feet ten inches tall, he was now down

to 140 pounds, his wife said. She tried to rouse him. "Charlie, open your eyes now. Charlie . . ."

He seemed to become attentive at the sound of her voice, but the eyes remained closed.

"There's someone here to meet you, Charlie. Remember that book you read about the lost maps?"

He nodded slightly, eyes still shut.

"Well, he's here, and now he's doing a book about Jacques Le Moyne."

His eyes flickered slightly open and a faint smile pursed his lips. He gave the air a bully-for-you punch.

I told him how much I admired his work on Fort Caroline, then reflexively held out my hand to him. He grasped it with an unexpected ease and confidence: a politician even in this final illness.

His wife had given me one of Bennett's personal copies of *Settlement of Florida,* the book that contained the engravings of Le Moyne's work. I told him how much I cherished the gift, and he seemed to want to put his autograph on it. But even with his wife's help, he could only leave a pen scratch across the page.

I asked him if he found Le Moyne to be one of the most fascinating characters from the Fort Caroline saga. He nodded.

"Le Moyne," he said, and then uttered something neither his wife nor I could understand. She asked him to repeat himself.

"Le Moyne," he said again, followed by a few indiscernible syllables.

"Le Moyne," he repeated, but the words would not come. He was getting agitated.

"Le Moyne—interesting."

"Le Moyne—interesting."

"Le Moyne—interesting."

I attempted to ask questions that he could answer yes or no. "Do you suspect that there is more information on Le Moyne's life that has yet to be discovered?"

A nod yes.

"If you were me, where would you look for it, England?"

Yes again.

"France?"

Another nod.

"Where in France?" his wife asked.

He grinned. "Par-ee," he said, as if a native of that country.

Then he seemed to fade again. A staff member from the nursing home explained that he was cogent but simply could not bring words to his mouth that day.

"Are you frustrated, Charlie?" his wife asked.

He nodded again—and then, just when it seemed as if he was going to give up, Charles Bennett moved his right hand. He lifted it out and brought it up in front of his face and began to make delicate sweeping gestures with his closed palm. It took his wife and me a few seconds to realize those movements were imaginary brushstrokes. In that one sudden moment of eloquence, the dying man had transformed himself into a painter.

Conclusion:
Searching for Roots

M Y SHOVEL SLICED OPEN THE EARTH, CUTTING THROUGH A BROWN-
ish surface layer and pushing into the gray-white sand. The air around
me was sticky and swarming with mosquitoes, but the hole opening at

Common millet, attributed to Jacques Le Moyne de Morgues.

my feet was cool and dark and full of mystery. I was digging for Jacques Le Moyne.

Years earlier, my adventure had begun in this same place. In various corners of the Fort Caroline National Memorial, college students were now carving square pits identical to the one I was hollowing out of the sandy soil, all of us attempting to locate the lost outpost. The leader of this undertaking was a tall and energetic archaeologist from the University of North Florida in Jacksonville. Tall and nattily clad in a Hawaiian shirt, khakis, and deck shoes, Robert Thunen, who goes by the nickname Buzz, cut a dashing figure. Yet he insisted he would be glad to sacrifice personal appearance in order to locate the fort. "I have issued a challenge to the students over the last couple of years," he explained. "If they find a French artifact, I have to shave my head."

Until recently, the odds of ever locating Fort Caroline had seemed impossibly long. For years, most experts assumed that whatever remained of the structure had washed into the Saint Johns River in the nineteenth century and that "ships now pass over the precise site of Fort Caroline," as one historian confidently asserted in 1925. But recent breakthroughs at other sites in the Southeast had cast doubt on this idea. Until the discovery of Charlesfort in 1996, for example, some experts had presumed this earlier French outpost had eroded into South Carolina's Port Royal Sound. That same year, researchers in Virginia announced the discovery of James Fort, later known as Jamestown, the first successful English settlement in what is now the United States. It too had previously been thought to be underwater, carried away by the James River.

Inspired by these finds, Thunen and his team were undertaking the largest archaeological survey ever conducted on the memorial's property, hoping that they might succeed where previous researchers had failed. At precise intervals along the bluff line bordering the river, students were hollowing out "shovel test pits," square holes, fifty centimeters across and one meter deep, to determine whether the soil contained any cultural remains. They did not expect to locate the fort on this largely elevated land, since several sixteenth-century eyewitnesses, including Le Moyne, had insisted the structure was built on a low-lying area along the

banks of the Saint Johns. Still, they hoped to stumble upon some clue that might eventually lead to the outpost.

They worked in pairs, one person handling the shovel, the other gripping the handles of a wood-framed wire screen that balanced horizontally on two metal legs. As the digger tipped earth onto the screen, careful not to spill even the smallest amount, his partner rocked the device back and forth, sand falling in a cloud toward his shoe tops. They were panning for archaeological gold, and each of the dozen or so students secretly dreamed of being the one who would make Buzz Thunen go bald. Yet it was not just French artifacts they were after. In South Carolina, researchers had failed to detect Charlesfort for decades because it was buried beneath the ruins of a Spanish outpost. To locate Fort Caroline, Thunen and his team knew they would first have to find San Mateo, the Spanish stronghold constructed from what had been left of the French colony.

The dig had already been going on for several days when I arrived. As Thunen led me to the wooded area where his students were working, we had to push our way through a tangle of underbrush, fallen logs, low branches, Spanish moss, and hanging vines. "When you get into the canopy, you realize just how easy it is to get lost," he said. "As I walk through this stuff, I wonder how Jacques Le Moyne managed to escape."

After years of searching for Le Moyne in the abstract world of books and old manuscripts, I was thrilled to move through the actual landscape he had inhabited, to wipe spiderwebs from my face and stumble over palmetto plants just as he must have done. Anxious for a chance to seek the artist with my own hands, I had volunteered to help with the excavation, and some of Thunen's colleagues consented to give me a crash course in the use of shovel and screen. Eventually I was teamed with a young archaeologist named Keith Ashley, a colleague of Thunen's at the University of North Florida. Wiry and intense, Ashley dug with a nonchalant fury, stomping away at his shovel with a pair of ripped Chuck Taylor All Stars, their soles worn off at the heels, their original color indeterminate, having long since taken on the shade of the soil. "These are probably fifteen or twenty years old," he told me. "They've seen *lots* of digs."

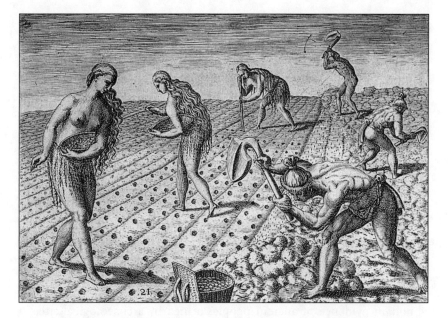

Ashley had ulterior motives for seeking Fort Caroline, he said. An expert on pre-Columbian cultures, he was less interested in finding the outpost for its own sake than as a means of locating nearby Indian villages. And although he obviously knew a great deal about Le Moyne's portrayals of Native American life, he found those engravings to be of dubious value to archaeologists. He asked me to recall, for example, one of the artist's better-known images, a picture that purports to show Timucuan men and women tilling the ground and sowing corn seed. Not only were these native farmers using tools of European design, but it also turned out that their method of planting in furrows rather than in mounds was also incorrect. The engraving, Ashley surmised, was a "total fabrication," perhaps designed to reassure potential colonists and investors of "the agricultural bounty of the natives of this area."

It was one more enigma to add to the long list comprising Le Moyne's career, and I hoped that the soil might hold answers to at least a few of these mysteries. Yet so far the excavation had not turned up a single clue that might lead to those ruins. Earlier in the day, Ashley had helped unearth the neck of a hand-blown glass bottle from the British colonial period, but not one French or Spanish artifact had been found. As John Whitehurst, the cultural resources manager for the Timucuan

Ecological and Historic Preserve, had joked: "If Charlie Bennett was going to erect a memorial anyplace that wouldn't impact the actual fort, this is a pretty good spot."

Still, I clung to the fantasy that my shovel might exhume an object that would cause Thunen and his colleagues to come running. And for a fraction of a second, I allowed myself to dream that I had. Looking up, I noticed Ashley bent over the screen, examining something small and reddish. I asked what it was, breathless with the thought that we had unearthed some rusted treasure from Le Moyne's time. Ashley, however, quickly disabused me of any such hope. Taking out a specimen bag, he explained that the artifact was a piece of coastal plains chert—a type of stone aboriginal people used to manufacture tools. Since the chert was not native to this coastal landscape, it was a sure sign of a human presence here, perhaps as early as six thousand years ago. Still, given the abundant evidence of ancient peoples at nearby archaeological sites, it was hardly an unexpected find.

The surprising thing, in fact, was just how little evidence of the past this stretch of land seemed to contain. By the time the excavation was complete, the students had dug more than a hundred test pits at the Fort Caroline National Memorial but had turned up almost nothing of archaeological interest, either prehistoric or European. "We didn't really expect to find anything French, but we did hope to find something from either the first or second Spanish period," Thunen said. The British, too, "were almost invisible."

Buzz Thunen would be spared the barber's chair, at least for now. Even so, he and his colleagues had not given up. "We just haven't found anything, which is discouraging for the students, because they like to find stuff," he told me as we strolled the memorial's grounds that day. "But it's significant for us, because it allows us to determine that there's no evidence of French and Spanish here and look somewhere else."

After I left Florida, Thunen and his team would search for the fort at two nearby locales—again in vain. Then the hunt would stall, in part because the most promising places to dig were on private property, and gaining access to those sites, many of them in upscale subdivisions, would require them to overcome considerable logistical and legal obsta-

cles. Nonetheless, Thunen continued to cling to the idea that the out-post might one day be found. "We're hopeful of being able to buy some ground-penetrating radar," he told me, "and if that were to happen, we would be able to look at some property where the homeowners might not want us to dig, which would help narrow down possible locations for the fort. So who knows, Fort Caroline may get a second or third look."

If the mystery of the lost outpost was ever to be solved, it did not seem likely to happen for years. I would have to look elsewhere for Jacques Le Moyne de Morgues. Taking Charles Bennett's advice, I headed for France. It was there that I would at last uncover some in-triguing clues—and a possible link to one of the most renowned and controversial figures of the Renaissance.

NORMANDY IS A LAND OF FOG. The nineteenth-century novelist Guy de Maupassant, who grew up on the coast, described how the place could sometimes be buried in "a gray shadow, dense but insubstantial, filling the sky and covering the sea . . . like a cloud dropped from the heavens." In a wall of vapor such as this (so thick, wrote Maupassant, that it reeks of "smoke and mildew, that strange smell of sea fogs"), a man might be invisible one moment and standing right in front of you the next. So it has always been with Jacques Le Moyne. Virtually nothing is known about the artist until he arrived at the Norman port city of Le Havre to sail for the New World. When he strode onto those docks in April of 1564, he was also striding into history.

It seemed fitting that fog shrouded the Norman coast when I arrived to look for Le Moyne. I knew that cutting through the mists of time would be anything but easy. The artist had left no written clues about his origins, other than to report that he traveled to Le Havre from Dieppe, another Norman port city just up the coast, where, presumably, he was staying prior to the start of the journey. So, after a stopover in Paris, it was to Dieppe that I took my search.

The sixteenth century has not entirely faded from the town. Inside the Church of Saint Jacques, for example, stands the first sculpture in France to depict Native Americans. Crafted around 1530, this bas-relief

serves as a reminder of Dieppe's close ties to the New World in the age of Jean Ango, the great ship outfitter and organizer of pirating expeditions, whose tomb is also lodged within the church. Saint Jacques also bears scars from the Wars of Religion, during which Protestant sailors ransacked the building in an iconoclastic frenzy. But if the world of Jacques Le Moyne de Morgues continues to haunt Dieppe, evidence of the artist himself is nowhere to be found. A fire in 1694 destroyed most of the town's records, and in the surviving documents, I came across none that even mentioned the painter.

This lack of archival evidence, however, has not stopped scholars from asserting that Le Moyne was born and trained in Dieppe, an idea repeated so many times it is accepted as fact by such standard references as *The Grove Dictionary of Art*. True, it seems Le Moyne was residing there just before his departure for the New World. Yet the longer I looked into his origins, the less certain I became that he received his artistic training in the Norman town.

Much of my doubt stemmed from Le Moyne's skill, or lack of it, as a mapmaker. Had he undergone the rigorous training typical of the legendary Dieppe school of cartography, he should have been well prepared to chart the New World. But his only surviving cartographic work, the clumsy and ill-proportioned map of Florida, offers no evidence of any such education—an indication, perhaps, that he arrived in Dieppe only after learning the art of painting somewhere else.

That he was in the Norman port prior to his departure is, in fact, of relatively little significance. A truly cosmopolitan city, Dieppe was full of newcomers: navigators from Italy, mapmakers from Portugal, merchants from Scotland, and artisans from across France. The idea that Le Moyne was among them—perhaps recruited primarily for his painting skills and brought to town for something of a crash course in cartography—would not be out of keeping with an age characterized by what one art historian called "wandering painters and sculptors" who were "willing, and indeed eager, to work almost anywhere." Le Moyne himself, after all, noted with apparent pride that organizers of the expedition "went through the whole kingdom on a most painstaking search for experienced men." But of all the indications that his roots lay elsewhere, the strongest is his very name.

—

DE MORGUES—LITERALLY "of Morgues"—would seem to indicate a place of origin. The scholar Paul Hulton, who wrote the most comprehensive biographical sketch of Le Moyne to date, had little luck tracking down this locale, other than to note that it "does not appear in records for the Dieppe area though it does occur in the sixteenth century in the Brussels region." Yet during my own research, I discovered that there was, in fact, a Morgues in France at the time of the artist's birth. The hamlet, which survives today, first appeared in the historical record in 1497. It is located in the Loire River Valley, a wide stretch of pasturelands known as the Garden of France, where kings set up court and nobles built magnificent country manors in the fifteenth and sixteenth centuries. One of the most elegant of these castles can be found just a few miles from Morgues in the town of Châteaudun.

Fragrant flowers, dangling from huge pots on light posts, lined the streets of Châteaudun on the bright summer day I came to search for signs of Le Moyne at the local archives. The town is now a sleepy provincial burg, but in his time it was a vital hub, located near both Blois, a royal chateau famous in the sixteenth century for its elaborate gardens, and Tours, a center of French manuscript illumination. Among the artists from Tours was Jean Bourdichon (1457–1521), whose miniatures are considered to be the first examples of French art in which plants were portrayed with botanical accuracy. Hulton, who characterized Bourdichon as a major influence on Le Moyne, argued that the younger artist must have had direct knowledge of his predecessor's work.

Châteaudun was also a cauldron of Protestant unrest. Beginning around Le Moyne's birth, prominent citizens were reading French-language Bibles and other banned religious books in public and making a lot of heretical speeches, according to one history of the Reform movement in the region. "It was by the books and the intervention of the cultured classes that these new ideas were spread; from there, they penetrated to the popular classes." During the First War of Religion, the town was the scene of a fierce battle between Huguenot and royal forces. In August of 1562, Protestant rebels ambushed a convoy as it skirted

Châteaudun, taking prisoners and blowing up the captured munitions. "You have never seen such an explosion," wrote one contemporary chronicler, "nor heard such a noise."

A Protestant, in short, was just as likely to have hailed from this region as from Dieppe—especially a Protestant named de Morgues. Nor would Châteaudun have been an improbable base of operations for a painter, or at least a certain kind of painter. The town, I was to discover, had a thriving artistic community of its own, near the center of which was a wealthy and stunningly well-connected man called Le Moyne.

HENRY LE MOYNE is an even more enigmatic figure than the painter who shared his name. Somehow he seems to have fallen through the cracks of history, despite his extraordinary artistic stature as royal embroiderer to Mary Queen of Scots.

Mary's love of needlework was legendary, a passion kindled in her childhood in the French court that only intensified during her mercurial career as queen of Scotland and France and her long imprisonment in England prior to her execution in 1587. Yet although Henry Le Moyne's service with this famous figure may have lasted as long as four decades, he was apparently unknown to previous researchers. I could find no mention of him in any biography of the monarch, including those, such as Margaret Swain's *The Needlework of Mary Queen of Scots,* that are devoted to her interest in needlework and the embroiderers under her patronage. Until I happened upon his name in the archives at Châteaudun and later at Chartres, Henry Le Moyne seems to have been lost to time.

His connection to the Queen of Scots almost certainly originated with her mother, Mary of Guise, who in 1534 received the castle and lands of Châteaudun as part of her marriage agreement with the duke of Longueville. It was while living at the castle that she apparently became familiar with Henry Le Moyne and his work.

The embroiderer must have left an impression on this noblewoman, for she continued to seek out his skills long after the death of her husband in 1537 and her departure from France in 1538 to live with her new spouse, James V, the king of Scotland. This marriage, also short-lived,

A sixteenth-century map of Châteaudun.

produced only one child who survived infancy. Born six days before her father died in 1542, Mary Stuart was crowned Queen of Scots nine months later. By 1545, according to archival records, Henry Le Moyne was already serving as the toddler's royal embroiderer. He apparently continued in that capacity throughout the queen's childhood, most of which was spent in the French court, following the girl's betrothal, at age five, to François, the eldest son of King Henri II and Catherine de Medici.

As one of a select group of professional embroiderers who served the young queen, Henry Le Moyne would have been responsible for any

number of tasks: designing the needlework for royal furnishings, creating showy decorations for court masques and pageants, and working on the most lavish of Mary's costumes. It seems probable that he helped her establish a reputation for elegance and style—*la plus parfaite,* as she was often described. Perhaps he even had his hand in on the "sumptuously and richly made" wedding dress, glimmering with jeweled embroidery, that the tall and attractive Mary, then fifteen, wore during her 1558 wedding to the dauphin, one year her junior.

The following year, after her father-in-law died in a jousting accident, Mary became queen of France. That Henry Le Moyne quickly gained a prominent status in her household is demonstrated by an April 22, 1563, receipt showing that the embroiderer had received 861 livres from Mary's general treasurer—partial payment for a debt of 1,780 livres owed since November 12, 1559, shortly after his patroness became queen. It is not clear whether this money, an unusually high sum, was for salary, materials, or some combination of the two. What the document makes certain is Henry Le Moyne's consequential standing in the young queen's entourage.

Mary's reign in France would last less than two years. In 1560, her sickly husband died after a short and agonizing illness, perhaps a brain tumor. A widow at age eighteen, Mary found that she was no longer welcome in a royal court now dominated by Catherine de Medici, who had used the boy-king's death to secure the regency for herself and viewed her charismatic daughter-in-law as a rival for power. Rather than attempt to match wits with the formidable Catherine, the young monarch decided to return to Scotland, with Henry Le Moyne apparently in tow.

A document from April of 1562, less than a year after Mary's arrival in her homeland, not only places the embroiderer at the Scottish royal palace of Falkland but also identifies him as a *valet de chambre,* a title that traditionally conferred even higher status than that of *peintre du roi,* or court painter. Such a designation would have indicated, at the very least, that Henry Le Moyne was now in the small circle of those who took personal care of the queen. And as one biographer noted, Mary Stuart was known for her "extreme attachment to her servants, partic-

ularly her own personal attendants, with whom she felt she could share her joys and woes without fear either of their presumption or of their disloyalty."

Her reign on the Scottish throne started well enough. Although a devout Catholic with close blood ties to ultra-orthodox military and church leaders in France, Mary gained considerable popularity by allowing Calvinism to remain the official religion of Scotland, as well as by naming a number of Protestants to her Privy Council. Attempting to immerse herself in day-to-day politics, she would bring her needlework to the council's meetings, "where she herself ordinarily sitteth the most part of the time," wrote one English envoy, "sewing at some work or other."

In 1565, however, the queen's life began to fall apart, thanks to her reckless and violently unhappy marriage to the handsome Lord Darnley, a brutal and narcissistic man. Darnley's murder under mysterious circumstances in February of 1567, followed by Mary's wedding to the chief suspect in the crime, ignited a scandal that led to her downfall. In June of that year she was imprisoned at the island castle of Lochleven and forced to abdicate her throne. She escaped the following year, but her forces suffered a resounding military defeat and she fled to England.

There, she spent the next eighteen years under house arrest, held in limbo by her cousin, Queen Elizabeth, who viewed the prisoner as a threat since Mary was next in line to the English throne. During this long confinement, Mary's needlework became a "passion and almost a mania," in the words of one biographer. Much of her time in England was spent under the custody of George Talbot, sixth earl of Shrewsbury, whose wife, Elizabeth, was herself a great embroidery aficionado. "This Queen," wrote the earl in 1569, "continueth daily resort unto my wife's chamber, where ... she sits working with the needle in which she much delights." That same year, an English royal envoy produced a similar report:

> I asked her Grace since the weather did cut off all exercise abroad how she passed the time within; she said that all that day she wrought with her needle and the diversity of the colors mak-

ing the work seem less tedious, she continued so long at it till very pain did make her to give over.

What role Henry Le Moyne played in her life during those troubled decades is uncertain. A document from 1582 makes no reference to his status as a valet de chambre, indicating that he no longer held that influential position, though it does clearly identify him as "embroiderer of Mary Queen of Scotland." Whether his service to the monarch was ongoing at this time is one of several intriguing questions about his status during her incarceration. Was he, for example, the unnamed embroiderer whose wife was banned from seeing the queen in 1578 because English authorities feared Mary would use the woman to convey secret messages back to France? Or might he have been the embroiderer, again unnamed, with whom she quarreled in 1585, apparently prompting her to dismiss the man and his wife?

Throughout the 1570s and 1580s, Mary had been involved in a number of intrigues against Elizabeth, all of them failures. The final one unraveled in 1586, when English authorities uncovered a plot to assassinate the Virgin Queen and bring about a Catholic uprising that would place Mary on the throne. Implicated by her co-conspirators, she was tried and convicted at Fotheringhay Castle, where she was beheaded on February 8, 1587. As a token at the scaffold, she is said to have presented an acquaintance with her embroidered glove, ornamented with roses, foliage, and a long-tailed bird in flight.

Henry Le Moyne died just six months later. His long association with the Queen of Scots, I realized, was the thing that would interest most researchers, but I was more intrigued by the part he may have played in the life of another fascinating figure from the sixteenth century. Archival documents indicate that Henry Le Moyne was born in or around 1510, making him roughly twenty-three years old at the time of Jacques Le Moyne's birth. And while Le Moyne seems to have been a common name in sixteenth-century France, there are a number of compelling reasons to conclude that the painter was indeed the embroiderer's son or nephew—not least the fact that Henry Le Moyne would have required the services of a first-rate plant portraitist.

—

SO INTERTWINED WERE embroidery and horticulture in the sixteenth century that those who plied their trade with the needle had begun to appropriate the language of botany. "Slip," a gardening term used to describe a cutting of fresh flowers, came to mean a small embroidered botanical motif, usually stitched to plain canvas, then cut out and applied as part of a larger work.

Before such a slip could be stitched, however, someone would have had to sketch—or, in the parlance of the day, "draw out" or "draw forth"—the image on canvas. And while there is no precise record of how such designs were prepared, this task almost certainly would have fallen to a professional embroiderer or one of his assistants. While Mary Stuart was a prisoner at Lochleven Castle in 1567, for example, she received, apparently from one of her embroiderers, a dozen and a half little flowers, painted on canvas and outlined in black silk, along with various supplies with which to stitch these slips. Still imprisoned at that same Scottish castle the following year, she requested "an embroiderer to draw forth such work as she would be occupied about." And an inventory of Mary's effects, taken one year before her execution, lists slips of "52 different flowers . . . drawn from life, of which 32 are uncut." There were also 124 birds, sixteen animals, and fifty-two fish, some of them already cut out and ready for mounting. Clearly, a man in Henry Le Moyne's position would have needed a talented draftsman in his workshop—especially one with a gift for natural-history painting.

Was Jacques Le Moyne this man? Local baptismal records are fragmentary for the period around the artist's birth, and I could find no other documents directly linking the painter to the older man. We do know, however, that under the system of workshops and guilds that originated in the Middle Ages, embroidery was typically a family business, with skills handed down from generation to generation. We know that skilled artists were needed to provide embroidery designs, that professional workshops may have employed their own draftsmen, and that watercolor was often the medium of choice for an initial illustration. We know that floral and plant motifs formed the basis of much sixteenth-

century needlework. We know that Jacques Le Moyne later worked for
Lady Mary Sidney, whose daughter, the countess of Pembroke, became
one of the most celebrated amateur embroiderers of her day. We know
that *La Clef des Champs,* the book of botanical patterns that Le Moyne
dedicated to Lady Sidney, was partly intended for "embroidery, tapestry
and also for all kinds of needlework." And while relatively little sixteenth-
century needlework remains intact, we know that some surviving ex-
amples do appear to contain motifs from the book. There is striking
similarity, for instance, between a woodcut image of grapes from *La Clef
des Champs* and a slip of grapes on a cushion cover that once belonged to
Elizabeth Talbot, the noblewoman and needlework enthusiast in whose
house Mary Queen of Scots was long imprisoned. Several other slips in
this same cushion cover may also be patterned after Le Moyne's work,
and at least one other piece of embroidery that belonged to Elizabeth
Talbot shows possible signs of his influence.

*Le Moyne's woodcut of grapes (left) and a detail from
an embroidery belonging to Elizabeth Talbot.*

In addition to explaining the painter's name, pinpointing his place of
origin, and lending coherence to his past, a link between Le Moyne "of
Morgues" and the embroiderer from Châteaudun would shed light on
at least two other historical mysteries. The first concerns Jacques Le
Moyne's stature as an artist. "Nowhere is Le Moyne referred to as *'peintre*

du roi,' but the possibility that he was a court painter cannot be dismissed," wrote the scholar Paul Hulton, who cited several indications that the artist enjoyed royal support, including the fact that he "appears to have been received by Charles IX as by an interested patron. Access to the King in this way could hardly have been obtained by someone entirely unknown at court."

The mystery of how Jacques Le Moyne managed to gain entrée to royal circles would, of course, be solved if he turned out to be closely connected to Mary Stuart's valet de chambre, a position that afforded "easy access" to the court, in the words of one expert. Although the Queen of Scots had already left the country before French officials began organizing the Florida expedition, Henry Le Moyne, who had by then served as a royal embroiderer for some twenty years, must have had other royal connections. It is even conceivable that he would have been in a position to appeal directly to Catherine de Medici or her young son, King Charles IX. We can imagine, moreover, why Henry Le Moyne might have wanted the younger man to leave France at that time. The First War of Religion had ended less than a year earlier, and sectarian tensions were still tearing apart many French families, perhaps including the embroiderer's own. We can presume that Henry Le Moyne was Catholic, both because he was buried at the local Church of the Madeleine and because his longtime patron was a noted adherent of the faith who once boasted that all those in her entourage shared her religious views. The fact that Jacques Le Moyne was a Calvinist would not necessarily lessen the probability of a blood tie between the two men, but it might suggest that the younger artist was an embarrassment to his family. Sending Jacques Le Moyne to America would have served a dual purpose: keeping him an ocean away from the violence at home, while allowing him the chance to rebuild whatever perceived damage he had done to the family name. The idea of the painter as something of a black sheep also jibes with a certain contempt for authority that underlies the tone of his own narrative.

The notion that Jacques Le Moyne learned his skills as a painter by designing patterns for embroidery would also help explain one final mystery, this one involving those books of flower paintings he compiled.

Such works, known as florilegia, from a Latin word for flower gathering, were virtually unknown before Le Moyne arrived on the scene. Unlike the earlier botanical encyclopedias called herbals, florilegia served no scientific function and often contained no text save for picture captions. Their sole purpose was to please the eye. Yet here we come to one of the most perplexing aspects of the artist's career. Florilegia did not come into vogue until the early seventeenth century, decades after Le Moyne began assembling his own volumes of flower paintings. Clearly, wrote one scholar, he was "one of the originators of the genre." In fact, because no other examples of florilegia are known to predate his work, it's possible he invented the form. But how and why?

One potential clue comes from a famous florilegium called *Le Jardin du Roy*. Published in 1608, the volume is the earliest example of this new art form to reach a wide audience. Yet although scholars have praised *Le Jardin du Roy* for combining "great artistry with impressive scientific accuracy," the book's illustrator, Pierre Vallet, was neither *peintre du roi* nor a scientist. He was, it turns out, a royal embroiderer—just like Henry Le Moyne. Could it be that this new genre emerged from embroidery workshops? Could it even be that Jacques Le Moyne, whose volumes represent the earliest known florilegia, was the first embroidery designer to realize his work could stand on its own as an independent art form? I could only pose such questions, not answer them. But the more I searched for Le Moyne, the more confident I became that creating illustrations for needlework was his earliest and steadiest form of employment, one constant in an otherwise wildly improbable career—a career that was still taking unexpected twists at the beginning of the twenty-first century.

IN JANUARY OF 2005, I found myself back in the Manhattan salesroom of Sotheby's for yet another auction of work attributed to Jacques Le Moyne de Morgues. For centuries, this enigmatic figure had gone unrecognized as a botanical painter; now, for the second time in two years, a previously unknown collection of his plant portraits had been discov-

ered and put on the block. It was surely one of the most unusual come-backs in the history of art.

In certain ways, this new batch of paintings was even more impres-sive than the previous group, which had included the study of apples, chestnuts, and medlars that sold for $120,000. Those works were painted on loose sheets of paper and were apparently never intended as a cohesive set. Instead, they comprised what one expert described as "a reference collection of plants," after which Le Moyne may have fash-ioned other paintings. This new body of work, by contrast, was an intact florilegium: the largest single volume of his paintings ever discovered, consisting of eighty watercolor and gouache drawings of plants and flowers. It was also the first book of Le Moyne's botanical portraits to come on the market since 1961. Sotheby's expected it to fetch between $600,000 and $800,000.

As I examined this gorgeous work close up, I was once again re-minded of the epic strangeness of Le Moyne's life. Great care and ex-pense had gone into making the volume. Not only had the paper been glazed prior to the execution of the paintings—a time-consuming process, more common in the Islamic world than in Europe, that in-volved rubbing the surface with a heavy stone to give it a highly polished texture—but the artist had also used gold in the painted borders of each portrait, as well as in other details. Although Sotheby's offered few clues about the provenance of the work, it had clearly been crafted for a rich client, possibly even a royal one. Le Moyne's story, I reflected, was one of astonishing contrasts, taking him from the staid drawing rooms and manicured gardens of noble ladies to the untraveled wilds of America, from the quiet of the workshop to the chaos of Indian wars, from the delicate craft of flower illustration to the desperate task of staying alive. Such disparities made it all the more remarkable that he had come home in one piece—almost as remarkable, in fact, as the mysterious reemer-gence of this book. It was as if he had somehow imbued the paintings with his own knack for survival.

The sale had been much anticipated in the art world, and I expected feverish bidding. Yet to my surprise—and to the clear bafflement of

many others in that room—it was over almost before it started. No sooner had the auctioneer announced the opening bid of $300,000 than a gruff voice boomed out from the back of the room and the words "One million" echoed through the hall. Heads whirled amid a hush of whispers. Standing at the rear was a middle-aged man of sturdy build who wore a brown sport coat, white running shoes, and the defiant look of a barroom brawler ready to take on all comers.

"We have a bid of one million in the room," said the auctioneer, who himself seemed somewhat taken aback. "One million. On my right at one million dollars. In the room at one million. At a million dollars. Who'll say one million one?"

No one spoke. Would-be buyers exchanged anxious glances, wondering if anyone would have the guts to jump into a game in which the stakes were already so high, while auction-house employees with telephones at their ears and tense expressions on their faces waited for word from off-site bidders. "At one million dollars," repeated the auctioneer, his eyes scanning the crowd. "A million dollars. In the room, on my right, at one million. At one million dollars. We'll take the time for the telephone bidders to adjust to that idea."

There was nervous laughter but no new bidding. "You'll have to think quickly," the auctioneer warned, though he was obviously stalling for time, repeating "One million" over and over and over as he waited for someone, anyone, to join the action. But nobody came forward, and as the hammer slammed down to close the sale, many in the audience turned to take one more glance at the book's new owner, now flashing a satisfied smirk.

I knew that smirk well, just as I knew the man's fierce, intelligent eyes, square frame, and look of practiced impertinence—the trademark sport coat and running shoes that flaunted the formality of the salesroom. As it happened, I had devoted an entire chapter of my previous book, *The Island of Lost Maps,* to the charismatic and controversial W. Graham Arader III.

One of the most successful antiquities dealers of his time, Arader, who grew up in Philadelphia and now operates out of an impressive Beaux Arts townhouse on Madison Avenue, has helped create big-time

markets for old maps and botanical prints, transforming these items from scholarly collectibles to fashionable commodities and sending prices skyrocketing. His cutthroat tactics, brash persona, and self-serving bravado, however, have earned him few friends over the years in the polite, clubby world of dealers, collectors, scholars, curators, and librarians. Even his name, pronounced *uh-raider,* has a piratical ring, and many contemporaries view him as a kind of modern-day *corsario,* whose heretical attitude and swashbuckling approach to business pose a threat to their realm. For his own part, the combative Arader seems to feed on this outlaw image, disparaging rival dealers as "rich WASPs who haven't worked very much." His competitors at Sotheby's that day, he would later tell me, may have included representatives of Queen Elizabeth, but he had trumped them all by jumping the bidding from $300,000 to $1 million—a ploy designed to "break their rhythm." It had worked, he gloated, because "their mommies taught them . . . to always stop and freeze when the unusual happens. And that was real unusual."

Many months after the auction, Arader was still glorying in the idea that "a shitty little dumpy American" such as himself had managed to get his hands on one of the "greatest treasures" of French art. It reminded him of a similar coup he had pulled off in 1985, when he bought sixteen volumes of botanical watercolors by the nineteenth-century artist Pierre-Joseph Redouté for $5.5 million. The Redoutés had once belonged to Empress Josephine, the wife of Napoleon, but Arader considered the Le Moynes to be of equal importance and greater beauty. With the purchase of these two great bodies of work, he proudly declared, "I have single-handedly raped France."

He would also ravish the book itself. Just as he had done twenty years earlier with those Redouté volumes, Arader no sooner purchased the Le Moyne florilegium than he began razoring out individual pages and putting them on the market for as much as $375,000 apiece. This practice, known as "book breaking," is anathema to most bibliophiles and librarians, who consider it nothing short of vandalism, comparable to taking a sledgehammer to Michelangelo's *David* and selling off the fragments as souvenirs. Arader had been a notorious book breaker early in his career, but when I interviewed him for *The Island of Lost Maps,* he assured me that

he was a changed man. "Is it how I made my money in the first place? You bet your ass it is," he said at the time. "Do I feel badly about it? Yes, I do feel badly about it. Looking back now from a very secure and lofty perch, I can say I wish I hadn't been able to do it."

Apparently, however, the potential profits of the Le Moyne volume were just too much to resist. Arader told me that he would have been willing to pay as much as $7 million for the book, because the individual paintings inside were worth far more than that: "Let's be conservative. Let's just say you multiply $120,000 times eighty, right? You get $9.6 million."

More than four hundred years ago, in a dedicatory letter to Lady Mary Sidney, Jacques Le Moyne de Morgues praised those patrons of the arts, who, "caring little for their private profit, have more regard for the public good." But even in his age, art was a commodity to be used as its owner saw fit. I knew that Graham Arader was not the first person to slice up books in pursuit of profits, nor would he be the last. I also knew that many of his critics were less pure than they let on: glad to buy, sell, collect, and curate images that had once been bound, as long as they didn't have to do the dirty work of destroying the books with their own hands. Still, when I thought about those paintings being scattered all over the world, I was overcome by a sense of loss. It was not just that the artist had intended them as a set or that the volume had remained intact for more than four centuries. What really bothered me, I came to realize, was that Le Moyne himself seemed to be vanishing as fast as he reappeared.

THE HAMLET OF MORGUES contains no more than twenty modest homes, pressed together by a smothering embrace of cornfields. In the distance stands an old wooden windmill, the only local landmark. There are no stores, no restaurants, no commercial buildings of any sort, unless you count barns. The place would be the very definition of bucolic if not for the occasional roof-rattling flyover by military planes from a nearby airbase.

A lone country lane winds through Morgues, its course unaffected by modern grids, still conforming, apparently, to the contours of some ancient animal path. It may have been on this road that Le Moyne began his adventure. Now it was where mine would end.

At the far end of the hamlet I came upon an old man, leather-skinned with a neck like a tortoise, whose most striking attribute, other than some prominent white sideburns, was his lack of clothing. Wearing only underpants and slippers, he was tending his garden with the unself-conscious air of a man alone in his living room.

He had never heard of Jacques Le Moyne. Nonetheless he invited me into his cottage, promising to make a phone inquiry on my behalf. There seemed something otherworldly about this half-clad ancient, as if he'd been plucked from the same fairy tale as the lawn gnomes that lined his garden, and it occurred to me that this soil might have produced the very flowers, fruits, and vegetables Le Moyne had enshrined for the ages in his exquisitely detailed paintings. As my host ushered me toward his door, past a little pond of glittering goldfish, I was gripped by a strange feeling that he might turn up some clue that would help me close my quest. His call to a local history buff proved futile, however, so I offered the old gardener my thanks and left him standing in his skivvies outside his house.

On my way back down the lane, I met a middle-aged man in Harold Lloyd glasses riding an antique bicycle. He, too, was unfamiliar with the artist and declared that there was no one in Morgues named Le Moyne. I garnered even less information from a retired couple who had recently settled in this forgotten corner to escape the hubbub of Paris, buying a house and updating it with indoor plumbing. The hamlet seemed to be full of older people living out their days, and it occurred to me that in a few years Morgues might finally cease to exist. But if there was one thing I had learned from the centuries-long saga of Jacques Le Moyne and his art, it was that some things endure against all odds.

Le Moyne liked to paint plants right down to their roots, and I had hoped that in coming here I, too, might be able to get to the bottom of things, to portray my subject in its totality. But now, standing in that

lonely lane, I realized that the truth would remain obscured. Perhaps Le Moyne's story had begun in this very spot—or perhaps Morgues was my own version of the Apalatci Mountains, a landscape formed out of false assumptions. I contemplated the place for a few more moments, gripped by an irrational wish that the artist would send me some signal from across the ages. There was only silence. So I climbed into my waiting taxi and was carried off, those drab buildings vanishing in the distance, along with bright bursts of wildflowers shooting out from the side of the road.

Acknowledgments

This book was the most difficult professional undertaking of my life, a journey both long and grueling. Luckily, I've had some excellent guides. Susanna Porter was a patient and perceptive editor, to whom I am profoundly grateful. I also consider myself blessed to have worked with Jon Karp, the original editor of this project and my mentor on *The Island of Lost Maps*. And I owe special debt of thanks to Sloan Harris, my superb agent at ICM, who pushed me hard to rethink and reshape *Painter in a Savage Land*. Also offering vital input on various drafts were Michael Paterniti, William Lychack, Kevin Davis, and Rengin Altay.

The project has received guidance from three accomplished scholars. Boston University's John T. McGrath, author of *The French in Early Florida*, read a draft of the book to check its historical accuracy. The textile historian Santina M. Levey, formerly of the Victoria and Albert Museum in London, also examined sections of the text, as did Lucia Tongiorgi Tomasi, a professor of art history at the University of Siena. All three offered invaluable suggestions.

I consider myself extremely lucky to have worked with Dominic Olariu, a talented art historian at the Heinrich Heine University of Düsseldorf, who accompanied me on my travels in France, acting as translator, fixer, and all-around wise man. I value his friendship and his scholarly insights. I am also grateful to Bernard Allaire for his transcriptions of sixteenth-century documents. Alexandra Fitzsimmons did research on my behalf in London, and Margaret P. Hannay, author of *Philip's Phoenix: Mary Sidney, Countess of Pembroke*, was kind enough to do some snooping for me during her own investigations at the Centre for Kentish Studies.

Jean Bennett, who died as this book was going to press, was generous with both her time and her memories of her late husband, Charles E.

Bennett. So was the late congressman's son, James Bennett. I would also like to thank current and former Fort Caroline National Memorial staff members Craig Morris, Paul Ghiotto, John Whitehurst, and especially Anne R. Lewellen, who went well out of her way to help me on several occasions. The archaeologists Robert Thunen, Keith Ashley, Jerald T. Milanich, and Chester B. DePratter gave me exceptional assistance and access, as did Rebecca Gorman, whose fascinating work on the possible site of Fort Caroline deserves more attention than it wound up getting in this book. W. Graham Arader III, as always, was open to my inquiries and frank in his responses.

The list of librarians who have showed me kindness during the course of my research is as long as Jacques Le Moyne's journey across the Atlantic and back. Space allows me to mention only a few: R. Russell Maylone at Northwestern University, Robert Karrow and the entire staff at the Newberry Library, Brian Leigh Dunnigan, Clayton Lewis, and Oksana Linda at the William L. Clements Library, Gina Douglas and Lynda Brooks at The Linnean Society of London, Lucy Gwynn of the Huguenot Society of Great Britain and Ireland, Mark Greenberg and Merilyn Burke at the University of South Florida, Salima Desavoye-Aubry at the Médiathèque Jean-Renoir in Dieppe, and the helpful curators of the Archives Départementales d'Eure et Loir.

I was blessed to work with top-notch professionals at Random House, including Jillian Quint, Benjamin Dreyer, Vincent La Scala, Will Georgantas, Beck Stvan, Barbara M. Bachman, and Deborah Foley. I would also like to thank, in no particular order, Tom Henry and Francesca Castaño, Liana Fruchtman Colas and Jean-Pierre Colas, Mark and Rita Allen, Dave and Kristen Huffman-Gottschling, Ian Belknap and Hallie Gordon, Jean and Monique Legeard, Susan Kosinski, Jean Franczyk, Rachel Hradecky, Carla Zecher, Art Holzheimer, Kristyn Keene, Frederic J. Baumgartner, Peter Bower, Kay Staniland, Cristiana Romalli, Paul E. Hoffman, Nira Kaplan, Yannick Grandcolas, Klaus Tappe, Michael Hallett, John F. Pruski, John L. Strother, James J. White, Gill Saunders, and Tamara Spike.

The Illinois Arts Council provided me with a fellowship during my work on this book. I am also grateful to Simon and Kimberly Blattner, as

well as to the English Department at Northwestern University, where I was proud to be the 2007 Simon Blattner Visiting Assistant Professor of Creative Writing. It has been a pleasure to work with a group of gifted colleagues at Northwestern, including Reginald Gibbons, S. L. Wisenberg, John Keene, Brian Bouldrey, Sheila Donohue, and Michael McColly. Thanks, as well, to Stephanie Friedman and Cary Nathenson at the University of Chicago, and to all my students at both schools.

I write this from the University of Michigan, where I am a Knight-Wallace journalism fellow for 2007–2008. It has been a hugely enriching experience, for which I would like to thank Charles and Julia Eisendrath, Birgit Rieck and the rest of the staff at Wallace House, as well as my wonderful and inspiring colleagues.

Now that this tome is published, I can only hope that my mother, Tinker Harvey, will stop asking me to remind her of the main character's name. No, Mom, it's not Jacques Cousteau. But here's one detail I hope you'll never forget: your faith and love mean the world to me. Likewise, I get endless inspiration from my brother, Matthew Harvey, and from my super-pals in El Grupo del Hombres, The Writers Who Rarely Meet, Club Linscott, Operation Elephant House and the cult of C.L.U.C.K.

For five long years, my beautiful wife and children—Rengin, Azize, and Julian—have had to put up with an irritating houseguest named Old Uncle Jacques. They have been more than patient, but they will not be sorry to see him go. I confess that I've finally grown tired of him, too. He's been a fascinating companion, but a demanding one, and the more he has dragged me away from my family, the more I have realized how much I adore them. So thanks for everything, old man, but it's time to pull on your boots and pack up your paints and brushes, your armor, your rusty arquebus. You can take your historical mysteries with you, too. Go bother some other writer. I'm taking the kids to the movies. Adieu, Uncle Jacques, adieu!

Notes

INTRODUCTION: UNSTILL LIFE

xiv *sale at Sotheby's* See Cristiana Romalli, "An Explorer's Eye," *Sotheby's Preview* (January 2004): 58–59. See also the Sotheby's catalog *Old Master Drawings: Including an Important Set of Natural History Studies by Jacques le Moyne de Morgues* (New York: Sotheby's, 2004), pp. 38–66.

xiv *"a great deal of schmoozing"* Catherine Bindman, "Art Market Watch," Feb. 4, 2004, from the online magazine Artnet, http://www.artnet.com/magazine/news/bindman/bindman2-4-04.asp.

xiv *$85,000 for a study of a dragonfly* These prices, of course, do not include the buyer's premium or taxes.

xvi *sprawling area* The French cosmographer André Thevet, a contemporary of Le Moyne, portrayed Florida as so expansive that "the country of Canada . . . neighbors it to the north, [there] being only a few mountains between them." See André Thevet, *André Thevet's North America: A Sixteenth-Century View,* trans. Roger Schlesinger and Arthur P. Stabler (Kingston, Ont.: McGill–Queen's University Press, 1986), p. 127.

xvii *"curiously inexact"* Francis Parkman, *Pioneers of France in the New World* (Lincoln: University of Nebraska Press, 1996), footnote 1, p. 50.

xvii *"compiled from a series of disjunct sketches"* R. A. Skelton, "The Le Moyne–De Bry Map," in Paul Hulton et al., *The Work of Jacques Le Moyne de Morgues: A Huguenot Artist in France, Florida and England* (London: Published for the Trustees of the British Museum by British Museum Publications, 1977), vol. I, p. 53.

xvii *an important map* In fact, many of the details—and errors—of Le Moyne's map were repeated in other cartographic works for more than 150 years. See William P. Cumming, *The Southeast in Early Maps,* 3rd ed., revised and enlarged by Louis De Vorsey, Jr. (Chapel Hill: University of North Carolina Press, 1998), p. 126.

xix *"The essence of the explorer's peculiar profession"* Eric Leed, *Shores of Discovery: How Expeditionaries Have Constructed the World* (New York: BasicBooks, 1995), p. 13.

CHAPTER ONE: FORBIDDEN FLESH, FORBIDDEN FRUIT

3 *unicorns roamed* An important map made in 1550 by Pierre Desceliers, a leader in the Dieppe school of cartography, prominently depicts a unicorn in North America. The Spanish also believed La Florida was inhabited by unicorns.

4 *three hundred soldiers and sailors* See deposition of Stefano de Rojomonte in Charles E. Bennett, *Laudonnière & Fort Caroline: History and Documents* (Tuscaloosa: University of Alabama Press, 2001), p. 95.

4 *first French attempt to establish a settlement in La Florida* For a good summary of this expedition, see John T. McGrath, *The French in Early Florida: In the Eye of the Hurricane* (Gainesville: University Press of Florida, 2000), pp. 73–83. For a sixteenth-century account, see René Laudonnière, *Three Voyages*, trans. Charles E. Bennett (Tuscaloosa: University of Alabama Press, 2001, c. 1975), pp. 17–51. This book, which I quote from frequently, also contains Laudonnière's account of the 1564–1565 voyage. It was originally published in 1586 as *L'Histoire Notable de la Floride*.

4 *"They were restricted"* This passage from Henri Lancelot Voisin's *Les Trois Mondes* (Paris, 1582) is reproduced in Bennett, *Laudonnière & Fort Caroline*, pp. 81–82.

5 *as many as four survivors* See depositions of Robert Meleneche and Stefano de Rojomonte in Bennett, *Laudonnière & Fort Caroline*, pp. 88, 97, as well as Laudonnière, *Three Voyages*, p. 113. Meleneche and Rojomonte accompanied Laudonnière to Florida and were among the mutineers later captured by the Spanish. Under questioning from Spanish authorities, Meleneche said four Charlesfort survivors had returned to Florida in 1564; Rojomonte testified that only one survivor was on the new expedition.

5 *second French expedition* One colonist later described the flagship as being "over 200 tons," while another stated that the vessel was three hundred tons. Likewise, one colonist put the *Petit Breton* at 120 tons, while the second described it as being two hundred tons. See depositions of Robert Meleneche and Stefano de Rojomonte in Bennett, *Laudonnière & Fort Caroline*, pp. 87–88, 94.

5 *"On our arrival"* Jacques Le Moyne de Morgues, "Narrative of Jacques Le Moyne de Morgues," trans. Neil M. Cheshire, in Hulton et al., *The Work of Jacques Le Moyne de Morgues*, vol. 1, p. 119. I also occasionally draw from three other versions of Le Moyne's *Brevis Narratio Eorum Quae in Florida Americae Provincia Gallis Acciderunt*: the original English translation by Fred B. Perkins, which was republished as "The Narrative of Le Moyne" in Charles E. Bennett, comp., *Settlement of Florida* (Gainesville: University of Florida Press, 1968); a more informal translation in Stefan Lorant, ed.,

The New World: The First Pictures of America, rev. ed. (New York: Duell, Sloan and Pearce, 1965); and some translations of Le Moyne's picture captions from Sarah Lawson, *A Foothold in Florida: The Eye-Witness Account of Four Voyages Made by the French to That Region and Their Attempt at Colonization, 1562–68, Based on a New Translation of Laudonnière's "L'Histoire Notable de la Floride"* (West Sussex, England: Antique Atlas Publications, 1992).

6 *as much as 15 percent of the population* See Frederic J. Baumgartner, *France in the Sixteenth Century* (New York: St. Martin's Press), p. 148.

6 *"without doubt a man of many accomplishments"* Le Moyne in Hulton et al., *The Work of Jacques Le Moyne de Morgues,* vol. 1, p. 119.

6 *"not so experienced in military theory"* Ibid.

6 *"too easily influenced by others"* Le Moyne in Bennett, *Settlement of Florida,* p. 95.

6 *late May or early June of 1564* The chronology is fuzzy here. Laudonnière wrote that the fleet left the Canary Islands on May 5 and sailed fifteen days before reaching the Lesser Antilles. This would seem to put the arrival in late May. But later he wrote that it took fifteen days to reach Florida from Dominica; because the Florida landing was June 25, this would seem to suggest a later arrival on the island.

7 *"excellent fruit"* See John F. Mariani, *The Dictionary of American Food and Drink,* rev. ed. (New York: Hearst Books, 1994), p. 235.

8 *"ferocious and loathsome people"* Quoted in Susi Colin, "The Wild Man and the Indian in Early 16th Century Book Illustration," in *Indians and Europe: An Interdisciplinary Collection of Essays,* ed. Christian F. Feest (Lincoln: University of Nebraska Press, 1999), p. 19. For more information on this woodcut, see Colin's essay as well as Frank Lestringant, *Cannibals: The Discovery and Representation of the Cannibal from Columbus to Jules Verne,* trans. Rosemary Morris (Berkeley: University of California Press, 1997), pp. 15–22.

8 *"with dogs' snouts who eat men"* Christopher Columbus, *The Log of Christopher Columbus,* trans. Robert H. Fuson (Camden, Maine: International Marine Publishing, 1987), p. 102.

8 *Conflating two mythical races of antiquity* Columbus soon added another monster to the mix, claiming that the Indians told him of a dog-headed man-eater who had only one eye, like a Cyclops. "I do not believe any of this," he wrote. "I feel that the Indians they fear belong to the domain of the Great Khan." In other words, he thought the cannibals were from China. Ibid., pp. 117–18.

8 *"Caniba"* Ibid.

8 *"brave men"* Robert K. Barnhart, ed., *The Barnhart Concise Dictionary of Etymology* (New York: HarperCollins, 1995), p. 102.

8 *matter of debate* See Philip P. Boucher, *Cannibal Encounters: Europeans and Island Caribs, 1492–1763* (Baltimore: Johns Hopkins University Press, 1992), pp. 6–7.

8 *"a man's neck . . . cooking in a pot"* Account of Diego Álvarez Chanca in Peter

Hulme and Neil L. Whitehead, eds., *Wild Majesty: Encounters with Caribs from Columbus to the Present Day: An Anthology* (Oxford: Clarendon Press, 1992), p. 34.

8 *"allowed open season on all Indians"* Boucher, *Cannibal Encounters: Europeans and Island Caribs, 1492–1763,* p. 16.

8 *"as a cannibal, chopping up another Indian"* Hugh Honour, *The New Golden Land: European Images of America from the Discoveries to the Present Time* (New York: Pantheon Books, 1975), p. 57.

8 *Wild Man of the Woods* See Olive Patricia Dickason, *The Myth of the Savage: And the Beginnings of French Colonialism in the Americas* (Edmonton: The University of Alberta Press, 1984), pp. 70–80.

10 *sending painters to distant lands* See Helen Wallis's description of Norman artist-adventurers in *The Maps and Text of the Boke of Idrography Presented by Jean Rotz to Henry VIII, Now in the British Library,* ed. Helen Wallis (Oxford: Printed for presentation to the members of the Roxburghe Club, 1981), pp. 44–45.

10 *"the medium for the quick notation"* Graham Reynolds, *Watercolors: A Concise History* (New York: Thames and Hudson, 1971), p. 12.

10 *"to chart the sea-coast"* Le Moyne in Hulton et al., *The Work of Jacques Le Moyne de Morgues,* vol. 1, p. 119.

10 *Le Moyne's patron was King Charles himself* Paul Hulton, "Jacques Le Moyne de Morgues: A Biographical Sketch," in ibid., p. 4.

10 *Men of the island went completely naked* See descriptions of Caribs in accounts of various early explorers in Hulme and Whitehead, eds., *Wild Majesty.* See also the section on Caribs in *Native Peoples A to Z,* vol. 2, ed. Frank H. Gille, (Santa Barbara, Calif.: Native Peoples Press, 2000), pp. 495–506.

10 *"like devils"* The seventeenth-century adventurer John Nicholl, quoted in Hulme and Whitehead, eds., *Wild Majesty,* p. 68.

11 *"As they approached our barque"* Laudonnière, *Three Voyages,* p. 56.

11 *castrating captives from rival groups* See, for example, the account of Diego Álvarez Chanca, who accompanied Columbus on his second voyage, in Hulme and Whitehead, eds., *Wild Majesty,* p. 34.

11 *"a shirt and certain trifles"* Laudonnière, *Three Voyages,* p. 56.

11 *"Spanish civilization crushed the Indian"* Francis Parkman, *The Jesuits of North America in the Seventeenth Century* (Boston: Little, Brown and Company, 1867), p. 44.

11 *"conquest by love"* Patricia Seed, *Ceremonies of Possession in Europe's Conquest of the New World, 1492–1640* (New York: Cambridge University Press, 1995), p. 56.

11 *many similar instructions in the past* See Bill M. Donovan's introduction to Bartolomé de las Casas, *The Devastation of the Indies: A Brief Account,* trans. Herma Briffault (Baltimore: Johns Hopkins University Press, 1992), pp. 6–7, and Henry Kamen, *Philip of Spain* (New Haven: Yale University Press, 1997), pp. 23, 30.

11 *all but alien* The dearth of Spanish artists in the New World constitutes what one expert called a "great gap" in history. Only two painters could arguably compete with Le Moyne for the title of first European artist in North America, but the case for both is weak. Rodridgo de Cifuentes is often reported to have accompanied Hernando Cortés on an expedition to Honduras in 1525. But modern scholars have determined that the entire story was a fraud, the apparent practical joke of a nineteenth-century writer. Another artist, Cristóbal de Quesada, may have accompanied Francisco Vázquez de Coronado during his 1540–1542 wanderings through the American west. But none of his paintings survive, and there appears to be no firm evidence he took part in the journey. See Manual Toussaint, *Colonial Art in Mexico,* trans. and ed. Elizabeth Wilder Weismann (Austin: University of Texas Press, 1967), p. 47.

11 *Gonzálo Fernández de Oviedo y Valdés* See Fredi Chiappelli, ed., *First Images of America: The Impact of the New World on the Old,* vol. 1, co-ed. Michael J. B. Allen and Robert L. Benson (Berkeley: University of California Press, 1976), pp. 424–25. See also Paul Hulton and David Beers Quinn, *The American drawings of John White, 1577–1590,* vol. 1 (London: Trustees of the British Museum; Chapel Hill: University of North Carolina Press, 1964), pp. 31–32.

12 *"no request seems to have been made for drawings"* Hulton and Quinn, *The American drawings of John White,* p. 33.

12 *Simón Pereyns* While in Mexico, Pereyns was arrested by the Holy Office of the Inquisition and charged with, among other things, preferring to paint portraits rather than saints. As punishment, he was forced to paint additional religious scenes. One can only imagine what would have become of him had he dared to paint portraits of Native Americans. See Toussaint, *Colonial Art in Mexico,* p. 134.

12 *"In wisdom, skill, virtue and humanity"* Quoted in Tzvetan Todorov, *The Conquest of America,* trans. Richard Howard (New York: Harper & Row, 1987), p. 153. Sepúlveda advocated a "just war" against the Indians. He was famously opposed by Bartolomé de Las Casas, a Dominican missionary and outspoken critic of Spanish cruelties in the New World. Not surprisingly, someone in Las Casas's circle—perhaps another missionary—appears to have produced a few of the only Spanish images of native Mexicans painted in the New World. See Honour, *The New Golden Land,* p. 62.

13 *"flavor and fragrance"* Quoted in Waverly Root, *Food: An Authoritative and Visual History and Dictionary of the Foods of the World* (New York: Smithmark, 1980), p. 356. The other explorers' quotes on the pineapple also come from this source.

13 *"pine of the Indies"* Mariani, *The Dictionary of American Food and Drink,* p. 235.

14 *"begged us not to go near their homes"* Laudonnière, *Three Voyages,* p. 58.

14 *more than a source of food* See Root, *Food,* p. 354.

14 *"One day some of our Frenchmen"* Laudonnière, *Three Voyages,* p. 58.

CHAPTER TWO: FIRST SIGHT

16 *"the whole coastline"* Le Moyne in Hulton et al., *The Work of Jacques Le Moyne de Morgues*, p. 120.

16 *"regarded it as a miracle"* Peter Martyr, *De Orbe Novo: The Eight Decades of Peter Martyr D'Anghera*, vol. 2, trans. Francis Augustus MacNutt (New York: G.P. Putnam's Sons, 1912), p. 255.

16 *"They were somewhat astonished"* Le Moyne in Hulton et al., *The Work of Jacques Le Moyne de Morgues*, vol. 1, p. 120.

16 *with four hundred tattooed men and bare-breasted women* The number comes from an eyewitness account by an unknown author, "Copy of a Letter Coming from Florida," in Bennett, *Laudonnière & Fort Caroline*, p. 66.

17 *one of the local chieftains* Laudonnière identifies this man as Saturiwa, who was "accompanied by two of his children"; Le Moyne identifies him as Saturiwa's son (though in fact he may have been a son-in-law) Atore. A third French witness mentions "three chiefs." It may be that Saturiwa was present but that Atore was sent forward to greet the French.

17 *When they had exchanged gifts* Le Moyne in Hulton et al., *The Work of Jacques Le Moyne de Morgues*, vol. 1, p. 141.

17 *first eyewitness depiction of the New World* This is Le Moyne's first known portrayal of the 1564 voyage; his images of the 1562 journey were probably not based on his own experience. We can be fairly sure that Le Moyne witnessed this particular scene firsthand, in part because he refers to the French who were present in the first-person plural and in part because his description of the incident differs from others who were present, indicating, in the words of the researcher W. John Faupel, "an independent recollection of the same event." See W. John Faupel, "An Appraisal of the Illustrations," in Lawson, *A Foothold in Florida*, p. 169.

17 *an ornate ceremony in 1562* See Seed, *Ceremonies of Possession in Europe's Conquest of the New World, 1492–1640*, pp. 57–58.

18 *a complex protocol of symbolic acts* See ibid., pp. 1–15, 41–68. See also Stephen Greenblatt, *Marvelous Possessions: The Wonder of the New World* (Chicago: The University of Chicago Press, 1991), pp. 55–56.

18 *"Drawing close [the French] noticed that the Indians were worshipping this stone"* Le Moyne in Hulton et al., *The Work of Jacques Le Moyne de Morgues*, vol. 1, p. 141.

19 *Saturiwa* This name is also spelled "Satouriwa," "Saturioa," "Saturiona," "Satouriona," "Satoriva," or "Saturiba" in various accounts. I generally use the spellings of Native American names found in Jerald T. Milanich, *The Timucua* (Cambridge, Mass.: Blackwell Publishers, 1996). Le Moyne's illustration does not depict Saturiwa, but his son (or son-in-law) Atore. Laudonnière places both Saturiwa and Atore at the stone column. Le

Moyne mentions only Atore—who, in various narratives, is also identified as "Athore" or "Etore"—as being at the site, though he does not explicitly exclude Saturiwa. The other eyewitness account, a letter home from an anonymous Frenchman, does not mention any Indians by name.

19 *"he seemed to be very well pleased"* Laudonnière, *Three Voyages,* p. 61.

19 *"grossly unequal gift exchange"* Greenblatt, *Marvelous Possessions,* p. 110.

19 *eleven gross of mirrors and some felt hats* See Eugene Lyon, "Forts Caroline and San Mateo: Vulnerable Outposts" (unpublished: funded by grants from the Fort Caroline National Memorial and National Parks Association, 1982), p. 5.

19 *almost twenty thousand square miles* See Milanich, *The Timucua,* p. 60. This book is the source for much of my information on the Timucua, pp. 56–60 and 150–51. See also John H. Hann, *A History of the Timucua Indians and Missions* (Gainesville: University Press of Florida, 1996), pp. 4–8, 21–25, and 122–36.

20 *begun to assert their strength* See McGrath, *The French in Early Florida,* pp. 103–104, as well as John E. Worth, *The Timucuan Chiefdoms of Spanish Florida,* vol. 1 (Gainesville: University Press of Florida, 1998), pp. 19–23.

20 *Utina* The name is also spelled "Outina," "Hotina," and "Aotina" in various texts.

20 *"We stayed with the marker for half an hour"* Author unknown, "Copy of a Letter Coming from Florida," in Bennett, *Laudonnière & Fort Caroline,* p. 67.

20 *TYMANGOUA* Laudonnière wrote the same word as "Thimogona." This term, used by Saturiwa's people to describe their enemies, may be the source from which "Timucua" derives. See Milanich, *The Timucua,* p. 46.

21 *"a number of little trinkets"* Laudonnière, *Three Voyages,* p. 62.

21 *"I was of the opinion"* Ibid., p. 68.

21 *"The sea may be seen clearly and openly from [the site]"* Ibid., p. 65.

21 *"The place is so pleasant"* Here I use the translation from Lawson, *A Foothold in Florida,* p. 56.

22 *"favorable and happy arrival"* Laudonnière, *Three Voyages,* p. 70.

22 *"The chief was escorted by seven or eight hundred splendid-looking men"* Le Moyne in Hulton et al., *The Work of Jacques Le Moyne de Morgues,* vol. 1, pp. 120–21.

22 *"To increase his friendship"* Laudonnière, *Three Voyages,* p. 66.

22 *"Gifts were presented on both sides"* Le Moyne in Hulton et al., *The Work of Jacques Le Moyne de Morgues,* vol. 1, p. 121.

23 *"Our fort was quickly built"* Ibid.

23 *"are very improbable—really impossible—for Florida"* William C. Sturtevant, notes on the illustration, in Hulton et al., *The Work of Jacques Le Moyne de Morgues,* vol. 1, p. 163.

23 *the library of a chateau outside Paris* See E. T. Hamy, "Sur Une Miniature de Jacques Le Moyne de Morgues, Représentant une Scène de Vòyage de

Laudonnière en Floride (1564)," Académie des Inscriptions et Belles-Lettres, *Comptes Rendus des Séances de l'Année 1901*, vol. I (Paris: 1901): pp. 8–17.

24 *"outrageously wrong"* Christian F. Feest, "Jacques Le Moyne Minus Four," in *European Review of Native American Studies*, vol. I, no. I (1988): pp. 33–39.

24 *"near-contemporaneous copy by an anonymous artist"* Ibid.

CHAPTER THREE: *CÓRSARIOS*

25 *Hernando Manrique de Rojas* His journey is summarized in Paul E. Hoffman, *A New Andalucia and the Way to the Orient: The American Southeast During the Sixteenth Century* (Baton Rouge: Louisiana State University Press, 1990), pp. 213–15, and Eugene Lyon, *The Enterprise in Florida: Pedro Menéndez de Avilés and the Spanish Conquest of 1565–1568* (Gainesville: University Press of Florida, 1983), pp. 33–34. See also "Manrique de Rojas' Report on French Settlement in Florida, 1564," trans. Lucy L. Wenhold, in *The Florida Historical Quarterly*, vol. 38, no. I (July 1959): pp. 45–62. The quotes I use here come from this translation.

26 *"one of the best men of the sea in Christendom"* Quoted in McGrath, *The French in Early Florida*, p. 52.

26 *"held prisoner under close guard"* The Spanish later used Rouffi to interrogate captured mutineers from Fort Caroline. He served the Spanish for four years as an interpreter before his short life came to an end in Florida in 1568. See Eugene Lyon, "Captives of Florida," in *The Florida Historical Quarterly*, vol. 50, no. I (July 1971): pp. II, 22.

26 *a day those officials remembered all too well* For information on Sores's raid, see I. A. Wright, *The Early History of Cuba, 1492–1586* (New York, Octagon Books, 1970), pp. 233–41; Kenneth R. Andrews, *The Spanish Caribbean: Trade and Plunder, 1530–1630* (New Haven: Yale University Press, 1978), pp. 83–84; and Jan Rogozinski, *Pirates!: Brigands, Buccaneers, and Privateers in Fact, Fiction, and Legend* (New York: Facts on File, 1995), p. 323.

27 *hacked up the Virgin Mary* See a Spanish report on the raid in *Colección de Documentos Inéditos Relativos al Descubrimiento, Conquista y Organización de las Antiguas Posesiones Españolas de Ultramar*, ser. 2, vol. 6, ed. Real Academia de la Historia (Madrid: Est. tip. Sucesores de Rivadeneyra, 1891), p. 373.

27 *"huge Lutheran heretic"* Ibid.

28 *"an armed fleet from France"* Christopher Columbus, *Four Voyages to the New World*, trans. and ed. R. H. Major (New York: Citadel Press, 1961), p. III.

28 *Jean Fleury* See Rogozinski, *Pirates!*, pp. 124–25; Kris E. Lane, *Pillaging the Empire: Piracy in the Americas, 1500–1750* (Armonk, N.Y.: M. E. Sharpe, 1998), p. 18; Peter Wood and the editors of Time-Life Books, *The Spanish Main* (Alexandria, Va.: Time-Life Books, 1979), pp. 17–18; and Charles de La

Roncière, *Histoire de la Marine Française,* vol. 3 (Paris: E. Plon, Nourritt et cie, 1906), pp. 244–55.

28 *680 pounds of pearls, five hundred pounds of gold dust* See Wood et al., *The Spanish Main,* p. 18.

28 *"so marvelous"* Quoted in ibid., p. 17.

29 *Jean Ango* See Wallis, "Jean Ango and the Dieppe Voyages," in *The Maps and Text of the Boke of Idrography,* pp. 3–5; McGrath, *The French in Early Florida,* p. 14; La Roncière, *Histoire de la Marine Française,* vol. 3, pp. 244–55, 305–306; and Rogozinski, *Pirates!,* pp. 10–11.

29 *François Le Clerc* See Andrews, *The Spanish Caribbean,* p. 83; Rogozinski, *Pirates!,* p. 194; and La Roncière, *Histoire de la Marine Française,* vol. 3, pp. 574–79.

29 *"the men had not a coat to their backs"* Quoted in Wright, *The Early History of Cuba,* p. 234.

29 *forty Jesuit missionaries* See Rogozinski, *Pirates!,* p. 323, and McGrath, *The French in Early Florida,* p. 167.

30 *condemned to serve at the oars* See Hoffman, *The New Andalucia,* p. 140, and McGrath, *The French in Early Florida,* p. 113.

30 *largest kingdom in the world* See Kamen, *Philip of Spain,* p. 64.

30 *"the vulnerability of Spain"* Ibid., p. 89.

30 *thirty-five million pounds of American silver* See J. H. Elliott, *Imperial Spain, 1469–1716* (London: Penguin, 1990), p. 183. Elliott gives these figures in kilograms. I've converted them to pounds.

31 *flotas* See Andrews, *The Spanish Caribbean,* pp. 65–69; McGrath, *The French in Early Florida,* pp. 20–21; Wood et al., *The Spanish Main,* pp. 30–31, 42–51. See also Timothy R. Walton, *The Spanish Treasure Fleets* (Sarasota, Fla.: Pineapple Press, 1994), pp. 44–64.

31 *Conditions were unfavorable* See "Manrique de Rojas' Report on French Settlement in Florida, 1564," p. 63.

32 *"full of unknown lands and seas"* Giles de Pysière, "Description of the Land and Sea Animals and Monstrous Beasts Encountered on the Island of Florida," in Bennett, *Laudonnière & Fort Caroline,* pp. 74–75.

CHAPTER FOUR: FORT

34 *"was tender"* Nicolas Le Challeux, a carpenter who went to Florida with Jean Ribault in 1565, published his memoirs of the event the following year under the title *Discours de l'Histoire de la Floride.* This translation is from Lorant, *The New World,* p. 96.

34 *"sweet and plump"* See deposition of Robert Meleneche in Bennett, *Laudonnière & Fort Caroline,* p. 91.

34 *singing psalms in the afternoon* See Wiley L. Housewright, *A History of Music and*

Dance in Florida, 1565–1865 (Tuscaloosa: The University of Alabama Press, 1991), pp. 35–36.

34 *a revolution in military architecture* See Lyon, "Fort Caroline and San Mateo: Vulnerable Outposts," pp. 18–22. See also Ian V. Hogg, *The History of Forts and Castles* (New York: Crescent Books, 1985), pp. 100–101, as well as Christopher Duffy, *Fire and Stone: The Science of Fortress Warfare, 1660–1860,* new ed. (Mechanicsburg, Penn.: Stackpole Books, 1996), pp. 9–10.

34 *"that is the only cover"* Laudonnière, *Three Voyages,* p. 72.

34 *"a building was erected"* Le Moyne in Hulton et al., *The Work of Jacques Le Moyne de Morgues,* vol. 1, p. 142.

34 *sixty houses within its walls and twenty more outside* This information comes from a Spanish source, quoted extensively in Lyon, "Fort Caroline and San Mateo: Vulnerable Outposts," pp. 20–21.

35 *Gaspard de Coligny* See McGrath, *The French in Early Florida,* pp. 33–40, 56–66. See also J. Shimizu, *Conflict of Loyalties: Politics and Religion in the Career of Gaspard de Coligny, Admiral of France, 1519–1572* (Geneva, Switzerland: Librairie Droz, 1970), pp. 23–31, 112–16.

35 *admiral of France* This was not a naval title. Coligny was in charge of coastal defenses and is not known to have ever taken an oceangoing voyage.

35 *one hundred thousand francs* Le Moyne himself cites this sum. See Hulton et al., *The Work of Jacques Le Moyne de Morgues,* vol. 1, p. 119.

35 *forced to publicly protest his innocence* See R. J. Knecht, *The Rise and Fall of Renaissance France, 1483–1610,* second ed. (Oxford: Blackwell Publishers, 2001), p. 322.

35 *provoke the Spanish into a war* See McGrath's summary in *The French in Early Florida,* pp. 57–61. He disputes the arguments of other historians that Coligny hoped to unite the French against a common Spanish enemy.

36 *"do no wrong against the subjects of the king of Spain"* Laudonnière, *Three Voyages,* p. 99.

36 *criminals who had been promised their freedom* See Giles de Pysière, "Discourse of the Venture by the Criminals of the Island of Florida Against their Captains and Governors," in Bennett, *Laudonnière & Fort Caroline,* pp. 72–74. Pysière, a captain associated with the mission, wrote that "all the criminals whom we had brought from the Kingdom of France" were freed upon their arrival in Florida, "except that none of them was allowed to leave the shores of that land."

36 *about fifty "Africans of unrecorded countries"* See deposition of Robert Meleneche in ibid., pp. 88, 89.

36 *granted their liberty upon arrival* Pysière mentioned "captives whom we had taken prisoner in the environs of [Florida]," who, like the French convicts, were "granted the right to live in complete freedom and to roam." The historian John T. McGrath posited that these men were "captured Spaniards," whom the French had taken prisoner en route to Florida. But Pysière himself described them as "Moors and savages," an indication,

perhaps, that they were not Spanish nationals but the "Africans of un-recorded countries" noted by Meleneche. It was not unusual for French corsairs to liberate black slaves in the West Indies. See Pysière, "Dis-course of the Venture by the Criminals of the Island of Florida Against their Captains and Governors," in ibid, p. 72, and McGrath, *The French in Early Florida,* p. 107.

36 *a small number of women* Meleneche later told his Spanish captors that "four housewives" were among the ranks of the colonists. See deposition of Robert Meleneche in ibid, p. 89.

36 *"a poor chambermaid"* Laudonnière, *Three Voyages,* p. 155.

36 *adultery by death* See Robert M. Kingdon, *Adultery and Divorce in Calvin's Geneva* (Cambridge, Mass.: Harvard University Press, 1995), pp. 116–19.

36 *"minister of God's Word"* Le Moyne in Hulton et al., *The Work of Jacques Le Moyne de Morgues,* vol. 1, p. 122.

37 *"a great many noblemen"* Ibid., p. 119. His other quotes about these aristocrats are on p. 121.

37 *"evidence of the importance attached to his mission"* Hulton, *The Work of Jacques Le Moyne de Morgues,* vol. 1, p. 4.

37 *a puzzle to historians* See Hulton's notes on the engravings in *The Work of Jacques Le Moyne de Morgues,* vol. 1, pp. 205–206. See also Faupel, "An Ap-praisal of the Illustrations," in Lawson, *A Foothold in Florida,* pp. 169–70, as well as Paul H. Gissendaner, "The Proposed Location of the 1565 French Huguenot Fort Le Caroline," in *The Florida Anthropologist,* vol. 49, no. 3 (September 1996): pp. 131–48. It was Gissendaner who insisted, "Fort Caroline was constructed as an elongated arrow."

39 *"a certain place near a hill"* Le Moyne in Hulton et al., *The Work of Jacques Le Moyne de Morgues,* vol. 1, p. 142.

41 *a dazzling discovery* Most of the information from this section comes from my phone conversations with Chester B. DePratter. See also DePratter and Stanley South, "Charlesfort: The 1989 Search Project," Research Manuscript Series 210, University of South Carolina, S.C. Institute of Archeology and Anthropology), pp. 11–17.

CHAPTER FIVE: AMONG THE INDIANS

44 *"when . . . out hunting with some of my companions"* Here I use the translation from Lawson, *A Foothold in Florida,* p. 53.

44 *"an evening walk alone"* Le Moyne in Hulton et al., *The Work of Jacques Le Moyne de Morgues,* vol. 1, p. 151.

44 *"Next to the chief walked two young men"* Again I use the translation from Law-son, *A Foothold in Florida,* p. 53.

44 *"Because their gestures and countenances are so different"* Quoted in Dickason, *The Myth of the Savage,* p. 17.

45 *received his training as a botanical painter* The forensic paper historian Peter Bower has used watermarks to determine that some botanical illustrations attributed to Le Moyne were drawn on French paper that can be dated to around 1540. This might seem to suggest that Le Moyne was already working as a flower painter *before* he left for Florida—though Bower himself warns against such a conclusion. In phone and e-mail correspondence, he noted that throughout the sixteenth century, there were "considerable variations between the date of making of a paper and its use," and that given the sophistication of the drawings, he suspects Le Moyne simply executed them on older paper. For more information on Bower's work, see the Sotheby's catalog *Old Master Drawings: Including an Important Set of Natural History Studies by Jacques le Moyne de Morgues,* p. 39. See also Peter Bower, "Powerful Connections: Interdisciplinary Collaboration in the Investigation and Discovery of Works of Art on Paper," in *Edinburgh Conference Papers 2006, Proceedings of the Fifth International Conference of the Institute of Paper Conservation,* ed. Shulla Jaques (London: Institute of Conservation, 2007), pp. 41–50.

45 *School of Fontainebleau* See Edward Lucie-Smith, *A Concise History of French Painting* (New York: Praeger, 1971), pp. 31–50, and Arnold Hauser, *Mannerism: The Crisis of the Renaissance and the Origin of Modern Art* (New York, Knopf, 1965), pp. 240–44.

46 *"a wondrous document of the mannerist penchant"* Gloria-Gilda Deák, *Discovering America's Southeast: A Sixteenth Century View Based on the Mannerist Engravings of Theodore de Bry* (Birmingham, Ala.: Birmingham Public Library Press, 1992), p. 128. Her other quotes in this section come from the same passage.

46 *"it took two days to remove the bodies"* Quoted in Philip Benedict, *Rouen During the Wars of Religion* (New York: Cambridge University Press, 1981), p. 102.

47 *"almost as dangerous as being one"* Jacques Barzun, *From Dawn to Decadence: 500 Years of Western Cultural Life, 1500 to the Present* (New York: HarperCollins, 2000), p. 137.

47 *"so many tall, bearded men"* Michel de Montaigne, "On Cannibals," in *Essays,* trans. J. M. Cohen (Harmondsworth, England: Penguin, 1993), p. 119. Montaigne's other quotes also come from this same translation of the essay, pp. 105–19.

48 *believed would mark the onset of the Final Judgment* See Denis Crouzet, "Circa 1533: Anxieties, Desires, and Dreams," trans. Jonathan Good, in *Journal of Early Modern History,* vol. 5, no. 1 (2001): pp. 24–61.

48 *numerical proof that the end would come* The mathematician Michael Stifel was a close friend of Martin Luther. As the moment drew near, crowds gathered at the German village of Lochau, where Stifel was pastor. When nothing happened, they trudged back home—in a foul mood, judging by

the title of a contemporary song: "Stifel Must Die." See Eugen Weber, *Apocalypses: Prophesies, Cults, and Millennial Beliefs through the Ages* (Cambridge, Mass.: Harvard University Press, 2000), pp. 91–92, as well as Martin Brecht, *Martin Luther: The Preservation of the Church, 1532–1546,* vol. 3, trans. James L. Schaaf (Minneapolis: Fortress Press, 1993), pp. 8–9.

49 *"they go there for supplies"* Here I use the translation from Lorant, *The New World,* p. 79.

49 *"They certainly put Christians to shame"* Le Moyne in Hulton et al., *The Work of Jacques Le Moyne de Morgues,* vol. 1, p. 148.

49 *"The Indians, dressed like this, were able to approach"* This time I use the translation in Lawson, *A Foothold in Florida,* p. 24.

CHAPTER SIX: PROMISED LAND

52 *"A long way from the place where our fort was built"* Le Moyne in Hulton et al., *The Work of Jacques Le Moyne de Morgues,* vol. 1, p. 152.

52 *Apalatci* In various accounts, these mountains were also called the "Apalatcy," "Appalesse," "Apalassi," "Palacy," and "Palassy."

53 *"high mountains which are full of many things"* Laudonnière, *Three Voyages,* p. 77.

53 *"which must have had as one of its prime objectives"* Hulton, *The Work of Jacques Le Moyne de Morgues,* vol. 1, p. 6.

53 *Utina* See Milanich, *The Timucua,* pp. 51–52.

53 *"His friendship was essential to us"* Le Moyne in Hulton et al., *The Work of Jacques Le Moyne de Morgues,* vol. 1, p. 122.

53 *Potano* Also spelled "Potanou" or "Potavou." See Milanich, *The Timucua,* pp. 53–54.

54 *"would return victorious"* Laudonnière, *Three Voyages,* p. 77.

54 *"friendship and everlasting alliance"* Le Moyne in Hulton et al., *The Work of Jacques Le Moyne de Morgues,* vol. 1, p. 121.

54 *"had discovered a gold and silver mine"* Author unknown, "Copy of a Letter Coming from Florida," in Bennett, *Laudonnière & Fort Caroline,* p. 70.

54 *"I would like to be shown"* Quoted in McGrath, *The French in Early Florida,* p. 12.

54 *François gained enough diplomatic leverage* See Samuel Eliot Morison, *The European Discovery of America: The Northern Voyages, A.D. 500–1600* (New York: Oxford University Press, 1971), p. 341.

55 *"certain islands and countries"* Quoted in James Axtell, *The Invasion Within: The Contest of Cultures in Colonial North America* (New York: Oxford University Press, 1985), p. 24.

55 *Francisco Pizarro* See James Lockhart, *The Men of Cajamarca: A Social and Biographical Study of the First Conquerors of Peru* (Austin: Published for the Institute of Latin American Studies by the University of Texas Press, 1972), pp. 135–41.

55 *"No loot equaled this one"* Pedro de Cieza de Lêon, *The Discovery and Conquest of Peru: Chronicles of the New World Encounter,* ed. and trans. Alexandra Parma Cook and Noble David Cook (Durham, N.C.: Duke University Press, 1998), p. 317. Cieza, an explorer and chronicler, spent much of his life in Peru, though he was not part of Pizarro's expedition.

55 *Saguenay* See Morison, *The European Discovery of North America: The Northern Voyages,* pp. 415, 420, 430–63.

55 *"They were convinced"* Henri Lancelot Voisin in Bennett, *Laudonnière & Fort Caroline,* p. 80.

56 *"not merely to confirm the treaty"* Le Moyne in Hulton et al., *The Work of Jacques Le Moyne de Morgues,* vol. 1, pp. 121–22.

56 *"some of our men were with [Utina]"* Ibid., p. 122.

56 *"wished to assist"* Laudonnière, *Three Voyages,* p. 82.

57 *"Taken aback by such a stipulation"* Ibid.

57 *"He was terribly frightened"* Again I use the translation in Bennett, *Settlement of Florida,* p. 96.

58 *"The warriors gathered around their chief"* This time the translation is from Lawson, *A Foothold in Florida,* p. 69.

59 *"Laudonnière began to ration food"* Le Moyne in Hulton et al., *The Work of Jacques Le Moyne de Morgues,* vol. 1, p. 121.

59 *roughly two hundred men* See deposition of Stefano de Rojomonte in Bennett, *Laudonnière & Fort Caroline,* p. 95.

59 *"Laudonnière was too easygoing"* Le Moyne Hulton et al., *The Work of Jacques Le Moyne de Morgues,* vol. 1, p. 121.

CHAPTER SEVEN: PRISONERS

60 *"foremost man of his time"* Gonzalo Solís de Merás, *Pedro Menéndez de Avilés: Memorial,* trans. Jeannette Thurber Connor (Gainesville: University of Florida Press, 1964), p. 64. Solís de Merás went to Florida with Menéndez and wrote this biography of his brother-in-law in 1567.

60 *"still of tender age"* Bartolomé Barrientos, *Pedro Menéndez de Avilés: Founder of Florida,* trans. Anthony Kerrigan (Gainesville: University of Florida Press, 1965), p. 9. Barrientos, a professor of Latin at the University of Salamanca, wrote his biography of Menéndez in 1568. He did not accompany the conquistador to Florida but had access to firsthand accounts and apparently spoke to participants. The other quotes about the young mariner's sea battle also come from this passage.

60 *"an armada"* Solís de Merás, *Pedro Menéndez de Avilés: Memorial,* p. 40.

60 *daring and aggressive* contra-corsarios Good summaries of the early part of the conquistador's career can be found in Lyon, *The Enterprise of Florida,* pp. 10–37, and McGrath, *The French in Early Florida,* pp. 110–15.

62 *"carried out against the instructions given him"* Solís de Merás, *Pedro Menéndez de Avílés: Memorial*, p. 47.

62 *only son was missing* See Lyon, *The Enterprise of Florida*, pp. 29–30.

62 *pulled off a jailbreak* See ibid., pp. 34–35.

63 *the Spanish effort had disbanded* See Hoffman, *A New Andalucia and the Way to the Orient*, p. 200.

63 *came home, however, to a different France* See McGrath, *The French in Early Florida*, pp. 84–88.

64 *a high-priced maritime mercenary* See ibid., pp. 50–52.

64 *Thomas Stukeley* See ibid., 88–95. See also Juan E. Tazón, *The Life and Times of Thomas Stukeley, (c.1525–78)* (Burlington, Vt.: Ashgate Publishing Company, 2003), pp. 62–78.

64 *raiding Spanish galleons* Stukeley (also spelled Stucley) did indeed turn the venture into a pirating expedition. In October of 1563, while looking for ships to attack between England and Brittany, he spotted an odd little vessel floundering adrift and rescued its crew. In a bizarre twist of history, that ship happened to contain the half-dead survivors of the Charlesfort colony—the very men that Ribault had been trying so hard to save.

65 *"great numbers of Englishmen committed to the galleys"* Letter from Ambassador Nicholas Throckmorton to Secretary of State William Cecil, April 8, 1564, *Calendar of State Papers, Foreign Series, of the Reign of Elizabeth*, vol. 7 (1564–1565), ed. Joseph F. Stevenson (London: Longman & Co., 1870), p. 98 (item 298).

65 *already faced each other as enemies* See McGrath, *The French in Early Florida*, p. 52.

65 *"the most experienced seaman and corsair known"* Letter from Menéndez to King Philip II, Oct. 15, 1565, reprinted in Bennett, *Settlement of Florida*, pp. 174–75.

66 *August of 1564* The exact date of Saturiwa's return was not documented by either Le Moyne or Laudonnière. It clearly happened sometime during the month of August, however.

66 *took twenty-four captives* See Laudonnière, *Three Voyages*, p. 85.

66 *scalps and human limbs* The historian John H. Hann notes that no other descriptions of Timucuan victory rites mention the use of severed legs or arms. But Hann gives some credence to Le Moyne's account, because the artist seems to have witnessed the use of these limbs himself. See Hann, *A History of Timucua Indians and Missions*, p. 103.

66 *the real subject of the picture is Saturiwa* See Faupel, "An Appraisal of the Illustrations," in Lawson, *A Foothold in Florida*, pp. 170–71.

66 *"They have a certain place"* Le Moyne in Hulton et al., *The Work of Jacques Le Moyne de Morgues*, vol. 1, p. 145.

67 *"I sent a soldier"* Laudonnière, *Three Voyages*, p. 86. The captain's other quotes in this section are from this same passage, pp. 86–87.

CHAPTER EIGHT: MUTINY

69 *"in whom I had placed great confidence"* Laudonnière, *Three Voyages*, p. 92. The captain's descriptions of this supposed scheme can be found on pp. 92–95.

69 *"of distinguished family"* Le Moyne in Hulton et al., *The Work of Jacques Le Moyne de Morgues*, vol. 1, p. 122. Le Moyne's quotes about the events leading up to the mutiny are from this same page.

70 *"a quantity of gold"* Ibid., p. 123.

70 *"preventing the great chief Utina"* Here I use the translation in Bennett, *Settlement of Florida*, p. 99.

70 *"whose verbosity gave the impression that he knew everything"* Le Moyne in Hulton et al., *The Work of Jacques Le Moyne de Morgues*, vol. 1, p. 124. The artist's account of La Roche-Ferrière's visit is on pp. 123–24.

70 *on its way home from pirating raids* See David Beers Quinn, "The Attempted Colonization of Florida by the French," in Hulton et al., *The Work of Jacques Le Moyne de Morgues*, vol. 1, p. 25.

71 *November 10* Laudonnière wrote that this departure took place on the "tenth of the month," though he did not say which month. Since the commander's previous reference to time was La Roche-Ferriere's departure on November 7 or 8, it would appear that Bourdet embarked around November 10.

71 *stole one of the expedition's only two barques* The term "barque" was often used to refer to any kind of small vessel. Spanish authorities later described the stolen ship as "a very good 18-bench galley boat," meaning that it was powered by oars as well as sails. See deposition of Robert Meleneche in Bennett, *Laudonnière & Fort Caroline*, p. 91.

71 *"treated badly"* Ibid. The commander's other quotes about this initial desertion can be found on pp. 96–97.

71 *"It is quite certain"* Le Moyne in Hulton et al., *The Work of Jacques Le Moyne de Morgues*, vol. 1, p. 123.

71 *"common and lowly work"* Laudonnière, *Three Voyages*, p. 98. The commander's other comments about growing resentment at this time are on pp. 97–99.

72 *"a man of integrity"* Again I use the translation from Bennett, *Settlement of Florida*, p. 97.

72 *"his own life should be endangered"* Le Moyne in Hulton et al., *The Work of Jacques Le Moyne de Morgues*, vol. 1, p. 123.

72 *one Sunday in November of 1564* Le Moyne reported that La Caille's speech came on "the Lord's Day," but pinpointing the precise date—or even the month—is difficult, due to the vagaries and contradictions of Le Moyne and Laudonnière's accounts. By working backward and forward from

fixed dates, we can determine that the event took place in mid- to late November.

72 *"representative of our lord the King"* Le Moyne in Hulton et al., *The Work of Jacques Le Moyne de Morgues,* vol. I, p. 123. This is also the source of the other quotes from La Caille's speech.

73 *"I greatly feared"* Laudonnière, *Three Voyages,* p. 98.

73 *"more than enough provisions for their needs"* Le Moyne, quoting his commander, in Hulton et al., *The Work of Jacques Le Moyne de Morgues,* vol. I, p. 123.

73 *"pretended to be satisfied with this response"* Laudonnière, *Three Voyages,* p. 99.

73 *"the rest of the soldiers were so swayed"* Le Moyne in Hulton et al., *The Work of Jacques Le Moyne de Morgues,* vol. I, p. 124. The artist's other quotes about the insurrection and the departure of the mutineers can be found on pp. 124–25.

75 *"some small casks of fine Spanish wine"* Ibid., p. 126.

75 *the vessels were heavily armed* See deposition of Stefano Rojomonte in Bennett, *Laudonnière & Fort Caroline,* p. 96.

75 *"sailed from Fort Caroline on December 8"* Le Moyne in Hulton et al., *The Work of Jacques Le Moyne de Morgues,* vol. I, p. 125.

76 *"I doubt there ever was anywhere a captain"* Laudonnière, *Three Voyages,* p. 107.

CHAPTER NINE: WARPATHS

78 *three officers and ten soldiers* See Laudonnière, *Three Voyages,* p. 90.

78 *arquebuses* See Andrew Cunningham and Ole Peter Grell, *The Four Horsemen of the Apocalypse: Religion, War, Famine and Death in Reformation Europe* (New York: Cambridge University Press, 2000), pp. 115–16.

79 *"how swiftly they can take the arrows into their hands"* Le Challeux in Lorant, *The New World,* p. 94.

79 *"made a solemn treaty"* Le Moyne in Hulton et al., *The Work of Jacques Le Moyne de Morgues,* vol. I, p. 143.

79 *"They came out in a great company"* Laudonnière, *Three Voyages,* p. 91.

79 *"a thousand thanks from the chief"* Ibid., p. 92.

80 *"when this enemy was defeated"* Ibid., p. 117.

80 *"with great joy"* Le Moyne in Hulton et al., *The Work of Jacques Le Moyne de Morgues,* vol. I, p. 143.

80 *"obliged to carry the Frenchmen"* Ibid.

80 *"The sorcerer prepared a place"* Ibid.

81 *two thousand warriors* See Laudonnière, *Three Voyages,* p. 120.

82 *"contemptible and spineless"* Le Moyne in Hulton et al., *The Work of Jacques Le Moyne de Morgues,* vol. I, p. 143.

82 *"there was never a fight"* Here I use the translation from Lawson, *A Foothold in Florida,* p. 99.

82 *"consisted of secret incursions"* Ibid.

82 *"The first side to kill an enemy"* Ibid.

83 *a popular incarnation of the noble-savage myth* See James Axtell, *The European and the Indian: Essays in the Ethnohistory of Colonial North America* (New York: Oxford University Press, 1981), pp. 16–35. Axtell called Le Moyne's illustration "the first public representation of Indian scalping."

83 *"never leave the battlefield"* Le Moyne in Hulton et al., *The Work of Jacques Le Moyne de Morgues,* vol. 1, p. 144.

83 *"sometimes cannot be done without great danger"* Ibid.

84 *"I now question"* Jerald T. Milanich, "The Devil in the Details: What Are Brazilian War Clubs and Pacific Seashells Doing in 400-Year-Old Engravings of Florida Indians?" in *Archaeology,* vol. 58, no. 3 (May/June 2005): pp. 26–31.

84 *"I think Le Moyne's engravings are accurate representations"* DePratter, phone conversation with author.

85 *"As a historian"* McGrath, e-mail correspondence with author.

85 *"a very rough sketch by Le Moyne"* Faupel, "An Appraisal of the Illustrations," in Lawson, *A Foothold in Florida,* p. 175.

86 *"a combination of realism and idealism"* John Wilmerding, *American Art* (Harmondsworth, England: Penguin Books, 1976), p. 6.

86 *"Although the engravings may be inaccurate"* Milanich, phone conversation with author.

CHAPTER TEN: AVENGER

88 *no more than ten* See deposition of Robert Meleneche in Bennett, *Laudonnière & Fort Caroline,* p. 91. Meleneche was one of the initial group of deserters from Fort Caroline and was interrogated by Spanish officials after his capture. Much of the information in this section comes from his deposition.

89 *"perhaps God wanted them to miss the port"* Deposition of Robert Meleneche in Bennett, *Laudonnière & Fort Caroline,* p. 91.

89 *other three sent to Spain* See ibid.

89 *anchored at a harbor in Jamaica* Le Moyne reported that this event took place in Cuba; his secondhand account is clearly contradicted by Spanish documents.

89 *enough food to last only two days* See deposition of Francisco Ruiz Manso in Bennett, *Laudonnière & Fort Caroline,* p. 104. Much of the information in this section comes from the seaman's report, pp. 103–106.

90 *"ardent Lutherans"* Deposition of Robert Meleneche in Bennett, *Laudonnière & Fort Caroline,* p. 91.

90 *a great public spectacle was held in Barcelona* See Henry Kamen, *The Phoenix and the Flame: Catalonia and the Counter Reformation* (New Haven: Yale University Press, 1993), pp. 44–45, 231, 257.

90 *all but six of whom were French* See ibid., p. 231.

90 *Eight others were sentenced to death* See Louis-Prosper Gachard, *Don Carlos et Philippe II* (Brussels: Muquardt, 1863), p. 107.

91 *"an emergency without precedent"* Henry Kamen, *The Spanish Inquisition: A Historical Revision* (New Haven: Yale University Press, 1997), p. 96.

91 *more than one hundred people were condemned to death* See ibid., p. 98.

91 *people of French descent* See ibid., pp. 98–102, as well as Kamen, *The Phoenix and the Flame*, pp. 231–36.

91 *"The flames are spreading everywhere"* Quoted in Kamen, *Philip of Spain*, p. 113.

91 *"good inquisitor"* Barrientos, *Pedro Menéndez de Avilés: Founder of Florida*, p. 68.

92 *asked Menéndez to write a report* The document, known as a "memorial," is undated, but the historian Eugene Lyon argued that it was written at some point between February 1, 1565, and March 15 of that same year. A translation of the memorial appears in Bennett, *Laudonnière & Fort Caroline*, pp. 127–30.

92 *"If other nations should go on settling and making friends"* Ibid., p. 129.

92 *"their way of life was vicious"* Barrientos, *Pedro Menéndez de Avilés: Founder of Florida*, p. 28.

93 *"would encounter no opposition"* Ibid.

93 *"it would be necessary"* Menéndez in Bennett, *Laudonnière & Fort Caroline*, p. 130.

93 *"for the salvation of so many souls"* Ibid., p. 129.

93 *"his boy might be restored to life"* Barrientos, *Pedro Menéndez de Avilés: Founder of Florida*, p. 21.

93 *issuing a contract* The "Agreement Between Dr. Vazquez of the Council in the Name of the King, with Pedro Menéndez de Avilés, March 15, 1565" is translated in Lyon, *The Enterprise of Florida*, pp. 213–19. Much of the information in this section comes from that text.

94 *Menéndez was overtaken on the road* See Barrientos, *Pedro Menéndez de Avilés: Founder of Florida*, p. 31.

94 *"stated he had not believed"* Ibid.

94 *"Seeing that they are Lutherans"* Quoted in Woodbury Lowery, *The Spanish Settlements Within the Present Limits of the United States: Florida, 1562–1574* (New York: G. P. Putnam, 1911), p. 105.

CHAPTER ELEVEN: WANT

95 *"oppressed by famine"* Laudonnière, *Three Voyages*, p. 104.

95 *late March of 1565* Laudonnière reported that the mutineers returned to the Florida coast on March 25. See ibid., p. 103.

96 *"When [the mutineers] saw our pinnace"* Le Moyne in Hulton et al., *The Work of Jacques Le Moyne de Morgues*, vol. 1, pp. 130–31.

96 *put to a firing squad* See Bennett, *Three Voyages*, pp. 105–106. See also a sec-

ondhand account by the English adventurer John Sparke in *Early English and French Voyages, Chiefly from Hakluyt, 1534–1608*, ed. Henry S. Burrage (New York: Barnes & Noble, 1967), p. 123.

96 *no later than the end of April* See Laudonnière, *Three Voyages*, ibid., p. 121.

97 *spent two months deep in Indian country* See Hulton, *The Work of Jacques Le Moyne de Morgues*, vol. 1, p. 7.

97 *"hermaphrodites"* Ibid., pp. 145, 147.

97 *two spirits* See Tamara Spike, "To Make Graver This Sin: Conceptions of Purity and Pollution Among the Timucua of Spanish Florida," dissertation, History Department, Florida State University, 2006, pp. 102–115.

98 *able to assume their own sexual and gender identities* See Walter L. Williams, *The Spirit and the Flesh* (Boston: Beacon Press, 1986), pp. 44–64.

98 *latest incarnation of the noble-savage myth* See Richard C. Trexler, "Making The American Berdache: Choice or Constraint?" in *Journal of Social History*, vol. 35, no. 3 (2002): pp. 613–36.

98 *"black drink"* See Milanich, *The Timucua*, pp. 173–74, and Charles M. Hudson, *The Southeastern Indians* (Knoxville: University of Tennessee Press, 1976), pp. 226–29.

98 *"When they have drunk this brew"* Le Moyne in Hulton et al., *The Work of Jacques Le Moyne de Morgues*, vol. 1, p. 149.

100 *"uniquely important"* Faupel, "An Appraisal of the Illustrations," in Lawson, *A Foothold in Florida*, p. 176.

100 *"Every year, a little before their spring"* Le Moyne in Hulton et al., *The Work of Jacques Le Moyne de Morgues*, vol. 1, p. 150.

101 *"The month of May coming"* Laudonnière, *Three Voyages*, pp. 121–22.

102 *"The mischievous Indians"* Ibid., p. 124.

102 *"A great famine followed"* Le Moyne in Hulton et al., *The Work of Jacques Le Moyne de Morgues*, vol. 1, p. 131.

CHAPTER TWELVE: FALSE STARTS

104 *seven hundred to a thousand people* The information in this section comes from the report of the Spanish spy Gabriel de Enveja, reprinted in full as "A Spy's Report on the Expedition of Jean Ribaut to Florida, 1565," ed. Antonine Tibesar, *The Americas*, vol. 11, no. 4 (April 1955): pp. 589–92.

104 *"news of this voyage was quickly spread"* Le Challeux in Lorant, *The New World*, p. 88. His other quotes about French preparations can be found on p. 90.

104 *cited a more dramatic reason for the delay* See McGrath, *The French in Early Florida*, pp. 122–23.

105 *"with a good fleet of 600 men"* Quoted in ibid., p. 123.

106 *"renowned as an honest and valiant man"* Enveja in "A Spy's Report on the Expedition of Jean Ribaut to Florida, 1565," p. 591.

106 *"to conquer the land"* Ibid.

106 *"amazement"* Quoted in Lyon, *The Enterprise of Florida,* p. 69.

107 *"partisan[s] of the perverse and pestilential Lutheran sect of the devil"* Barrientos, *Pedro Menéndez de Avilés: Founder of Florida,* p. 32.

107 *On May 18* See Lyon, *The Enterprise of Florida,* footnote 44, p. 63. This book details the mariner's logistical, military, and financial preparations, pp. 58–99.

108 *"A great tempest arose"* Le Challeux in Lorant, *The New World,* p. 90.

108 *"a sincere desire to know and see the country"* Ibid., p 88.

109 *"Every day he lost"* Barrientos, *Pedro Menéndez de Avilés: Founder of Florida,* p. 32.

109 *an armada of as many as nineteen ships* Solís de Merás places the number at nineteen; Barrientos at ten. See Solís de Merás, *Pedro Menéndez de Avilés: Memorial,* p. 76, and Barrientos, *Pedro Menéndez de Avilés: Founder of Florida,* p. 32.

109 *thirty-four vessels carrying 2,646 people* See Solís de Merás, *Pedro Menéndez de Avilés: Memorial,* p. 74.

109 *stonemasons, carpenters, tailors* See Solís de Merás, *Pedro Menéndez de Avilés: Memorial,* p. 75, as well as Lyon, *The Enterprise of Florida,* p. 92.

109 *"some of the principal gentlemen"* Ibid., p. 76.

CHAPTER THIRTEEN: FAMINE AND FOLLY

111 *"Some . . . died of hunger"* Le Moyne in Hulton et al., *The Work of Jacques Le Moyne de Morgues,* vol. I, p. 131.

111 *devour puppies fresh from the womb* See Laudonnière, *Three Voyages,* p. 131.

112 *"If anyone wanted to describe in detail the deprivations"* Le Moyne in Hulton et al., *The Work of Jacques Le Moyne de Morgues,* vol. I, p. 131.

112 *"neither grain, nor beans, nor acorns"* Laudonnière, *Three Voyages,* p. 131. The commander's other quotes concerning the onset of famine, preparations for returning to France, and plans for the kidnapping of Utina can be found on pp. 124–31.

113 *"senseless" and "perverse"* Le Moyne in Hulton et al., *The Work of Jacques Le Moyne de Morgues,* vol. I, p. 131.

113 *slow to abandon his belief* See ibid. Le Moyne wrote that by the time the colonists decided to sail for home, "even Laudonnière was despairing of receiving help from France."

115 *pinocqs* Bennett identifies these as water chinquapins. See ibid., note 94, p. 224.

117 *"tough and lively young soldier"* Le Moyne in Hulton et al., *The Work of Jacques Le Moyne de Morgues,* vol. I, p. 126. The artist's other quotes about Gambié are from this same page.

118 *"going to revenge the evil that he had done"* Laudonnière, *Three Voyages,* p. 131. The commander's account of this journey appears on pp. 131–32.

119 *"When one chief is going to declare war"* Le Moyne in Hulton et al., *The Work of Jacques Le Moyne de Morgues,* vol. I, p. 150.

120 *"we were leading the captive chief Utina round"* Ibid.
120 *"no difficulty"* Laudonnière, *Three Voyages,* p. 134. The rest of the quotes in this chapter come from pp. 134–39.

CHAPTER FOURTEEN: SAILS

124 *medieval and macabre affair* See Cunningham and Grell, *The Four Horsemen of the Apocalypse,* pp. 124–34.
124 *A soldier with an arrow lodged in his flesh* For information on sixteenth-century treatment of arrow wounds, see Giovanni da Vigo, *The Most Excellent Workes of Chirurgerye* (London: Edwarde Whytchurch, 1543), folios 110 and 250, as well as Ambroise Paré, *The Method of Curing Wounds Made by Gun-shot Also by Arrowes and Darts, With Their Accidents,* trans. Walter Hamond (London: Printed by Isaac Iaggard, 1617), pp. 116–23.
124 *cauterized with hot oil* Vigo, whose book was originally published in 1514 and went through no fewer than forty editions, advocated cauterizing wounds with hot oil. Paré broke from this painful and ineffective treatment—a real advance in field surgery.
124 *noting simply that he had received a leg injury* See Le Moyne in Hulton et al., *The Work of Jacques Le Moyne de Morgues,* vol. 1, p. 133.
125 *"shot at their faces and legs"* Sparke in *Early English and French Voyages,* p. 124. Sparke arrived at Fort Caroline with John Hawkins shortly after the battle between the French and Utina. I have modernized spellings and punctuation when quoting him.
126 *"not above forty soldiers left unhurt"* Ibid.
126 *"the most productive in corn"* Laudonnière, *Three Voyages,* p. 114. His descriptions of the preparations for the departure and arrival of the ships are on pp. 139–41.
127 *"the most wild and violent"* Francisco López de Mendoza Grajales, "Memoire of the Happy Result," in Bennett, *Laudonnière & Fort Caroline,* p. 142.
127 *Two other ships never made it that far* See Lyon, *The Enterprise of Florida,* p. 102.
129 *John Hawkins* Much of my biographical information comes from two books: Harry Kelsey, *Sir John Hawkins: Queen Elizabeth's Slave Trader* (New Haven: Yale University Press, 2003), and Nick Hazlewood, *The Queen's Slave Trader: Jack Hawkyns, Elizabeth I, and the Trafficking of Human Souls* (New York: William Morrow, 2004).
130 *"if any African were carried away"* Quoted in Hazlewood, *The Queen's Slave Trader,* p. 91.
130 *an informant in England* See Kelsey, *Sir John Hawkins,* p. 29.
130 *attempting to find a good place to replenish his fresh water* See Sparke in *Early English and French Voyages,* pp. 116–17, as well as Laudonnière, *Three Voyages,* p. 142.
130 *"well-dressed and unarmed gentlemen"* Laudonnière, *Three Voyages,* p. 142.

131 *"but they being soldiers"* Sparke in *Early English and French Voyages,* p. 124. Sparke's other quotes in this section are from pp. 123–24.

131 *"certain sheep and poultry"* Laudonnière, *Three Voyages,* p. 142. The commander's other quotes about the animals are from pp. 142–43.

131 *the expedition had a secret agenda* See James A. Williamson, *Hawkins of Plymouth: A New History of Sir John Hawkins and of the Other Members of His Family Prominent in Tudor England,* 2nd ed. (London: Adam and Charles Black, 1969), pp. 60–67.

131 *"[Hawkins] quickly understood"* Laudonnière, *Three Voyages,* p. 143. The commander's other remarks about Hawkins's offer are from the same page.

133 *"a certain plant, whose name escapes me"* Le Moyne in Hulton et al., *The Work of Jacques Le Moyne de Morgues,* vol. 1, p. 146.

134 *Jean Nicot* Much of my information on Nicot comes from Iain Gately, *Tobacco: A Cultural History of How an Exotic Plant Seduced Civilization* (New York: Grove, 2001), pp. 38–40. This was also the source for much of my information on the popularity of tobacco in England, the production of the crop in Virginia, and the introduction of slaves to the colony, pp. 44–53, 70–75, and 105.

134 *"The Floridians when they travel have a kind of herb dried"* Sparke in *Early English and French Voyages,* pp. 125–26.

134 *credited with introducing tobacco to England* See Kelsey, *Sir John Hawkins,* pp. 31, 270, and Gately, *Tobacco,* p. 40. There are a number of theories about who brought tobacco to England, but Gately calls the members of Hawkins's crew "the most likely candidates."

135 *"if we had been reinforced at the time and place promised"* Laudonnière, *Three Voyages,* p. 141. The commander's remaining quotes in this chapter are from pp. 141–46.

CHAPTER FIFTEEN: ARRIVAL

137 *"put my men in order"* Laudonnière, *Three Voyages,* p. 151. The commander's other quotes about the approaching vessels come from pp. 149–51.

138 *"They could not be discovered, dead or alive"* López, "Memoire of the Happy Result," in Bennett, *Laudonnière & Fort Caroline,* p. 145.

139 *"In taking this risky step with his diminished forces"* Lyon, *The Enterprise of Florida,* p. 106. Lyon offers an excellent description of the Spanish fleet's journey from Puerto Rico to Florida, pp. 102–107.

139 *"felt as if he had already gained a victory"* Barrientos, *Pedro Menéndez de Avilés: Founder of Florida,* p. 37.

139 *"He ordered celebrations throughout the fleet"* Ibid.

140 *"the voyage was not being pursued safely"* Mendoza Grajales, "Memoire of the Happy Result," in Bennett, *Laudonnière & Fort Caroline,* p. 147.

140 *"fighting in defense of the Holy Catholic Faith"* Barrientos, *Pedro Menéndez de Avilés: Founder of Florida*, p. 35.

140 *"Our Lord showed us a mystery of the sky"* López, "Memoire of the Happy Result," in Bennett, *Laudonnière & Fort Caroline*, p. 150.

140 *"very much distressed"* Solís de Merás, *Pedro Menéndez de Avilés: Memorial*, p. 81.

141 *"had but little food"* Enveja in "A Spy's Report on the Expedition of Jean Ribaut to Florida, 1565," p. 591.

141 *"had been told that we were all dead"* Le Moyne in Hulton et al., *The Work of Jacques Le Moyne de Morgues*, vol. 1, p. 131.

141 *"oblivious to the realities of his situation"* McGrath, *The French in Early Florida*, p. 137.

141 *"God bestowed happiness upon us"* Le Moyne in Hulton et al., *The Work of Jacques Le Moyne de Morgues*, vol. 1, p. 131.

141 *"with honor and delight"* Laudonnière, *Three Voyages*, p. 153. The mariner's descriptions of his replacement as commander are on pp. 151–54.

142 *"They promised that in a few days"* Ibid., p. 157.

143 *"Everything resounded with joy"* Le Moyne in Hulton et al., *The Work of Jacques Le Moyne de Morgues*, vol. 1, p. 132.

143 *a group of soldiers who had gone to the beach* Ibid.

CHAPTER SIXTEEN: WINDS OF FORTUNE

144 *"I found myself with 800 persons"* Letter from Menéndez to King Philip II, September 11, 1565, trans. Jeannette Thurber Connor, in Bennett, *Settlement of Florida*, p. 148.

144 *"sensible and sound"* Barrientos, *Pedro Menéndez de Avilés: Founder of Florida*, p. 39.

145 *"all might be lost"* Ibid.

145 *"Not a word was spoken from one side to the other"* López, "Memoire of the Happy Result," in Bennett, *Laudonnière & Fort Caroline*, p. 152.

145 *" 'Gentlemen,' he said, 'whence comes this fleet?' "* Barrientos, *Pedro Menéndez de Avilés: Founder of Florida*, p. 43.

146 *"did this unwillingly"* Solís de Merás, *Pedro Menéndez de Avilés: Memorial*, p. 87.

146 *"made us extremely worried all night long"* Le Moyne in Hulton et al., *The Work of Jacques Le Moyne de Morgues*, vol. 1, p. 132. The artist's other quotes about the events of that night are from this same page.

146 *a lone swimmer* Ibid. Laudonnière does not mention this detail.

147 *"lodged themselves on the land"* Laudonnière, *Three Voyages*, p. 159.

147 *"a great and continual fever"* Ibid., p. 157. His other quotes about the illness are also from this page.

147 *"The more reasonable part of this council"* Le Moyne in Hulton et al., *The Work of Jacques Le Moyne de Morgues*, vol. 1, p. 132. The artist's description of this meeting is on pp. 132–33.

148 *"In making an inspection"* Ibid., p. 133.

149 *the soldiers had no shovels* See letter from Menéndez to King Philip II, September 11, 1565, trans. Jeannette Thurber Connor, in Bennett, *Settlement of Florida*, p. 153.

150 *"If the French had attacked at once"* López, "Memoire of the Happy Result," in Bennett, *Laudonnière & Fort Caroline*, p. 155.

150 *Aboard one of the vessels, in fact, was Menéndez* See Solís de Merás, *Pedro Menéndez de Avilés: Memorial*, p. 90.

150 *"the Spaniards could not escape"* McGrath, *The French in Early Florida*, p. 143.

150 *"For two hours the Lutherans lay to"* Barrientos, *Pedro Menéndez de Avilés: Founder of Florida*, pp. 45–46.

151 *"It was Our Lord's will to save us miraculously"* Letter from Menéndez to King Philip II, October 15, 1565, trans. Jeannette Thurber Connor, in Bennett, *Settlement of Florida*, p. 161.

151 *"was no doubt the will of God"* Here I use the translation from Bennett, *Settlement of Florida*, p. 113.

151 *"the Indians assured me . . . was the worst"* Laudonnière, *Three Voyages*, p. 161.

151 *"I advised that if misfortune had come"* Ibid.

151 *"the poorest soldiers"* Barrientos, *Pedro Menéndez de Avilés: Founder of Florida*, p. 47.

152 *"were either servants or craftsmen"* Le Moyne in Hulton et al., *The Work of Jacques Le Moyne de Morgues*, vol. 1, p. 133.

CHAPTER SEVENTEEN: ONE THOUSAND EVIL THINGS

154 *"did not foresee that the enemy would come by land"* Le Challeux in Lorant, *The New World*, p. 100.

154 *"All wet through as I was"* Here I use the translation from Bennett, *Settlement of Florida*, p. 115.

154 *"dispirited and depressed"* Barrientos, *Pedro Menéndez de Avilés: Founder of Florida*, p. 49.

154 *"I swear to God that I am expecting the news"* Quoted in Solís de Merás, *Pedro Menéndez de Avilés: Memorial*, p. 96.

155 *"but the ground was so flooded"* Barrientos, *Pedro Menéndez de Avilés: Founder of Florida*, p. 50.

155 *"without sleep and even without a place to lie down"* Ibid., p. 55.

155 *"feared greatly to take counsel with the captains"* Solís de Merás, *Pedro Menéndez de Avilés: Memorial*, p. 96.

155 *"no more about land warfare than an ass"* Ibid.

155 *"would be plainly foolhardy"* Barrientos, *Pedro Menéndez de Avilés: Founder of Florida*, p. 51.

155 *a misadventure in the Brazilian jungle* The leader of this mutiny was the notorious and possibly insane Lope de Aguirre, who styled himself "Wrath of God, Prince of Freedom, King of Tierra Firme." He was later captured and killed by Spanish authorities.

156 *"all must follow him, under penalty of death"* Solís de Merás, *Pedro Menéndez de Avilés: Memorial*, p. 98.

156 *"God is helping!"* Ibid., p. 100.

156 *"Whenever I call to mind the great wonder"* Again I use the translation from Bennett, *Settlement of Florida*, p. 115.

156 *"nothing but carnage"* Le Moyne in Hulton et al., *The Work of Jacques Le Moyne de Morgues*, vol. 1, p. 134.

156 *"cries and frightful groans"* Ibid.

156 *"it was as if God gave me back my consciousness"* Le Moyne in Bennett, *Settlement of Florida*, p. 115.

157 *"A pikeman chased me"* Le Challeux in Lorant, *The New World*, p. 100. His other descriptions of the escape are from this same page.

157 *"They struck me with their pikes"* Laudonnière, *Three Voyages*, pp. 164–65.

157 *132 of Le Moyne's colleagues lay dead* Menéndez, writing to King Philip shortly after the massacre, put the death toll at 132, noting that ten more Frenchmen were captured in the woods on the following day and killed. Father López also wrote that the total death toll at the fort was 142. Barrientos, who was not a witness and wrote about the incident long after it had happened, claimed four hundred Frenchmen were slaughtered at the fort.

157 *their corpses* Barrientos, who was not an eyewitness, states that "everyone" in the fort was beheaded. Le Challeux reports that the bodies were piled in heaps.

157 *"anxiety at seeing them in the company of my people"* Menéndez to Philip II, October 15, 1565, in Bennett, *Settlement of Florida*, p. 163. He claimed he spared the women and children because "I feared Our Lord would punish me if I used cruelty toward them." According to Barrientos, Menéndez "issued strict instructions" not to kill women and children "on penalty of death." Le Challeux, on the other hand, insisted that such innocents were slaughtered: "They vied with one another to see who could best cut the throats of our people—healthy and sick, women and children. It was a pitiful, grievous sight." Neither Le Moyne nor Laudonnière mentions the killing of innocents.

158 *"thoroughly familiar"* Le Moyne in Hulton et al., *The Work of Jacques Le Moyne de Morgues*, vol. 1, p. 134. His descriptions of the escape are from pp. 134–35, as well as the translation in Bennett, *Settlement of Florida*, p. 116.

158 *"in dark woods"* *The Inferno of Dante*, trans. Robert Pinsky (New York: Farrar, Straus and Giroux, 1994), p. 3.

159 *"we perceived they were as desolate and naked as we"* Le Challeux in Lorant, *The New World*, p. 108.

160 *perhaps with a second French vessel* Menéndez claimed that two French ships were near the fort, one of which he sank with captured artillery. Solís de Merás also described the sinking of a French ship near the fort. None of the French accounts mention the sinking of a second vessel. See Menén-

dez to Philip II, October 15, 1565, in Bennett, *The Settlement of Florida*, p. 162. See also Solís de Merás, *Pedro Menéndez de Avilés: Memorial*, pp. 102–103.

160 *"no lack of ammunition"* Le Moyne in Hulton et al., *The Work of Jacques Le Moyne de Morgues*, vol. 1, p. 135. The artist's other quotes about Jacques Ribault's "cowardly" behavior outside the fort are on this same page.

161 *"whether they ought not to search for his father"* Le Moyne in Bennett, *Settlement of Florida*, p. 117.

161 *"He wanted to go back to France"* Ibid.

161 *"knowing what they had inflicted on our comrades"* Le Moyne in Hulton et al., *The Work of Jacques Le Moyne de Morgues*, vol. 1, p. 136.

161 *"yet he did not do it"* Laudonnière, *Three Voyages*, p. 167.

162 *"poorly equipped with sailors and provisions"* Le Moyne in Hulton et al., *The Work of Jacques Le Moyne de Morgues*, vol. 1, p. 136.

162 *"We should recall that he was an experienced campaigner"* Hulton in ibid., p. 9.

162 *"a Lutheran who was a great mapmaker and necromancer"* López in Bennett, *Laudonnière & Fort Caroline*, p. 160. In the Bennett version, *cosas malas* is translated as "bad things." I've changed it to "evil things," which seems more accurate, given the religious context. For the original Spanish version of this curious passage, see *Relacion de la Jornada de Pedro Menéndez* in *Colección de Documentos Inéditos, Relativos al Descubrimiento, Conquista y Organización de las Antiguas Posesiones Españolas de América y Oceanía*, vol. 3 (Madrid: Manuel B. de Quirós, 1865), p. 474.

162 *We do not know whether this refers to Le Moyne* The passage is made all the more mysterious by the fact that López referred to this mapmaker as a former friar and stated that he had died in the massacre at Fort Caroline. It is possible, of course, that a second French mapmaker had been on the journey, but if so it seems odd that Le Moyne did not mention him. It is also possible that the Spanish received inaccurate intelligence.

162 *the Spanish, who believed native religious practices to be black magic* For example, a chief of the Guale Indians, who lived just north of the Timucua along the Georgia coast, complained in 1597 that Spanish missionaries "persecute our old men, calling them wizards." See Maynard Geiger, *The Franciscan Conquest of Florida, 1573–1618* (Washington: Catholic University of America, 1937), p. 90.

163 *"great quantity of Lutheran books"* López in Bennett, *Laudonnière & Fort Caroline*, p. 160.

163 *promptly ordered burned* This information comes from Barrientos, who described the incineration of "six strong boxes filled with well-bound, gilded books, all of them heretical." See Barrientos, *Pedro Menéndez de Avilés: Founder of Florida*, p. 55.

163 *the flames consuming those pages* Even if Le Moyne's illustrations were not burned along with the Protestant materials, it is possible that they were destroyed by fire. The Spanish reported an accidental blaze at Fort Caro-

line—renamed San Mateo—on October 10, in which "all the stores were burned and everything that had been captured therein." See Menéndez to Philip II, October 15, 1565, in Bennett, *Settlement of Florida*, pp. 173–74.

CHAPTER EIGHTEEN: MATANZAS

164 *"We were incapable of thinking of anything at all"* Elie Wiesel, *Night* (New York: Bantam, 1986), pp. 33–34.

164 *biscuits and water to live on* See Laudonnière, *Three Voyages*, p. 167, as well as Le Challeux in Lorant, *The New World*, p. 112.

164 *barely enough clothing to cover his back* See Le Challeux in Lorant, *The New World*, p. 110. Although Le Challeux and Le Moyne were in different ships, we can safely assume that the lack of adequate clothing was universal among French survivors.

166 *"I answered him that we had taken their fort"* Menéndez to Philip II, October 15, 1565, in Bennett, *Settlement of Florida*, p. 164.

166 *a ransom of fifty thousand ducats* See Solís de Merás, *Pedro Menéndez de Avilés: Memorial*, p. 113.

166 *"place themselves at his mercy"* Ibid., p 112.

166 *"with all possible cruelty"* Ibid.

167 *"much parley"* López in Bennett, *Laudonnière & Fort Caroline*, p. 163.

167 *soldiers knifed them to death, lopping off a head here and there for good measure* Menéndez wrote simply that the men were "put to the knife" and both Solís de Merás and Father López were even more general in their descriptions of the killings. Barrientos explicitly stated that "many" of the French castaways were also beheaded. See Barrientos, *Pedro Menéndez de Avilés: Founder of Florida*, p. 64.

167 *events purportedly transpired much as they had in the first encounter* Menéndez and Solís de Merás both left eyewitness accounts of the encounter. See Menéndez to Philip II, October 15, 1565, in Bennett, *Settlement of Florida*, pp. 174–76, and Solís de Merás, *Pedro Menéndez de Avilés: Memorial*, pp. 115–22.

167 *as many as 350 shipwrecked men* Solís de Merás put the number at 350; Menéndez put it at two hundred.

167 *"put themselves at my mercy"* Menéndez to Philip II, October 15, 1565, in Bennett, *Settlement of Florida*, p. 174.

168 *"a certain sailor of Dieppe"* Le Moyne in Hulton et al., *The Work of Jacques Le Moyne de Morgues*, vol. 1, p. 136.

168 *"sworn promise in writing and endorsed with his seal"* Ibid., p. 137.

168 *Some historians have dismissed this tale* See, for instance, John T. McGrath's appendix, "A Note on Sources," in *The French in Early Florida*, pp. 171–84.

168 *particulars of the artist's narrative are consistent with Spanish eyewitness accounts* There is a striking number of similarities between the account told by Le

Moyne and the eyewitness versions described by Menéndez and Solís de Merás, as well as the version in the contemporary biography by Barrientos. Indeed, Le Moyne's account shares a basic structure, as well as a few uncanny details, with the Spanish narratives:

a) Ribault's dispatch of an officer to do the initial negotiating. The Spanish did not name the envoy, calling him a "sergeant major of Jean Ribault" or simply "the sergeant." Le Moyne insisted the envoy was his former housemate, François La Caille, who was variously described as sergeant or captain in French texts. Barrientos described this man as "retaining his composure in a most excellent fashion," a trait Le Moyne often attributed to La Caille.

b) The return of the envoy to the French camp and the subsequent arrival of Ribault himself, followed by the surrender of the French.

c) The tying of the prisoners' hands, and the killing of them in groups.

d) The language used by Ribault's killers. Barrientos reported that the men assigned to kill the French commander had reminded their prisoner, "Captains must obey their generals and carry out their orders." Le Moyne, meanwhile, wrote that one of the killers told Ribault, "I . . . intend to obey my commander's instructions. My orders are to kill you."

e) The sparing of French musicians. Le Moyne wrote that "all were slaughtered . . . apart from a certain drummer called Drouet, and someone else from Dieppe, named Masselin, who was a flute-player and lutanist. These two were saved to play for them at their revels." Solís de Merás, meanwhile, reported that "the fifers, drummers and trumpeters alone were spared, in addition to four men who said they were Catholics." Menéndez wrote that he spared the lives of "a fifer, a drummer, and a trumpeter."

It is unlikely Le Moyne lifted these details from Spanish accounts. Menéndez offered only a general description of the second slaughter; and in any case, his letter to the king, never intended for a general audience, was buried in Spanish archives until the 1800s. The eyewitness account by Ganzalo Solís de Merás did not make it into print until 1893 and existed only as a manuscript in Le Moyne's lifetime. The same is true of the biography by Bartolomé Barrientos, which was not published until 1901. And it is equally unlikely that the Spanish chroniclers copied these details from Le Moyne: Solís de Merás wrote his narrative in 1567, and Barrientos penned his biography the following year, while Le Moyne's text was not published until 1591.

168 *"great composure"* Ibid., p. 117.

168 *"in a large ship splendidly equipped with all requirements"* Le Moyne in Hulton et al., *The Work of Jacques Le Moyne de Morgues,* vol. 1, p. 137.

168 *"Ribault repeatedly begged to speak to the commander"* Ibid.

169 *"Ribault had been wearing a felt hat"* Barrientos, *Pedro Menéndez de Avilés: Founder of Florida,* p. 66.

169 *between seventy and 250 Frenchmen were slaughtered* Barrientos wrote that 250 of the 350 stranded Frenchmen surrendered. Solís de Merás wrote that only 150 of that total laid down their arms. Menéndez was somewhat vague on numbers, but seems to suggest that only about seventy Frenchmen were slaughtered, while an additional seventy to eighty fled.

169 *"without opposition or anxiety"* Menéndez to Philip II, October 15, 1565, in Bennett, *Settlement of Florida,* p. 175.

169 *the French who remained at large* The Spanish continued to pursue French survivors for many months, at one point rounding up between 70 and 150 men who had holed up in an improvised fort on the coast. These prisoners were not immediately slaughtered, but a number of them were put in a makeshift stockade, where they seem to have met an even more brutal death. According to one Spanish account, the captives were eaten by their starving captors, whose isolated garrison had been besieged by the Indians. Other prisoners were put to work as oarsmen in the Spanish fleet or in other capacities. Eventually some of them made it back to France. See Eugene Lyon, "Captives of Florida," pp. 1–25.

169 *"badly damaged"* Menéndez to Philip II, October 15, 1565, in Bennett, *Settlement of Florida,* p. 175.

169 *"as they are ill-provided and ill-equipped"* Ibid.

169 *Jacques Ribault had the superior ship* See Laudonnière, *Three Voyages,* p. 167.

169 *"perilous and lamentable voyage"* Le Challeux in Lorant, *The New World,* p. 112. His description of the journey can be found on pp. 110–12.

170 *"Who wants to go to Florida?"* Le Challeux, "Poems of Le Challeux," in Bennett, *Laudonnière & Fort Caroline,* p. 164.

170 *"We suffered much."* Le Moyne in Hulton et al., *The Work of Jacques Le Moyne de Morgues,* vol. 1, p. 136.

170 *"feared by all navigators"* Laudonnière, *Three Voyages,* p. 168.

170 *"I went to Bristol"* Ibid., p. 169.

CHAPTER NINETEEN: MAP

172 *"a recent and most exact draft of Florida"* The text can be found in Hulton et al., *The Work of Jacques Le Moyne de Morgues,* vol. 1, pp. 201–203. The other map notations are also from this section.

173 *"cutting off the heads"* Quoted in Irene Mahoney, *Madame Catherine* (New York: Coward, McCann & Geoghegan, 1975), p. 117.

174 *"did not spare anyone at all"* Quoted in McGrath, *The French in Early Florida,* p. 158.

174 *Forced to borrow fifty crowns* See Lowery, *The Spanish Settlements Within the Present Limits of the United States: Florida, 1562–1574,* p. 316.

174 *offering his services to Spain* See ibid., p. 317.

174 *"to the best of my ability"* Le Moyne in Bennett, *Settlement of Florida*, p. 92.

175 *"He was urged by the king"* Theodor de Bry, "Concerning the Circumstances and Author of This History," in Hulton et al., *The Work of Jacques Le Moyne de Morgues*, vol. I, p. 118.

175 *"vied with one another"* Le Challeux in Lorant, *The New World*, p. 100. His other quotes about the carnage come from pp. 100, 112, and 116.

175 *two editions in its first year* See Lowery, *The Spanish Settlements Within the Present Limits of the United States: Florida, 1562–1574*, p. 317.

175 *"Ribault was burned alive"* Quoted in McGrath, *The French in Early Florida*, p. 162.

176 *"beside myself"* Quoted in Mahoney, *Madame Catherine*, p. 120.

176 *"the venom of that kingdom"* Quoted in Lowery, *The Spanish Settlements Within the Present Limits of the United States: Florida, 1562–1574*, p. 311.

176 *ten thousand Spanish troops skirted the French border* See Knecht, *The Rise and Fall of Renaissance France, 1483–1610*, pp. 339–44, and Kamen, *Philip of Spain*, pp. 116–20.

176 *Catholic nobleman* Regarding this and other details of Gourgues's life, see Jeannette Thurber Connor's biographical sketch in Bennett, *Settlement of Florida*, pp. 186–201.

177 *"cut the throats of the little children"* Author unknown, "The Recapture of Florida," trans. Jeannette Thurber Connor, in Bennett, *Settlement of Florida*, p. 203. The other quotes about Gourgues's reasons for the expedition are on pp. 203–204.

177 *a violent uprising at the outpost* For background on antagonisms between the Spanish and Saturiwa, see Hann, *A History of the Timucua Indians and Missions*, pp. 54–66; Lyon, *The Enterprise of Florida*, pp. 150–53, 166–70, 198; and Solís de Merás, *Pedro Menéndez de Avilés: Memorial*, pp. 152–63, 235–37.

177 *killing a priest who had just arrived to convert the natives* See Menéndez's letter, "To a Jesuit Friend," in Bennett, *Settlement of Florida*, p. 158.

177 *"never ceased to love the French"* Author unknown, "The Recapture of Florida," trans. Jeannette Thurber Connor, in ibid., p. 211. The other passages quoted here come from pp. 214, 221, and 225.

179 *how Le Moyne could have gotten it all so wrong* See David Beers Quinn's analysis of the map in Hulton et al., *The Work of Jacques Le Moyne de Morgues*, vol. I, pp. 37–44.

180 *"intended to deceive"* Ibid., p. 43.

181 *"monstrous cruelty"* Le Challeux in Lorant, *The New World*, p. 116.

181 *"extreme treachery and atrocious cruelty of the Spaniards"* Le Moyne in Hulton et al., *The Work of Jacques Le Moyne de Morgues*, vol. I, p. 119.

181 *"For the destruction of Ribault and his men"* Here I use the translation from Lorant, *The New World*, p. 86.

CHAPTER TWENTY: BLOOMS AND BLOOD

182 "is a Renaissance discovery" Germain Bazin, A Gallery of Flowers (New York: Appleton-Century, 1960), p. 14.

182 "like roofless outdoor rooms" Helen M. Fox, André Le Nôtre, Garden Architect to Kings (New York: Crown Publishers, 1962), p. 39.

182 first recognizable commercial nurseries See Keith Thomas, Man and the Natural World: A History of the Modern Sensibility (New York: Pantheon Books, 1983), pp. 223–28.

182 "unsurpassed in his time" Hulton, "Jacques Le Moyne de Morgues, Peintre," in Hulton et al., The Work of Jacques Le Moyne de Morgues, vol. 1, p. 82.

183 wanted to withdraw into a silent world of beauty and color The artist seems to have turned his back even on the flora of the New World. "In Le Moyne's work we find none of those exotic and horticultural species that so fascinated the collectors and botanists of the period. It was . . . the humble wild flower . . . and the simple blooms that could be found in every kitchen garden . . . that attracted the artist's eye," wrote the scholar Lucia Tongiorgi Tomasi in An Oak Spring Flora: Flower Illustration from the Fifteenth Century to the Present Time: A Selection of the Rare Books, Manuscripts and Works of Art in the Collection of Rachel Lambert Mellon, trans. Lisa Chien (Upperville, Va.: Oak Spring Garden Library, distributed by Yale University Press, 1997), p. 29.

183 a plant believed to ward off evil spirits See Edwin Radford and Mona Augusta Radford, The Encyclopedia of Superstitions, revised and enlarged ed., edited and rev. Christina Hole (New York: Barnes & Noble, 1996), p. 248.

183 "for the driving away of sorrow" John Gerard, The Herball or Generall Historie of Plantes. Gathered by John Gerarde of London Master in Chirurgerie Very Much Enlarged and Amended by Thomas Johnson Citizen and Apothecarye of London (London: Adam Islip Joice Norton and Richard Whitakers, 1633), p. 797.

183 "For the flesh of God, we must kill all Huguenots!" Quoted in Knecht, The Rise and Fall of Renaissance France, 1483–1610, p. 314.

184 "God will not suffer this execrable coupling" Quoted in ibid., p. 358.

184 at least some link to the Guise family See ibid., p. 361.

185 dragged the butchered carcass through the streets See ibid., p. 362, as well as Barbara B. Diefendorf, Beneath the Cross: Catholics and Huguenots in Sixteenth-Century Paris (New York: Oxford University Press, 1991), p. 103.

185 two to three thousand men, women, and children were shot or hacked to death See Baumgartner, France in the Sixteenth Century, p. 216.

185 approximately three thousand additional lives See Philip Benedict, "The Saint Bartholomew's Day Massacres in the Provinces," in The Historical Journal, vol. 21, no. 2 (June 1978): pp. 205–25.

185 slaughtered several hundred heretics See Benedict, Rouen During the Wars of Reli-

gion, p. 128. Estimates of the death toll range from three hundred to more than six hundred.

185 *A mob then marched on nearby Dieppe* See Philippe Erlanger, *St. Bartholomew's Night: The Massacre of Saint Bartholomew,* trans. Patrick O'Brian (New York: Pantheon, 1962), p. 186, as well as Guillaume Daval and Jean Daval, *Histoire de la Réformation à Dieppe, 1557–1657* (Rouen: Imprimerie de Espérance Cagniard, 1878), pp. 117–20.

185 *the most frequent destination of French citizens bound* See W. J. Hardy, "Foreign Refugees at Rye," in *Procedings of the Huguenot Society of London,* vol. 2 (1887–1888): pp. 406–421, 567–76. The quotes (in which I use modern spellings) and most of the other information in the section come from this article.

CHAPTER TWENTY-ONE: ALIAS MORGEN

187 *the Blackfriars district* See Irwin Smith, *Shakespeare's Blackfriars Playhouse: Its History and Design* (New York: New York University Press, 1964), pp. 3–154, as well as L. W. Cowie, "Blackfriars in London," in *History Today,* vol. 24, no. 12 (December 1974): pp. 846–53.

188 *bustling city of 120,000* These figures are from Geoffrey Trease, *London: A Concise History* (London: Thames and Hudson, 1975), p. 90.

188 *"James Le Moyne, alias Morgen, painter"* Reprinted in R. E. G. Kirk and Ernest F. Kirk, eds., *Returns of Aliens Dwelling in the City and Suburbs of London from the Reign of Henry VIII to that of James I,* pt. 2, 1571–1597 (Aberdeen: Printed for the Huguenot Society of London, 1902), p. 354. I have modernized the spelling of "paynter."

188 *Jeane* The first name of the artist's wife can be found in her will (August 9, 1593), which is published in Hulton et al., *The Work of Jacques Le Moyne de Morgues,* vol. I, p. 220.

189 *May 12, 1581* See *Calendar of the Manuscripts of the Most Hon. the Marquis of Salisbury, Preserved at Hatfield House, Hertfordshire,* pt. 13, Addenda (London: Historical Manuscripts Commission, 1915), p. 221.

189 *required to be a denizen prior to that child's birth* See Liza Picard, *Elizabeth's London: Everyday Life in Elizabethan London* (London: Weidenfeld & Nicolson, 2003), p. 119.

189 *two thousand rowboats* See John Fisher, introductory notes to *The A to Z of Elizabethan London,* compiled by Adrian Prockter and Robert Taylor (London: London Topographical Society, 1979), p. x.

190 *"vagabond[s] and idle strumpet[s]"* Quoted in Austin Van der Slice, "Elizabethan Houses of Correction," in *Journal of Criminal Law and Criminology,* vol. 27, no. 1 (May–June 1936): pp. 45–67.

190 *"stately and high, supported with lofty marble pillars"* This quote, in which I have used modern spellings, can be found in Sir George Gater and E. P.

Wheeler, eds., *The Parish of St. Martin-in-the-Fields*, pt. 2, The Strand (London: London County Council, 1937), p. 86. Much of my information on Durham House comes from this text, pp. 84–94.

192 *"The truth is, she took him for a kind of oracle"* Quoted in Raleigh Trevelyan, *Sir Walter Raleigh* (London: Allen Lane, 2002), p. 46. Much of my biographical information on Raleigh comes from this book.

192 *"a misery more lamentable than can be described"* Quoted in ibid., p. 11.

193 *"at a most liberal salary"* Quoted in Lesley B. Cormack, "Mathematics and Empire: The Military Impulse and the Scientific Revolution," in *The Heirs of Archimedes: Science and the Art of War Through the Age of Enlightenment.* Brett D. Steele and Tamera Dorland, eds. (Boston: MIT Press, 2005), p. 185.

193 *the Reverend Richard Hakluyt* To the eternal confusion of history buffs, there were two Richard Hakluyts operating in the same circles at this time. All references in this book are to Richard Hakluyt the minister and geographer, not his cousin Richard Hakluyt the lawyer.

193 *reconnaissance mission to the New World* See David Beers Quinn, *Set Fair for Roanoke: Voyages and Colonies, 1584–1606* (Chapel Hill: University of North Carolina Press, 1985), pp. 20–44.

193 *"no small charges"* Richard Hakluyt, dedicatory letter to Walter Raleigh, in Hakluyt's translation of René Laudonnière, *A Notable Historie Containing Foure Voyages Made by Certayne French Captaynes unto Florida* (London: Thomas Dawson, 1587). Hakluyt's other quotes about Le Moyne, for which I have used modern spellings, also come from this dedication, described in the manuscript as "The Epistle."

CHAPTER TWENTY-TWO: PROTÉGÉ

195 *John White* For biographical information on White, see Paul Hulton, *America 1585: The Complete Drawings of John White* (Chapel Hill: University of North Carolina Press, and London: British Museum Publications, 1984), pp. 7–16, as well as Paul Hulton and David Beers Quinn, *The American Drawings of John White, 1577–1590, with Drawings of European and Oriental Subjects,* vol. 1 (London: Trustees of the British Museum and Chapel Hill: University of North Carolina Press, 1964), pp. 12–24.

195 *two copies of Le Moyne's now-vanished Florida paintings* White's surviving work includes two portraits of Timucua Indians. These works are generally presumed to be copies of Le Moyne's vanished paintings, since White is not known to have set foot in Florida. It is at least possible, however, that Francis Drake brought some Timucua with him to Virginia after his raid on Saint Augustine.

195 *"must have learned much from Le Moyne"* Hulton in Hulton and Quinn, *The American Drawings of John White,* p. 9.

195 *"may well have learned all the older artist could teach"* Ibid., p. 8.

197 *as much as two million pesos* See Harry Kelsey, *Sir Francis Drake: The Queen's Pirate* (New Haven: Yale University Press, 1998), p. 216.

197 *seizure of all English, Dutch, and German ships* See Simon Adams, "The Outbreak of the Elizabethan Naval War Against the Spanish Empire: The Embargo of May 1585 and Sir Francis Drake's West Indies Voyage," in *England, Spain and the Grand Armada, 1585–1604: Essays from the Anglo-Spanish Conferences in London and Madrid, 1988*, eds. M. J. Rodriguez-Salgado and Simon Adams (Edinburgh: John Donald, 1991), pp. 45–69.

198 *as much as a million ducats* See *The Roanoke Voyages, 1584–1590: Documents to Illustrate the English Voyages to North America Under the Patent Granted to Sir Walter Raleigh in 1584*, vol. 1, ed. David Beers Quinn (London: for the Hakluyt Society, 1955), pp. 221–22. This figure—about three hundred thousand pounds—comes from German sources. It is much higher than English or Spanish estimates, published in the same text on pp. 220, 226.

198 *"Spain, France, Italy or the East"* Quoted in Quinn, *Set Fair for Roanoke*, p. 74.

198 *"their old accustomed dainty food"* Thomas Harriot, *A Briefe and True Report of the New Found Land of Virginia* (Frankfort: Theodor De Bry, 1590), p. 6. I have modernized spellings and punctuation.

199 *"unusual ability to free himself from the European artistic conventions"* Hulton in Hulton and Quinn, *The American Drawings of John White*, p. 11.

199 *"more spontaneously naturalistic"* Ibid., p. 10.

200 *"towards the end of the year showed themselves too fierce"* Harriot, *A Briefe and True Report of the New Found Land of Virginia*, p. 30.

200 *"Whether they were friends or foes"* The quote comes from Ralph Lane's account of the voyage in *The Roanoke Voyages, 1584–1590*, vol. 1, p. 288. I have used modern spelling and punctuation.

201 *Pedro Menéndez Marquéz* See ibid., pp. 720–23; Quinn, *Set Fair for Roanoke*, pp. 131–34; and Hoffman, *A New Andalucia and a Way to the Orient*, pp. 299–302.

201 *"had organized an expedition to Virginia"* This testimony comes from an unidentified foreign gentleman who spoke with Drake after the mariner returned from Virginia. His letter about their conversation is republished in *New American World: A Documentary History of North America to 1612*, vol. 3, ed. David Beers Quinn (New York: Arno Press, 1979), pp. 307–10.

201 *"The very hand of God"* Lane in *The Roanoke Voyages, 1584–1590*, vol. 1, p. 293.

201 *"All our cards [i.e., charts and maps]"* Ibid., p. 293.

CHAPTER TWENTY-THREE: REBORN SPRING

203 *"Discordant harmony and stable movement"* Trans. R. N. Currey, in Hulton et al., *The Work of Jacques Le Moyne de Morgues*, vol. 1, p. 165. Currey translated *le stable mouvement* in the first line to "balanced movement." This strikes me as a poor choice, since the earlier phrase, *le discordant accord*, makes it obvious

that the poet intended to use oxymorons. Thus I have changed "balanced movement" to "stable movement."

204 *"the elegant structure of the visible world"* Quoted in Alister E. McGrath, *A Life of John Calvin: A Study in the Shaping of Western Culture* (Cambridge, Mass.: Basil Blackwell, 1990), p. 254. McGrath wrote that Calvin "encouraged the scientific study of nature," while "eliminating a major obstacle to the development of the natural sciences—biblical literalism."

204 *"the colors of a gay spring"* Quoted in the Sotheby's catalog *Old Master Drawings* (New York: Sotheby's, 2005), p. 24. The forensic paper historian Peter Bower has dated the book in which this unsigned poem appears to the early 1560s.

204 *Lady Mary Sidney* Much of my information comes from Simon Adams, "Sidney, Mary, Lady Sidney (1530 x 1535–1586)," in the *Oxford Dictionary of National Biography,* online edition.

204 *"two of the best offices in the kingdom"* Quoted in Margaret P. Hannay, *Philip's Phoenix: Mary Sidney, Countess of Pembroke* (New York: Oxford University Press, 1990), p. 20.

205 *"When I went to [Le Havre]"* Henry Sidney, in *A Viceroy's Vindication?: Sir Henry Sidney's Memoir of Service in Ireland, 1556–1578,* ed. Ciaran Brady (Cork: Cork University Press, 2002), p. 105.

205 *"to hide herself from the curious eyes"* The poet Fulke Greville, quoted in Millicent V. Hay, *The Life of Robert Sidney* (London: Associated University Presses, 1984), p. 18.

205 *contemplating the prospect of a new marriage* See Henry Sidney, in *A Viceroy's Vindication?: Sir Henry Sidney's Memoir of Service in Ireland, 1556–1578,* p. 43.

205 *believed to have been the "Madame Sidney"* Mary Dudley Sidney is not esteemed for her literary patronage. Her name, in fact, is known to appear in the dedication of only one other book. By contrast, her daughter—Mary Sidney Herbert, the Countess of Pembroke—was both a frequent patroness of literature and a legendary embroiderer. Yet while it is tempting to conjecture that Le Moyne was referring to the daughter and not the mother, I could find no other dedications in which the Countess of Pembroke was referred to as "Madame Sidney." And as Mary Sidney Herbert's biographer Margaret P. Hannay informed me via e-mail, "It seems rather unlikely that the Countess of Pembroke would have been addressed as 'Madame Sidney,' which would have been perfectly appropriate for her mother's name and rank. The Countess of Pembroke even signed her name as 'M. Pembroke,' so I doubt that she would have been addressed without her title, especially by someone seeking patronage." For more information on the literary patronage of these two women, see Franklin B. Williams, Jr., *Index of Dedications and Commendatory Verses in English Books Before 1641* (London: The Bibliographical Society, 1962), pp. 94, 170.

205 *learned of Le Moyne from Walter Raleigh* See Hulton in Hulton et al., *The Work of Jacques Le Moyne de Morgues,* vol. 1, p. 11.

206 *"I have chosen among the animals"* Quoted in ibid.

207 *Mary Sidney Herbert* For information on her upbringing and interest in embroidery, see Hannay, *Philip's Phoenix,* pp. 15–32, 129–30.

207 *"She wrought so well in needle-work"* John Taylor, *The Needles Excellency* (London: James Boler, 1631), p. B3.

207 *Queen Elizabeth wears sleeves embroidered with roses* See M. Jourdain, *The History of English Secular Embroidery* (London: Kegan, Trenc, Trübner and Co., 1910), p. 33, as well as Santina M. Levey, *An Elizabethan Inheritance: The Hardwick Hall Textiles* (London: National Trust Enterprises, 1998), pp. 36–37.

207 *"The love of flowers is evident"* George Wingfield Digby, *Elizabethan Embroidery* (New York: Thomas Yoseloff, 1964), p. 36. The other quotes from this text can be found on pp. 36 and 41.

208 *"Your Virtue, holy ornament"* Quoted in Hulton et al., *The Work of Jacques Le Moyne de Morgues,* vol. 1, p. 187.

208 *"Their tone, at once deferential and flattering"* Hulton in ibid., pp. 11–12.

209 *"hath put down in writing many singularities"* Hakluyt, dedicatory letter to Walter Raleigh, in Hakluyt's translation of René Laudonnière, *A Notable Historie Containing Foure Voyages Made by Certayne French Captaynes unto Florida.*

209 *eighty-four men, seventeen women, and eleven children* See Hulton, *America 1585,* p. 13. David Beers Quinn put the total number at fewer than one hundred. See Quinn, *Set Fair for Roanoke,* p. 268.

210 *"expected nothing but . . . to perish at sea"* White in *The Roanoke Voyages, 1584–1590,* vol. 2, p. 537.

210 *130 ships carrying 19,000 troops* See Geoffrey Parker, *The Grand Strategy of Philip II* (New Haven: Yale University Press, 1998), p. 202.

210 *"evil disposed mariners"* White in *The Roanoke Voyages, 1584–1590,* vol. 2, p. 568.

210 *"was wounded twice in the head"* Ibid., p. 567.

211 *"Johne Morgayn, painter" was buried in Blackfriars* Parish of St. Ann Blackfriars, burial registers, Guildhall Library, Ms 4510/I. "Morgayn" was laid to rest just five days after Le Moyne wrote his will. I was surprised that no previous researchers had discovered this record and wondered if they simply had not expected to locate the artist in a Church of England cemetery. I would learn, however, that such burials were apparently common at that time. Although French Calvinists had their own church in London, "Huguenots were not particularly interested in recording burials, and did not normally maintain their own burial grounds," explained Robin D. Gwynn in *Huguenot Heritage: The History and Contribution of the Huguenots in Britain* (London: Routledge & Kegan Paul, 1985), p. 180.

CHAPTER TWENTY-FOUR: DEATH AND DELIVERANCE

212 *His last will* This document is published in Hulton et al., *The Work of Jacques Le Moyne de Morgues,* vol. I, p. 219. It is the source of the material quoted here.

212 *Life expectancy for men of that era* See Picard, *Elizabeth's London,* p. 89.

213 *In the spring of 1572, Laudonnière put to sea* See Bennett, *Laudonnière & Fort Caroline,* pp. 50–52.

214 *"infamous people, Sodomites, sacrificers to the devil"* Quoted in David J. Weber, *The Spanish Frontier in North America* (New Haven: Yale University Press, 1992), p. 75.

214 *"after the salvation of my soul"* Menéndez to his nephew, Pedro Menéndez Marquéz, September 7 and 8, 1574, in Solís de Merás, *Pedro Menéndez de Avilés: Memorial,* p. 255.

214 *"human capital management consultancy"* The firm, Penna, has moved to another part of London since my visit. This description comes from its website.

215 *water-taxi pilots having gone off to join the English navy* See Picard, *Elizabeth's London,* p. 15.

215 *"Nothing less is at stake"* Quoted in Kamen, *Philip of Spain,* p. 274.

215 *"It is easier to find a flock of white crows"* The Italian calligrapher and writer Petruccio Ubaldini, quoted in Garrett Mattingly, *The Armada* (Boston: Houghton Mifflin, 2005), p. 344.

215 *"if, this year, total catastrophe does not befall"* This prognostication, widely distributed at the time of the Armada, was from the fifteenth-century mathematician Regiomontanus, quoted in ibid., p. 176.

215 *"year of wonders"* This is from a different translation of Regiomontanus, in Anne Somerset, *Elizabeth I* (New York: St. Martin's Press, 1992), p. 451.

215 *"afflicting mankind with woeful destiny"* Ibid.

215 *"It would appear that what has just happened"* Colin Martin and Geoffrey Parker, *The Spanish Armada* (New York: W. W. Norton, 1988), p. 159.

217 *"my books torn from the covers"* Quoted in Hulton, *America 1585,* p. 15. I have modernized spelling.

217 *Theodor de Bry* Much of my biographical information comes from M. S. Giuseppi, "The Work of Theodore De Bry and his Sons, Engravers," *Proceedings of the Huguenot Society of London,* vol. II, no. 2 (1917): pp. 204–226. See also Deák, *Discovering America's Southeast,* pp. 41–42, 47–62, 74–80; and the British Museum, Department of Prints and Drawings, *Early Engraving & Engravers in England (1545–1695): A Critical and Historical Essay by Sidney Colvin* (London: British Museum, 1905), pp. 6, 37–41.

217 *"formed a deep friendship"* De Bry, introduction to 1591 edition of Le Moyne's narrative, in Hulton et al., *The Work of Jacques Le Moyne de Morgues,* vol. I, p. 117.

217 *"I was the offspring of parents born to an honorable station"* Quoted in Giuseppi, "The Work of Theodore De Bry and his Sons, Engravers," pp. 204–205.

219 *"the first attempt to introduce"* Bernadette Bucher, *Icon and Conquest: A Structural Analysis of de Bry's Great Voyages,* trans. Basia Miller Gulati (Chicago: University of Chicago Press, 1981), p. 3.

219 *"gathered information on a great many questions"* De Bry, introduction to 1609 edition of Le Moyne's narrative, in Hulton et al., *The Work of Jacques Le Moyne de Morgues,* vol. I, p. 119.

219 *"reached an agreement about publishing"* Ibid.

219 *"Filled with joy"* Translated from the preface of the Latin edition to Le Moyne's Florida volume, in Giuseppi, "The Work of Theodore De Bry and his Sons, Engravers," p. 209.

219 *"diligent pains in engraving the pictures"* Ibid.

220 *he witnessed this macabre scene with his own eyes* See the picture caption in Hulton et al., *The Work of Jacques Le Moyne de Morgues,* vol. I, p. 149.

221 *"taken from life"* De Bry, introduction to 1591 edition of Le Moyne's narrative, in ibid., p. 117.

221 *"pleasing entertainment"* Pierre Joly, quoted in Giuseppi, "The Work of Theodore De Bry and his Sons, Engravers," p. 216.

221 *"Tower of Babel of the Amerindian peoples"* Bucher, *Icon and Conquest,* p. 18.

221 *"despite the fancifulness of many details"* Ibid., p. 14.

222 *"I have in hand the history of Florida"* Harriot, *A Briefe and True Report of the New Found Land of Virginia,* p. 37.

222 *a major outbreak of the bubonic plague* See J.F.D. Shrewsbury, *A History of Bubonic Plague in the British Isles* (Cambridge, England: University Press, 1970), pp. 222–30.

222 *killing as many as twenty-six thousand people* See ibid., p. 227. This figure includes burial records from the "liberties" (quasi-independent districts, such as Blackfriars) and the "out parishes" (districts lying outside London's walls but still belonging to the urban area).

223 *"Mrs. Moorge, widow"* Parish of St. Ann Blackfriars, burial registers, Guildhall Library, Ms 4510/1. "Mrs. Moorge" was buried four days after Jeane Le Moyne's last will. Next to her name in the burial record is "pl."—an abbreviation for plague.

223 *"sick of body but sound in her soul and spirit"* Jeane Le Moyne, "The Will of Jeane Le Moyne," August 9, 1593, in Hulton et al., *The Work of Jacques Le Moyne de Morgues,* vol. I, p. 220.

CHAPTER TWENTY-FIVE: VANISHINGS

224 *one of his Indian allies set off a fire* See Lowery, *The Spanish Settlements Within the Present Limits of the United States: Florida, 1562–1574,* p. 33; Lyon, *The Enterprise of*

Florida, p. 200; and Lyon, "Forts Caroline and San Mateo: Vulnerable Outposts," pp. 55–56.

224 *Menéndez decided to abandon it for good* See Lyon, "Forts Caroline and San Mateo: Vulnerable Outposts," p. 57.

225 *British built a defensive earthwork* See Charles E. Bennett, *Southernmost Battlefields of the Revolution* (Bailey's Crossroads, Va.: Blair, 1970), pp. 18–19, 21. For information on the bluff during the Civil and Spanish-American wars, see George E. Buker, *Jacksonville: Riverport-Seaport* (Columbia, S.C.: University of South Carolina Press, 1992), pp. 64–65, 120–27.

225 *"We are the ones who are subduing"* Father Francisco Pareja, quoted in Jerald T. Milanich, *Florida Indians and the Invasion from Europe* (Gainesville: University Press of Florida, 1995), p. 172.

225 *"derides and laughs"* Pareja, quoted in ibid., p. 198.

225 *European diseases* See Milanich, *The Timucua,* pp. 196–204. All quotes and statistics about epidemics cited here are from this book.

227 *By 1717, only 250 Timucua were known to survive* See ibid., p. 214. The other statistics about dwindling populations are also from this text, pp. 212–16.

228 *live out their lives in exile* According to the historian John E. Worth, at least 25 percent of the Timucua who emigrated to Cuba died within five years. The dead included Juan Alonso Cavale, who appears to have been the last living full-blooded Timucuan Indian whose parents were born in the interior of Spanish Florida. See Worth, *The Timucuan Chiefdoms of Spanish Florida,* vol. 2 (Gainesville: University Press of Florida, 1998), p. 156.

229 *"What toil, difficulty, perplexity, anxiety"* Thomas Frognall Dibdin, *The Library Companion, Or, The Young Man's Guide, and the Old Man's Comfort, in the Choice of a Library,* 2nd ed. (London: Harding, Triphook, and Lepard, 1925), pp. 382–84.

229 *"half-forgotten chapter"* Parkman, *Pioneers of France in the New World,* p. xxiii.

CHAPTER TWENTY-SIX: REDISCOVERERS

230 *"I often feel as if I were already dead"* Stefan Lorant, *I was Hitler's Prisoner: A Diary* (New York: G. P. Putnam's Sons, 1935), p. 9. The other passages quoted here are from pp. 9 and 46.

230 *six hundred of those prisoners died in custody* See Richard J. Evans, *The Coming of the Third Reich* (New York: Penguin, 2004), p. 348.

231 *"a certain affinity for celebrity"* Robert McG. Thomas, Jr., "Stefan Lorant, 96, Author and Magazine Editor," *The New York Times* (Nov. 18, 1997): p. D27.

231 *Leni Riefenstahl* See Michael Hallett, *Stefan Lorant: Godfather of Photojournalism* (Lanham, Md.: Scarecrow Press, 2006), p. 24. Hallett's text hints that Lorant and Riefenstahl were lovers. Lorant's quotes on various subjects are from pp. 23, 33, and 106–107.

233 *Prime Minister Winston Churchill* This story comes from Lorant's biographer, Michael Hallett, who provided me with details in a letter.

233 *"the most important historical volume of the year"* Henry Steele Commager, quoted in Hallett, *Stefan Lorant: Godfather of Photojournalism,* p. 109.

234 *"so completely off as to bear slight resemblance"* Samuel E. Morison, letter to the editor, *William and Mary Quarterly,* 3rd ser., vol. 4, no. 3 (July 1947): pp. 395–402. Morison was sharpening his criticism of the reproductions, which in an earlier book review he had described as only having "a smudgy, dull effect that does not do justice to the originals."

234 *"That book really made people aware"* Jerald T. Milanich, phone interview with author.

235 *Spencer Savage* Much of my biographical information on the librarian comes from his obituary in *The Times* of London (Nov. 8, 1966): p. 12. See also Wilfrid Blunt and William T. Stearn, *The Art of Botanical Illustration,* new ed., rev. and enlarged (Woodbridge, Suffolk: Antique Collectors' Club in association with the Royal Botanic Gardens, 1994), pp. 96–97, as well as Andrew Thomas Gage and William Thomas Stearn, *A Bicentenary History of the Linnean Society of London* (London: Academic Press, 1988), pp. 102, 103, 106, 117, 222, 223.

235 *purchased in 1856* See author unknown, "A Tudor Flower Artist. Le Moyne Drawings on View," in *The Times* of London (March 10, 1922): p. 15.

236 *"a keen love and perception of the delicate beauties of plants"* The quotes about Le Moyne's work come from two sources: Spencer Savage, in "The Discovery of Some of Jacques Le Moyne's Botanical Drawings," *The Gardeners' Chronicle,* 3rd ser., vol. 71 (Jan. 28, 1922): p. 44, and Spencer Savage, "Early Botanical Painters. No. 3—Jacques Le Moyne de Morgues," in *The Gardeners' Chronicle,* 3rd ser., vol. 73 (March 14, 1923): pp. 148–49.

237 *"a discovery which has many points of interest"* Author unnamed, "Notes on Sales; Le Moyne's 'Le Clef des Champs,' " *The Times Literary Supplement* (Feb. 9, 1922): p. 96.

237 *"never had the opportunity of becoming a trained thinker"* Spencer Savage, letter to Agnes Arber, April 24, 1931, manuscripts collection, The Linnean Library, Linnean Society of London.

238 *"that subtle pleasure"* Spencer Savage, unpublished manuscript of a book on *La Clef des Champs,* manuscripts collection, The Linnean Library, Linnean Society of London.

CHAPTER TWENTY-SEVEN: CRUSADER

239 *pilgrimages to the Saint Johns Bluff* Much of my information about Bennett's early experiences in Jacksonville comes from his recollections in "Charles E. Bennett Oral History," an eleven-tape video made by the National

Park Service/Timucuan Ecological and Historic Preserve in 2002. The material about Bennett's car trips to the Saint Johns Bluff and encounters with the historian T. Frederick Davis is drawn from tapes 1 and 2.

240　*an historical moving picture*" Bennett to MGM Moving Pictures Studios, Sept. 1, 1939, box 65, file 1, Charles E. Bennett Papers, Special and Area Studies Collections, George A. Smathers Libraries, University of Florida, Gainesville, Florida.

240　*Ripley's Believe It or Not!* Bennett to Mr. Robert L. Ripley, June 5, 1940, in ibid.

240　*"If this idea is accepted by you"* Bennett to the Honorable James A. Farley, Postmaster General of the United States, July 6, 1940, in ibid.

241　*first order of business* See "Fort Caroline Park Proposal to Be Offered," *The Florida Times-Union* (Dec. 31, 1948): p. 2.

241　*the Department of the Interior* See Oscar L. Chapman, Under Secretary of the Interior, to the Honorable Andrew L. Somers, Chairman, Committee on Public Lands, U.S. House of Representatives, April 4, 1949, in Charles E. Bennett Papers, box 65, file 3.

241　*the board of commissioners for Duval County* See "Board Votes Against Bluff Site; Commissioners to Inform Rep. Bennett and Land Group Chairman," in *The Florida Times-Union* (Feb. 28, 1950): p. 19.

241　*"I hope you will forget this 'dream' "* Loren O. Martin to Bennett, June 24, 1950, in Charles E. Bennett Papers, box 65, file 3.

241　*"Why in the name of goodness"* Mrs. M. T. Vickers to Bennett, Aug. 16, 1950, in ibid.

241　*"As to my own political fortunes"* Bennett to Mrs. Vickers, Aug. 18, 1950, in ibid.

241　*"epitome of a Southern gentleman"* The political consultant Mike Tolbert, quoted in David DeCamp, "City Was Changing as His Tenure Ended," *The Florida Times-Union* (Sept. 7, 2003): p. A1.

241　*a square-dance caller* See Charles Bennett: Oral History, tape 6.

242　*an order establishing the Fort Caroline National Memorial* See "Fort Caroline National Memorial Established," press release, Department of the Interior, Jan. 19, 1953, in Charles E. Bennett Papers, box 67, file 6.

242　*"He told someone the reason he married me"* Jean Bennett, interview with author.

242　*he contributed about nineteen thousand himself* See Bennett to R. W. Patrick, Oct. 16, 1951, in Charles E. Bennett Papers, box 66, file 5. Bennett reported that he had to borrow "a substantial part of the money."

242　*"Mr. Clean"* See John Files, "Charles E. Bennett Dies at 92; Put 'In God We Trust' on Bills," in *The New York Times* (Sept. 10, 2003).

243　*"the great artist"* From Charles Bennett: Oral History, tape 2.

243　*"I have forgotten the name of"* Bennett to the Honorable Arthur G. Hudd, British Museum, Oct. 14, 1952, in Charles E. Bennett Papers, box 67, file 6.

243 *"An act of Parliament has to be passed"* Hudd to Bennett, Nov. 6, 1952, in ibid.

243 *"probably not an original Le Moyne"* J. O. Brew, director, Peabody Museum of Archaeology and Ethnology, Nov. 21, 1951, in ibid., box 66, file 5.

243 *a 1591 edition of the artist's narrative* According to Anne R. Lewellen, museum curator at the Timucuan Ecological and Historic Preserve, the Fort Caroline National Memorial's copy of Le Moyne's narrative "has an indeterminate provenance, but is probably on long-term loan from the Library of Congress." Lewellen, e-mail correspondence with author.

243 *"He knew I would respect them"* James Bennett, interview with the author.

244 *Bennett did not miss a single vote on legislation* For background on Bennett's accomplishments and ethical standards, see Stacy Mason, "In Surprise, Bennett Decides He'll Retire; Sixth Floridian, Giving State 10 Open Seats," *Roll Call* (June 11, 1992): p. 15. See also Rudy Maxa, "It Took Years, But Mr. Ethics At Last Succeeds; Representative Charles Bennett," *The Washington Post Magazine* (April 9, 1978): p. 9, as well as "Charles E. Bennett; A Noble Life," *The Florida Times-Union* (Sept. 9, 2003): p. B4.

244 *"When dealing with Bennett"* "Charles E. Bennett; A Noble Life."

245 *"perhaps the least successful attempt"* John Matzko, *Reconstructing Fort Union* (Lincoln: University of Nebraska Press, 2001), p. 4.

245 *a farewell gift of more than $270,000* See Guy Gugliotta, "The Book of Lives After the Hill," *The Washington Post* (January 17, 1995): p. A17.

CONCLUSION: SEARCHING FOR ROOTS

249 *digging for Jacques Le Moyne* This excavation took place in June of 2004.

249 *"ships now pass over the precise site of Fort Caroline"* T. Frederick Davis, *History or Jacksonville, Florida and Vicinity, 1513 to 1924* (Jacksonville: The Florida Historical Society, 1925), p. 9.

249 *presumed this earlier French outpost had eroded* See Brian Hicks, "Charlesfort Find Enriches Parris," in *The Post and Courier* of Charleston, S.C. (Dec. 8, 1997): p. A1.

249 *the discovery of James Fort* See John Noble Wilford, "Jamestown Fort, 'Birthplace' of America in 1607, is Found," in *The New York Times* (Sept. 13, 1996): p. A1.

252 *search for the fort at two nearby locales* See Rebecca Gorman, "Searching for Fort Caroline: New Perspectives," a paper submitted in partial fulfillment of the requirements for the Degree of Master of Arts, Department of Anthropology, University of Florida (November 2005), pp. 13–14.

252 *most promising places to dig* See ibid., pp. 1–39. Gorman, a graduate student in anthropology at the University of Florida who was working on the dig as a paid research assistant, devoted her work on a master's degree to locating the vanished fort. She concluded that an area called Fulton, just west of the Fort Caroline National Memorial, should be considered "a prime

location" as the site of the lost outpost. That locale, however, is developed with upscale homes, presenting future researchers with formidable legal and logistical challenges. Still, Gorman told me, "if somebody gave me a grant right now, I'm pretty sure I could take a year and find something."

253 *"ground-penetrating radar"* As this book went to press in the fall of 2007, Thunen reported that he had finally been able to get access to this equipment and hoped to resume the search for Fort Caroline in the near future.

253 *"a gray shadow"* Guy de Maupassant, *Pierre and Jean,* trans. Leonard Tancock (Harmondsworth, England: Penguin Books, 1979), p. 88.

253 *"smoke and mildew"* Here I use the translation in Maupassant, *Pierre et Jean,* trans. Julie Mead (New York: Oxford University Press, 2001), p. 57.

253 *staying prior to the start of the journey* See Le Moyne in Hulton et al., *The Work of Jacques Le Moyne de Morgues,* vol. 1, p. 119.

254 *Protestant sailors ransacked the building* See Daval and Daval, *Histoire de la Réformation à Dieppe, 1557–1657,* pp. 22–23, and François Deshoulières, *Dieppe* (Paris: H. Laurens, 1929), pp. 22–23.

254 *born and trained in Dieppe* The art historian Paul Hulton flatly asserted that Le Moyne was "described by [Theodor] De Bry as a citizen of Dieppe." The truth is more complicated, however. De Bry, in fact, made no mention of Dieppe in his introduction to the first edition of Le Moyne's narrative, published in 1591. It was not until the second edition, which appeared in 1609, that the artist was described as "Jacques le Moyne, also known as Jacques Morgues of Dieppe." Yet by the time Theodor de Bry had been dead for more than a decade, and Le Moyne had been buried for more than twenty years. The assertion that Le Moyne was from Dieppe appears to have been made by De Bry's sons, who took over their father's publishing business. If so, it was almost certainly based on hearsay or conjecture. (See Hulton et al., *The Work of Jacques Le Moyne de Morgues,* vol. 1, pp. 3, 117–18.) Nor could I find any other evidence linking Le Moyne to Dieppe. A census taken of foreigners living in London in 1583, for example, is often quite specific about place of origin, regularly describing French immigrants as having been born in Normandy, or even in specific cities, including Dieppe. Le Moyne, by contrast, is simply described as having been "born under the obedience of the French king." See Kirk and Kirk, eds., *Returns of Aliens Dwelling in the City and Suburbs of London from the Reign of Henry VIII to that of James I,* pt. 2, p. 354.

254 *"wandering painters and sculptors,"* Bruce Cole, *The Renaissance Artist at Work: From Pisano to Titian* (New York: Harper & Row, 1983), p. 22.

254 *"willing, and indeed eager"* Ibid., p. 21.

254 *"went through the whole kingdom"* Le Moyne in Hulton et al., *The Work of Jacques Le Moyne de Morgues,* vol. 1, p. 119.

255 *"does not appear in records for the Dieppe area"* Hulton in ibid., p. 3.

255 *first appeared in the historical record in 1497* See Raymond Bouquery, *Les Noms de Lieux en Eure-et-Loir,* vol. 13, "Canton de Châteaudun" (Chartres: Helio Plans, 1998), p. 116.

255 *Jean Bourdichon* See Hulton et al., *The Work of Jacques Le Moyne de Morgues,* vol. 1, p. 79.

255 *"It was by the books"* Henry Lehr, *La Réforme et les Églises Réformées dans le Département Actuel d'Eure-et-Loir, 1523–1911* (Chartres: E. Garnier, 1912), p. 4.

256 *"You have never seen such an explosion"* Quoted in ibid., p. 174.

256 *I could find no mention of him* While records show that as many as ten embroiderers were employed by the queen at one time, the only ones consistently mentioned are Pierre Oudry, Ninian Miller, and Charles Plouvart. While held in England, Mary also utilized the skills of Bastian Pagez, a valet and stage designer, who sometimes drafted needlework patterns for her. See Levey, *An Elizabethan Inheritance,* p. 70; Margaret Swain, *The Needlework of Mary Queen of Scots* (New York: Van Nostrand Reinhold Company, 1973), pp. 36, 42, 45, 51, 72, and 91; Margaret Swain, *Scottish Embroidery: Medieval to Modern* (London: B. T. Batsford, 1986), pp. 19, 21, and 38; Margaret Swain, *Historical Needlework: A Study of Influences in Scotland and Northern England* (London: Barrie & Jenkins, 1970), pp. 15, 16, and 20; Wingfield Digby, *Elizabethan Embroidery,* p. 55; and Jourdain, *The History of English Secular Embroidery,* p. 32.

256 *Mary of Guise* Much of this biographical material comes from Rosalind K. Marshall, *Mary of Guise* (London: Collins, 1977), pp. 34–35.

256 *Henry Le Moyne and his work* In fact, this craftsman may have been part of a prominent family of needleworkers. Records from 1514 show that an embroiderer named "John de Molyne" was residing near London, where he was helping with the lavish preparations for the marriage between Princess Mary of England and King Louis XII of France. I am grateful to the textile historian Santina M. Levey for calling this possible family link to my attention. See Public Record Office, Great Britain, *Letters and Papers, Foreign and Domestic, of the Reign of Henry VIII,* 2nd ed. (London: H.M. Stationery Office, 1920), vol. 1, part 2, no. 3343, p. 1407. See also Public Record Office, Great Britain, *Letters and Papers, Foreign and Domestic, of the Reign of Henry VIII* (London: Longmans, Green Reader & Dyer, 1867), and vol. III, part 2, no. 3349, p. 1555.

257 *By 1545, according to archival records* See undated notary entry from 1545, Archives Départementales d'Eure et Loir, "Titres de familles et notaires avant et apres 1790," book 2B, series E, No. 2947, p. 363.

257 *would have been responsible for any number of tasks* See Wingfield Digby, *Elizabethan Embroidery,* pp. 29–35.

258 *la plus parfaite* See John Guy, *Queen of Scots: The True Life of Mary Stuart* (Boston: Houghton Mifflin, 2004), p. 78.

258 *"sumptuously and richly made"* A contemporary account, quoted in ibid., p. 83.

258 *an April 22, 1563, receipt* See notary entry from that date, Archives Départementales d'Eure et Loir, "Titres de familles et notaires avant et apres 1790," book 2B, series E, No. 3064, p. 382.

258 *A document from April of 1562* See notary entry for April 29, 1562, Archives Départementales d'Eure et Loir, "Titres de familles et notaires avant et apres 1790," book 2B, series E, No. 3060, p. 381.

258 *even higher status than that of peintre du roi* See Martin Warnke, *The Court Artist: On the Ancestry of the Modern Artist,* trans. David McLintock (New York: Cambridge University Press, 1993), pp. 5–6, 114–19.

258 *"extreme attachment to her servants"* Antonia Fraser, *Mary Queen of Scots* (New York: Delta Trade Paperbacks, 2001), p. 180.

259 *"where she herself ordinarily sitteth"* Quoted in Swain, *The Needlework of Mary Queen of Scots,* p. 36. I have modernized the spellings, here and elsewhere in the chapter.

259 *"passion and almost a mania"* Fraser, *Mary Queen of Scots,* p. 412.

259 *"This Queen," wrote the earl* Quoted in E. Carleton Williams, *Bess of Hardwick* (London: Longmans, Green and Co., 1959), p. 73.

259 *"I asked her Grace"* Ibid., p. 71.

260 *A document from 1582* See undated notary entry from 1582, Archives Départementales d'Eure et Loir, "Titres de familles et notaires avant et apres 1790," book 2B, series E, No. 3115, p. 390.

260 *banned from seeing the queen in 1578* See Jourdain, *The History of English Secular Embroidery,* footnote 1, p. 32.

260 *with whom she quarreled in 1585* See ibid.

260 *presented an acquaintance with her embroidered glove* See ibid., p. 43.

260 *Henry Le Moyne died just six months later* See burial records for the Church of the Madeleine, Archives Municipales, Châteaudun, "Henry Le Moyne the embroiderer," August 27, 1587.

260 *born in or around 1510* A document from 1562 describes Henry Le Moyne as being fifty-two years old. See notary entry for April 29, 1562, Archives Départementales d'Eure et Loir, "Titres de familles et notaires avant et apres 1790," book 2B, series E, No. 3060, p. 381.

261 *"Slip"* See Wingfield Digby, *Elizabethan Embroidery,* p. 132.

261 *a dozen and a half little flowers, painted on canvas* See Swain, *The Needlework of Mary Queen of Scots,* p. 43.

261 *"an embroiderer to draw forth"* Quoted in ibid., p. 42.

261 *"52 different flowers"* Quoted in ibid., p. 91.

262 *embroidery was typically a family business* From the fourteenth century on, French embroidery workshops "probably had family dynasties of craftsmen, running their own workshops and passing their skills on to the next generation in the family," wrote Kay Staniland in *Embroiderers* (London:

British Museum Press, 1991), p. 14. By 1770, Charles Germain de Saint-Aubin, the royal embroidery designer to King Louis XV, was reporting that the Parisian guild required that "an embroiderer can only be assisted by the sons or daughters of master embroiderers." Saint-Aubin, *Art of the Embroiderer,* trans. Nikki Scheuer (Los Angeles: Los Angeles County Museum of Art, 1983), p. 19.

261 *skilled artists were needed to provide embroidery designs* See Wingfield Digby, *Elizabethan Embroidery,* pp. 51–52.

261 *professional workshops may have employed their own draftsmen* See Santina Levey, "Embroidery, Renaissance to Rococo," in Donald King and Levey, *The Victoria & Albert Museum's Textile Collection Embroidery in Britain from 1200 to 1750* (London: Victoria & Albert Museum, 1993), p. 17.

261 *watercolor was often the medium of choice* See Staniland, *Embroiderers,* p. 52.

262 *"embroidery, tapestry and also for all kinds of needlework"* Le Moyne, dedicatory letter to *La Clef des Champs,* in Hulton et al., *The Work of Jacques Le Moyne de Morgues,* vol. 1, p. 187.

262 *a cushion cover that once belonged to Elizabeth Talbot* See Hulton in ibid., pp. 80–81.

262 *"Nowhere is Le Moyne referred to as a 'peintre du roi' "* Hulton in ibid., p. 4.

263 *"easy access"* Warnke, *The Court Artist,* p. 117.

264 *florilegia* For a good overview, see Gill Saunders, *Picturing Plants: An Analytical History of Botanical Illustration* (Berkeley: University of California Press in association with the Victoria and Albert Museum, London, 1995), pp. 41–64.

264 *"one of the originators of the genre"* Tongiorgi Tomasi, *An Oak Springs Flora,* p. 18.

264 *"great artistry with impressive scientific accuracy"* Ibid., p. 40.

264 *a previously unknown collection of his plant portraits* See the 2005 Sotheby's catalog *Old Master Drawings,* pp. 23–39.

265 *"a reference collection of plants"* The forensic paper historian Peter Bower, phone interview with author.

265 *a time-consuming process* See Bower, "Powerful Connections."

266 *W. Graham Arader III* For background on this controversial and fascinating figure, see Miles Harvey, *The Island of Lost Maps: A True Story of Cartographic Crime* (New York: Random House, 2000), pp. 45–77. See also Mark Singer, "Wall Power," in *The New Yorker,* vol. 63, no. 41 (November 30, 1987): pp. 44–46ff.

267 *"rich WASPs who haven't worked very much"* Phone interview with author.

267 *as much as $375,000 apiece* See Arader Galleries, *The Syndication of an Exceptionally Rare Manuscript by the Master of Sixteenth-Century Florilegia: Jacques Le Moyne de Morgues* (New York: Arader Galleries, 2005). By October of 2007, Arader reported that he had sold twelve of the paintings. Some of the others were on display in his New York gallery. He had also "hung twenty

of the best watercolors in my daughter's bedroom," he told me via e-mail. "It is now the most spectacular little girl's bedroom in the world."

268 *"Is it how I made my money in the first place?"* Quoted in Harvey, *The Island of Lost Maps,* p. 61.

268 *"caring little for their private profit"* Le Moyne, dedicatory letter to *La Clef des Champs,* in Hulton et al., *The Work of Jacques Le Moyne de Morgues,* vol. 1, p. 187.

Index

Page numbers in *italics* refer to illustrations.

Illustration Credits

The author and publisher wish to thank the following institutions for photographs and photographic reproductions: Special Collections Department, University of South Florida (cover, title pages, xix, 3, 12, 18, 33, 38, 39 left, 40, 42, 43, 45 right, 48, 50, 52, 57, 66, 68, 77, 78, 81, 86, 88, 97, 99, 100, 103, 111, 118, 119, 122, 133, 137, 153, 162, 180, 224, 251); private collection (xiii); William L. Clements Library, University of Michigan (xvi, 9, 13, 27, 61, 82, 172, 196, 199, 220); Special Collections Library, University of Michigan (191); University of Michigan libraries (218); John Carter Brown Library at Brown University (7, 39 right); the Huntington Library, San Marino, California (125); Rare Books Division, the New York Public Library, Astor, Lenox, and Tilden Foundations (178); General Research Division, the New York Public Library, Astor, Lenox and Tilden foundations (226); the Metropolitan Museum of Art, Rogers Fund, 1941 [41.48] (45 left); the Newberry Library, Chicago (128, 187, 213, 257); Collection of Rachel Lambert Mellon, Oak Spring Garden Library, Upperville, Virginia (206, 208 right, 262 left); Albert Field Collection of Playing Cards, Rare Book and Manuscript Library, Columbia University (216); Linnean Society of London (236); family of Charles E. Bennett (239); V&A Images, Victoria and Albert Museum (208 left, 248); the National Trust Photo Library (262 right).

INSERT

Page One: Print Collection, Miriam and Ira D. Wallach Division of Art, Prints and Photographs, the New York Public Library, Astor, Lenox and Tilden Foundations; *Page Two:* (top and bottom) National Park Service—Fort Caroline National Memorial; *Pages Three and Four:* V&A Images, Victoria and Albert Museum; *Page Five:* (top and bottom) National Portrait Gallery, London; *Pages Six and Seven:* A. J. Cassaigne/ Photononstop; *Page Eight:* Miles Harvey.

ABOUT THE AUTHOR

. . .

MILES HARVEY is the author of *The Island of Lost Maps: A True Story of Cartographic Crime,* a national and international bestseller that was named one of the top ten books of 2000 by *USA Today* and the *Chicago Sun-Times.* The recipient of a 2004–2005 Illinois Arts Council Award for prose and a 2007–2008 Knight-Wallace fellowship at the University of Michigan, he teaches at Northwestern University and lives in Chicago with his wife and children. He can be reached at www.milesharvey.com.